Writing About Eakins

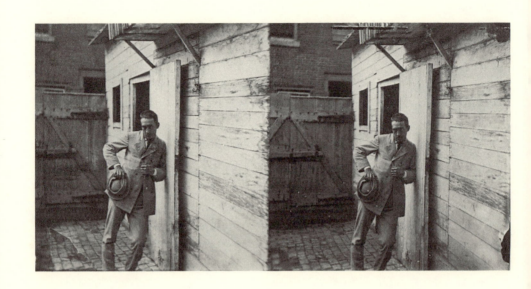

Writing About EAKINS

The Manuscripts in Charles Bregler's Thomas Eakins Collection

Kathleen A. Foster
Cheryl Leibold

Published for the Pennsylvania Academy of Fine Arts
by the University of Pennsylvania Press
ʊᴘᴘ PHILADELPHIA

Frontispiece. Photographer unknown, Thomas Eakins leaning against a building, 1870–76, modern print from a 7¹⁵⁄₁₆ × 4⅛″ glass negative.

This new image of Eakins is from a glass negative that carries two almost identical images of the artist at about 30 years of age. The photo must have been taken before the spring of 1876 because the reversed image of Eakins' face, clipped from a print of this negative, appears on his exhibitor's pass to the Centennial Exhibition. Eakins' contrived pose, and the light grid of pencil lines added to a print made from this negative, suggest that the photograph was taken for a special purpose.

*Copyright © 1989 by the
Pennsylvania Academy of the Fine Arts
All rights reserved*

Published with the support of The Henry Luce Foundation

Printed in the United States of America

*Library of Congress Cataloging-in-Publication Data
Foster, Kathleen A.
 Writing about Eakins : the manuscripts in Charles Bregler's Thomas Eakins Collection / Kathleen A. Foster, Cheryl Leibold.
 p. cm.
 Includes bibliographical references
 ISBN 0-8122-8107-1
 1. Eakins, Thomas, 1844–1916—Manuscripts—Catalogs. 2. Bregler, Charles—Library—Catalogs. 3. Manuscripts—Private collections—Pennsylvania—Philadelphia—Catalogs. 4. Pennsylvania Academy of the Fine Arts—Catalogs. I. Leibold, Cheryl. II. Pennsylvania
Academy of the Fine Arts. II. Title.
Z6616.E23F67 1989
[ND237.E15]
016.7'092—dc20 89-40402
 CIP*

Design: ADRIANNE ONDERDONK DUDDEN

Contents

THE MANUSCRIPTS OF SUSAN MACDOWELL EAKINS

THE MANUSCRIPTS OF CHARLES BREGLER

Illustrations

Foreword

It is with great pleasure that the Pennsylvania Academy of the Fine Arts publishes *Writing About Eakins: The Manuscripts in Charles Bregler's Thomas Eakins Collection*. The acquisition of this collection in 1985, with its trove of art objects, manuscripts, photographs, and memorabilia, was a landmark event in Eakins studies. Most of these materials had been lost to scholarship for over fifty years, and we are fortunate to have been able to acquire the collection with the generous support of The Pew Charitable Trusts. This guide to the manuscripts is the first of three publications documenting Charles Bregler's Thomas Eakins Collection. A major exhibition of paintings, drawings, sculptures, and photographs by Eakins and his circle will be mounted by the Pennsylvania Academy in 1991, and a large catalogue is being prepared to accompany it. A comprehensive catalogue will also be published of the photographs in the Bregler Collection with essays by major scholars in the field.

The manuscript collection demanded separate treatment, and the lively interest in these texts has dictated their choice for the first book in the series. The Pennsylvania Academy is pleased to bring these papers to light in a new kind of publication, befitting the start of a new era in the biographical and critical analysis of one of America's greatest painters. Kathleen A. Foster and Cheryl Leibold are to be congratulated on this excellent guide to the manuscripts in the Bregler Collection. They have produced a work that is much more than an overview. It will be an indispensable guide to Eakins' writings as a whole, as well as a useful tool in research on his wife, Susan Macdowell

Eakins. We are indebted to the staff of the University of Pennsylvania Press, especially to Jo Mugnolo and Alison Anderson, for their patience and perseverance in producing this book.

I have the pleasant task of acknowledging with great thanks the contributions of several organizations. The papers have been housed and conserved thanks to support from the National Endowment for the Humanities, the Henry Luce Foundation, and the J. Paul Getty Trust. Their funds underwrote expert work on the letters by the staff of the Conservation Center for Art and Historic Artifacts in Philadelphia and careful cleaning and repair of many of the photographs by Debbie Hess Norris. In addition, the Henry Luce Foundation very generously provided complete funding for the preparation of this book and the accompanying Microfiche Edition.

LINDA BANTEL
Director of the Museum

Preface and Acknowledgments

In the preparation of this book and the accompanying set of microfiche reproductions we have had no model, for none exists. Previous publications of manuscript collections have usually followed a traditional format, printing selected letters alongside critical commentaries or notes. By this method, many papers necessarily remain unpublished. More modern, all-inclusive publications with microform reproductions of all the manuscripts in a given collection or series have typically been accompanied by a guide that serves as an index to these films, a checklist and nothing more. We have invented a hybrid of these two types, specifically designed for this medium-sized, narrowly focused body of material. Charles Bregler's Thomas Eakins Collection is small enough to allow attention to all its parts and rich enough to deserve such consideration, but it is too large and uneven to merit indiscriminate publication in typeset or individualized annotation. The desire to present the material thoughtfully and promptly to readers with a range of interests has created this mixture of critical and descriptive purposes, this combination of selective analysis and comprehensive publication. We hope that this book can be used independently, as a digest of the most important material in the collection, or in the company of the microfiche reproductions, as a guide to more detailed study.

Many past and present members of the Academy's staff have been swept up in the excitement of the Bregler Collection, contributing time and expertise to the present publication. Frank H. Goodyear, Jr., made an important impression on Mary Bregler when he was the Academy's curator; now its

President, he has worked hard to acquire the collection. Linda Bantel, director of the Academy's museum, has lent support to all the staff members working on the project. We thank her and our associates Marietta Bushnell, Mary Mullen Cunningham, Rick Echelmeyer, Robert Harman, Susan James-Gadzinski, Catherine Kimock, Helen Mangelsdorf, David Rashkis, Gale Rawson, Catherine Stover, Jeanette M. Toohey, Cynthia Haveson Veloric, and James Voirol. Elizabeth Milroy deserves special credit for her early assistance with the acquisition and inventory of the entire collection and her thoughtful comments on the book as it developed.

Colleagues outside the Pennsylvania Academy have been extremely helpful with research queries, particularly persons working with kindred collections at the Philadelphia Museum of Art, the Hirshhorn Museum and Sculpture Garden, and the Bryn Mawr College Library. Thanks go to David Bridgman, Susan P. Casteras, Judith Keller, Mary Leahy, Jack Lindsay, Henry Reed, Phyllis Rosenzweig, Darrel Sewell, James Tanis, Michelle Taylor, Mark Thistlethwaite, and Judith Zilczer. At MICOR, Inc., James Cavallero and John Dennis were instrumental in the production of the excellent set of microfiche. As the manuscript of this book progressed, other friends and scholars gave time to this project: Kathleen Foster is especially grateful to William I. Homer, Elizabeth Johns, and Theodore E. Stebbins, Jr., who were kind enough to read portions of the text and offer good suggestions. At Indiana University, Jacki Anderson helped her with the last details, and Thomas Ehrlich added encouragement. Isabella Chappell gave sound advice and welcome enthusiasm. Most of all, she thanks Henry Glassie, who made many wise and helpful observations in reading and discussing the manuscript, and patiently, unstintingly, supplied moral support. Cheryl Leibold would like to thank Douglas M. Klieger for his loyal support.

We regret that the two persons most interested in these papers did not live to see their publication, although both celebrated with the Academy upon learning of the collection's acquisition. Lloyd Goodrich was pleased to see these manuscripts come to the Academy and lent his support to our efforts to purchase them. Seymour Adelman, who rescued the Eakins house and gave it to the city of Philadelphia, wept when he saw the long-lost Eakins armchair in the Academy's vault. The present book rests on the dedicated work of Goodrich and Adelman, who stand with Susan Macdowell Eakins and Charles Bregler as the four pillars of contemporary knowledge of the artist Thomas Eakins.

KATHLEEN A. FOSTER
CHERYL LEIBOLD

Tom last fall had a serious attack of "Malarial Fever" which kept him in the house for 10 or 12 weeks, since then he is all right, painting away—. . . he will be able to make a living, that is all any of us get. This is a fast age and I hope it will not prove with him as it did with many of the old Master,—receive great honors a hundred years after they had starved to death."

(from Benjamin Eakins to Henry Huttner, July 29, 1874)

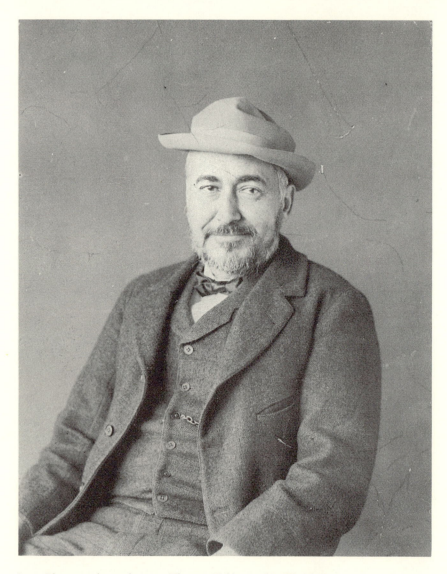

1. Photographer unknown, Thomas Eakins at 50–55, 1890s,
gelatin print, 4⁹⁄₁₆ × 3⅝″.

*The unusual appearance of the artist in a hat adds to the informality of this
portrait of Eakins in his fifties. Even more remarkable than the hat is the affable
expression on his face, rarely seen in photographs or portraits at any time in his
life. Perhaps this mood was elicited by his student Samuel Murray, who has been
suggested as the photographer. This original photograph has previously been known
only through a copy print made by Bregler for the Metropolitan Museum of Art.*

Introduction: The History and Character of the Manuscripts

KATHLEEN A. FOSTER

Charles Bregler's collection of Thomas Eakins material has tantalized the American art world for decades. Rescued, according to legend, from the trash heaps and bonfires that rose in the aftermath of Susan Eakins' death in 1938, the papers Bregler saved were last glimpsed around 1944, when a handful of manuscripts were exhibited, sold, or shared with scholars. Under cover since then, Bregler's material has inspired curiosity, rumor, and frustration among those interested in Thomas Eakins and his circle. The story of the collection's creation and development, its descent into obscurity, and its return to light, makes in itself an engrossing tale, full of picturesque characters and alternating scenes of mystery, tragedy, and melodrama. Distilled into a sequence of names and dates, this narrative forms the provenance record of the collection; reinvested with contextual detail, it becomes a historiographic investigation of the fall and rise of Eakins' reputation since 1886. The story of the Bregler Collection also provides an introduction to the special character of the material, which has been decisively shaped—reduced, expanded, damaged, restored—by its sequence of changing circumstances and custodians. Three principal writers, three separate households, and a large cast of interested bystanders have all had an impact on the total assembly of extant papers. The interplay of human will and accident that forms such an aggregate historical record must be assessed along with the texts themselves. Before losing ourselves in detail or speeding to general conclusions about the significance of these papers, we must consider a few contextual questions. Do we have everything? If not, why did these items survive and not others? What is *not*

here? When did things disappear? The history of the collection allows us to pinpoint the likely moments when—and why, and by whom—some items were saved and others lost or diverted. From this history also flows the organization of this book, the sequence of the accompanying microfiche reproductions, and the arrangement of the papers in the Academy's Archives.

The material as it is now presented clearly expresses a sequence of major periods and protagonists, but it was found in no such order. In the spring of 1984, when my assistant, Elizabeth Milroy, and I pulled out an assortment of shopping bags, portfolios, and dress boxes from under the bed in the upstairs back room of Mary Bregler's South Philadelphia row house, the collection tumbled helter-skelter into the light. A few large groups of similar items, such as Eakins' letters from Paris in the 1860s, emerged together, but in jumbled sequence, with pages often lost or scattered into other boxes. More typically, diverse manuscripts from all decades of the century between 1860 and 1960 were scrambled together with photographs of many periods, newspaper and magazine clippings, catalogues, art reproductions, Japanese prints, and Charles Bregler's business correspondence. The pleasant puzzle of this disorder was first taken up by Milroy, who read, sorted, and safely housed the papers as she compiled an inventory for the appraisers.[1] Following the Academy's purchase of the collection in 1985, Milroy's general organization was refined by submission to the rigorous logic of the Academy's professional archivist, Cheryl Leibold. The work of Milroy and Leibold, identifying handwriting styles and proposing dates based on context, yielded three large subcollections organized around successive eras and voices: Thomas Eakins, Susan Macdowell Eakins, Charles Bregler.

Thomas Eakins was the protagonist of the first period, which embraced his lifetime from 1844 to 1916. His family's home at 1729 Mount Vernon Street in Philadelphia provided the initial household context. Eakins' manuscripts and papers found in the Bregler Collection, dating from 1863 to 1915, must have accumulated naturally in this spacious house along with all the other art, daily possessions, and debris of a life spent almost uninterruptedly at the same address. Eakins never felt the pressure to discard things that falls upon those who move, or those who stay in confined quarters. He could have saved almost all his papers, by neglect if not intention, and some of the items found by Bregler, particularly letters received late in Eakins' life, may have been saved inadvertently. But if we consider the many occupants of this house during these decades, the selection of extant papers appears neither random nor comprehensive. The irregular chronological distribution of these manuscripts—with dense concentrations in the late 1860s and mid-'80s alongside sparse groups from the '70s—and the one-sidedness of most

of this correspondence suggests deliberate patterns of "collecting" at work even during Eakins' lifetime.

Normally, people will not possess many of their own letters unless correspondents have saved and returned them to the sender or the self-consciousness of the author (usually a businessman, a lawyer, or a professional writer) has inspired the retention of drafts or copies. Neither of these categories accounts for the majority of Eakins' letters in this collection. Tom's letters to his fiancée, Kathrin Crowell, most likely given to him by her brother Will after her death, indicate a lone instance of returned correspondence; the retention of personal drafts and copies by Eakins himself seems to be exceptional rather than habitual practice. Benjamin Eakins' business correspondence relating to his investments and his career as a writing master must have made a considerable stack of items, but none of it remains.

Most of Eakins' original letters found in Bregler's collection are of another, more familiar type: letters sent home, addressed to other members of the family at times when Eakins was away—in Paris, the Dakotas, Maine. The retention of suites of letters from these journeys tells us something about the selective historical self-consciousness of Eakins' family, for even in an unusually literate and historically minded culture their respect for his letters built a rich archive. Winslow Homer and his family, by comparison, either wrote little or saved much less. Perhaps the Eakins circle, centered on the writing master, Benjamin, had more respect for the word and page, in addition to a secure sense of Tom's greatness. Benjamin and Caroline Eakins clearly treasured the letters their son sent home from Europe. Probably Benjamin Eakins kept these letters among his own papers until his death in 1899, just as Eakins' sister Fanny sequestered her collection, which was not discovered until after her death.[2] Susan Eakins seems to have kept letters from every occasion when her husband was away long enough to write, which was not often. Rarely apart during thirty years of marriage, they had few occasions to correspond, so his letters were additionally special. Susan, like Benjamin and Fanny, seems to have saved almost everything he wrote.

Evidently Tom did not return the compliment. There is no trace of Susan's letters to him in Maine or the Dakota Territory, nor—with only a few exceptions—the letters sent from family and friends while he was in Europe. William and Emily Sartain saved many of his letters to them (now held among the Sartain papers at the Historical Society of Pennsylvania, or at the Pennsylvania Academy); Eakins saved two of theirs. J. Laurie Wallace carefully retained his teacher's letters, bequeathing them to his own student George Barker (who turned some of them over to Bregler); Eakins apparently kept nothing from Wallace. With perfect consistency, Eakins guarded only

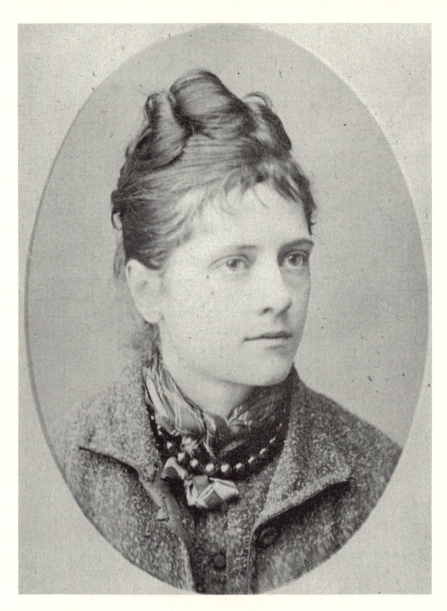

2. L. Horning, Susan Macdowell Eakins, 1870s,
 albumen print, $3^{13}/_{16} \times 2^5/_{16}''$.

This lovely carte-de-visite *image of Susan in her early twenties tells much about
her appearance in 1876, when she first met Thomas Eakins and began her studies
at the Pennsylvania Academy of the Fine Arts.*

the letters from *his* master, Gérôme. With this one exception, the unilateral survival of just Eakins' side of the correspondence seems too near-perfect to have occurred by chance, but too inconsistent to be the result of strict weeding by some other household member, such as his wife, affectionately bound to many of the other writers as well. Many letters, some controversial and some quite vapid, survived in the custody of later owners; why not the newsy letters to Tom from home? Susan's modesty might have prompted her to discard her own letters, or destroy those from her husband's early sweethearts (Sartain and Crowell) or from her estranged sister-in-law, Fanny, but would she have thrown out her father-in-law's correspondence if her husband had respectfully laid it aside? Judging by the nonchalant treatment he gave his drawings, all too evident in their condition, Eakins was not sentimental or fastidious about most of his personal papers. "Why do you keep all that, Susie?" he asked his wife when he found her storing his drawings. "Look how much closet space they take up. They will all be burned after we're gone, anyway—so why not burn them now?" As Seymour Adelman noted in telling this story, Eakins expected little of posterity.[3] If a preliminary conclusion can be drawn from the shape of the Bregler Collection, it would be that most of Eakins' extant papers survived in spite of Eakins' neglect, or thanks to the concern of others.

When Eakins *did* care about the contents of a letter, his actions make an electrifying difference in the record. Deeply concerned about the survival of an accurate account of his side of the story, Eakins made and retained drafts as well as copies of correspondence that took place at the time of his forced resignation from the Pennsylvania Academy in 1886. He sent official letters to the Academy and later to the Sketch Club (now held in the archives of each institution), while guarding complete copies and drafts for himself. In the case of the Sketch Club proceedings, he prepared a running transcript of the entire sequence of eleven incoming and outgoing letters. The preparation of this kind of elaborate document, perhaps intended as a dossier to share with his contemporaries if not as a record for posterity, illustrates the vigilance of Eakins' own historical consciousness on certain crucial occasions. Twenty years earlier, in Paris, he had copied into his notebook the three letters that opened the way for his entrance into the École des Beaux-Arts.[4] Although these letters are now lost, along with most of the mail Eakins received in Europe, he held the transcriptions as a record of his passage into professional life. A decade later, in 1876, Eakins observed the distortion in contemporary photographic reproduction of color values, and made his own black-and-white replica of *The Gross Clinic* for the cameras of the Braun Company, to insure an accurate image of the painting for distribution in the United States and abroad.[5] Mistrusting others—particularly those perceived

as prejudiced, such as the Academy's directors, the Sketch Club's officers, or imperfectly "panchromatic" film—Eakins took responsibility on such occasions for his own history. The formal and premeditated tone of Eakins' letters "for the record" contrasts dramatically with the conversational run-ons of his Dakota letters written not long after. The more formal letters look strikingly different, too: the paper is larger and better, the handwriting polished like a writing master's. The public manner recurs in the other texts that Eakins himself chose to copy and thereby save: letters about disputed commissions, such as the Robert C. Ogden portrait, or concerning the troublesome behavior of his student Lilian Hammitt.[6] We can assume that Eakins would not have made such copies if he were not concerned about clarifying his position or defending his reputation. Though he insisted to those who questioned him that "my life is all in my works,"[7] such texts are clearly deliberate gifts to his biographical record, polemical donations intended to influence any history written on his behalf.

After the artist's death in 1916, his wife took charge of the mission to defend and enhance Eakins' reputation. Her opinions and actions had already stayed her husband's impulse to burn things, and after 1916 her curatorial zeal only increased. As Seymour Adelman recalled, "she treasured *everything* that came from Eakins' hand."[8] Mrs. Eakins' companion at 1729 Mount Vernon Street, Mary Adeline ("Addie") Williams, was a one-quarter owner of Eakins' estate, but her voice appears nowhere in the Bregler manuscripts of this period. Although she consented, with Mrs. Eakins, to the donation or sale of artworks from the estate, Addie left the correspondence to Sue.[9] Most of Mrs. Eakins' extant papers are from the two decades at the end of her life, which she largely dedicated to the care, exhibition, and disposition of her husband's art, always with the intention of securing a lasting place for Eakins in the nation's cultural history. In 1929 and 1930, encouraged by Fiske Kimball, the Director of the Pennsylvania Museum (now the Philadelphia Museum of Art), Mrs. Eakins and Miss Williams donated a magnificent selection of Eakins' art to establish a projected Eakins Memorial Gallery in the new museum building.[10]

The "Eakins Gallery" donation included no manuscripts, probably because Mrs. Eakins felt them too personal, too controversial, or simply incidental to the art. Perhaps she had not yet given them adequate consideration. Her attention to the papers was soon stirred by the arrival of young Lloyd Goodrich, who announced his plan to write a biography of Thomas Eakins along with a catalogue of his work. Between 1929 and 1932 Mrs. Eakins shared dozens of manuscripts with Goodrich, who conscientiously transcribed the texts of many letters and notebooks. Other items were copied by

3. Thomas Eakins, Mary Adeline Williams, ca. 1890,
 albumen print, 4⅝ × 3¼".

_Addie Williams, a family friend from childhood, joined the Eakins household at
1729 Mt. Vernon St. in 1900 and remained until Susan's death in 1938.
Thomas left her a portion of his estate, and it was in both Susan's and Addie's
name that the 1929–30 gift of many works by Eakins was given to the
Pennsylvania Museum (now the Philadelphia Museum of Art)._

Mrs. Eakins, perhaps as a helpful gesture at times when Goodrich could not visit, or perhaps because she felt it necessary to restrict his access to sensitive material within a given letter. Together, their transcripts provided the basis for fact and quotation in Goodrich's monograph of 1933 and his much-enlarged revision of 1982. The original letters stayed with Mrs. Eakins; the transcripts remained in Goodrich's files, where they became almost inaccessible.[11]

A comparison of Goodrich's published texts and the original manuscripts, now part of the Bregler Collection, validates the accuracy of his copies, which vary only slightly in small matters of punctuation, spelling, word order, or word recognition. Surprise lies in the amount of material that he never chose to publish. Mrs. Eakins' transcripts are another story. The simple fact of her editing has provoked questions about what she left out, encouraging the suspicion that the excised pages or paragraphs contain provocative new information. When Goodrich later had an opportunity to compare one of her transcripts with an unedited text, he found her editing "minor."[12] However, in the five cases where her extant transcripts can be compared to letters now in the Bregler Collection, Mrs. Eakins' versions show drastic abbreviations, reducing many pages to one sentence and sometimes conflating texts from two different dates.[13] The material she deleted or condensed is interesting to us now, but it is hardly incendiary. Evidently, she felt Eakins' anecdotes about student life in Paris were unnecessary to Goodrich's task, being either too mundane and trivial, or too confusing to the story line. Eakins' entrance into the École was a complex and slightly murky procedure, as his letters now reveal. In the interest of simplicity, Sue must have decided that the fact of his attendance at the École and the nature of his relationship with Gérôme were paramount. Eakins' maneuvers to gain admission, so intriguing to us now as an early demonstration of persistence, resource, and guile, must have struck his wife as needlessly convoluted and unflattering. Her editing shows an attitude voiced elsewhere in her remarks about Eakins: always positive, supportive; simplifying rather than qualifying; seeking strong contours rather than niggling details; driving toward epic, not anecdote.

Unfortunately, the Bregler Collection does not provide a very wide sample of Mrs. Eakins' editing style, with only five Paris letters to compare to her transcripts. Three-quarters of her transcripts—including Tom's suite of eight letters to his father from Seville in 1870—still stand alone, the originals lost or as yet unlocated. The spirit of her editing can be judged in the light of her broad treatment of the Bregler texts, but speculation about deleted material cannot entirely cease.

Better proof of Mrs. Eakins' editorial policy lies elsewhere in the Bregler Collection, in the material that she completely withheld from Goodrich: the letters alluding to the insanity of Eakins' student, Lilian Hammitt, her own memorandum on the circumstances surrounding the suicide of Eakins' niece, Ella Crowell, and the affidavit of Eakins' brother-in-law, William Crowell, made at the time of Eakins' resignation from the Pennsylvania Academy in 1886. Her retention of such documents from three of the most controversial incidents in her husband's life would seem to indicate apprehension about their release but unwillingness to bury these documents herself, notwithstanding her instruction to Addie Williams, attached to the packet of Hammitt letters: "The contents of this box destroy."(fig. 4) Since the general outline of all Eakins' scandals was known, Mrs. Eakins' discretion simply suppressed renewed discussion and obscured circumstantial detail, perhaps to spare further grief to those still alive in the 1930s or, again, to cleanse and simplify the story line of the Eakins legend as it emerged in the decades following the artist's death. For her purposes, it was sufficient to disclose Eakins' injury at the hands of an envious and narrow-minded conspiracy; the particulars of his enemies' contemptible allegations deserved oblivion. In such cases she concealed unhappy and perplexing material but no previously unsuspected circumstances or dark family secrets. The revelations won from this bundle of hidden material tend to relax further speculation about Mrs. Eakins' editorial decisions on other occasions, for it would be contradictory for her to mark these extremely sensitive papers for destruction and then burn others herself.[14] In any event, this new cache throws light into the darkest corners of Eakins' life; additional detail might be interesting, but it is hardly needed, for the present manuscripts already bring us close to the limits of whatever large truths can be known about Eakins from written evidence.

If Susan Eakins withheld material from Lloyd Goodrich with one hand, she gave with the other far more information than he could use in 1933. His selective citation of the texts he held in transcript has created a different kind of confusion for scholars relying on his published fragments. The early monograph stood for fifty years as the principal fountainhead of quotations from primary sources, although he used only a tiny fraction of his material, referenced it imprecisely (or not at all), and sometimes manipulated remarks out of context. Separate quotations, published pages apart, were used to illustrate Tom's discouraging struggle with his color studies at the École followed by gradual progress and optimism; the original texts show that both statements quoted came from the same letter. Such minor distortions were to a degree corrected in the fuller citations appearing in Goodrich's revised

May 6 - 1919

Addie.

The contents of this box destroy You can look at them if you care too, but they are to be burned — destroyed completely.

Sue. M. Eakins

4. Susan Macdowell Eakins to Addie Wiilliams, 6 May 1919.

When Bregler discovered this note shortly after Mrs. Eakins' death, it accompanied a group of letters relating to Eakins' dismissal from the Academy and his friendship with Lilian Hammitt.

version of the 1933 text, published in 1982.[15] Further error can now be forestalled by the present microfiche reproduction of all these letters, with their wealth of detail unabridged.

But what of the items shown to Goodrich or copied by him and Mrs. Eakins that have *not* emerged among the Bregler manuscripts? Considering only the extant texts from the European sojourn, including some 120 letters or fragments to or from Eakins during the years 1866–70, Elizabeth Milroy listed 21 letters now known only through Mrs. Eakins' transcripts, and 2 items known only in Goodrich's copies.[16] When Charles Bregler visited the Eakins house after Mrs. Eakins' death in 1938, he reported that many of the papers had already "gone elsewhere," probably to Addie Williams or the Macdowell heirs. Bregler unsuccessfully "searched every drawer [and] closet" looking for Gérôme drawings that he and Murray knew Eakins had once owned, and he remarked that he "failed to find" certain other items, commenting darkly that "if they were taken by some person during [Mrs. Eakins'] life time without her knowledge, one can only surmise."[17] Bregler did not leave us an inventory of his own collection, so we will never know what exactly he found—or failed to find—after Mrs. Eakins' death, but it seems possible that some of the letters seen by Goodrich in the early 1930s had "gone elsewhere" by 1939.

Did Susan Eakins destroy these lost originals? Since she was unable to bring herself to burn some of the most volatile items, preferring to delegate the task to Addie Williams, it seems unlikely that she purposefully discarded a very interesting and seemingly harmless group such as the Seville letters, or a flattering series of remarks from Jean-Léon Gérôme. According to Bregler, many things were given away spontaneously to enthusiastic visitors. Others may have been thrown away, wilfully or accidentally, in the course of housecleaning. One round of sorting took place two years after Eakins' death, when Susan set aside the Hammitt letters for Addie's attention ("You can look at them if you care too, but they are to be burned"; see figure 4) alongside another, more boring pile ("letters do not read / just destroy / they only interest Tom and Sue"). Because these notes and a good many controversial letters survived, we can assume that her plans were never carried out. A decade later, reinspired by Goodrich's inquiries, or by Charles Bregler's publication of his reminiscences of Eakins' teaching, or by a sense of her own advancing age, Susan slowly began to organize her papers again. Her own letters in the late 1920s and '30s refer to painting the house and reinstalling the paintings, "sorting and weeding out" her things, and generally "simplifying." In the course of such campaigns, much could have been discarded.[18] Still, Mrs. Eakins' weeding of her husband's papers seems to have been slight,

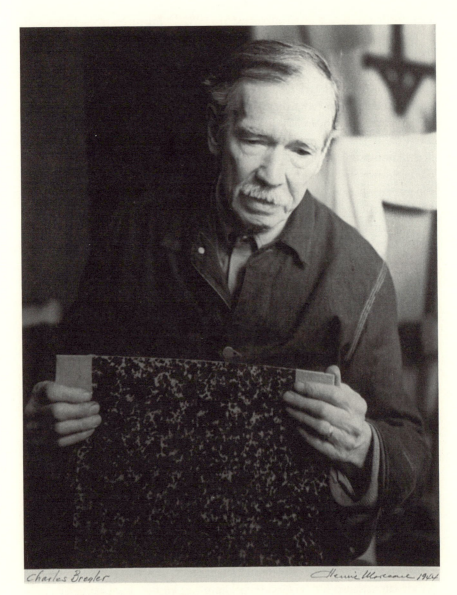

Charles Bregler *Henri Marceau 1944*

5. Henri Marceau, Charles Bregler, 1944 ,
 silver print, 9⅜ × 7⅞⁄₁₆″.

*In 1944 Bregler lent a selection of objects from his Eakins collection to the
Pennsylvania Museum for its Eakins centenary exhibition. Marceau, then chief
curator of the museum, took a series of six photographs of Bregler at the age of 80,
holding one of the portfolios containing his treasured collection.*

judging from the range of material now extant as well as from accounts of her home and its reverential atmosphere in the 1930s, when it still seemed "that things had changed little since the days of young Tom and his father Benjamin."[19]

Mrs. Eakins' hand on the collection was gentle in comparison to the upheaval that followed her death in December of 1938. After more than eighty years of continuous occupation by the same family, the house at 1729 Mount Vernon Street was emptied and sold, its most valuable contents distributed to heirs, art dealers and auction houses. For Charles Bregler (figure 5), who became at this time a principal actor in the history of the collection, the disruption was profoundly upsetting. A disciple of Eakins for fifty years, Bregler was now over seventy himself. His retiring manner hid a fierce devotion to "the Boss" and his wife. Never an intimate member of the family circle during Eakins' lifetime, he drew closer to Mrs. Eakins after 1916 by assisting her in the framing, cleaning, shipping, hanging, and selling of her husband's work. The vague terms of her will, which blindly assigned the distribution of her estate to Francis McGee, a Macdowell family advisor, left the specific handling of her possessions undescribed, and Bregler, with his long experience of the collection as well as Mrs. Eakins' wishes, stepped forward to identify, label, clean, and frame the paintings and sculpture before they left the house. While Bregler composed an inventory and conserved the paintings in preparation for sale or dispersal, the house remained occupied by Addie Williams, her niece Lucy, and Susan's sister, Elizabeth Macdowell Kenton (figure 22), who had lived in the house off-and-on for many years. Williams and Kenton, both strong-minded, battled constantly. Bregler's misery in this "poisonous mental atmosphere" turned to despair as efforts to collect payment for his services dragged on into 1940. He had lived modestly, even precariously, his finances burdened by the illness of his wife and his welfare frequently dependent upon employment by Mrs. Eakins and generous gifts from her. The strain of uncompensated work in this year, added to the tense relations all around, must have intensified Bregler's grief over the loss of Mrs. Eakins and the stable memorial to her husband's life and work that the Mount Vernon Street home represented.[20]

With Samuel Murray, a student who had become something like a son to Eakins in the 1890s, and Seymour Adelman, a much younger art lover who had introduced himself to Mrs. Eakins in 1931, Bregler shared a sense of anxiety and responsibility, as if the mission to preserve the Eakins legacy had fallen on their shoulders, even while the actual contents of the estate passed into the hands of others. In this mood, Bregler and Adelman launched a campaign to save the house as a memorial site, and together they morosely

attended the sales at Samuel T. Freeman's Philadelphia auction house in July and October of 1939, when furniture and small paintings from the house were sold. Bregler and Adelman bid on the familiar armchair that had held so many of Eakins' sitters, a chair that Bregler always insisted Mrs. Eakins had promised to him and that he saw as a prime piece of the "Eakins Room" of his dreams.[21] More than three decades would pass before their schemes for the house (since 1972 a community arts center) and the memorial gallery (installed in 1976) would bear fruit, so all three disciples had reason to be discouraged. "These past months I have learned, seen, heard much. It's a sorrowful and tragic ending," wrote Bregler to Murray in July of 1939. "You know all this as I do."[22]

During this unhappy period Bregler emerged as the new curator of the Eakins papers. His hand would be dominant for the next twenty years, until his death in 1958. The circumstances of his acquisition of the material remain murky, although they can be imagined from information contained in some of the manuscripts in the collection. Bregler had daily access to the house for five months as he compiled an inventory and worked on the paintings. At this time he claimed a certain number of things as his own. Mrs. Eakins had shared the fourth floor studio with Bregler, and some of the art supplies were his. Other items he described as gifts from Mrs. Eakins in years past, such as the perspective drawings, or promised to him in the future, like the chair.[23] The bank officer from Fidelity-Philadelphia Trust Company, A. C. Morgan, had asked Bregler to remove "his things" in June 1939, but Bregler had delayed, awaiting the removal of the furniture. In his letter to Murray the following month Bregler stated that he had not learned of the final clearing of the house until it was over, and he worried that items left unlabeled—like the chair—might have been mistakenly removed by the auctioneers. "I do hope they have not carted away [any]thing, Mrs. E. had given me and which it was my plan to preserve for the Eakins room," he wrote.[24] His fears proved justified when he visited the house the following week with Morgan. Bregler was met by

> the most tragic and pitiful sight I ever saw. every room was cluttered with debris as all the contents of the various drawers closets etc were thrown upon the floor as they removed the furniture. All the life casts, etc. were smashed. One of the horse Clinker I saved and gave to the Graphic Sketch Club, as Mrs. Eakins wished. The frames and other things she wanted me to give to students. But I could find no one who wanted them. So they were carted away. I never want to see anything like this again.[25]

Perhaps in that moment of shock and disappointment Morgan granted Bregler leave to take the remaining "debris," all of it material insignificant to the

heirs, or to the representatives of Babcock Galleries or Freeman's auction house, who had been asked to cull the estate for salable material. Morgan himself acquired Eakins' first exhibition record book, initially kept by the artist's sister Maggie, and Eakins' medal from the Carnegie annual exhibition of 1907.[26] Adelman, whose collection contained material akin to Bregler's, probably rescued some things at this moment, too. Bregler annotated the first page of the book containing Eakins' "Notes to Class" (recorded by Bregler in 1887 and then copied by Mrs. Eakins) with the circumstances of its discovery.

> This book in the present condition was found on the 3rd floor of Eakins' home in 1729 Mt. Vernon among the rubbish strewn about by the men who removed the furniture. . . . the floor was covered with clippings of pictures which Mrs. Eakins had collected from magazines and newspapers also letters, photos, and some personal trinkets of Mrs. Eakins. Seymour Adelman was with me.

Some division of this "rubbish" probably took place then: Adelman, Bregler, and Morgan each took home at least one notebook, and Adelman received sample items—a selection of Paris letters, one from the Dakotas, a sheaf of photographs, and so forth—from the larger trove that Bregler rescued.[27]

Anticipating this kind of debacle, Bregler had already seized some manuscripts, with the full knowledge of Morgan and Mrs. Kenton, prior to the emptying of the house. "The letters I have were taken solely to keep them safe," he explained to Murray. "If I had not acted when I did, they probably would have gone elsewhere, as many of them did."[28] Bregler's unsafe "elsewhere" may allude to some distant, unappreciative party or, more likely, to those all-too-interested or opinionated household members, such as Elizabeth Kenton and Addie Williams, who might destroy sensitive documents too hastily. Bregler's letters often criticized Williams for her impatient, careless, and sometimes hostile treatment of both Mrs. Kenton and the estate's business, and she may be one of the figures lurking in the smoke of the backyard bonfire that, according to Seymour Adelman, Bregler interrupted at 1729 Mount Vernon Street that spring. Adelman remembered that "a well-meaning but tragically misguided family friend" destroyed many photographs of female nudes. Names, dates, motives, and other details are not elaborated by Adelman or Bregler; like the bonfire stories, these tales now told among art historians are not easily documented.[29] Bregler nowhere mentions such a fire, but he too cites evidence of destruction, noting on the flyleaf of the "Notes to Class" book that "Many of the pages were torn out. no doubt by her sister Elizabeth Kenton / I found many other[s] / that had been destroyed." Such discoveries account for the apprehensiveness and relief in Bregler's remarks

to Murray in the summer of 1939. "In a box I found letters relating to the trouble at the Academy, and the Miss Hammit case, with a note by Mrs. Eakins that they were to be complet[el]y burned," wrote Bregler. "I was surprised to find them, But glad they were discovered before they fell into strangers hands."[30]

Five months later, on December 3, 1939, Bregler evidently informed Mrs. Kenton that he was returning to Mr. Morgan of Fidelity-Philadelphia "the letters etc. which were saved from falling into the hands of persons unfriendly and otherwise." According to his draft, Bregler planned to include Susan Eakins' diary among these papers, with the assurance to Mrs. Kenton that he had reviewed it and "deleted the enclosed papers which should not concern any one but you." More than one diary in Susan's hand, and a collection of loose pages from these same books, plus the Hammitt and Academy letters, were all found in Bregler's collection, suggesting that Bregler never followed through with his promise. However, the loose diary pages do not bear entries of more than ordinary interest to Mrs. Kenton, and Bregler's other papers contain notes jotted down from diaries—or diary entries—that cannot be found in the collection now. Bregler may have returned some things (now unlocated or lost) to Mrs. Kenton and Mr. Morgan. Other items he retained, no doubt fearing Kenton would destroy them. Always outspoken and impulsive, Elizabeth Kenton sided against Eakins at the time of his "trouble" in 1886–87, and although she later confessed her error and apologized, she continued to feel that his behavior invited controversy. For Eakins' sake as well as her own, Kenton had reason to wish the documents of this period forever repressed. Knowing this, Bregler may have felt he had no one to trust but himself.[31]

Bregler's motives and rights at this moment are nowhere documented, except in his own words to Murray, which must be read in the light of the two men's subtle rivalry.[32] Perhaps his fears for the safety of these manuscripts went unallayed, and Bregler decided to safeguard them pending the creation of the long-awaited "Eakins Gallery" at the museum. Perhaps, as Cheryl Leibold has proposed from her reading of Bregler's many pathetic letters seeking payment from the estate for his services, he held the papers as compensation. Generalizing from the attitudes of Morgan and the heirs, and knowing that the material had been assigned no value in the estate inventory, he may have decided to keep it all.

Bregler gathered up this material in 1939 and took it to his home at 4935 North Eleventh Street in the Logan section of Philadelphia. In this new home, under Bregler's reverent care, the papers were less threatened by "weeding," although Bregler's clandestine note to Mrs. Kenton reveals a sense

of discretion that he may have exercised on other occasions. Accidental loss, rather than wilful destruction, endangered the collection under Bregler's custody. He admitted losing Eakins' draft of a letter to Gérôme (although he had only misplaced it), and he may have owned and somehow mislaid the now-missing Spanish letters, but such disappearances must have been rare in his day, as proven by his faithful retention of much more sensitive material.[33] Probably under his management the torn manuscripts received careful but unwise mends with cellophane tape. Others were annotated with comments, indicating Bregler's review of the material, and some items, such as entries from Mrs. Eakins' diary, or the letter from Gérôme, were copied by Bregler for his own use. Rather than shrinking, the collection grew enormously in this period as Bregler assembled his own library and archives to complement the material found in the Eakins house: scrapbooks of reproductions of Eakins' work, newspaper clippings, articles, and catalogues, and many copy photographs of items in the collection, made by Bregler himself, all testifying to the hours he devoted to the memory of Thomas Eakins. His correspondence shows that he tried to purchase new paintings (although often with the intent to resell), and received at least one donation of new material, from J. Laurie Wallace's student George Barker, who sent some Eakins letters to Bregler in 1944, acknowledging that he was now "keeper of the gate."[34] In this role, Bregler generously shared his collection with Margaret McHenry from 1942–45, as she prepared her biography.[35] He also worked on (but never completed) his own "small book" on Eakins, based on the material in his 1931 *Arts* articles, and he published short pieces on Eakins' painting materials, on Eakins' innovations as a photographer, and on Susan Eakins' life and art. Gradually, he established himself as an expert on the conservation and identification of Eakins' work.[36]

Bregler's correspondence with collectors, dealers, and museum curators will be, like Mrs. Eakins' papers, of great interest to the present owners and admirers of work he handled in this period. Certainly his notes and reminiscences from Eakins' lectures and studio visits are an invaluable primary source concerning Eakins as a teacher and painter. Bregler was young and impressionable when his notes from the Art Students' League sessions were taken, but his memories were endorsed by Mrs. Eakins, who remarked that his articles were "really the best writing" about Eakins because, unlike Goodrich's book, they were based on firsthand knowledge of the man.[37] Bregler's impulse to record his master's remarks testifies to Eakins' charismatic presence and the historical awareness of his most loyal admirers. Like Bregler and Murray, many of Eakins' students must have been awed by his accomplishments, outraged by his undeserved injuries, and convinced that the future

would vindicate their faith in his greatness. Bregler felt honored to know Thomas Eakins and burdened with a historical responsibility that followed from his privilege and good fortune. Perhaps he began to take notes as personal memoranda, just because, as one of his friends observed, he liked "to read things over," or he may have been struck immediately by the historical importance of his own experience. Even if he had no plans for publication when he began these notes, Bregler may have consciously imitated Thomas Couture's *Méthode et entretiens d'atelier*—a book Eakins owned and mentioned in his letters—or the more recent and relevant publication of *William Morris Hunt's Talks on Art,* compiled by a devoted student.[38]

In his efforts to describe Eakins, as in his other papers, Bregler imitated his master's self-conscious and deliberate method, saving multiple variant drafts and copies of texts that were difficult to write or important to remember. In the composite created by these many overlapping versions of Bregler's story the reality of his experience emerges: his anger and frustration, his abiding conviction in the greatness of Thomas Eakins. The words of Charles Bregler, like those of Susan Macdowell, are charged with the presence of Eakins as a real person. In repetition and distillation over the years, these same anecdotes gradually become part of a figure larger than life. Decade by decade, the heroic contours grow sharper as the process of myth-making evolves in the years following Eakins' death.

Bregler's experience as well as his formidable collection drew the attention of those organizing an Eakins centennial exhibition at the Philadelphia Museum of Art in the spring of 1944, which appeared in variant versions at Knoedler and Company in New York and in Wilmington, Boston, Raleigh, and Pittsburgh. Bregler lent many things to this exhibition, including letters and memorabilia. At the same time, he consigned to Knoedler's the choicest items from his collection, including most of the pieces lent to the show. Although this decision to sell clearly took advantage of the interest stirred up by the exhibition, Bregler was also in need. His wife, a perennial invalid, died abruptly following an accident in early 1944. Bregler, nearing the age of eighty, was alone, depressed, confused, and in debt. "I am all upset now and trying to put my affairs in order," he wrote to a friend, "so I too shall be ready when that day comes that eventually comes to all of us."[39]

Bregler carefully selected the Eakins items for sale by Knoedler's in 1944: the largest and most finished oils, the most "colorful" memorabilia (such as Eakins' cowboy suit), and manuscripts containing the artist's own sketches as illustrations, such as the well-known letter to his mother that described the furnishings of his room in Paris.[40] This was one of the most appealing letters, visually, and therefore one of the most salable. Market

considerations may have influenced Bregler's choices, but apparently he was not interested in divesting himself, just for simplicity's sake, of the whole collection. Some of the art consigned to Knoedler's and at least one letter (Eakins' note to Larry Phillips about Bregler's drawing board, no. 90) remained unsold, and eventually came back to Bregler. Most of the manuscripts and many works of art never left his custody at all. Bregler found homes for a few other items. Gifts made at the same time as the sale, such as a perspective drawing donated to the Pennsylvania Academy, a plaster cast given to the Graphic Sketch Club, and two oils and many photographs presented to the Philadelphia Museum of Art, demonstrate Bregler's selfless perpetuation of Mrs. Eakins' method of placing key items in appropriate institutions.[41] As late as 1951 he still planned to give his papers to the Philadelphia Museum of Art "for the benefit of some future historian," but his profound disappointment over the delayed construction of the promised Eakins room may have stalled his bequest. Ultimately, like Thomas and Susan Eakins, he made no explicit plans for his collection. Perhaps, as Cheryl Leibold has suggested to me, Bregler still felt that the more controversial papers needed to be safeguarded from "unfriendly" readers, or perhaps he just enjoyed the continued possession of the "Boss's" things.

Bregler received a comfortable sum from the sale of work at Knoedler's, but he continued to live modestly, somewhat adrift and forlorn. In the late 1940s Mary Louise Picozzi, a young woman from South Philadelphia, found him depressed, reclusive, and in poor health. By her account, she was working in a dry cleaner's shop when Bregler came in one day. Moved by his appearance, she dreamed about him on successive evenings and, convinced that he was in trouble, went to his home to find him ill and unable to feed himself.[42] Mary's charitable instincts gradually made her indispensible to Bregler; she became his housekeeper and eventually his "dear wife" and stalwart defender.

Mary Picozzi Bregler was born in 1914, a half-century after her husband and two years before the death of Thomas Eakins. She knew none of the persons or circumstances of her husband's earlier life, except as household legends. Coming from a large Italian Catholic family, she shared little of Bregler's past and was excluded from his renewed life as a painter, which her moral and physical support made possible. Bregler put her in charge of a frugal household allowance and then retreated to his studio, emerging only for meals. She did not interrupt his work (although she posed for him for an oil sketch and for a series of photographic portraits) and learned little about his methods or concerns as an artist. Mary Bregler did become acquainted with her husband's collection, however, for it was a source of frequent discussion. Still incensed by the "loathsome conspiracy" that drove

Eakins from the Pennsylvania Academy, Bregler often turned the conversation to Eakins' ideals and accomplishments even when interviewed on the radio about his own life as an artist.[43] Such self-effacement annoyed Mary Louise, who felt her "Charley" should have promoted himself and his own art more aggressively, but she absorbed the profound respect for the Eakins collection that was displayed in every room of their home.

After Charles Bregler's death in 1958 at the age of 93, Mary Bregler moved back to South Philadelphia, taking the collection with her to her mother's row house on South Warnock Street. Obscure as it had been in Bregler's custody during the last decade of his life, the collection became almost completely inaccessible in this last household. Fearful of theft or even undue attention, Mrs. Bregler hid everything in the basement or in an upstairs bedroom; when Milroy and I first visited in 1983 there were not even examples of Charles Bregler's paintings on view. The collection may have been stored just as it had been moved, with items left in the packing boxes and portfolios assembled in 1958. Mrs. Bregler's writing on a few packages and wrappers indicated her review of some of the papers, and it is possible that she discarded items, although the survival of the most controversial texts and photographs would indicate that, like Susan Eakins and Charles Bregler, she respected everything. By her own account, one box of letters was missing, and she suspected that it had been stolen; perhaps it held the letters from Seville and other items now known only through transcripts. Other packages, such as the "Christmas Silver Paper Box" of old photographs and papers, were found exactly as described in Bregler's estate inventory of 1958. It remains unclear, then, whether the state of disorganization in which the collection was found in 1984 represented conditions in Bregler's lifetime, or whether it resulted from the jumbling created by Mary's move and her subsequent handling of the collection. The miscellaneous clippings of poetry, aphorisms, current events, and spiritual texts found among the papers, all from the post-1945 period, must be considered as the contributions of either Charles or Mary Bregler.

The paintings by Thomas Eakins in this collection were seen by a few people after 1958, including E. P. Richardson, who visited Mrs. Bregler in 1966 in his capacity as a member of the Board of the Pennsylvania Academy. Richardson, in tandem with the Academy's director, Joseph Fraser, opened the first round of negotiations for the purchase of the collection. The manuscripts were not discussed at this time, however, and it is unlikely that they were shared with Richardson, Fraser, or any of the scholars, collectors, and dealers who contacted Mrs. Bregler in hopes of seeing her material. She

answered no inquiries and allowed few visitors to come past the door. Some who did get in were later chased out. About 1972 Mrs. Bregler invited appraisers from Sotheby's to make a partial inventory of the artwork, anticipating a sale that never took place, but evidently the manuscripts were not assessed at this time. These occasional openings of the door at Warnock Street indicated Mrs. Bregler's growing unease about the security of her collection, a worry increased by awareness of her own naiveté in the face of the offers she received.[44]

Growing older and plagued by illnesses, Mrs. Bregler sought relief from the burden of anxieties brought upon her by her husband's collection. When Elizabeth Milroy and I first visited her in the spring of 1983, she was happy to consider the idea of shifting responsibility onto the shoulders of others. Milroy was completing a year-long project funded by the Luce Foundation to organize and enlarge the Thomas Eakins Research Collection at the Philadelphia Museum of Art. In search of Eakins' manuscripts, she contacted me for advice on approaching Mrs. Bregler. With my own longstanding curiosity about the source of Goodrich's transcripts, I quickly offered to join forces to unlock the secrets of the famous collection. Stories of rebuffs to earlier visitors prepared us for a suspicious if not hostile reception, but Mary Bregler was loquacious and friendly. Predisposed to the Pennsylvania Academy by the earlier contact in the 1960s, followed by the friendly visits of the Academy's curator, Frank Goodyear, in the 1970s, Mrs. Bregler divined good intentions in our mission and seconded our worries about her collection's vulnerability to fire and theft. After wrestling with her decision for a year, she agreed in May 1984 to lend her collection to the Academy for safekeeping and preparation of an inventory. Half-expecting her to change her mind, as she had in the past, we arrived with a crew of preparators to wrap and transport whatever we discovered. Mrs. Bregler reminisced with Helen Mangelsdorf, an Academy assistant who was busy wrapping artwork in the living room, while Milroy and I worked upstairs, gasping as we uncovered envelopes with Parisian postmarks, addressed in the unmistakable hand of a writing master's son. With no time to pause and read the texts or stop to assess and identify the material, we simply numbered the boxes, portfolios, paintings, and sculptures, and packed them off into the truck.

The preliminary inventory of the collection, prepared by Milroy after she joined the Academy's staff as my research assistant that summer, led to professional appraisals and negotiations in 1984–85, following Mrs. Bregler's decision to take the next step and sell the collection. With the assistance of her lawyer, William J. Kelly, she concluded an agreement with the Pennsyl-

vania Academy in 1985. All the manuscripts and papers in the collection, excluding some of her own books and correspondence, were included in the sale.

The Academy, as the fourth home and fifth curator of these papers, has arranged them to express the sequence of principal voices and owners. Professional archival procedures have been followed, with just a few methodological inconsistencies to maintain coherent chronological and topical groupings: as a result, some of Susan Eakins' manuscripts appear in all three series of papers, according to the main concern of her texts, and Charles Bregler's classroom notes are found in series I, with Thomas Eakins' own lecture texts. Such organizational decisions are explained in greater detail by Leibold in her chapter on "Editing and Filming Procedures." The protagonists of the collection then follow, each one introduced by biographical or critical notes describing in greater detail the persons involved and the highlights of each set of papers.

Like all the earlier custodians of the collection, the Academy has contributed some of its own papers to the pile. These are described in the chapter on "Manuscripts Pertaining to Thomas Eakins in the Archives," with the hope that the Academy's institutional records, along with the personal papers given to our Archives by the Sartain family, will be usefully integrated into the sequence of the Bregler manuscripts. Cheryl Leibold has also prepared transcripts of the most difficult and important texts for easier reading, a descriptive survey of complementary holdings outside the Academy, and a "Who's Who" identifying the persons who figure in the correspondence of Thomas and Susan Eakins. We hope that such aids, created in the interests of lucidity and accessibility, will compensate for years of obscurity and make this guide a useful handbook for all those engaged in primary-source research on Thomas Eakins' life and art.

Notes

1. Milroy's early work on this collection also informed her doctoral dissertation; see Elizabeth Lamotte Cates Milroy, "Thomas Eakins' Artistic Training, 1860–1870" (University of Pennsylvania, 1986). Milroy's thesis offers a careful investigation of the manuscripts in the Bregler Collection in relation to Eakins' experience in Europe, discussed below in "Letters from Abroad" and "Learning in Paris."

2. Fanny Eakins Crowell denied owning any letters when Lloyd Goodrich interviewed her in the 1930s. In fact, she owned many letters from her brother in Paris. Most of these manuscripts were given by her heirs to the Archives of American Art. See Milroy, p. 30.

3. Adelman's story came from Charles Bregler, who heard it from Mrs. Eakins. See

Seymour Adelman, "Thomas Eakins: Mount Vernon Street Memories," in *The Moving Pageant: A Selection of Essays* (Lititz, Pa.: Sutter House, 1977), p. 164.

4. This notebook was given to the Philadelphia Museum of Art by Seymour Adelman. The texts of the three letters from Lenoir, Bigelow, and Gérôme were published in Gordon Hendricks, *The Life and Work of Thomas Eakins* (New York: Grossman, 1974), p. 292.

5. The ink wash version of *The Gross Clinic* is in the Metropolitan Museum of Art. On the Braun autotype or "collotype," see Theodor Siegl, *The Thomas Eakins Collection* (Philadelphia: Philadelphia Museum of Art, 1978), pp. 64–65; and Lloyd Goodrich, *Thomas Eakins* (Cambridge, Mass.: Harvard University Press, for the National Gallery of Art, 1982), two vols., Vol. I, p. 130 and note, p. 323 [hereafter cited as I/XX, II/XX].

6. Full references to Eakins' letters in the Bregler Collection discussed in this essay, such as the Ogden or Hammitt correspondence, can be found by consulting either the Index to the Microfiche Edition or the Index to this Volume. Some of these letters are discussed or reproduced in full in the section discussing Eakins' manuscripts in particular.

7. Quoted in Goodrich II/6. This letter of 1893 was first quoted by Bryson Burroughs in his introduction to the catalogue for the Metropolitan Museum of Art's Eakins Memorial Exhibition of 1917.

8. Adelman, *The Moving Pageant,* p. 164.

9. Miss Williams probably took charge of her own papers when she left the Mount Vernon Street house in 1939. Bregler's letters from this period indicate that Addie had a falling out with him that summer, and he blamed her for much of the acrimony in the household following Mrs. Eakins' death—circumstances that might have led him to treat Williams' papers unkindly if he had found them. In correspondence with Elizabeth Macdowell Kenton, Bregler remarked that Addie had received monthly wages from the Eakins family, and that her inheritance from Thomas Eakins was simply intended to ensure her continuing care for his wife. Bregler understood that the disposition of the art was entirely Mrs. Eakins' domain. See CB to EMK, 21 Sep 1939; 3 Dec 1939; and n.d. [1939].

10. The history of this donation is recounted by Evan H. Turner in his introduction to Siegl, pp. 7–12.

11. See Lloyd Goodrich, *Thomas Eakins: His Life and Work* (New York: Whitney Museum of American Art, 1933). His account of the circumstances of his research in 1929–32 and SME's assistance at that time appears in the preface of his revised version, I/vii–x. and see Elizabeth Milroy, "Transcript of Interview with Lloyd Goodrich: 23 March, 1983," typescript on deposit in the Thomas Eakins Research Collection, Philadelphia Museum of Art. In this interview Goodrich described Mrs. Eakins' silence on certain topics (Eakins' resignation from the Academy; Ella Crowell's suicide) and her omissions from the letters, although in the latter case he concluded that "it was not so much editing on grounds of morality or anything like that, but more on grounds of what would interest me" (p. 47). In the late 1960s Goodrich began to prepare his expanded text, restricting access to his papers pending the fuller publication of primary sources in the new edition. Thanks to the help of Theodore E. Stebbins, Jr., I was able to consult Goodrich's transcripts of the Paris letters as I prepared my master's thesis, "Philadelphia and Paris: Thomas Eakins and the Beaux-Arts" (Yale University, 1972). Because of my agreement with Goodrich, the publication or circulation of quotations and analysis in this thesis was restricted for a decade, until the appearance of his new text. After 1982 Goodrich was generous with these materials.

12. Goodrich I/viii. Goodrich based this conclusion on a comparison of SME's transcript of a letter against the same text published fully by Margaret McHenry, in *Thomas Eakins, who painted* (Oreland, Pa.: privately printed, 1946). See Elizabeth Milroy, "Transcript of Interview with Lloyd Goodrich: 23 March, 1983," p. 47; and note 33 below.

13. Photocopies of many, but not all, of SME's transcripts were integrated by Elizabeth Milroy into the photocopied sequence of Eakins' letters in the Thomas Eakins Research Col-

lection at the Philadelphia Museum of Art. Other transcripts may be discovered among Goodrich's papers, bequeathed to the Philadelphia Museum of Art and currently undergoing systematic cataloguing. Susan's transcripts for the letters of 6 Oct 1866, 13 Oct 1866 (including material from 26 Oct), 23 Dec 1866, 16 Jan 1867, and 3 Jan [1868] have been matched to Bregler letters by Cheryl Leibold or Elizabeth Milroy. Another transcript by SME known to be in Goodrich's possession (but currently unlocated) was taken from the Bregler letter of 21 Mar 1867.

14. The loss of the most inflammatory letters from the Sketch Club proceedings, the Lilian Hammitt "case," and the Ella Crowell suicide suggest deliberate destruction, perhaps not long after the receipt of correspondence containing upsetting allegations. It is possible that, in sorting this material later, Mrs. Eakins saved only the letters that supported Eakins' side of the story. These events are discussed at length in separate chapters below.

15. Goodrich's limited use of these papers can be understood in the context of his mission in 1933, when Eakins' accomplishment required broad and comprehensive treatment. Goodrich's rich and thoughtful revision and expansion of his text in 1982 did not entirely escape the attitudes embodied in his early work, however. See Kathleen A. Foster, "Review Essay: Thomas Eakins Reconsidered," *The Pennsylvania Magazine of History and Biography,* vol. CVII, no. 3 (July 1983), pp. 457–62.

16. A list of letters or transcripts, with minor omissions, from the 1866–70 period appears in Milroy, Appendix I, pp. 342–50.

17. CB to SM (copy), 23 Jul 1939. The full text of this letter is reproduced on p. x. His actual letter, which varies slightly from this text, is in the Murray papers at the Hirshhorn Museum and Sculpture Garden; see also note 30 below. Bregler's draft notes to his inventory of SME's estate suggest that the other items he was searching for were watercolor studies (series IV, fiche 4).

18. See Figure 4, and note 14, above. The second remark appears on the blank side of a letter from Eakins to Franklin Schenck, 26 Jan 1894. Although the text makes it appear to be a third-person annotation, the handwriting is Mrs. Eakins'. Evidently Schenck's annotated letter was once at the top of a stack of letters slated for destruction but, like the first "destroy" note, it was later separated from the items it referred to. Because of the common tone in these remarks, I suspect that they are both from 1919. Her later rounds of reorganizing are clear in SME's letters to CB of 5 May 1934, 18 Jul 1934, 22 [Jul] 1934, and several letters in the spring and summer of 1927, when she discussed renovating the "old studio" for the display of pictures and "other material." Proof of Mrs. Eakins' weeding was discovered by Bregler, who remarked to Murray that "In the course of years I wrote Mrs. Eakins many letters. But I did not find a single one" in the house after her death. CB to SM 23 July 1939.

19. Roland McKinney, *Thomas Eakins* (New York: Crown, 1942), pp. 20–21.

20. The story of this period can be read in Bregler's papers (series IV), which are not indexed in this volume because so many are undated or without an addressee. His *incoming* letters have been selectively listed in the corresponding chapter below. Most relevant are his drafts and copies from 1939–40, and incoming correspondence from the same years, particularly letters to and from A. C. Morgan, Samuel Murray, and Elizabeth M. Kenton, series IV, fiche 1–5, 9, 12.

21. CB to SM (copy), 23 Jul 1939. The version actually sent to Murray, now in the Hirshhorn Museum, is more explicit about Mrs. Eakins' gift of the chair. Susan Eakins considered making the Mount Vernon Street house into a museum, and she took steps in the late 1920s to refurbish "the old studio" as an exhibition gallery. Encouraged by Adelman, she was counseled against this plan by Bregler, who reminded her of the expense and the fire hazard. After her death Bregler joined Adelman, however, in approaching Mary Butler, president of the Academy's Fellowship (an alumni organization), and the president and director of the Academy to seek support for the purchase of the house. (See letters reproduced in the chapter on Bregler's papers.) Both men purchased items from the estate sales at Freeman's (on July 26 and October 18–19,

1939) for use in the proposed house museum. A catalogue of the first sale has not been located, although Bregler and Adelman both mention it (and the chair) in correspondence now in the Adelman Collection at Bryn Mawr College Library. Paintings by artists other than Eakins and antique furniture from the house were in the October sales; both men bought paintings, and Adelman purchased the well-known tilt-top table; see Adelman to CB 18 Oct and 19 Oct 1939, Bryn Mawr. The failure of the house-museum scheme must have increased the disappointment of bystanders like Bregler, but Adelman stood firm in his resolve. Thirty years later he successfully raised the money for the purchase of the Eakins house, largely by selling his own Eakins collection to Mr. and Mrs. Daniel W. Dietrich II. Adelman then gave the house to the city of Philadelphia. See Goodrich II/282, and Ann Barton Brown, "Thomas Eakins: A Personal Collection," *Eakins at Avondale, and Thomas Eakins: A Personal Collection,* ed. William Innes Homer, (Chadds Ford, Pa., Brandywine River Museum, 1980), pp. 43–44. I am grateful to Mary S. Leahy, of the Bryn Mawr College Library, for sharing relevant letters from Adelman and Bregler in their collection.

22. CB to SM (copy), 23 Jul 1939.

23. Bregler frequently claimed in his papers that he had painted in Eakins' studio for twenty years; see, for example, in his letter draft to Mary Butler [ca. 1939] reproduced in full below, p. 334. When Roland McKinney visited the house in the 1930s, he described meeting Bregler at work in the studio; see his *Thomas Eakins,* pp. 20–21. Bregler's draft list of the items given to him by Mrs. Eakins is included in the inventory he prepared for the estate in 1939, see series IV 4/G/4.

24. CB to SM (copy), 23 Jul 1939, and the variant text at the Hirshhorn.

25. CB to Elizabeth Macdowell Kenton (copy) 21 Sep 1939.

26. The circumstances of Morgan's acquisition of this material remain as vague as those of Bregler's; both could have received gifts or permission directly from the heirs, particularly Mrs. Kenton. Morgan's mementos were discovered after his death and donated to the Philadelphia Museum of Art.

27. Adelman acquired most of his Eakinsiana from the Freeman's auction, from Mrs. Eakins, or from Charles Bregler, who noted in his "diary of visits to 1729 Mount Vernon St." his gift to Adelman of a small drawing in 1939. See *Eakins at Avondale,* pp. 43–44, and catalogue nos. 13 and 14. Many of the Eakins clippings and reproductions found in Bregler's papers may be items saved by Susan that were recovered from the "rubbish."

28. CB to SM (copy), 23 Jul 1939. Bregler added that the executors already had "the most important letters," that is, those referring to financial matters. "Elsewhere" may refer specifically to the backyard bonfire; see note 29.

29. The various versions of the bonfire story, which I heard first as a graduate student at Yale in the 1970s and later in Philadelphia, all lead back to conversations with Seymour Adelman. His remark about the destruction of photographs appears in the introduction of *Thomas Eakins: 21 Photographs* (Atlanta, Ga.: Olympia Galleries, Ltd., 1979), p. xiv; Goodrich quoted this same remark, I/246, and described the bonfire to Elizabeth Milroy; see "Transcript of an Interview with Lloyd Goodrich," p. 46. Bregler's relationship with Williams and Kenton is discussed below; see note 31.

30. CB to SM (copy), 23 Jul 1939. The Hirshhorn's version of this letter is quoted in Goodrich II/97; and Rozensweig, p. 129. The note that Bregler describes was found in the company of the Hammitt letters (see Figure 4); the manuscripts concerning the "troubles" at the Academy were no longer boxed with these letters when found in 1984.

31. EMK to TE, 8 Nov 1888 (no. 174) and n.d. [Sep 1894] (no. 181), discussed below in "Art Club Scandals." Bregler's solicitousness towards Mrs. Kenton in 1939 must be understood in the light of their mutual interests. Bregler defended Mrs. Kenton against Addie Williams that spring, and Mrs. Kenton in turn defended Bregler's case to the bank executors when he later had difficulty collecting a fee for the work he had done on the paintings. The diary pages he refers to may contain references to Mrs. Kenton's brief and stormy marriage to Louis Kenton.

While Mrs. Kenton may have destroyed items she felt were controversial, the entire Macdowell family remained affectionate custodians of "Aunt Susie's" legacy. Manuscripts still held by the family have not been completely catalogued, although some of their letters were published by David Sellin in "Eakins and the Macdowells and the Academy," in *Thomas Eakins, Susan Macdowell Eakins, Elizabeth Macdowell Kenton* (Roanoke, Va.: North Cross School, 1977), pp. 13–45.

32. Bregler's defensive tone throughout his correspondence with Murray in 1939 stems from a dispute over a bronze statuette (by Murray) that both Bregler and Murray claimed as a gift from Mrs. Eakins. Murray had always enjoyed a filial relationship with the Eakinses that Bregler must have envied; following their argument over the statuette Murray evidently made Bregler feel that he had to account for all his claims against the estate. Bregler, already overwhelmed by the "sordid" circumstances at 1729 Mount Vernon Street, felt Murray's suspicions to be the final straw: "May God in his infinite mercy forgive you for your unjust thoughts and accusations. I can only believe you do not realize what you have done to me." CB to SM (copy of postcard), 25 Jul 1939. Murray hastened to make amends, and their friendship was restored.

33. Bregler confessed the loss of Eakins' draft in 1945, as Goodrich reports (I/320), but the letter emerged with his collection in 1984; see "Correspondence with Gérôme," below. Some of the letters from Spain, known today only in Mrs. Eakins' abbreviated transcripts, may have been seen in Bregler's home about 1943–45 by Margaret McHenry when she was preparing her biography, *Thomas Eakins, who painted*. McHenry's bibliography (p. 153) lists a letter from TE to his father from Seville in the "Spring" of 1870 as being owned by Bregler, although the collection now contains only one letter from Spain, dated 7 December 1869. McHenry's text (pp. 19–20) also indicates familiarity with the contents of several other letters from the spring of 1870 that are not cited in her bibliography. She may have relied on Goodrich's information, or Bregler may have had all the Spanish letters at this time. Given Bregler's reverence, it seems likely that these letters were lost after his death, as discussed below. A fragmentary loss, such as the disappearance of the bottom of Eakins' letter to E. H. Blashfield (22 Dec 1894), which was known to Goodrich in its entirety, must have been the result of accident, but, as with the more mysterious disappearance of all the Gérôme letters, the date of the loss is difficult to establish.

34. Barker to CB, 30 Jul 1944.

35. McHenry listed seventeen letters owned by Bregler (see note 33 above) and described the highlights of his collection on page 56 of her text.

36. "Thomas Eakins As a Teacher," *The Arts*, vol. 17 (Mar. 1931), pp. 378–86; "Thomas Eakins As a Teacher: Second Article," *The Arts*, vol. 18 (Oct. 1931), pp. 28–42; "Eakins' Permanent Palette," *Art Digest*, vol. 15 (Nov. 15, 1940), p. 4; "Photos by Eakins: How the Famous Painter Anticipated the Modern Movie Camera," *Magazine of Art*, vol. 36 (Jan. 1943), pp. 28–29; his obituary for SME appeared in *Art Digest*, vol. 13 (Jan. 15, 1939), p. 26. Notes for some of these publications are among his papers; they are discussed in letters to SME (13 Mar 1933) and Goodrich (30 Oct 1940). Bregler's methods as a paintings conservator will be discussed in the forthcoming catalogue of the Bregler Collection, to be published by the Pennsylvania Academy of the Fine Arts in 1991.

37. See CB to George Barker, undated draft ca. 1940; and to Lloyd Goodrich, 30 Oct 1940.

38. Couture's work was published in Paris in 1867; Eakins records purchasing a copy in his letter of 17 Mar 1868 (no. 39). It was translated by S. E. Stewart as *Conversations on Art Methods* (New York: 1879). Helen M. Knowlton edited two volumes of Hunt's teachings, both published in Boston by Houghton Mifflin; series I appeared in 1875 and series II in 1883, after Hunt's death. Bregler's friend, the writer Elizabeth Dunbar, made her remark in a letter to CB from China, 8 Sep 1938. On the nature of Bregler's notes, see "Eakins As a Teacher," and "Eakins Described by Others," below. Elizabeth Milroy has also suggested to me the relevance of Robert Henri's *The Art Spirit*, first published in 1923 (Philadelphia: J. B. Lippincott) and

reissued in 1930 after Henri's death. Bregler's articles in 1931 (cited in note 36) may have been an effort to reiterate Eakins' role in the formation of Henri's aesthetic.

39. CB to George [Barker?], [February, 1944]. Bregler's papers show that prior to 1944 he had corresponded with several collectors, notably Stephen C. Clark, attempting to sell individual paintings, but manuscripts were never offered for sale until 1944.

40. The manuscripts and other printed materials sold by Bregler through Knoedler's were purchased *en bloc* in 1944 by Joseph Katz, along with the paintings and other items in the consigned collection. All Katz's Eakins material came to Joseph Hirshhorn in 1961. The Bregler pieces were then published in Phyllis D. Rosenzweig's definitive catalogue, *The Thomas Eakins Collection of the Hirshhorn Museum and Sculpture Garden* (Washington, D.C.: Smithsonian Institution Press, 1977); see cat. nos. 7–12, 25, 37, 55, 59, 62, and 125 and pages 11–13 for a history of the collection. The only manuscripts to take a different course at this time were Eakins' notes on perspective and drawing, which were sold to Katz but later given to the Philadelphia Museum of Art by his daughter, Ruth Strouse; see Siegl, *Thomas Eakins Collection,* no. 56., p. 109.

41. Eakins' *Perspective Drawing for the Schreiber Brothers* was given by Bregler in 1948; see *In This Academy* (Philadelphia: Pennsylvania Academy of the Fine Arts, 1976), cat. no. 220; reproduced in Hendricks, *Life and Work of Thomas Eakins,* p. 73. Bregler's gift of the plaster relief of *Clinker* to the Graphic Sketch Club is documented in letter drafts to Samuel S. Fleisher in 1939; see also note 25 above. The holdings of the Fleisher Art Memorial are now administered by the Philadelphia Museum of Art, so that this gift is catalogued in Siegl's handbook along with the oils and photographs given to the museum; see pp. 70, 110, 134–35, 167–68. Bregler's gift and sale of photographs to the Metropolitan Museum of Art are also documented in his correspondence with A. Hyatt Mayor; see Mayor to CB, 31 Jan 1944.

42. The biographical details of Mary Bregler's life were obtained from conversations with her in the spring of 1983 and 1984. Another account of this part of the story is given in my article "An Important Eakins Collection," *The Magazine Antiques,* vol. CXXX, no. 6 (Dec. 1986), pp. 1228–37.

43. See CB's draft letter to Julius Block [Bloch], 28 Feb 1944; and his draft to the Pennsylvania Academy [1951]; also Foster, "An Important Eakins Collection," p. 1228. Bregler evidently did not hold a grudge against the later administrators of the Academy, as witnessed by his gift of a drawing in 1948 and the Eakins memorial prize fund he established there at about the same time; see "The Life and Papers of Charles Bregler" in this volume.

44. A 3-page typescript inventory, evidently prepared by Sotheby's and shared with Goodrich, itemizes paintings and sculptures in Mrs. Bregler's collection but does not list manuscripts, except in "unspecified quantities." (Philadelphia Museum of Art, Eakins Research Collection) Goodrich did not attempt to see her material, but he recounted stories of others who visited Mrs. Bregler before 1983. Some were received cordially, but no one saw her collection. See Milroy, "Transcript of Interview with Lloyd Goodrich," pp. 21–22.

Editing and Filming Procedures

CHERYL LEIBOLD

Editing and Arrangement

On arrival at the Academy, the manuscripts in Charles Bregler's Thomas Eakins Collection were in an extremely disorganized state. The original order of the papers had long since been destroyed. There is little doubt that Bregler sorted and rearranged them many times. Papers related to five separate sources were found and were divided into four series: 1) Thomas Eakins; 2) Susan Macdowell Eakins; 3) Benjamin Eakins and the Macdowell family; and 4) Charles Bregler.

For the papers of Thomas Eakins and Susan Macdowell Eakins complete inventories of the manuscripts were prepared (see the corresponding chapters). In these chapters, correspondence is listed first, followed by miscellaneous manuscripts and printed matter. Each correspondence entry is arranged as follows:

Sender to Recipient/ Day Month Year/ Place of Origin
Summary of Contents
Length/ Format/ Signature/ published reference/ [Editorial comments]

All letters are autograph unless specified otherwise. Pagination has been calculated by the editor, except where specifically marked "author paginated." The Format segment of the entry specifies either 1) a *received copy,* i.e., the actual letter sent to the recipient and later returned to the writer or the estate; 2) *Copy* or *draft,* i.e., a version of the letter retained for reference. The word "copy" indicates a letter clearly marked by the writer as a copy. If no format specification appears, the item is probably an unmarked retained copy. A signature other than the writer's name is specified as either "initialed" or "unsigned." Dates or other information not actually appearing on the letter are suggested in brackets. Editorial comments are given in brackets.

Throughout this volume and in the Microfiche Edition the following abbreviations have been used to describe or list the papers:

TE	Thomas Eakins
SME	Susan Macdowell Eakins
BE	Benjamin Eakins
CE	Caroline Cowperthwait Eakins
FE	Frances Eakins
FEC	Frances Eakins Crowell (after 1872)
CB	Charles Bregler
EMK	Elizabeth Macdowell Kenton
SM	Samuel Murray
WJC	William J. Crowell
PAFA	Pennsylvania Academy of the Fine Arts
PMA	Philadelphia Museum of Art
n.d.	no date
n.p.	no place
ca.	circa
p.	page
pp.	pages

TRANSCRIPTIONS

Transcriptions were prepared (and filmed) for many items where legibility was a problem. Punctuation marks were added to the transcriptions only when necessary for the sake of readability. Crossed-out words or passages were omitted only when duplicated in the text; for example, in the sentence "I went to the ~~store~~ store for a pen," the crossed-out word was *not* transcribed. All other crossed-out words or passages were transcribed. Ampersands in the originals were transcribed as such. Illegible words are indicated with brackets,

and a question mark in brackets [?] indicates a word for which the editor has had to make a guess. Undated letters have been dated in brackets by the editor.

BIOGRAPHICAL KEY

Names of senders or recipients of letters (in the Bregler Collection) to or from Thomas Eakins or Susan Macdowell Eakins are in full capitals. Susan's correspondents are differentiated with an asterisk. Names not capitalized represent individuals who are mentioned in the correspondence of the principals or are very important to the study of their lives.

LOCATION INDEX TO THE MICROFICHE EDITION

The index lists dates and names for all correspondents of Thomas Eakins, Benjamin Eakins, and Susan Macdowell Eakins, as well as selected subjects of important documents. The location of the desired item on the microfiche can be determined; see below for further details. The letter R indicates an item for which the transcription has been included in this volume.

The Microfiche Edition

In order to disseminate the papers to scholars and at the same time to protect them from heavy anticipated use, every relevant document has been filmed for the Microfiche Edition. Libraries and museums, as well as interested individuals, may purchase the separate Microfiche Edition of the papers in Charles Bregler's Thomas Eakins Collection, which is distributed for the Pennsylvania Academy of the Fine Arts by the University of Pennsylvania Press.

For the Microfiche Edition the papers were arranged and filmed in four series:

Series I:	The papers of Thomas Eakins, 12 fiche
Series II:	The papers of Susan Macdowell Eakins, 8 fiche
Series III:	The papers of Benjamin Eakins and the Macdowell family, 1 fiche
Series IV:	The papers of Charles Bregler, 16 fiche

Many transcriptions were also filmed. They immediately follow the original document on the fiche. If no transcription appears on the fiche, one

is usually available from the Archives at the Pennsylvania Academy of the Fine Arts. For each series a group of explanatory "target" frames precede the documents. They summarize the arrangement of the papers and give a brief biographical summary of that principal.

THE PAPERS OF THOMAS EAKINS—SERIES I OF THE MICROFICHE EDITION

In both this volume and the Microfiche Edition, incoming and outgoing letters are arranged separately, because in only a few instances are both parts of an exchange of letters preserved. Two exceptions to this are the correspondence with Lilian Hammitt and her family (which arrived as a discrete group along with Mrs. Eakins' note to Addie Williams about burning them) and letters exchanged between Eakins and the Sketch Club (because both incoming and outgoing letters have been preserved). Technically, letters written by Eakins to his wife should have been included with *her* correspondence. This has not been done because, in the four instances in which his letters to her are preserved, the letters document a specific work or event in *his* life—the *Knitting* and *Spinning* panels, the Dakota trip, the Rowland portrait, and the Falconio portrait. Miscellaneous papers other than letters are arranged by subject. Envelopes are filmed after the letter or group of letters to which they refer. The papers of Eakins are filmed in the following order:

Correspondence (Fiche Location I 1/A/7 to 8/B/8)
1. Letters sent, 1863–1914
2. Letters to and from the Philadelphia Sketch Club, 1886
3. Letters exchanged between TE, SME, Lilian Hammitt, and her family, 1887–1893.
4. Letters received, 1868–1915

Personal Papers (Fiche Location I 8/B/9 to 12/B/11)
1. Notes on art
2. Notebook (SME's hand) "Talks to Class"
3. Notes for specific paintings
4. Miscellaneous notes
5. Printed matter saved by, or related to, TE
6. Notebook ("Spanish notebook")

7. Notebook (Exhibition Record)
8. Contents of wallet thought to be TE's
9. Lectures (CB's notes)
10. Art Students' League printed matter
11. Theatrical playbills apparently saved by TE and SME
12. Clippings, n.d., and 1878–1889

The corresponding chapters of this volume contain an item-by-item inventory of all the Thomas Eakins papers in this collection, selected letters transcribed in full, and a critical essay. Whenever possible, page references for Lloyd Goodrich's 1982 two-volume work on Thomas Eakins are included.

THE PAPERS OF SUSAN MACDOWELL EAKINS—SERIES II OF THE MICROFICHE EDITION

The arrangement is the same as for the manuscripts of Thomas Eakins. Separate groups have been retained for Susan's correspondence with Horatio C. Wood, the Pennsylvania Museum, and the Salko family. Letters from her to Bregler are filmed with Bregler's papers. Envelopes are not filmed. The papers of Susan Macdowell Eakins are filmed in the following order:

Correspondence (Fiche Location II 1/A/4 to 4/A/2)
1. Letters sent, n.d. and 1887–1937
2. Letters exchanged between SME, Samuel Murray, and Horatio Wood re dispute over ownership of TE's portrait of Wood, 1917
3. Letters and documents to and from SME and the Pennsylvania [Philadelphia] Museum, 1929–1933
4. Letters exchanged between SME and the Samuel Salko family, 1934–1938
5. Letters received, n.d. and 1886–1938

Personal Papers (Fiche Location II 4/A/3 to 8/D/3)
1. Biographical notes on TE
2. Lists of paintings and prices
3. Printed ephemera re SME
4. Diaries and diary pages
5. Memorandum on Ella Crowell

6. Miscellaneous notes
7. Clippings apparently saved by SME

The corresponding chapters of this volume contain an item-by-item inventory of her papers, an essay describing the collection, and selected letters transcribed in full.

THE PAPERS OF BENJAMIN EAKINS AND THE MACDOWELL FAMILY—SERIES III OF THE MICROFICHE EDITION

The collection yielded three letters to or from Benjamin Eakins. (Letters to him from TE are in Series I.) Six items related to the Macdowell family were also found. See the corresponding chapter for a complete list.

THE PAPERS OF CHARLES BREGLER—SERIES IV OF THE MICROFICHE EDITION

Charles Bregler's papers were selectively filmed for the Microfiche Edition. The omitted materials include his photographs of Eakins' works, his copy prints of Eakins' photographs, correspondence with his family, printed matter unrelated to art, his business files, and Masonic materials. These items may be consulted at the Archives of the Pennsylvania Academy of the Fine Arts. Bregler's notes taken from Eakins' lectures have been filmed with Eakins' papers. Envelopes were not filmed. Newspaper clippings about Eakins, saved by Bregler, were not filmed because of space limitations encountered at the time of filming, although the introductory target for series IV lists clippings as the last item.

The papers of Charles Bregler were filmed in the following order.

Correspondence (Fiche Location IV 1/A/5 to 12/A/3)
1. Letters sent (drafts and copies), n.d. and 1923–1951
2. Correspondence re estate of SME, 1939–1941
3. Correspondence with Pennsylvania Museum re 1944 TE exhibition
4. Correspondence with M. Knoedler & Co., 1944
5. Letters received, n.d. and 1894–1955

Personal Papers (Fiche Location IV 12/A/4 to 16/G/14)
1. "Diary"-type notes on visits to 1729 Mt. Vernon St., and biographical notes on SME
2. Notes on TE and TE paintings
3. CB [?]—inventory of works of art at 1729 Mt. Vernon St.
4. Printed matter (exhibition catalogues and magazine articles) related to TE

The corresponding chapters of this volume contain a biographical essay on Bregler, a brief discussion of the nature of the manuscripts in the collection, a selected list of his incoming correspondence, and several letters reproduced in full.

FILMING PROCEDURES

After conservation treatments were completed at the Conservation Center for Art and Historic Artifacts in Philadelphia, filming took place in October 1986 on the Academy premises. Retakes were accomplished later in the year at the studio of the production company, using photocopies of the documents that needed to be reshot.

TECHNICAL SPECIFICATIONS

Edition size: 37 105mm by 148mm microfiche cards
Film type: Silver halide.
Reduction ratio: 1:14 to 1:27; documents with a vertical measurement of more than 15 inches were filmed on two frames.
Camera type: Kodak AHU 16mm × 100', planetary.
Producer: MICOR, Inc., Bensalem, Pennsylvania

COPYRIGHT AND REPRODUCTION FROM THE MICROFICHE EDITION

All transcriptions, targets, and explanatory material, as well as the arrangement of the manuscripts, are copyrighted. Single microfiche reader/printer copies of any part of this collection are permitted *for research purposes only*. Publication or reproduction for any other purpose must be authorized in writing by the Pennsylvania Academy of the Fine Arts. Contact the Archivist, Broad and Cherry Sts., Philadelphia, PA 19102. Any bibliographical citation of a manuscript in this collection must include the name of the repository.

ARCHIVES OF THE PENNSYLVANIA ACADEMY OF THE FINE ARTS
Charles Bregler's Thomas Eakins Collection
Series I: The Papers of Thomas Eakins

	1	2	3	4	5	6	7	8	9	10	11	12	13	14
A														
B														
C														
D														
E											■	■	■	
F														
G														

Location chart for TE to George D. McCreary, 13 June 1877

HOW TO USE THE MICROFICHE EDITION

The Location Index to the Microfiche Edition lists correspondence by or to named individuals and major subjects within the miscellaneous personal papers. Column 3 gives the Fiche Location Number. For example, to locate the letter and transcription *TE to George D. McCreary, June 13, 1877,* the Fiche Location Number I 3/E/11–13 directs the researcher to series I, fiche 3, row E, frames 11–13 (see the accompanying diagram).

Or to locate the subject-indexed document *Eakins, Susan Macdowell– Memorandum on Ella Crowell* (Fiche Location II 7/G/7 to II 8/A/10, i.e., the end of one fiche and beginning of another), one would consult series II, fiche 7, row G, frame 7 through fiche 8, row A, frame 10.

The Manuscripts of Thomas Eakins

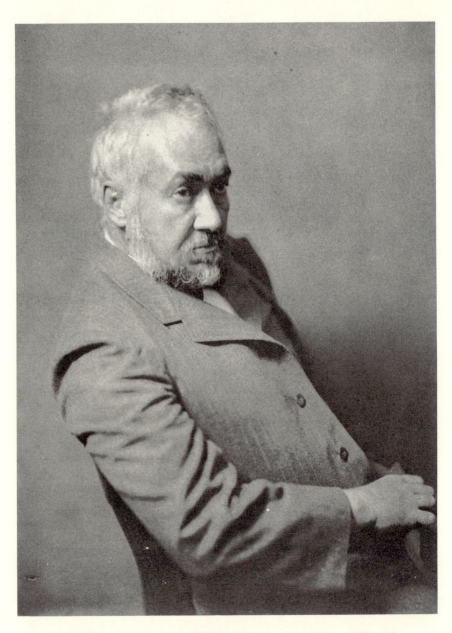

6. Frederick J. von Rapp [?], Thomas Eakins at about 60, ca. 1901–05, platinum print (toned?), or salted paper print, 9¾ × 6¹⁵⁄₁₆″.

Eakins is seen at the time of his late, great portraits. This is a variant pose, taken at the same sitting, of more familiar full face portrait photographs attributed by Hendricks and others to Frederick J. von Rapp in 1901. Mrs. Eakins' diary records von Rapp's visits to their home in 1899 "to print."

Writing About Eakins

KATHLEEN FOSTER

Introduction: A Life in Words

"Thomas Eakins is a difficult subject for the usual biography, because of his objection to having private life written about," wrote his widow, Susan Eakins, to her great-niece Peggy Macdowell. He "did not see any use, except to gratify unnecessary curiosity."[1] She wondered, upon examining Lloyd Goodrich's monograph in 1933, what Eakins would have thought about so many words dedicated to a man who had insisted that, for the public, "my life is all in my work."[2] Eakins would be astonished therefore, by the bibliography that has accumulated on the subject of his life and art since then; he would no doubt be amazed and offended by this present volume, entirely devoted to "writing about Eakins"—his own writings, the written opinion of his family and friends, and our own wordy conclusions or speculations based on this record. The publication of his papers and the scrutiny of their meaning and context necessarily invade private realms that sometimes contain information of little relevance to his art; many details, like the circumstances of Lilian Hammitt's or Ella Crowell's insanity, or his trial by rumor in 1886, would seem merely to "gratify unnecessary curiosity." Individually, these episodes might be dismissed as Eakins' unfortunate, coincidental implication in other people's problems. But together they indicate a pattern, something special about his life and character that attracted a succession of related scandals and miseries. An

examination of the common issues lurking in all these troubles, which invariably rose out of the repressed sexuality of this period, tells us much about the Eakins' catalytic personality and about the environment in which he produced some of America's greatest paintings.

The discussion of the Bregler Collection papers that follows tries to seek larger issues of character and attitude as well as important new facts, drawing attention to the highlights—or lowlights—in the collection. Because the circumstances of every manuscript have not been considered in detail, this book opens a door to further scrutiny of these papers by many scholars to come. Future researchers and present readers may calm their scruples about "unnecessary curiosity" by knowing that Mrs. Eakins, for all her doubts, could not bring herself to destroy these papers. She saved them, as did Charles Bregler, for us to read, remembering that "Mr. Eakins was quiet under abuse, he believed in writing rather than talk."[3]

Letters from Abroad, 1866–1870

Thomas Eakins sailed for France on September 22, 1866, at the age of twenty-two. Except for one brief visit home, from mid-December of 1868 to March 6, 1869, he remained in Europe until June 15, 1870. While studying in Paris at the École des Beaux-Arts or traveling in Central Europe and Spain, he wrote home regularly, composing a record of his experience abroad that would justify his father's financial and emotional support. Far from friends and family, who made a very interested and anxious audience, Eakins poured anecdotes, observations, reassurances, and aspirations into these letters, introducing his own voice to later readers with astonishing vitality. There is no other dense, protracted series of letters like this from Eakins, save perhaps his much shorter sequence from the Dakota Territory in 1887, because he would never again be so far from home for so long, under such heavy terms of obligation. The resulting body of correspondence is a trove for historians; it brings the young Eakins to life and compensates for the rarity of actual paintings and drawings from this important, formative period in his career.

These letters form the most familiar as well as the least known components of Charles Bregler's Thomas Eakins Collection. They seem familiar because half of them have been known, although sometimes only in tiny fragments, from earlier publication by Lloyd Goodrich and Margaret McHenry, who saw them when they were in the custody of Mrs. Eakins or Charles Bregler. The other half of the collection is entirely fresh, however,

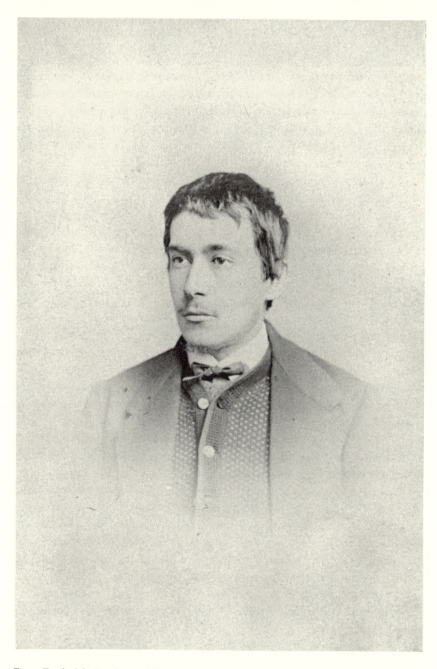

7. Frederick Gutekunst, Thomas Eakins at about 24, ca. 1868,
 albumen print, 3⁹/₁₆ × 2³/₈″.

*This portrait by a famous Philadelphia commercial photographer reveals the artist
as he looked during his student years in Paris. Like the similar carte-de-visite of
his sister (Fig. 10), it may have been made during his return to the U.S. for the
holiday season from December of 1868 to early March of 1869. The first letter he
wrote back to the family on April 23, 1869 asks that they send him photographs of
himself "for the boys."*

having escaped the notice or the attention of earlier historians, including Mrs. Eakins. Although there is much new material in both parts, it fits comfortably into a structure already established by complementary letters known from other collections. The major story line and principal characters have not been overturned or replaced as the result of information in these new letters, nor have any suppressed incidents been revealed that would change our sense of Eakins' basic experience. What is new is a wealth of supplementary detail—about persons, events, opinions—and the rich context of a completed chronological sequence.

The unique character of the entire suite of European letters deserves special description, if only to remark its unusual nature within Eakins' life and within the larger course of American art history. We now have about 130 letters (including fragments and transcripts) from the fall of 1866 to the spring of 1870. Since all but a half-dozen are from Eakins himself, this total suggest that he wrote nearly three letters each month during the three-and-a-half years he resided abroad—an average production that is, in fact, borne out in the fairly even distribution of these letters.[1] This regular reporting, across several years, makes an astonishing record for those wishing to know more about Eakins as he moved from the rank of apprentice to that of journeyman, or more about the experience of one American in Paris during an exciting decade.

Of the total correspondence from this period, more than half is now in the Pennsylvania Academy's Archives, including 12 items from the earlier Sartain Collection (see "Manuscripts Pertaining to Thomas Eakins in the Archives of the Pennsylvania Academy") and 57 manuscripts from Charles Bregler. Of the latter group, 20 letters are partly new, being known to Goodrich through Mrs. Eakins' transcripts and frequently cited in his original biography of 1933 and its revised version of 1982. Mrs. Eakins' copies were often more like excerpts or digests, however, so that even when Goodrich published every word (and he frequently did not), the known text represented only a small percentage of the actual text.[2] As a result, there is much to learn from the original versions of these "known" letters, by way of context, sequence, and supplementary detail. In addition to these texts seen by Goodrich, 6 items quoted or paraphrased by McHenry in her biography of 1946 have come to light in Bregler's collection. These previously published items in the checklist can be identified by a reference to McHenry or Goodrich at the bottom of the entry. Most exciting, of course, are the 31 letters completely unexamined by these earlier scholars. These letters comprise a quarter of Eakins' known correspondence from Europe and therefore offer a wide range of new information about his activities and opinions in this period.[3]

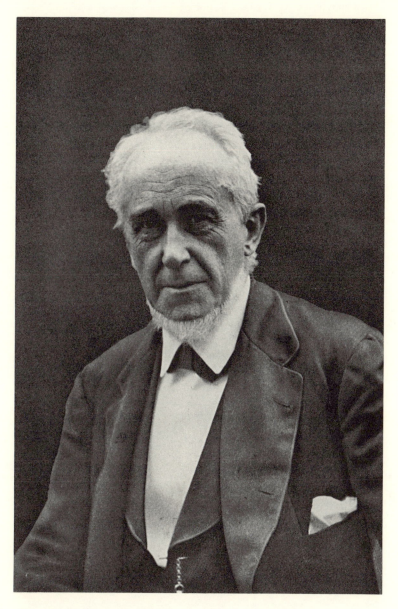

8. Photographer unknown, Benjamin Eakins, ca. 1880–90,
 photogravure, 5½ × 3⁹⁄₁₆".

*While studying in Europe, Tom wrote regularly to his father, acknowledging
Benjamin's unstinting financial and moral support. Thirty-five of these letters in
the Bregler Collection demonstrate their affectionate and respectful relationship.
This previously unpublished portrait resembles other photographs by Eakins of his
father, but the use of photogravure may indicate the hand of a commercial
photographer as well as the sentimental importance of this image.*

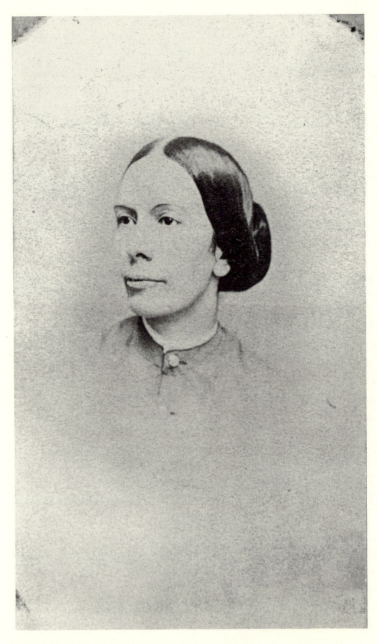

9. Edward R. Morgan, Caroline Cowperthwait Eakins, ca. 1860 [?], albumen print, 2⅞ × 3¹¹/₁₆″.

This carte-de-visite *portrait of Eakins' mother was probably taken earlier than those of the artist and his sister Fanny (Figs. 7, 10). Perhaps he had it with him in France. To his mother Eakins addressed many letters itemizing and justifying his expenses in France.*

Eakins' principal correspondent was, predictably, his father, to whom he addressed more than half of his letters, including 35 manuscripts in the Bregler Collection.[4] These items are most likely to contain his thoughts about the progress of his training and remarks on aesthetics, politics, and current events. He wrote a third as often to his mother Caroline and her sister Eliza Cowperthwait, mostly on topics concerning social life and customs in Paris, or to reckon his expenses down to the last centime.[5] Anecdotes inspired by his recollection of odd expenditures (and a wish to justify them to his parents) make a lively addition to these periodic accounts. The scrupulousness of these records tells much about Eakins' sense of obligation to his parents, and his earnest desire to prove that his time and money in Paris were not being frittered away.[6]

More playful are Eakins' letters or comments to his sisters—Fanny, Maggie, and Caddy—who were 18, 13, and 1 ½ when he left for Paris. His remarks to Maggie and Caddy are affectionately condescending, echoing the superior big-brother tone of his letters to his fiancée Kathrin Crowell in the 1870s. Fanny, however, was addressed more than the others as an equal, and his letters to her are often as thoughtful as those to his father.[7] A streak of male arrogance occasionally surfaces in comments to his sisters or his sweetheart Emily Sartain, revealing an opinion of women made more explicit in his correspondence with E. H. Coates: "I do not believe that great painting or sculpture or surgery will ever be done by women, yet good enough work is continually done by them to be well worth their doing," and well worth giving them the best education. (12 Sep. 1886; no. 70, reproduced in full below). Not much of Eakins' correspondence with either Emily or Fanny is found in the Bregler Collection, however, since most of Emily's letters remained in her family (whence they came to the Academy) and Fanny saved hers in Avondale, where they were discovered and, in large part, given to the Archives of American Art.

The dispersal of half of Eakins' Paris correspondence into other households and ultimately into other archives deserves brief consideration, if only to underscore the richness of the Bregler Collection. Although numerically similar to the Academy's holdings, the letters held in other collections include many incomplete or problematic items. Better than half of these letters are published or accessible in public collections (see "Other Repositories of Thomas Eakins and Susan Macdowell Eakins Papers"), but the remainder (some 26 items) are actually lost, being known only through published quotations in McHenry or Goodrich, or from Mrs. Eakins' sometimes highly condensed transcripts. With the discovery of the manuscripts in Charles Bregler's custody, it would seem that the last great cache of such letters has

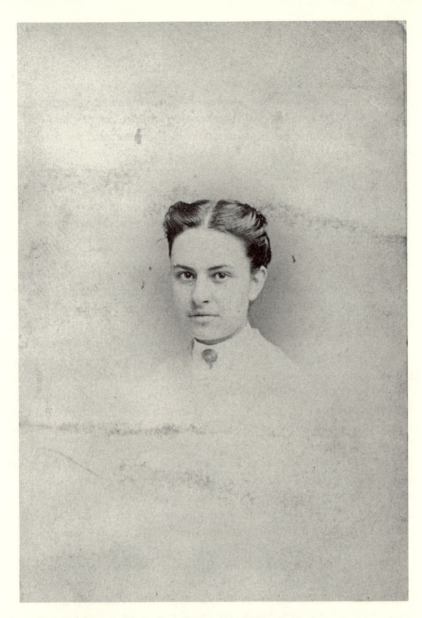

10. Frederick Gutekunst, Frances Eakins, ca. 1868,
 albumen print, 3¹⁵⁄₁₆ × 2½″, Pennsylvania Academy of the Fine Arts,
 acquired from the estate of Gordon Hendricks, 1988.

The same photographer took this carte-de-visite *portrait of Eakins' sister, Fanny,
and one of Tom himself (see Fig. 7), perhaps during Eakins' visit home in the
winter of 1868–69. His sister's picture may have been made expressly for him to
take back to France. While in Europe he wrote often to Fanny of his love for music
and language as well as of their mutual friends including Emily Sartain.*

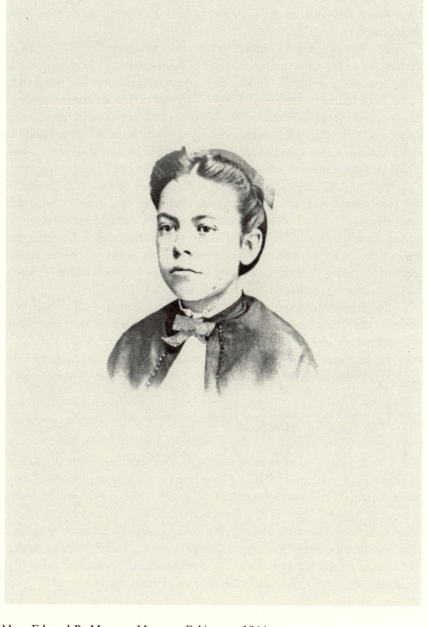

11. Edward R. Morgan, Margaret Eakins, ca. 1866,
albumen print, 3⅝ × 2⁵⁄₁₆″.

This carte-de-visite shows Margaret, the middle sister, at about the age of 12, when Eakins was exhorting her in letters from Paris to work hard at her studies. Even at this age Maggie assumed for the camera a characteristic dour expression, which would become more pronounced in Eakins' later photographs of her. Appearances aside, her fun-loving and spirited nature drew her close to her brother, who enjoyed her efforts as his secretary-"manager" in the 1870s.

been found and that all texts known only in transcripts must truly have disappeared.

The fate of the lost originals is not clear, although likely moments of destruction or detachment from the main body of letters have been pinpointed in the Introduction. Oddly, all Mrs. Eakins' transcripts from "lost" texts seem to be from letters to Benjamin Eakins, suggesting that an entire packet of his correspondence went astray at one time. The ragged and fragmentary condition of the extant letters may also tell us something about the handling of the collection, for several items are lacking portions of text. In some cases, a page or two seem to have been lost in the shuffle. In one instance (fragment, Oct 1867, no. 30) the neat trimming with scissors of an entire section of the page, along with several complaints about the miscarriage of this text (and its evident delay) in other letters, suggest the political censorship that Eakins mentioned as a threat in this period. In most cases, however, the losses seem to be the result of carelessness at some point of transfer, not of deliberate editing. The reader of these letters must be prepared for fragmentary, sometimes tantalizingly incomplete texts.

The letters and fragments that remain provide more than enough material for rewarding study. Since the task of integrating these new letters into the larger story of Eakins' Paris experience has been accomplished already,[8] only the highlights of these texts need remark here, to guide readers to the most interesting or novel material.

The Siege of the École

The tale of Eakins' enrollment at the École impériale et spéciale des Beaux-Arts in Paris is told at entertaining length in two largely unpublished letters to his father, written on October 13 and 26–27, 1866 (nos. 5 and 6; reproduced pp. 189–97, 197–203). All accounts of Eakins' first month in France must be revised as a result of the information contained in these two letters.[1] The enrollment process was long, taking up almost a month "running about, on account of the red tape," and it verged on defeat more than once. The difficulty, and finally the victory, arose from Eakins' ignorance of the procedures for the admission of foreign students—or even the likelihood of acceptance—and his inability to take no (or "rien") for an answer. The school had not admitted any foreigners for a year, and several other Americans (Howard Roberts, Earl Shinn, Conrad Diehl, and Frederic Bridgman) had been waiting as long as six months for an opening.[2] Suspecting that influential connections might help, as indeed proved true, Eakins arrived with at least

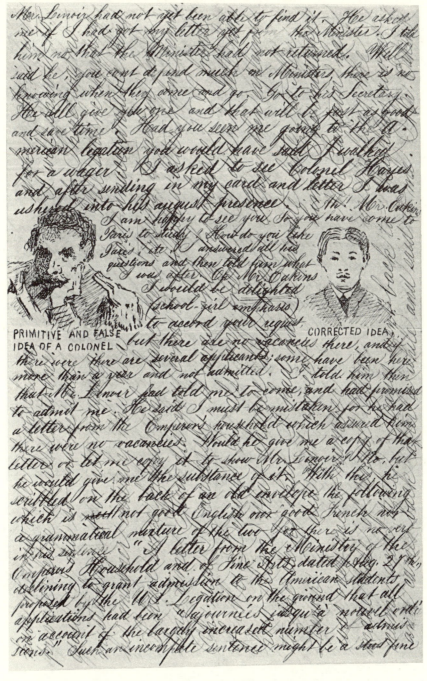

12. Thomas Eakins to Benjamin Eakins, 13 Oct 1866, page 2.

Eakins' satirical sketches of Colonel Hayes [Hay], an American consul in Paris, reflect his disgust with the problems he encountered in gaining entrance to the École des Beaux-Arts.

five letters of introduction, none of which produced an effective sponsor. Lucien Crépon³, a French painter once resident in Philadelphia, was to become Eakins' best friend in Paris, but he knew little about the École since its reorganization in 1863. The expatriate American painter Edward H. May was less friendly and much less helpful; he was the first to tell Eakins that his only hope for admission lay in the direction of the more expensive private ateliers outside of the École. The American minister, John Bigelow, was out of town, but his aide, Colonel John Hay, had the same discouraging and condescending story. The Philadelphia engraver and art impresario John Sartain had sent Eakins to these men with letters; Sartain did not give him a letter to another acquaintance, Albert Lenoir, the Secretary of the École. Instead, he scribbled Lenoir's name on a slip of paper and asked Eakins to run an errand to Lenoir's office to find a copy of Sartain's "Art Report," filed there in 1855. Finding himself within the administrative center of the school, Eakins asked Lenoir about the report and then bravely changed the subject. "I want to be an artist," he told Lenoir, who listened kindly and assured Eakins he would find him a place. Lenoir sent him back to Bigelow for an official endorsement from the embassy. Eakins would have to return to bother Lenoir again for a written statement of his promise, which finally had the desired effect upon Bigelow's "jackanapes" aide, whose attitude changed dramatically under the assumption that Eakins had "a private letter to Mr. Lenoir" on his behalf. "I did not correct him," wrote Eakins. "The mistake was only one of number. Mr. Sartain had made use of several letters in spelling [Lenoir's] name and title" on the slip of paper Eakins had used to find his way. From this "slim chance" he learned the power of pretense and officiousness, and when further obstacles were thrown in his way he turned to elaborately addressed envelopes ("about the size of a small window frame"), another contrived "little slip of paper," and convenient deafness or incomprehension of French in order to barge past "rows of soldiers and servants" into the presence of Count Nieuwerkerke, Superintendent of the House of the Emperor and of the Fine Arts, and various other officials who proved more gracious and reasonable than their underlings in the anterooms. "On looking back at my month's work, I have certainly to regret that to get what I wanted I had sometimes to descend to petty deceptions," wrote Eakins, "but the end has justified the means," and he was in no way ashamed. "This pushing business is disgusting and although I find I can do it in dire necessity, I hope there will never again be occasion."

For his efforts Eakins was rewarded with a ticket to the atelier of Jean-Léon Gérôme and the gratitude of five Americans who swept into the École on his coat-tails: the four men already on the waiting list and another painter

recently arrived from Philadelphia, Harry Moore. The American minister personally complimented Eakins by expressing the hope that he "would make as good an artist as diplomat." Bigelow's remark rings with irony when Eakins' difficulties at the Pennsylvania Academy twenty years later are recalled, for diplomacy was never one of Eakins' talents. Perhaps, as he admitted, the strangeness of the entire scene—language, manners, procedures—threw individual character into relief, "while at home the same amount of character springing from the same motives would make no impression." Young, responsive, and desperate, with nothing to lose by trying, his situation in Paris was quite different from his circumstances in Philadelphia in 1886, when he was more confident about his position and far less astute about measuring his enemies. The qualities of character he showed in this encounter with French bureaucracy would show up again later, however: a persistence amounting to stubbornness in the pursuit of justifiable ends, a courage and resource, and an unmitigated contempt for the "little vermin" who stood in his way, preventing access to the "great men."

> When one sees a little more of the world he learns to despise vanity & affectation & show politness & useless knowledge & parrot talking specially if he manages to see some real big men & know them. (23–24 Feb 1868, no. 37)

Eakins' disdain for pettiness and affectation, expressed often in these early letters, would only grow more adamant, and like many of his strengths, invited trouble. In the confidence and conviction of a 22-year-old we can foresee the attitudes that, at 42, would strike his contemporaries as impatient, arrogant, and far from diplomatic.[4]

In his Paris days, Eakins recoiled from anything that smacked of affectation or perversion of the "honest" behavior or "manly sentiments" illustrated in the lives of the "big men." Bureaucrats and lapdogs thus came to join all Rubens' paintings, most English art, and the majority of English people on his list of unnatural, even despicable things.[5] By contrast, there was Spanish baroque painting, "so good so strong so reasonable so free from every affectation. It stands out like nature itself" (2 Dec 1869, no. 54). Ranked among the "big" painters, such as Velasquez and Ribera, came his own master, Gérôme, and Thomas Couture, but it was not necessary to be a famous painter to join this pantheon of heroes. Within his own homely circle in Philadelphia he found "big men," too: John Sartain; the local art teacher, George W. Holmes; his French teacher, Bertrand Gardel; his neighbor, Charley Boyer; all were honored as good, strong, reasonable, unaffected men (12 Jul 1867, no. 24). Intolerant of falseness, Eakins admired direct, truthful,

"honorable" conduct in heroes from all walks of life.[6] Such men provided the models for his own sense of right behavior, which grew mature as he encountered good and bad examples abroad.

Eakins' meritocracy had an American tone that, like some of his other native opinions and mannerisms, he seems to have cultivated, even flaunted—such as his distinctively American hat. "Americans are looked on in Europe as a people who may do as they please," he noted, and clearly he enjoyed the liberty, if not the marginality, of such status. Unlike most Americans, he could speak French well and made friends with fellow students (such as Paul Lenoir, Auguste Sauvage, Louis Cure, Germain Bonheur and his family), but his social life seems to have been dominated by fellow Americans (Moore, Will Sartain, Will Crowell, and other visitors) or those, like Crépon, with American experience. His vacations in 1867 and 1868 were spent touring in the most typical American fashion, with his family or other American friends, and his free time was often devoted to pursuing home sports like skating and wrestling.

National character interested Eakins, who was quick to characterize the French, English, Spanish, or Swiss with a confidence derived from his satisfaction as an American. Generally a Francophile, he often expressed sincere admiration for the culture around him in Paris, but he was not without scorn for French weaknesses. "It will be many a day before they can govern themselves as we do," he wrote, even though he admired the egalitarianism of French society (23 Dec 1866; n.d. [ca. 30 Dec 66 or Jan 67], nos. 9 and 10). He promised his parents to stay aloof from the turmoil of French politics, but he watched events with interest from a safe distance and sent newspapers home regularly, principally for the benefit of Gardel. Still, he attended with the same eagerness the American accounts of the impeachment of "His Excellent Superfluity," President Andrew Johnson.[7] As his stay in Paris extended, his letters contain friendly, even hilarious tales of escapades with "Gérôme's boys," but there is no corresponding decline in queries aout Max Schmitt's latest race on the Schuylkill, or Maggie's newest exploit on skates. These letters show that home ties remained strong. For all that he enjoyed Paris, Eakins had no yearning for expatriate freedom.

Tom and Emily

Only one of Eakins' important home ties failed to survive his four years abroad. Eakins' friendship with Emily Sartain (1841–1927), his best woman friend in Philadelphia in 1866, was apparently warmed by the threat of his

long absence, and the two parted in New York with much sadness. Emily may have hoped for a promise from Tom at that time, and she apparently led others to believe they were engaged, but he grew less interested in marriage as the problems of his art study and the pleasures of Paris intervened. Their correspondence soured as Emily grew more possessive and Tom more detached, and matters came to a breaking point in 1868, as letters in the Bregler Collection reveal.[1]

Eakins' sister Fanny precipitated things by asking outright, in her letter of Feb. 25, 1868, "Are you engaged to Emily Sartain, or do you expect ever to do so?" (no. 139). Her brother's vociferous response, published at length in Goodrich, denied that there had been anything more than friendship with Emily in the past and recounted the deterioration of their correspondence since his departure in 1866.[2] Several months after this exchange, Benjamin and Fanny Eakins arrived in Paris for a visit. With them was Emily Sartain, probably ignorant of Tom's letter to Fanny and perhaps still hoping to restore their relationship. As her letter from Geneva on July 8 (no. 140) makes clear, their reunion in Paris did not go well. Emily found the city "hateful," and was horrified by Eakins' attitudes, apparently learned from his "vicious companions." She advised him to turn away from Boccaccio and Rabelais (back to Shakespeare, Herbert Spencer, and Carlyle) and follow his father and sister who were traveling in Germany, to refresh old ties, and purge himself of his "weakness." Try "to look at things from a sound American, *home* point of view, to be a man," wrote Emily, who perceived Eakins, for all his closely guarded Americanisms, as dangerously decadent. "Am I offending you?"

Eakins was offended. His draft of a letter (n.d. [Jul 1868], no. 41) clearly illustrates his annoyance. Having failed to see Emily off at the railway station in Paris, he also found excuses to delay writing to her until her forwarding address was obsolete.[3] When he finally wrote, he did not discuss the contents of her letter (although the reference to his "vicious companions" was not allowed to pass) but instead occupied himself with challenging new insults from a more recent letter (now lost). Sartain had described Eakins as "likely" to cheat the government, comparing him to a man Eakins knew to be dishonest. Whatever the circumstances of her new anger, it is evident that the issues raised in her first letter had been evaded or clouded by the fresh accusations in the second, and poor face-to-face communication in Paris had grown even more disjointed in the mails.

No more letters from Emily survive in the Bregler Collection, and even her own trove of letters from Tom (see "Manuscripts Pertaining to Thomas Eakins in the Archives of the Pennsylvania Academy") has no further news from him until 1886. But the story was not over, as the irritation in Eakins'

letter to his father of October 29, 1868 reveals (no. 44; reproduced p. x). An angry Eakins accused Emily Sartain of lobbying for his return to Philadelphia, where his moral decline would be arrested and his training continued in the healthy as well as professional environment of the Pennsylvania Academy under the tutelage of Christian Schussele.[4] Emily and her brother Bill were taking classes there, and though Eakins respected Schussele, he did not find the prospective program in Philadelphia comparable to his opportunities in Paris.

> Perhaps she would like me to leave Gerome & this naughty Paris & join their sweet little class & come and fetch her & see her home after it & we would drawey wawey after the nice little busty wustys & have such a sweet timey wimey.
> (TE to BE, 29 Oct 1868, no. 44)

Sartain's pressure, added to Eakins' own constant anxiety about the length and expense of his stay in Paris, produced this exceptionally impatient outburst and the heated defense of his professor, his studies, and his progress that fills the remainder of this letter. His sense of humor, always more dependent on irony than on wit, descends to adolescent sarcasm. Uneasy about such protests, or swayed by Emily's arguments, Benjamin Eakins brought his son home for Christmas a month later. Evidently the air was cleared on all sides, for Tom returned to Europe for another year beginning in March 1869, and Emily disappeared from his correspondence for twenty years.

Learning in Paris

Eakins seems to have chosen Jean-Léon Gérôme as his master before he ever left Philadelphia, perhaps because his work and his reputation were well-known in America. It was a happy choice, for Gérôme proved to be a sympathetic teacher. Eakins remained his admirer, both in word and in the homage of his paintings, until the end of his life. Gérôme's influence on Eakins, neglected or disparaged until the publication of Gerald Ackerman's study in 1969, has now become accepted as a positive rather than a neutral force, but the importance of Gérôme's techniques and his attitudes, his posture as an artist and teacher, deserves reiteration, since acceptance of his impact on Eakins' career contradicts so many tenets of the mythology that would have him be, as Goodrich asserted, "an isolated figure, belonging to no school, having few ancestors or descendents."[1]

Eakins was impressed by Gérôme from their first meeting, when he

went to the painter's private studio ("the finest I ever saw") to gain approval for admission into his atelier at the École (no. 6; 26 Oct 1866). He returned two weeks later with Harry Moore to explain his friend's deafness to Gérôme and win Moore's acceptance into Gérôme's atelier. Downhearted by French bureaucracy, Eakins found Gérôme's polite efficiency wonderful. Instantly, Gérôme rose to join the ranks of the "big men"—Lenoir and Nieuwerkerke—who had met Eakins' application with an alert and unpretentious humanity. After Gérôme's first critique of his work, Eakins went out and bought a photograph of "le patron," whose image—like that of most celebrities in this period—could be purchased in carte-de-visite format. Sending a copy to his father, Eakins praised Gérôme's appearance, which reminded him of his affectionately held French teacher, Gardel.[2]

Gérôme's good grace on these first occasions was followed by other demonstrations of his concern for his students and his fair-minded supervision of the atelier. Two separate stories tell of disputes in the atelier caused by obnoxious students. Each case was taken to Gérôme, "our best friend," for adjudication, and each time his appraisal of the situation and his response matched the students' hopes for justice ([mid-Nov]-22 Nov 1867, 31 Jan 1867; nos. 32 and 14). From such stories, we understand Gérôme's reputation, across three decades of teaching, as one of the most popular professors in Paris. "I am delighted with Gérôme," wrote Eakins; "the oftener I see him the more I like him."[3]

Eakins had reason to be personally grateful for Gérôme's dignified, patient, and attentive guidance, for his progress at the École was initially slow and full of discouragement. When he joined the atelier at the end of October 1866, he was set to work at drawing—either from the model or, less frequently, from casts—and his accounts show expenditures for paper, charcoal, and stump leather (used to wrap the point of a stick for rubbing soft transitional tones in the charcoal) as late as June 28, 1867 (see no. 23). Evidently Eakins was content to establish himself in this medium, which was familiar to him from the Academy's life class in Philadelphia, for his assessment of the school at Christmastime was happy: "I do not think I have overrated the advantages of the Imperial school," he wrote his father.

> From 8 to 1 we have the living model. We have a palace to work in. We have casts from all the good antique and many modern statues. Twice a week our work is corrected by the best professors in the world.
>
> I no doubt appreciate them more for the trouble I had in getting them. . . .
>
> There are . . . three large studios for figure painters alone, Gerome's Cabanel's & Piltz's [Pils]. The Architects have other studios, the sculptors others, the engravers others still. Then there are lecture rooms innumerable & a dis-

secting room, and library, and exhibition rooms. (n.d. [ca. 30 Dec 1866 or Jan 1867], no. 10)

Gérôme's twice-weekly critiques could be sharp "when one makes a hippopotamus of himself," noted Eakins (16 Jan 1867, no. 12), who recounted the retreat of his fellow-Philadelphian, Earl Shinn, after two severe sessions with "le patron" (23 Dec 1866, no. 9). Shinn began to absent himself from the studio, and eventually dropped out. But Gérôme was evidently encouraged by signs of progress in Eakins' work and promoted him out of charcoal drawing after five months of practice.

On March 21, 1867, Eakins announced that Gérôme "at last told me I might get to painting" (no. 18), and at the age of twenty-two he set brush to canvas for the first time. As Goodrich has noted, Eakins' preparation up to this point was "unusual" and extensive, including training in penmanship, perspective and mechanical drawing, anatomical dissection, and life class study; but none of this prepared him for the difficulties of painting.[4]

Seeing color, mixing it correctly on the palette, and then applying it without muddiness and in proper relation to other tints and shades seemed to present overwhelming complexity. After summer vacation that year, Eakins realized he would need his own studio for private study on afternoons and holidays, and he moved to a ground-floor room at 64 rue de l'Ouest.

> The studio will enable me to commence to practice composing & to paint out of school which I could not do before. As soon as I can get knowledge enough to enable me to paint quickly I will make pictures, but I have been only 4 months at the brush & cant do it yet. (20 Sep 1867, no. 29)

The studio proved too damp and dirty, and by November he had moved upstairs to a cleaner, drier, cozier room ([ca. 30] Nov 1867, no. 33). The new studio did not yield immediate rewards, however, for he declared himself "in the dumps," anticipating Gérôme's response to "a devil of a mess" that he had made with his most recent study, even after Gérôme had mixed the colors for him on the palette ([ca. 30] Nov 1867, no. 33). Nonetheless, he claimed that he was "not so downhearted [about making pictures] as I have sometimes been."

> I see much more ahead of me than I used to, but I believe I am seeing a way to get at it & that is to do all I see from memory. I believe I am at last keeping my place in my class & have made friends with the best painters. Gerome is very kind to me & has much patience because he knows I am trying to learn & if I stay away he always asks after me & in spite of advice I always will stay

away the antique week and I often wish now that I had never so much as seen a statue antique or modern till after I had been painting for some time.

Eakins' sense that study from the antique had betrayed him, probably because the interplay of color and shadow in live models added so much complexity, would be carried back to the classes he was later to teach at the Pennsylvania Academy, where he diminished (or eliminated) the time students spent on cast drawing. His other statement, about working from memory, seems surprising in respect to his lifelong faith in naturalistic observation, and may be an index of how desperate he was for new routes out of the murkiness on his canvas. His comment may refer to his recourse to the controversial memory techniques of Lecoq de Boisbaudran, introduced in Parisian art circles some fifteen years earlier. Lecoq's basic exercise called for the intense scrutiny of an object or another painting, which was then removed from sight and drawn or painted by the student from memory. Two months after the rental of his new studio Eakins reported that he was "working from memory & composing" and "not so downhearted" as before.[5]

Eakins' struggles with technique were not without a larger, more philosophical perspective on the nature of his own endeavor as an artist. On March 6, 1868, he wrote to his father with great excitement, anxious to enter a dispute that had embroiled several of their friends in Philadelphia. This letter, well known from lengthy citations in Goodrich, has been reproduced here (p. xx) to give its complete text, which stands as an early manifesto of Eakins' beliefs about the artist's goals, particularly in relation to nature. His vivid and typically homely boating metaphor, clearly chosen for the benefit of his father, who had long experience as a hunter, is a text that brings to mind the several "Pushing for Rail" subjects and the context of the Delaware River marshes. In this statement, Eakins establishes a few basic principles. The first, bolstered by his reference to Herbert Spencer, argues that the artist is not a "creator" but instead combines past experience and present perceptions into new, personal amalgamations. To do this well, the artist must "steal Nature's tools"—light, color, and form—not just attempt to imitate surface appearance. Understanding the principles of Nature rather than measuring the details, a good artist can effectively second-guess Nature, even when painting from memory or imagination, or when Nature's own "mud-marks" cannot be seen. Such "Big" painters, "when they made an unnatural thing they made it as Nature would have made it." The corollary to this method of "sailing" parallel to Nature entailed rejection of the models provided by earlier artists, especially "the antique." Disparaging "fools & historians & critics" who advise study of classical sculpture, measuring it sagely but utterly

failing to understand its excellence, Eakins rejected art made from other art or derived from "mystic numbers" or based on conceited notions about artists' powers. The good artist is modest, trusting in Nature's guidance. With earnest work, he will have a good boat of his own, fit to discover the images of his own future "sailing"—landscapes where "you can see what o'clock it is," figures that express "what they are doing & why they are doing it," sweet faces, seen or imagined.[6]

The conviction that rings in this letter must have come from a sense of greater security about his progress.

> I am less worried about my painting now than at one time last spring & consequently am in better order to study. I see color & I think I am going to learn to put it on. I am getting on faster than many of my fellow students and could even now earn a respectable living I think in America painting heads but there are advantages here which could never be had in America for study and I will improve more this year than ever before. But I am a little child yet alongside of the big painters around me and fear I will be for some time yet, but I will try my best. (17 Mar 1868, no. 39)

This statement of mixed confidence and modesty was tellingly appended to thanks for his father's most recent check. Benjamin Eakins arrived in France several months later to examine his son's progress for himself. He found him sick, and surrounded by the studies that occupied every student at the École.[7] The "pictures" Eakins had planned to make by this time were still nowhere to be seen. Benjamin Eakins nonetheless renewed his support, but something in his heartiness "dispirited" his son. Writing to his father on October 29, 1868, Eakins expressed his sense that the encouraging words masked a fear "perhaps that I was not in the right path or had stopped working or some such idea." Eakins' full rejoinder insisted that he was working hard, and surpassing his fellows. "Whether or not I will afterwards find poetical subjects & compositions like Raphael remains to be seen, but as Gerome says the trade part must be learned first." Perhaps addressing his father's puzzlement over the lack of finish in his studies, he explained the special purpose of these studies and the inappropriateness—even the danger—of stopping to "finish" them. The method, coming as it did from Gérôme, who could finish a "picture" to enamelled perfection, had to be understood as a means, not an end. Eakins' earnestness in this letter may have come from the suspicion that his father's doubts were being encouraged by Emily Sartain, who, as we have seen, had her own reasons for wishing Eakins would cut short his studies and return to Philadelphia. From Eakins' three-month visit home beginning

at Christmas 1868, it would seem that he had to convince his father face-to-face.

Eakins returned to Paris in March 1869 and spent eight months working, regardless of the summer holidays, by moving to Léon Bonnat's atelier in August. The bulletins to his father continued on the same note: "You asked me how I am getting on with my studies," he wrote on June 24, 1869. "I am getting on as fast as any one I know of."

> There are often awful sticking points but at last by a steady strain you get another hitch on the thing and pass. When you first commence painting everything is in a muddle. Even the commonest colors seem to have the devil in them. You see a thing more yellow you put a yellow in it & it becomes only more gray when you tune it up. As you get on some you get some difficulties out of the way and what seems trying is that some of the things that gave you the greatest trouble were the easiest of all. (no. 50)

As these troubles were mastered, the work of others struggling with the same difficulties became more interesting for him to examine; judging himself against others, Eakins felt he could now paint better pictures than most.

> One terrible anxiety is off my mind. I will never have to give up painting, for even now I could paint heads good enough to make a living anywhere in America. I hope not to be a drag on you any longer. I had tried to make a long letter of this & it has been troubling me some time but I can't think of any more to say. All I can do is to work.[8]

From Eakins' accounts it seems to have rained steadily from March to November that year, and he had fewer funny stories in his letters. The regime at Bonnat's studio, which was an hour's walk across town, necessitated early rising, and Eakins admitted that he was often too tired at night to write letters. But Bill Sartain was with him, and Eakins sent enthusiastic accounts of operas, circuses, and concerts. He also started to invest in photographs "from nature" (evidently life studies and landscapes), plaster casts, and another picture of Gérôme, perhaps against the day of his return to America. (30 Aug 1869, no. 52). Gérôme was away that fall, and as the days grew darker, colder, and wetter, and as friends like Sartain began to plan trips south, Eakins began to "feel anxious to get away." He did not mean home to Philadelphia, although he had his sights on returning to America by the Fourth of July, but to someplace warmer in Europe where he could shake his chronic illness and work outdoors: Spain.

> If I can keep my health I think I can make a name as a painter for I am learning to make solid heavy work. I can construct the human figure now as well as any

of Geromes boys counting the old ones & I am sure I can push my color farther so I keep working hard & thinking of the reward of my troubles & long studies. My attention will now be much divided from my school work to making up sketches & compositions now that I am getting such a good start. (5 Nov 1869, no. 53)

Later that month he announced that "my school days are at last over," his goals in France accomplished. "What I have learned I could not have learned at home, for beginning Paris is the best place."[9] His education was not over, however, for six months in Spain lay ahead, full of the inspiration of the Old Masters and the challenges of real "picture-making."

Spain and the "Spanish Notebook"

Eakins left Paris in the rain on November 29, and arrived in Spain at Madrid, where he spent three days before traveling further south to Seville. In Madrid he encountered the work of Velasquez at the Prado; his famous letter to his father describes the thrill of seeing the kind of "big painting" he had always imagined possible: "O what a satisfaction it gave me" (2 Dec 1869, no. 54; reproduced p. x). This letter from Madrid, and one written five days later from Seville, are the only extant letters from Eakins at this exciting moment; another seven letters are "lost," being known only in Mrs. Eakins' excerpted texts.

Much more about Eakins' response to the Old Masters in Spain can be learned, however, from the pocket notebook he carried during this trip, which also survives in the Bregler Collection. The initial entries in this book date from 1868, when Eakins used it to jot down expenses that he would later report in his letters home. He took it along to Spain and continued to record miscellaneous notes, along with more extensive ruminations about paintings seen in Madrid and then in Paris, at the Salon of 1870 (see fig. 13). Goodrich borrowed this notebook from Mrs. Eakins in 1930 and, recognizing its importance, transcribed the entire contents. Information from this source, which he called the "Spanish Notebook" (although it was used before and after this trip), appears in Goodrich's revised biography I/59–64, with many lengthy quotations and translations from Eakins' French text. As well known as some of these citations may be, it is rewarding to examine the complete notebook, in Eakins' own hand, with the sequence of remarks uninterrupted and numerous new details revealed.

13. Thomas Eakins, Page from the "Spanish Notebook," 1869.

The so-called Spanish Notebook contains notes on the artist's trip to Spain in 1869–70. Although thoroughly recorded by Goodrich, its location was unknown until now. This page describes Velasquez' technique in Las Hilanderas, ca. 1657, *seen in the Prado, Madrid, in December 1869.*

Correspondence with Gérôme

Eakins exchanged letters with his master several times after leaving France in June of 1870. Like the bulk of his Spanish correspondence, most of these letters have disappeared, although copies and translations survived. About 1930 Goodrich apparently saw two original letters from Gérôme, dating from 1873 and 1874, for his published texts are based on his personal transcriptions, in French.[1] Bregler may have seen these same two letters, or—because he did not read French—acquired translations of them by Eakins' friend, Louis Husson (see nos. 144 and 145).[2] In these two letters Gérôme responds first to Eakins' gift of a watercolor, *John Biglin in a Single Scull,* in 1873, and second, to his submission of a second, revised version of the same subject in 1874, along with two paintings for Goupil's gallery. Gérôme's thanks and his critique of Eakins' work have been well described by Goodrich and others.[3]

Less well known is the draft of Eakins' letter to Gérôme, probably written in the spring of 1874, describing his paintings (no. 56). McHenry saw this manuscript when it was in Bregler's possession, and published a translation in her biography that has since been quoted by others.[4] According to Goodrich, Bregler admitted that he had lost this draft by 1945, although it turned up among his papers in 1984 along with another page of notes in French that McHenry did not translate or publish. The appearance of the original text allows us to correct a few small errors in her translation of page 1 (such as the omission of the third sentence), and consider the more ragged remarks on the second page, which may or may not have been included in his actual letter. These comments and questions indicate that the struggles Eakins had experienced in Spain, encountering color seen under strong natural light, were far from over. Notwithstanding the accomplishment of his rowing pictures by this date in 1874, Eakins was still having trouble keeping his tones from sliding together into muddiness at the dark end of his value scale, or into weakness, among the lights. No matter what the quality of the outdoor light while he was painting, his effect shifted disharmoniously when the painting was taken indoors or into another light. Eakins framed a question to Gérôme: "Quelle est l'habitude des meilleurs peintres?" (What is the practice of the best painters?), but he seems to have answered himself across the top of the page: "On devrait savoir l'endroit de l'exposition d'un tableau avant de commencer." (One ought to know the place where a picture will be shown before commencing.)

The other portion of his draft recounts his illness the previous fall,

which interrupted the completion of the paintings and forced him to work from older, incomplete studies and from memory. His malaria, contracted while he was hunting in the fashion shown in his paintings, put him in bed for eight weeks of delirium.

> On croyait les medecins que j'allais mourir. Quand je suis revenu à moi même les arbres n'avait plus de feuilles. jetais longtemps trop faible de travaille et mon intelligence aussi restait faible. Enfin j'ai repris mon travail des peu [?] d'etudes que j'avais faites et d'impressions qui n'était plus recentes. Un marais à des details ravissants. Jaurais gardé mon tableau jusqua l'automne de cette année, mais le medecin me defend de faire la chasse cette annee quoique j'y suis habitué depuis mon enfance. Il me serait [?] dangereux.
> Jai fait quelques portraits de genre et quelques portraits d'animaux.
> Je sens que je vais bientot faire beaucoup mieux. Dans cet espoir j'invite votre critique si vous voyez dans mes tableaux des tendances mauvaises.

> (They—the doctors—believed I was going to die. When I returned to myself the trees no longer had their leaves. For a long time I was too feeble to work and my mental faculties also remained weak. Finally I took up my work again from the few studies that I had made and memories that were no more recent. A marsh has ravishing details. I would have kept my picture until autumn of this year, but the doctor forbids me to go hunting this year, even though I have been used to it since my childhood. It would be dangerous.
> I have made a few genre portraits and a few portraits of animals.
> I feel that I will soon do much better. In this hope I invite your criticism if you see bad tendencies in my pictures.)

Some portions of this draft must have been sent to Gérôme, for his response on Sept. 18, 1874 (no. 144) laid to rest Eakins' humble fears about "bad tendencies."

Another exchange of letters, previously unknown, began in 1876. Eakins evidently wrote to Gérôme that summer to enlist his support for the continuation of the Academy's life classes, which John Sartain had allowed to lapse during the construction of the new building and which still were not being held after the opening of the Academy in the spring of 1876. Gérôme's forceful letter of February 22, 1877 (no. 145) must have been exactly what Eakins had hoped for to use as reinforcement for his position. Although this letter survives only in Bregler's copy of Louis Husson's stilted translation (reproduced pp. 212–213), Gérôme's dramatic choice between "truth" and "the abyss" echoed Eakins' opinion and must have strengthened his resolve. Gérôme's letter arrived late, after the directors had agreed to recommence the life classes, but its spirit surely fortified Eakins as he began to teach at the Academy and initiate curriculum reforms.[5]

Indirect references to additional correspondence between Eakins and Gérôme after 1877 show that a distant connection was maintained. While on the B-T ranch in 1877, Eakins received a letter from Gérôme, copied and forwarded by Susan, evidently responding to a letter of introduction carried to Paris by James Wood. Eakins was pleased to learn that "Gérôme is going to be good to Jim for my sake" (see 11 Aug 1877, no. 82).[6] Later, in 1894, Eakins sent another one of his "boys" from the Art Students' League, Frank Linton, to Paris with a similar letter. Linton received private criticisms from Gérôme, who announced that he was "at [Linton's] service" as a result of the reference from Eakins.

> You see what a letter from Eakins will do. He thinks a great deal of Eakins. He said that he was a great master and that he was a very intelligent man.[7]

By 1894 Gérôme could have seen several of Eakins' paintings exhibited in Paris, but it seems likely that Eakins had kept him abreast of his work, sending reproductions of *The Gross Clinic* and *The Agnew Clinic*, for example, to confirm Gérôme's opinion of him as a "great master." The many admiring references to Gérôme by Eakins and his wife prove that such compliments were returned. Eakins' revival of the "William Rush" theme about 1908, four years after Gérôme's death, seems to have been a reprise of his own work in terms of his master's painting, *Pygmalion*, making a last homage to the artist who had taught him how to paint the nude forty years earlier.[8]

Letters to His Fiancée, 1873–1877

In 1872 Eakins dedicated his first large, full-length portrait to the subject of twenty-one-year-old Kathrin (usually called "Kate" or "Katie") Crowell (Yale University Art Gallery, Figure 14). The first of Eakins' sitters to take a place in the armchair that would hold so many others, Kate Crowell posed for a picture that foretold the mood of future portraits; strongly cut by light and shadow, naturalistic, contemplative. The special tenderness of this portrait may have been inspired by the friendship between artist and sitter that, by 1874, led them into engagement. A handful of letters from Eakins to his fiancée in the years between 1873 and 1877 have come to light in the Bregler Collection (see entry no. 57), along with the famous armchair itself. These letters, all brief and somewhat superficial, tell us something about his relationship with Kate, who died of meningitis in April 1879 before their marriage was realized.

14. Thomas Eakins, *Kathrin*, 1872, oil, 62¾ × 48¼",
 Yale University Art Gallery, Bequest of Stephen C. Clark

*Eakins was engaged to Kathrin Crowell, the sister of his friend William J.
Crowell, from 1872 to her death in 1879. The Bregler Collection contains 11
letters Eakins wrote to her during the summers she spent at the New Jersey shore.
Bregler took photographs of many works of art by Eakins owned by himself and
Susan Eakins. This reproduction documents the appearance of* Kathrin *before the
painting was acquired by Stephen C. Clark in 1930.*

Sallie Shaw, a friend of Kate and of Maggie Eakins, remembered Kathrin Crowell as small, quiet, and without artistic talent of her own, "just a good decent girl." It has been suggested that Benjamin Eakins contrived the engagement in order to settle his flirtatious thirty-year-old son into a stable relationship. Such circumstances, added to Kate's mildness, may explain the tone of these letters.[1] Affectionate and solicitous, Eakins is gentle but condescending with Kate, whom he instructs to dress warmly and swim close to the shore. Seven years younger than Eakins, less educated and less well traveled, she was easily dominated by him. Although he wrote to her once in French (on August 20, 1877, from Washington, D.C., where he was painting a portrait of President Hayes), his letters to her have little intellectual or artistic content and dwell mostly on weather, health, and travel plans. Usually written from Philadelphia to Kate at a variety of summertime retreats, such as Cape May, Ocean Grove, and Fairton, New Jersey, these letters occasionally strain to find topics for discussion. However, students of Eakins' paintings will find random references to ongoing projects: difficulties getting Dr. Gross to pose (20 Aug 1875); plans for a painting of a yacht, the "Vesper," which was never realized (29 July and 22 Aug 1874); work on a new rail shooting picture, "the best I have ever made" (19 Aug 1876).[2] The momentous news of his paintings' safe arrival in Paris, where they were praised by Gérôme and his dealer, Goupil, is relayed in a contented but almost telegraphic style: "My pictures are all right. Gérôme and Goupil are in town and my pictures are much liked" (29 July 1874). The only truly provocative moment in these letters is a puzzling postscript jotted alongside a pen and ink sketch of the bust of a nude woman: "I didn't think of it once till you asked me the question" (20 Aug 1875; see Figure 15).

Tom complained to Kate, as he had to his father from Paris, that writing was tedious compared to talk, but his letters to her would seem to indicate a mismatch of talents and interests, notwithstanding naked women sketched in the margins. Their long engagement, although not unusual in this period and perhaps necessary while Eakins established his career, may be another another index of their (or his) willing but hardly passionate interest in marriage. As he had written to Will Crowell in 1868, "I look upon love & marriage as two very different things."[3] Nothing is known about Eakins' response to Kate's death in 1879, but he was not quick to recommit himself. Susan Macdowell was well known to him by this time, but there is no suggestion of her competition for Eakins' affection before 1879. They were not engaged until 1882, and did not marry until 1884.[4]

15.　Thomas Eakins to Kathrin Crowell, 20 Aug 1875.

Eakins' engagement to Kathrin Crowell was cut short by her death in 1879. His letters to her were often filled with news of the weather. In this one the sketch and the note beside it present a tantalizing puzzle.

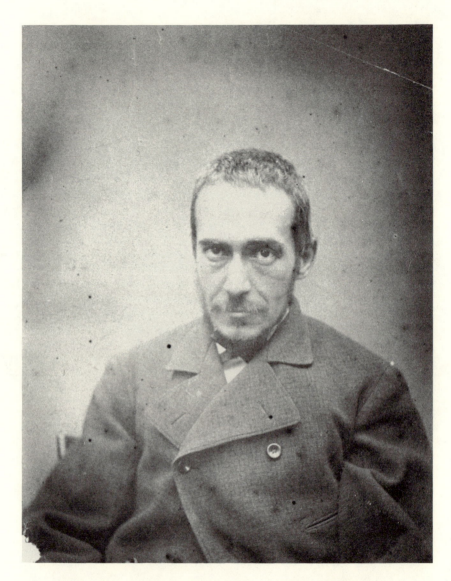

16.　　Photographer unknown, Thomas Eakins at 36–38, ca. 1880–82, albumen print, 4¼ × 3⁵⁄₁₆″.

Eakins is seen here at about the time he was appointed Director of the Schools of the Pennsylvania Academy of the Fine Arts, and a few years before he married Susan Macdowell. His intense expression suggests the force of the impression Eakins made on his students during this period.

"Trouble" at the Pennsylvania Academy

On February 8, 1886, Edward Hornor Coates, then chairman of the Committee on Instruction at the Pennsylvania Academy of the Fine Arts, wrote to Thomas Eakins, the Director of the Schools and Professor of Painting, asking for his resignation. Eakins complied the following day. Overnight, he had lost his "high position" in the American art world and fallen into "trouble" that mired him for more than a year and a half, interrupting his work, clouding his health, and tarnishing his reputation.[1] This crisis in Eakins' professional career, this moment of public and private disgrace, was discussed at length in the press then, and it has been recounted and analyzed extensively since.[2] Because the events of this year helped form Eakins' identity as an outcast—the victim, in his own words, of persecution and neglect—a deeper understanding of his ordeal has always seemed necessary to appreciate the extraordinary qualities that made Eakins unacceptable then, heroic now.

In the search for villains and causes, many explanations have been offered, with the persons and circumstances divided roughly into two camps: "official" and covert. The official reason for Eakins' dismissal, given in the newspapers and in Edward Coates' letter to Eakins, began with a need for "change in the management of the Schools." This euphemism covered several criticisms of Eakins' teaching. Specifically, his anatomy instruction, required as part of figure study and based on lecture-demonstrations using nude models, had just gone a step too far. Eakins' removal of the loincloth from a male model during one of his lectures in early January of 1886, given before an audience of women (or mixed men and women), precipitated complaints.[3] Whether done matter-of-factly or as an act of defiance, Eakins' action took on legendary proportions within days, becoming symbolic of his lifelong dedication to scientific methods and his indifference to prudish notions of modesty. As a single gesture, it expressed with appropriate bluntness everything to be admired—or hated—in Eakins' teaching.

The removal of the loincloth may have been cause enough for Eakins' downfall. Coates' stern letter of January 11 (no. 148, reproduced in full below) made it clear that Eakins' recent lecture had departed from what "has been generally done heretofore" in treating "the subject in anatomy."[4] In no uncertain terms, Coates forbade "removal of the band worn by the male model, for the purposes of Demonstration in class, until such change is decided upon by the Committee of Instruction." In addition, he advised Eakins, in his own best interest, that it was *"very important"* to make a show of cooperation, rather than forcing the Directors to intervene in the classes.

Eakins, rebuked for ignoring, overriding, or spontaneously revising school policy, must have bristled once again at the idea of laymen meddling in his professional domain. Coates' attempts at peacemaking, Eakins' implicit stubbornness, and the heat of this moment in early January are all apparent in this one letter.

Coates' urgency reveals how upset the Board really was and how quickly this one incident raised the issue of insubordination. Clearly, Eakins had tested the Directors on similar curriculum disputes in the past, and their patience was wearing thin. The Secretary of the Academy, George Corliss, had done his best to obstruct Eakins for years, and others had been battling his reforms and innovations in the school since the 1870s.[5] The loincloth incident gave Eakins' detractors justifiable grounds for his dismissal on at least two counts of refusing to abide the Directors' supervision.

As the official explanation, this was more than adequate, but it was not complete. The infamous loincloth became a flag for all those who, for a variety of reasons, wished for Eakins' departure or his reprobation. In his hour of trouble these people came forward to air still other grievances. Some of their reasons were honorable, some not; few were mentioned openly at the time. Being covert, or at least unofficial, these complaints had an impact on the Board's decision that is difficult to measure, but ultimately they were much more damaging to Eakins' career and happiness than the charge "abuse of authority." Generally, these supplementary criticisms came from three distinct constituencies.

1. The Academy's Directors, consistently characterized as a conservative lot, were mostly businessmen and professionals with a sharp eye on the financial ledgers and a firm sense of conventional moral rectitude. The school was running in the red, despite the recent instigation of tuition charges, and these men were not pleased to be reminded by Eakins that he had been promised a doubling of his salary, nor were they eager to maintain a curriculum (or a staff) that offended or discouraged tuition-paying students.[6] Unfortunately for these directors, enrollment in the life class dropped by about half after Eakins left; many of the strongest students followed Eakins out the door, forming the Art Students' League in defense of his teaching.

2. The student-critics came from two camps: amateurs and professionals. The amateurs, mostly women, sought accomplishment and refinement from the study of art, and they were appalled by mandatory dissection and rigorous perspective exercises. This group, represented by the oft-cited parent who wrote with indignation to the Academy's directors in 1882, would have included the young women who bolted from Eakins' "loincloth lecture" and subsequently complained.[7] Another, more sophisticated constituency of stu-

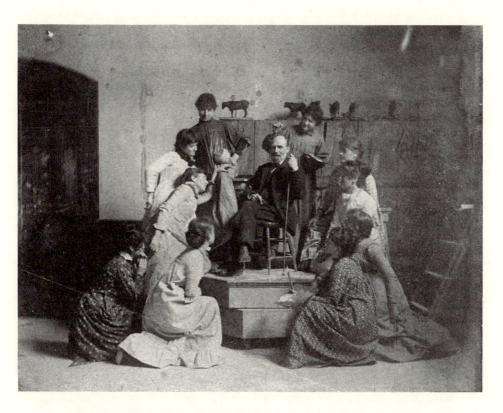

17. Thomas Eakins [?], Henry Whipple with a group of Academy students,
 ca. 1882–83, albumen print, 3¾ × 4⅞".

Eakins encouraged students to stage parodies, or tableaux vivants. *In this case
Ingres'* Apotheosis of Homer *may be the subject of the parody, although the
student painting Mr. Whipple's head is a light-hearted addition. Much loved by
the students, Henry C. Whipple was curator of prints and librarian at the
Pennsylvania Academy. Susan Macdowell, in her smock for painting or modeling,
joined this group at the lower right.*

dents, mostly male but including many women, had no dispute with Eakins' methods per se but argued that his curriculum was too restrictive. Even his friends admitted there was room for improvement.[8] Where were the discussions of art history and aesthetics, of composition and "picture-making," or the classes in fashionable genres like outdoor sketching, illustration, and design? Eakins was indeed guilty of forcing upon his students his own passionate emphasis on the human figure, which he believed should be studied from every scientific point of view. He felt that the figure was the center of the greatest art and that the professional art school had an obligation to promote the most thorough study of the human body, and no more. Other aspects, such as composition, were in Eakin's view to be learned from independent study of art or nature. Other genres and media—such as illustration—might, he felt, be learned from art schools with a commercial rather than "fine art" orientation. Eakins was not alone in this opinion, for his curriculum was a radical enactment of the philosophy of the French École des Beaux-Arts, and many students approved. Others did not. Their restlessness hardly approached revolution, however, for most of the students respected Eakins and appreciated the seriousness of his teaching plan.[9] As William J. Crowell pointed out in June of 1886, the students' dissatisfaction might never have been aired were it not for additional provocation and encouragement from those with more controversial moral complaints.

3. Student opinion as described above was to a large degree manipulated, if not invented, by an industrious coterie of senior students and instructors, all Eakins protégés now rising or aspiring to positions of authority and ambition. These individuals, including the Assistant Professor of Painting, Thomas Anshutz; the anatomy demonstrators Mary Searle, Charlotte Connard, and Jesse Godley; old friends and classmates of Susan Eakins', such as Alice Barber, and Eakins' own brother-in-law, Frank Stephens, all added to the official charges a list of more private grievances.[10] Some were indulging their own sense of rectitude or their resentment over various discourtesies suffered under Eakins' directorship. The women students, particularly those known to have modeled for Eakins (such as Alice Barber), had their own motivations, since their virtue had been called into question by association with Eakins. Some of the men, including Barber's overwrought fiancé Charles H. Stephens (Frank's cousin), took up the women's cause, while others were happy to encourage and distort their complaints to serve more selfish purposes[11]. Some, like Anshutz and James P. Kelly, had much to gain. They were promoted following Eakins' departure, and they won in addition to status and salary the freedom to adjust the curriculum according to their own desires.

18. G.C. Potter and Co., George Frank Stephens, ca. 1880,
 albumen print, 6½ × 4¼″, Pennsylvania Academy of the Fine Arts,
 acquired from the estate of Gordon Hendricks, 1988.

*This cabinet photograph shows Eakins' future brother-in-law at about age 20,
some five years before he became one of the chief instigators of the attack on Eakins
which led to his dismissal from the Pennsylvania Academy and his censure by the
Sketch Club. Stephens married Eakins' sister Caroline (Fig. 20) in 1885.*

The ringleader of the anti-Eakins forces, George Frank Stephens (usually called Frank, or "Kid" Stephens), did not profit from Eakins' downfall in any obvious way, for he had more complex and destructive ends. He disliked Eakins and intensely disapproved of his private and professional manners and values; armed with information from his wife, Eakins' much-younger sister Caroline ("Caddy"), he pursued Eakins' ruination with a vindictiveness and self-righteous vanity that bordered on madness.[12] In early March Eakins heard—in New York—reports of Stephens' "bragging" of his power to "put me out of the school and out of the city and out of any other school, and all this while living in my family & professing great friendship & admiration for me. I have been," concluded Eakins to Coates, "very blind."[13] Stephens, identified by Eakins and Crowell as the author and promoter of most of the "calumnies" circulating that year, filled the halls of the Academy with rumors and anecdotes concerning Eakins' "libertine" morals at home and at school. Told to the trustees in their moment of judgment, such stories only made their decision easier. Eakins "had a number of enemies who made trouble for him," commented one director after the Board meeting on February 13, 1886, "and the committee thought it best for the interests of the class that he should resign."[14]

The nature and extent of the damage done by this third group of critics can be read throughout the letters in the Bregler Collection. In these papers the enemies are not the Academy's Directors, nor is the "loincloth" a major issue. The Board had a right to fire him, even for a bad reason, and Eakins knew it. His exchange of letters with Coates is courteous, and though he defended his practices and made efforts as much as eight months later to set the record straight, he was more angry than bitter about the treatment he received from the Board. Blasting their proceedings and judgment as "cowardly cruel and dishonorable," he was really firing over their shoulders at those he felt had poisoned opinion against him. From these letters we can see that the "cabal" had begun to spread rumors before Christmas of 1885, rumors based mostly on indiscreet disclosures by one woman (probably Alice Barber) who admitted posing nude for Eakins and other women students in their private studios, including Eakins' own.[15] The impropriety of Eakins' conducting private sessions for middle-class women who might themselves occasionally strip and pose seems to have rocked the art community as well as the larger public, even if the participants were all adults acting with "the consent and knowledge of their mothers." The "nude posing business" was then worsened in conjunction with rumors of other scandalous practices said to have taken place in Eakins' household. It would be months before Eakins

understood the extent of these stories. To his dismay, the cloud of dishonor ultimately hung over Susan, Margaret, and Benjamin Eakins as well.

The impact of these rumors, and their content, can be read first in Eakins' correspondence with E. H. Coates. Notwithstanding his role as spokesman for the other directors, Coates tried at first to help Eakins, and he seems to have done his job without personal rancor. Coates was not a friend to Eakins as Fairman Rogers, the previous Chairman of the Committee on Instruction, had been, but he told Eakins that "everything you do interests me especially," and his patronage of Eakins' work was offered in a kindly and tactful, if not exactly enthusiastic spirit (Coates to TE, 27 Nov 1885; 24 Mar 1886, nos. 147, 156). Eakins looked to Coates for calm and so-phisticated guidance: "I am not in society nor skilled in the world's ways like you & Will Macdowell," wrote Eakins.

> My life has been spent with doctors and life students. If I am giving you trouble or have given you more than I ought, it is because I cannot keep everything to myself, and I hoped much from your power in appeasing wrath or making people see reason. (TE to Coates, 15 Feb 1886 no. 65, reproduced in full below)

The troubles Eakins poured out to Coates did not include the "loincloth incident," which must have been a matter of fact, allowing little dispute. Instead, he relived for Coates the dreadful "examination" by the Committee on Instruction, which devoted itself to topics churned up by student testi-mony and rumor, all concerning Eakins' moral character and, by extension, his fitness to direct a school. Disarmed by the interrogation on February 13, Eakins felt he had done a poor job of defending himself, and he wrote to Coates with second thoughts on February 15. Evidently the Committee had surprised him by dwelling on the subject of women students posing nude, for Eakins and for each other. Using student models had recently been for-bidden at the Academy. Eakins had tried to find models younger and healthier than the usual art-school professionals, but his most promising pool of tal-ent—impoverished art students—was denied him by the Board after a female student complained about the unseemliness of studying her own colleague nude.[16] The fact that this "private, professional" (to Eakins) activity went on surreptitiously outside the Academy shocked the directors, who found it incredible that "refined ladies" like Susan Macdowell Eakins, Maggie Eakins, Alice Barber, Mary Searle, and Amelia Van Buren might participate in such sessions. As a result, these women found themselves in a "nightmare" of vicious attacks by uncomprehending outsiders as well as unsympathetic peers.

Alice Barber, introduced without explanation into this discussion with Coates, suffered the most from these insults, as Fanny Eakins Crowell recollected later:

> Take Alice Barber, for instance. Her crime was having posed for her professor, yet when discovered her name was made subject of coarse jest among low New York students. (FEC to TE, 7 Apr 1890, no. 177)

Eakins was puzzled by the virulence of these attacks on both painter and model, and he was uneasy about the implications for his own reputation.

> Was ever so much smoke for so little fire? I never in my life seduced a girl, nor tried to, but what else can people think of all this rage and insanity. (TE to Coates, 15 Feb 1886, no. 65)

Grasping for respectability, Barber and Searle evidently defended themselves by attacking Eakins' discretion in suggesting or allowing such practices, even though—as Eakins pointed out—they were grown women with strong wills and mature professional ambitions. Too poor to hire models for themselves, they had "safeguarded" their private life classes by enlisting the company of Susan Eakins, as chaperone, though she proved slight protection, because her home at that time was also her husband's studio.

Further slurs on Eakins' character were made by those retelling "a coarse story not a lascivious one" he had shared with two girls out of school "many years ago." While admitting his lack of judgment, Eakins was appalled that this anecdote (evidently about plums) was "repeated through the school ad nauseam" as though it were typical of his behavior.[17]

Finally, Eakins touched upon the "dissecting room matter," an issue also used by Searle and Godley to discredit him.[18] Although the details remain unclear, Eakins' statement denouncing "affectation" in the dissecting room, when added to his later description of the controversy to Coates on September 11, helps us conclude that he had disapproved of the prudish castration of a cadaver before its dissection by women students: "the mutilation of the male subject for the false modesty is to me revolting." Searle and Godley, who were student supervisors of the dissecting room, probably testified to the Directors that Eakins' removal of the loincloth in lecture and his insistence on the integrity of the male cadaver amounted to an obsessive desire to assault the sensibilities of the women students—an attitude that Eakins' enemies as well as concerned, "incredulous" trustees were likely to accept as evidence of moral turpitude.

Eakins brought up the idea of a lawsuit to Coates, and noted the

relentless curiosity of the press, but insisted that he had done nothing and spoken to no journalists, even though the story was being carried outside the school. Coates in his response indicated that Eakins' supporters had not been so discreet, and he urged caution in an effort to contain "the facts in the case" within Committee walls. No report had been issued, and none ever was; even the minutes of these meetings were suppressed, perhaps thanks to Coates' sense that the press already had sufficient information to justify Eakins' departure. Certainly Coates knew that the revelation of other issues would do little to change opinions on either side, and might divide the school even more.

Coates' reply, although courteous, offended Eakins, whose ragged draft of a response sometime after February 18 (no. 66, reproduced in full below) tells how little success either man had in suppressing the testimony given before the committee. Further "evidence" used against him emerges in this letter: he "had made photographs of [his] female pupils naked," and was "a libertine," free from all moral restraint. Eakins bluntly denied the latter, and took pains to illustrate to Coates as late as September of that year the nature of his "naked series" photographs, a project that could not have been secret among the students, even if it was news to the Board.[19] The outrage Eakins felt upon hearing the rumors circulating in New York spluttered through in this draft, in which he nonetheless attempted a more distanced perspective: "I myself see many things clearer now than I did when in my first surprise I was stabbed from I know not where," he wrote.

> It was a petty conspiracy in which there was more folly than malice, weak ambitions and foolish hopes, and the actors in it are I think already coming to a sense of their shame. My conscience is clear, and my suffering is past. (no. 66)

If Eakins felt brave and hopeful at this moment, he would be disappointed soon, for almost as he wrote his enemies were carrying their attack to the art clubs in Philadelphia. That he had not put his suffering behind him, even in respect to the Academy's actions, is made clear in his two lengthy statements to Coates on September 11 and 12, six months after his final letter in the spring. Whereas the earlier letters are excited and somewhat disorganized, these two essays, both carefully copied on large sheets in a stately hand, show premeditation in their phrasing and special care in their presentation, as if Eakins anticipated sharing them with other readers. Despite Coates' attempts to bury the proceedings by insisting that written statements from either side would gain little (24 March 1886), Eakins must have con-

sidered these two September letters the official documentation of his defense. That Coates returned these papers to Eakins and refused to enter his copies into the files speaks for itself. Coates admitted that he did not agree with Eakins, but he also wanted the controversy ended. Neither Eakins nor the Board were allowed access to the record, a seeming discretion except that it left Eakins condemned by the Directors' action. As he wrote: "Your committee will judge if they won't rehire me." (no. 66.) Seen as guilty by reason of his dismissal, Eakins felt he deserved an opportunity to have a last word.

Eakins' first letter, of September 11, 1886 (reproduced in full below) defended the general issues of his painting and teaching methods, using analogies from other professions to assert his privilege. The topics of student models and dissection were discussed, as well as his opinions concerning education for women and their potential as artists. The second letter, of September 12 (also reproduced below), recounted the history of his association with Amelia Van Buren, clarifying older rumors that had recently come to his attention. Like his deceased sister Margaret, whose recollected statements were later used against Eakins by Frank Stephens in an especially cruel fashion, Van Buren made a convenient and malleable tool for the prosecution because she was ill and absent—in Detroit—and unable to defend herself or her teacher. Van Buren had been one of the promising students who had worked in Eakins' studio, sharing his models and benefitting from informal criticism. This in itself seems to have raised eyebrows, although "Minnie" was also a friend of Susan Eakins, who shared the studio space. More scandalous was the accusation implied in this letter: that Eakins had exposed himself to Van Buren's unwilling gaze, in a personal reenactment of the "loincloth" and "dissecting room" incidents. Eakins coolly explained the circumstance of his undressing—to demonstrate an anatomical point—and described the event as pedagogical and mutually unembarrassing. Far from being upset, Van Buren continued serious study and did not hesitate to support Eakins during his troubles or maintain close ties with the Eakinses in the 1890s. Yet even if their relationship had been entirely professional, and the choices were made in confidence, the confession of this event must have confirmed Coates' doubts about Eakins' judgment. Certainly the story illustrates the bluntness of Eakins' style and his dismissive treatment of proprieties. He must have felt sure of Van Buren's reaction before pulling off his trousers, but surely many other women—even dedicated students—would have been surprised or offended by such a display, even in the name of science. Was this an act born of blind innocence—the result, as he termed it, of so many years spent among doctors and life classes? There was something

perennially boyish and unworldly in Eakins, a quality that left him open to surprises from subtler, more devious, or simply more conventional minds. Insulated in his world and thoroughly steeped in conviction, he seems to have been genuinely amazed by the reactions of outsiders—both impatient of their opinions and astonished that they would bother to attack his. Can we believe without reservation this sturdy naiveté? Or was there also an element of exhibitionism, a kind of daredevil risk-taking, lurking subconsciously in Eakins' impromptu nudity—the same spirit that urged him to defy the Academy's Directors by removing the famous loincloth (again, coolly, in the name of scientific study and expediency) when he knew, at some level, that this meant trouble? Eakins' September statement, for all its reasonableness and "force" from his point of view (as Coates freely admitted), simply demonstrated to the Directors that they were dealing at best with an indiscreet man of unrealistic convictions, at worst with an intractable and provocative nonconformist. He complained bitterly of the Academy's secret investigation, conducted without recourse to his explanations and even without notifying him of the charges, and declared the Board's action "cruel, cowardly and dishonorable." Coates disagreed, reminding Eakins that his own testimony had formed the basis of the Committee's decision.[20] On the surface of things, Eakins' refusal to accept the Committee's jurisdiction over his classes and his dangerous polarization of the school offered adequate cause. Eakins' enemies made the circumstances of his dismissal immeasurably more painful and haunting by clouding the discussion with "evidence" of immoral behavior, but he had invited these troubles just as he had accrued enemies: with his own blunt and obstinate manner.

The Art Club Scandals: "Misrepresentations and foul lies"

Determined to turn Eakins "out of the Academy, the Philadelphia Sketch Club, and the Academy Art Club, and drive me out of the city" (TE to Emily Sartain, 25 Mar 1886, PAFA Archives), Frank Stephens did not wait long to take his campaign to the second organization on this list. An all-male society formed in 1860, the Philadelphia Sketch Club had asked Eakins to supervise its life classes in the mid-1870s, when the Academy was closed for new construction and opportunities for figure study were scarce. Grateful for his teaching, the Club named him an honorary member, although he never joined in its other activities. As a result, Eakins was surprised by the actions

of Anshutz and the two Stephens cousins, who on March 6, 1886 charged him with "conduct unworthy of a gentleman and discreditable to this organization," and asked the membership to vote his "expulsion from the Club" (see TE's Sketch Club dossier #4, reproduced below). Five days later the Club's Chairman, John V. Sears, notified Eakins of this complaint and the subsequent formation of a committee (made up of Sears and Eakins' students Walter Dunk and Henry R. Poore) to investigate the allegations.

Like Eakins' trouble at the Academy, the Sketch Club proceedings have been well described from available documents, mostly found in the Club's own archives. [1] The newly discovered papers in the Bregler Collection contain many items to complete our understanding of these events, which had a much lower public and professional impact on Eakins but a correspondingly higher level of personal acrimony and pain. An examination of Eakins' own transcription of the entire dossier of 11 letters (reproduced on pp. 218–25), which evidently was made for sharing with interested readers then and now, makes a complete and self-contained narrative, needing only the background of the Academy controversy to suggest the behavior that Stephens and his friends found so ungentlemanly. Supplementing these papers is a concluding statement by Eakins' brother-in-law, William J. Crowell, who rebutted the charges by turning the attack upon Stephens, revealing the mean-spirited mudslinging that went on behind the coy and officious club proceedings.

Eakins' first line of defense, which was that the club had no right to expel him because he had never asked to join, was procedurally neat but weak. Overly technical and off the point of his attackers, this first reaction cast into formal terms his anger and dismay upon learning that Anshutz and the Stephenses would drag matters outside the Academy. The Club's legal counselor indeed found that "the improper conduct charge relates to acts not within the jurisdiction of the club," making expulsion proceedings "inadvisable." Such legal niceties did give pause to some of the offended gentlemen. [2] Anshutz and Charles Stephens lost their taste for the proceedings when they learned that, in response to Eakins' second point of defense, charges would have to be presented in writing and backed with "specific evidence, which they [were] unwilling to give for reasons you will know." [3] Charley Stephens was, of course, Alice Barber's fiancé, and he had reason to wish her name kept off the record in hopes that further publicity on her role in the scandal would be contained. Anshutz may have been seconding Charley's wishes, or perhaps he had his own reasons for discretion. But Frank Stephens was not to be stopped. According to Walter Dunk, who reported his progress on the investigation privately to Sears, Stephens insisted on "pushing the thing to the utmost, regardless of any impropriety he may be guilty of in doing so." [4]

Dunk's remarks, however vague, imply that all three men felt strongly that their outrage was justified by specific events rather than merely by rumors of misbehavior. Even so, Eakins must have felt confident that they would lack the courage to summon specific evidence, or else he trusted that false-hoods and misrepresentations could be countered by his account of disputed events. Wisely, he avoided the circumstances of a hearing without previous announcement of the charges, probably because he still winced in recollection of the surprises delivered at the Academy during the Committee on Instruc-tion's similar interrogation. Perhaps he feared a loss of his composure again; certainly he planned to be better prepared. Sears and Dunk admitted that Eakins' request for a written statement of the charges was reasonable, but Stephens apparently side-stepped with generalities. Eakins' refusal to appear without advance notice of the specifics may have backfired, however, since— as Dunk warned him—this gave his friends no opportunity to defend him and prejudiced the committee in his "disfavor" (see dossier #8). Despite his repeated requests, but perhaps mindful of legal and moral risks, the club persisted in oral rather than written documentation, preparing "a long and carefully worded document" (which was, like the Academy's proceedings, never entered on the record), detailing "specifications" and testimony by "witnesses." On April 17, 1886, Eakins was found guilty of the charges and the members voted to ask for his resignation.

Before the Sketch Club investigation had concluded, "Stephens & Co." had filed similar charges at the Academy Art Club, whose Secretary, C. Few Seiss, duly notified Eakins of his expulsion on March 22, 1886. The Academy Art Club, which had been organized only three years earlier, was made up of Academy students and alumni only. Susan Macdowell had been a founder, as had Frank Stephens, who as the Club's first president had no difficulty enlisting the membership in support of his cause.[5]

The bylaws of the Art Club made it necessary for the accused party to appeal the expulsion ruling after the fact—a procedural turn that Eakins of course found "puerile" and "dishonorable." With no intention to appeal on such terms, he was nonetheless injured enough to lash out at the unjust proceedings of the Executive Committee, which included Charles Stephens. Again taking dignified refuge behind technicalities and stuffy prose, Eakins saw little advantage in coming out to meet his accusers. Perhaps he hoped that written charges could be dealt with item by item, as in his September letters to Coates. More likely he felt that judgment was foregone and defense hopeless. A year later the proceedings were overturned, thanks to a speech by Samuel B. Huey, who was thanked by Eakins for this friendly effort on April 5, 1887 (no. 75). Perhaps the unpleasant aftermath of the Sketch Club

proceedings, which stretched into June of 1886, chastened the members of the Art Club, for nothing further came of their charges.

The last act of the Sketch Club's investigation, which took place a month after the membership's vote, unfolds in Will Crowell's lengthy statement addressed to Chairman Sears on June 5, 1886.[6] Crowell's affidavit may have been one of the "two important papers" that Eakins gave to Huey to clarify his position and discredit the "calumnies" circulated by his detractors. The affidavit, in company with other letters from the same moment discovered in the Bregler Collection, exposes the most scurrilous of the rumors and reconstructs the nature of Eakins' defense within a small circle that gathered to support him. His correspondence as well as the documents written by others in his behalf seem to have been orchestrated by his brother-in-law William Gardner Macdowell—Susan Eakins' older brother—who had volunteered as an advisor and go-between by the time of the Sketch Club proceedings. Macdowell was a businessman whose good sense and worldliness had already put him—in Eakins' own terms—in a class with sophisticates like E. H. Coates (TE to Coates 15 Feb, see no. 65). Macdowell's handwriting on three of the Sketch Club or Art Club drafts shows that his logic and phraseology, or at least his sanction—stood behind Eakins' prose. Macdowell seems to have advised the cautious demeanor in these letters, drawing Eakins back from "all violence and law-suits whatever" (TE to Huey, see no. 75), and he served as a conduit for the two major statements by others in Eakins' defense—from Eakins' father, Benjamin Eakins (figure 8), and his brother-in-law William J. Crowell (figure 27). Probably these two documents formed the "important papers" that Eakins shared with Huey and others in 1886 and 1887. His father's affidavit is lost; we know that it existed only by references to it in other letters from this time (see WJC to TE, 8 Oct 86, no.163; TE to FEC, 4 Jun 86, no. 68; and SME's transcript of the Stephens interview, 9 May 87). Crowell's statement, (reproduced in full on p.) and other corollary letters from Will and his wife Frances ("Fanny") Eakins (figure 28), provide a much more personal and explicit account of Eakins' troubles than has been previously known.

These papers indicate that, far from being concluded by the Sketch Club's vote on April 17, Eakins' ordeal had still a year to run. As Crowell tells us, the issues broke out into a messy face-to-face confrontation when Eakins' friends met with some of the Sketch Club principals at 1729 Mount Vernon Street on May 29, 1886. Eakins, who was then living in his studio on Chestnut Street, was not invited to this meeting. Frank Stephens, who was living in the Eakins home with his pregnant wife, Caroline, produced at last a written statement of specific charges, which he read and apparently

19.　Thomas Eakins [?], William G. Macdowell, 1880s, albumen print, $2^{13}/_{16}$ × $2^{9}/_{16}''$.

Susan was very fond of her brother William. He provided much-needed moral support during the crisis of 1886–87, including assistance drafting letters of protest for Eakins to use in his defense.

sent to Eakins for his review. Although disgusted, Eakins was relieved to see "for the first time the utmost depth of the iniquity" (TE to FEC, 4 Jun, no. 68 reproduced below). Although Stephens' letter has been lost or destroyed, Crowell's affidavit, formed in response to the confrontation of May 29, allows us to understand Stephens' charges against Eakins, the evidence he used (or distorted) to ruin his brother-in-law's reputation, and the strange conflict that motivated his "sinister purpose."

Crowell identified the wellspring of all the troubles as Frank and Caroline Eakins Stephens' "insane resentment" provoked by Eakins' real and imagined insults. Charitably seen, their reaction was based on their "super-sensitiveness": an overly delicate and naive version of contemporary gentility that Eakins surely condemned, with much less charity, as affectation. The contrast between brother and sister reveals the paradox of the Eakins household, which produced children at two extremes of the spectrum of manners: Tom, the eldest, informal and earthy in dress and speech, and impatient of "conventional proprieties," must have somehow inspired the reactionary "Miss Caddy," the baby, twenty-one years younger and "dainty" in all respects. Their opposition was completed by Caddy's marriage to Stephens, a man no less fastidious and idealistic than she. From Will Crowell's vantage point, this conflict of personalities, exaggerated by Stephens' mania, lay at the base of the scandal. Stephens' "devilish malignity" sufficed, without recourse to conspiracy theories, to explain the origin of the various calumnies that formed the "true reason behind Eakins' forced resignation."

Stephens' charges in May included some familiar complaints—such as the "nude posing business"—and new, very surprising innuendoes of bestiality and incest which he alleged were based on testimony from Margaret Eakins. Because "Maggie" had died in 1882, Crowell took it upon himself to overturn this "evidence" by insisting that Stephens could never have heard such stories from her. Eakins, for his part, suggested soliciting a letter from the doctor who had attended Maggie before her death, a man who might testify to her sisterly "love and confidence" even at the last.[7] While incapable of believing Stephens' allegations, Crowell admitted privately to Eakins that the suspicion of "domestic improprieties" within the Eakins household might have begun with reports of Maggie's well-remembered complaints about Eakins' habit of walking from room to room upstairs dressed only in his shirttails (26 Apr 1886, no. 157 reproduced below). "Magnified and repeated in the style of filthy innuendo characteristic of [the Stephens cousins]," such remarks were used to construct a scenario of household depravity to complement the story of Eakins' undressing before Amelia Van Buren. Crowell spoke less about the more "hideous" allegations of bestiality, perhaps because

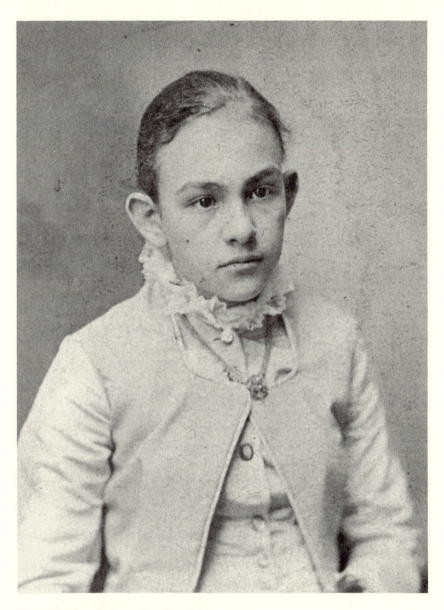

20. Schreiber & Sons, Caroline Eakins, 1878,
albumen print, 4⅛ × 2½", acquired from the estate of
Gordon Hendricks, 1988.

_Caroline, Tom's youngest sister, seen here at about 13 years of age, married
George Frank Stephens (Fig. 18) in 1885, when she was twenty. Stephens disliked
Eakins, and "Caddie" was repelled by her brother's manner; their criticisms
divided the family, and the couple were exiled from the Eakins home in 1886.
Caroline died in 1889 without making amends, but their son, Donald Stephens,
corresponded cordially with Susan Eakins in the 1930s._

Stephens disavowed such charges at the meeting and denied even suggesting the idea to others. Three men—Frank Macdowell, Will Sartain, and Henry Van Ingen—testified that Stephens' inferences in conversation had been unmistakable, and Crowell concluded that the whole topic simply demonstrated Stephens' style of malicious fabrication.

Apart from discrediting Stephens, Crowell was adamant in his defense of Eakins' purity of thought and conduct. He could find, however, kernels of truth in the rumors that, like Maggie Eakins' complaints, might have provided a source for imaginative perversions. Eakins' coarse or unconventional behavior was often judged rude or discourteous, and his contemptuous treatment of others' opinions had justly given offense and aroused resentment. While such "harmless, or at worst annoying breaches of conventional decorum" might seem "injudicious or dangerous" (as in the present instance), Crowell found in Eakins' behavior "no reason to modify my opinion of his essential uprightness and integrity." Praising Eakins' qualities of gentleness and compassion, Crowell concluded that he was guilty of nothing more than violating "the accepted canons of good taste."

Crowell's affidavit turned a defense of Eakins into an attack on Stephens, whose fate at the hands of public opinion can only be surmised by the fact that Benjamin Eakins turned him out of the house at 1729 Mount Vernon Street soon afterwards, inviting Tom and Sue to come live there instead. This public show of support from his father was important to Eakins, who was smarting from the implications of paternal approval vested in Stephens' residency in the family home, even though he knew that Benjamin was protecting Caddy's advancing pregnancy. Other upsetting rumors concerning the legality of Tom's marriage to Sue also seemed to turn upon the bohemian circumstances of their residence in the studio at 1330 Chestnut Street (see TE to A. B. Frost, 8 Jun 1887, no.78; Frost to TE, 19 May 1887, no. 165; TE to FEC, 4 Jun 1886, no. 68; and WJC to TE, 26 Apr 1886, no. 157). After the reorganization of living arrangements in July, Frank and Caddy Stephens were "sent away" from the family circle, never to be received again.[8]

Despite the departure of the Stephenses, the dispute continued for more than a year. Documents show that the following spring Eakins invited himself to a meeting with Louis Stephens and his son Charles, again hoping to contradict the "infamous lies" circulated by Frank. Susan's transcript of this meeting of May 9, 1887, from notes taken at the time or dictated by Eakins' soon afterwards, tells us that the issues were still hot for Eakins and "Charley" Stephens, who burst into the meeting between Eakins and his father "with tragic air, disheveled hair and wild eyes," demanding Eakins' confession of compromising behavior with his fiancée, Alice Barber. Stephens apparently

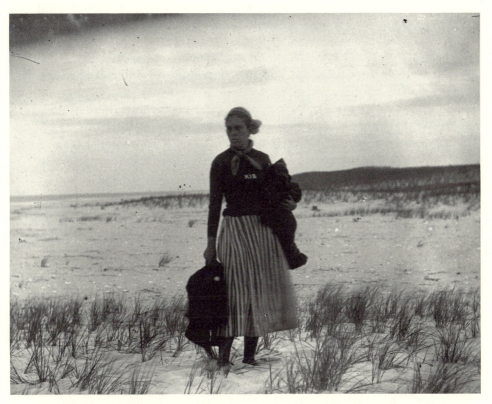

21. Thomas Eakins, Margaret Eakins at the beach, ca. 1881–82, modern print from a 4 × 5″ glass negative.

Eakins shared his love of the outdoors with his athletic sister Maggie and he was stricken by her death from typhoid in 1882, when she was only twenty-nine. Frank Stephens outraged Eakins in 1886 by spreading rumors about immoral behavior in the Eakins home, based on testimony he attributed to Maggie. Benjamin Eakins and Will Crowell both filed lengthy affidavits seeking to clear Tom and Maggie of these scandalous charges.

was upset by the photographs of nude women students (including Barber, no doubt) that Eakins had "dishonorably" shared with William G. Macdowell. Eakins explained that these photographs, surely items from his "naked series" of comparative figure studies, were given to Macdowell for safekeeping in the course of explaining to Macdowell his methods and the circumstances of the so-called "improprieties." Charley's other complaints were more in the vein of "boorish" behavior: the by-now-famous off-color "plums story" and other examples of coarse talk.[9] From these anecdotes, even half-told, we can surmise more about the low-level gossip that surrounded the more highly charged topics of scandal. The rumor mills apparently accepted even the smallest grains of "evidence" of offensive behavior once the premise of Eakins' "gross and vile" character had been made.

The women listed in the transcript of the Stephens interview as prime among the perpetrators of malicious gossip were "Alice" (Barber), "Trot" (perhaps Mary K. Trotter, a student at the Academy between 1876 and 1882), and "Lid"—Elizabeth Macdowell, Susan Eakins' sister (figure 22). "Lid" was also a painter who studied with Eakins in the same years Barber, Trotter, and Susan Macdowell attended classes at the Academy. Always strong-minded and outspoken, she took sides against her teacher and brother-in-law with typical energy. Macdowell later apologized and recanted the "misrepresentations and foul lies" she spread in 1886 (see 8 Nov 1888, no.174; n.d. Sep 1894, no.181) but she apparently lived for several years estranged from the Eakins family. Like Will Crowell and Will Macdowell, she maintained reservations about the wisdom of Eakins' "mingling of personal and business relations," suggesting that he had brought trouble upon himself.

Lid's betrayal in 1886 and the "treachery" of the Stephenses must have been especially hard on Susan Eakins, who took all the attacks her husband quite personally, much at the expense of her health and happiness. In *The Artist's Wife and his Setter Dog* Susan looked dreamy and a bit melancholy—like many of Eakins' sitters—when the picture was first painted in 1885, as early photographic reproductions show. Retouched some time after 1886, the revised portrait makes Susan appear much sadder and more haggard, as if prematurely aged by the troubles that year.[10] Her brother's worried letter of October 15, 1886, touched specifically upon her outrage over Lid's "dishonorable" behavior and advised laying down the sword: "Your own worn appearance tells the tale of worry and I grieve that you announce a plan that means no end of trouble except insanity or death." ("Inventory of the Manuscripts of Susan Macdowell Eakins," no. 101) The nature of Susan Eakins' plan remains unknown, but Will Macdowell's letter, coming a month after

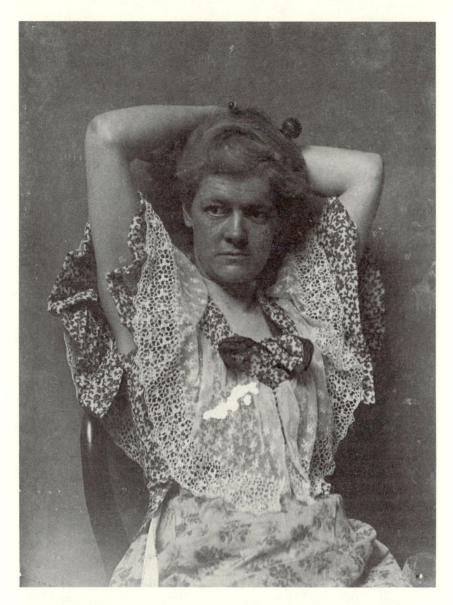

22. Thomas Eakins [?], Elizabeth Macdowell, ca. 1893,
collodion print, 4¼ × 3³⁄₁₆″.

Susan's sister Elizabeth Macdowell was an artist and a photographer. She took part in the rumor attack on Eakins at the time of his dismissal from the Pennsylvania Academy, but later she and her brother-in-law renewed friendly relations. Briefly married to Louis Kenton, she traveled widely, but often returned to Philadelphia to live with her sister in the Mt. Vernon St. house.

Eakins' last letters to Coates, reveals how much agitation still remained in the household that autumn. The following spring Eakins met with the Stephenses, solicited support from the painter A. B. Frost (8 June 1887, no. 78), and pursued students Fanny Sinn (through correspondence with her father, Andrew; see 10 May 1887 and 12 July 1887, nos. 77 and 80) and Charlotte Connard (2 Mar 1887, no. 124)—still seeking an opportunity to share "important papers" and rectify misunderstandings. In July both he and Susan wrote to "Minnie" Van Buren—she to warn against the influence of a fellow student, Lettie Willoughby, party to the "secret attack," and he to recapitulate the content of the troubles.[11] His letter of 9 July makes a succinct digest of his side of the story, with implicit references to Van Buren's participation in various controversial activities.

> Being the only ~~figure~~ painter in Philadelphia habitually using the naked model, I have whenever not too inconvenient to me allowed my most promising pupils to work from my models. I have also encouraged ~~my~~ advanced pupils to work from each other when the state of their purses precluded the employment of regular models at home, and I have corrected much of such work. I also have made many photographs of the naked figure including my own. I have spoken of medical things with the freedom of a physician.
>
> Misrepresentations of these affairs plain enough to professional artists or cultivated people, were made by participators the basis of an indecent attack upon my personal character.

The attack was "unsuccessful as far as I was concerned," he wrote bravely, and with the same courage went on to say, "My life has been very simple and honorable, and singularly free from complications and is all of it open to any friend." This plain statement, less angry and less contrived than his earlier letter, demonstrates the triumph of his convictions, if not the defeat of his enemies. His personal reputation had been soiled, his professional standing overturned, but his integrity had not been compromised. Weary, depressed, but unbeaten, he left two weeks later for the Dakotas, where his health and spirits would be revived by participation in the simple and honorable life of the cowboy.

Adventures on the Ranch

In the summer of 1887, Eakins boarded a train for the Dakota Territory, prepared to spend two-and-a-half months on a cattle ranch "studying Cow boy life in order to paint pictures of it" (Wood to Tripp, n.d. [ca. Jun 1887],

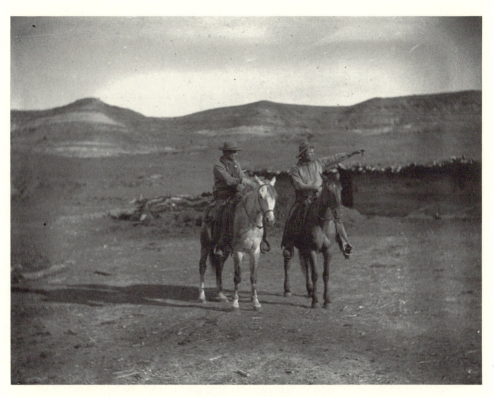

23. Thomas Eakins, Two cowboys in the Badlands, 1887,
 modern print from a 4 × 5″ glass negative.

*Eakins' newly discovered series of photographic images from the Dakotas contains
over 20 variations on the theme of horsemen, either one or two men standing next
to or mounted on their horses. Eakins apparently was thinking of producing a
number of cowboy paintings, writing to his wife of the two horses he had
purchased: "If I can sell any cowboy pictures at all they will be a good investment
for me."*

no. 166). The expedition also provided a much-needed vacation from his troubles in Philadelphia and may have been suggested by his friend and patron, Horatio C. Wood, M.D., a part-owner of the ranch.[1] Eakins was met at the station in Dickinson by Albert Tripp, manager of the B-T Ranch, and Dr. Wood's 15-year-old son George, who escorted him the forty-five miles to the "shack" (a log building) that served as the base of their operations, near the present site of Grassy Butte, North Dakota.[2]

Six letters (or fragments) survive recounting the cowboy life that Eakins led this summer. Mrs. Eakins shared all of them with Lloyd Goodrich about 1930–31, and the transcriptions he made from them were quoted extensively in his 1982 revised monograph. He evidently did not see the first 8 pages of one letter, however (28 Aug 1887, no. 83), and his citations published only a small percentage of the texts available to him.[3] After Susan Eakins' death, the letters must have been jumbled (causing the loss of the last page of no. 83) and divided, with Bregler bestowing the first letter, that of July 26, upon his young friend Seymour Adelman, while taking the other five home. Adelman's letter, now in the Dietrich Collection, supplies the opening scene for Eakins' arrival, along with anecdotes about his train trip.[4] The first Bregler letter, written five days later, begins the saga of ranch life that Eakins heartily entered. Riding hard over long distances, often sleeping on the ground, Eakins found his appetite and strength returning, bringing him back to "first class physical condition," exactly as his friends and family had hoped (W. G. Macdowell to TE, 29 Aug 1887, no. 170).

Eakins could ride and shoot well, and these skills helped him enter the cowboy realm and quickly grasp its concerns. His letters are full of detailed description of the ranch's activities that show he was an appreciative student of the professional expertise displayed by Tripp, his son George, and the many cowboys, "grangers," and trackers he met. Eakins observed them as he had watched Max Schmitt or Samuel Gross, with an eye to the characteristic qualities of their dress and behavior as well as their skill. His accounts therefore have an elucidating as well as entertaining merit of their own, and can be read for description and insight into the life of Western ranchers in this period. His account of the capture of a horse thief, in which he was assigned the job of holding down the ranch, and his hilarious story about an Indian's dental examination (both in no. 85) make engrossing reading. Although it is apparent from all of Eakins' writings that he was not "a man of letters" in any sense, these accounts make us suspect that he was a good storyteller.

The overt motive behind Eakins' trip—preparation for painting cowboy pictures—is little discussed in these letters. From his remarks, he seems to

have preferred rounding up horses to painting, although George Wood remembered constant sketching forays. However, the small number of extant studies from this trip may confirm the infrequency of his painting.[5] The subject was on his mind, however, as he justified the purchase of a broncho, "Billy," and an Indian pony, "Baldy," as future models. "If I can sell any cow boy pictures at all [the horses] will be a good investment for me" (28 Aug 1887, no. 83). We also know that he acquired a complete cowboy suit (now in the Hirshhorn Museum), which he indeed used for several later paintings.

Rather than sketching or taking notes, Eakins let his camera record the picturesque or characteristic details of cowboy life, and his letters contain a few references to the photography that was to inform his later paintings. On September 24 he rode to the top of a nearby butte and "stopped to photograph several things" on the way home. The following day, still in the company of the young man "Monte," or Jimmie O'Connor, who was later identified as the horse thief, Eakins noted that "Yesterday [Monte] shaved & we photographed & staid around all the time."[6]

Eakins returned east in early October. His trip back, accompanying his horses on a cattle train, his arrival in Philadelphia with all his cowboy traps, and his joyous procession to the farm at Avondale, can be read in various letters to his student, "Johnny" (J. Laurie) Wallace (nos. 86, 87, 88, reproduced pp. 244–45).[7] From the tone of these letters, it is clear that Eakins was reinvigorated by this trip, for he immediately set to work on the major painting from this experience, *Cowboys in the Badlands,* completed in 1888.[8]

The "Nude" at Drexel

The infamous "loincloth incident" of 1886 was reenacted by Eakins with a few variations in March 1895 during an anatomy lecture at Drexel Institute, about a mile from the scene of the earlier scandal. After more than one announcement of his intentions, Eakins disrobed a young man before a class of men and women. Protests, petitions, and newspaper stories followed, the remaining lectures were canceled, and Eakins once again found himself arguing for the necessity of his actions while the Institute charged that well-defined school policy had willfully been broken. Aside from criticism of his method, still seen as inappropriate for women, dispute centered on the terms of his contract and whether both parties had adequately expressed their policies in advance. According to one newspaper account the misunderstanding arose from the term "nude," which in Institute parlance assumed the loincloth, but to Eakins simply meant "naked." As a result, repeated warnings

that he intended to lecture with "nude" models made no impression on students or faculty until his meaning was demonstrated in class.[1]

A few sidelights on this moment of renewed controversy come from letters discovered in Bregler's collection expressing hearty sympathy or ugly disapproval. The latter came from Clifford Prevost Grayson (1857–1951), a painter who had studied very briefly at the Academy before enrolling in 1879 at the École des Beaux-Arts in Paris. Like Eakins, Grayson studied with Gérôme, but he then settled in France, successfully submitting subjects from Pont-Aven and Concarneau to the Salon as early as 1882. Grayson returned to Philadelphia in 1891 to head the art department at the new Drexel Institute of Art, Science, and Industry, where he surely had a role in hiring Eakins. Grayson was out of the country during Eakins' first set of troubles in 1886, but a knowledge of this or other scandals—perhaps the Hammitt case—seems to have informed his acidic letter to Eakins on March 27 (no. 183 reproduced below). Noting that payment would be made for the entire series, although only four lectures were given, Grayson remarked that Eakins therefore would have no cause to sue the Institute. "In view of your weakness for cheap notoriety, this no doubt will be a sad disappointment to you." Grayson's sarcasm may tell us more about his character and opinion than it does about the general reaction of the art community, but he must have aired his disagreeable estimation of Eakins to sympathetic friends. Eakins did the same, sharing Grayson's letter with colleagues in New York via his friend Robert Arthur[2], who passed it around to the other painters in his circle—George W. Maynard, Will H. Low, and Charles Y. Turner.[3] All these men were Eakins' contemporaries and veterans of European study—the latter two having worked with Gérôme and Bonnat—and, according to Arthur, they found Grayson's letter "pathetically silly" (31 Mar 1895, no. 184 reproduced below). Another strong letter of support, from J. R. Wilcraft, reveals approval of Eakins' methods among "all us Whitman fellows" (15 Mar 1895, no. 182).

Such statements of solidarity must have been welcome. The letters from Arthur and Grayson indicate that Eakins was angry enough to threaten a lawsuit, feeling that the series had been canceled for reasons never discussed in his contract. The President of Drexel, James MacAlister, insisted that the school's policy about total nudity (which was not allowed, even in classes segregated by gender) had been well explained in advance. MacAlister's speedy decision to pay the full fee may have been an admission that Eakins "did not break [his] promise and contracts" or—in keeping with Grayson's opinion—simply an act of discretion.

Given Eakins' reputation, it would seem naive of Grayson and MacAlister to have hired him without an awareness of his policies and a full

discussion of the ramifications. Eakins, on the other hand, had no reason to deceive or surprise anyone at Drexel. On the contrary, he seems to have made special efforts to clarify his intentions. From his earlier correspondence with F. S. Church (25 Oct 1888, no. 92), when he was negotiating a similar lecture series for the National Academy of Design in New York, Eakins' practice of spelling out his methods explicitly, in advance, seems well established.[4] The identical issues had been raised at the NAD in the winter of 1894, leading to fresh conversations with Maynard and E. H. Blashfield in January 1895, so it seems very unlikely that Eakins would have entered into a new arena without full discussion of expectations on both sides.[5]

As Goodrich has noted, the most remarkable aspect of this controversy is Eakins' surprise. Sufficiently educated by previous disputes at least to give repeated warnings before proceeding, he was nonetheless taken aback by the stormy response of the offended. Forever innocent and unyielding, he shows in his correspondence with the National Academy of Design a friendly, candid but essentially uncompromising attitude. With the ascendency of ideal and "poetic" tastes in the 1890s, his naturalism received an even chillier welcome, however, and invitations to lecture came less frequently, or were declined. Perhaps as a result of his winter negotiations with Blashfield and Maynard, compounded by publicity in New York concerning the Drexel "affair," Eakins did not teach again at the National Academy of Design. He continued to lecture at the Cooper Union but in controlled circumstances (to women only, using female models only) that avoided controversy. His cessation of even this type of lecturing after 1898 may have been decided by the school, or inspired by his own sense of weariness, increased at this time by the "cheap notoriety" of other unhappy events related to his teaching, such as the "Hammitt incident" and his niece's suicide. For a man who loved teaching, it was a bitter conclusion to twenty years of service.

The Hammitt Case: "A most unfortunate lady"

A group of letters concerning Eakins' student Lilian Hammitt was found in the company of a note written by Susan Eakins to Addie Williams in 1919: "The contents of this box destroy" (see figure 4).[1] Charles Bregler discovered these papers in 1939 and, without relating particulars (probably all too well known to him), he quoted Sue's note in a letter to Samuel Murray. Bregler's letter, subsequently discovered and published, has raised eyebrows over the "Hammitt case" in exactly the way Mrs. Eakins feared.[2] Those whose curiosity

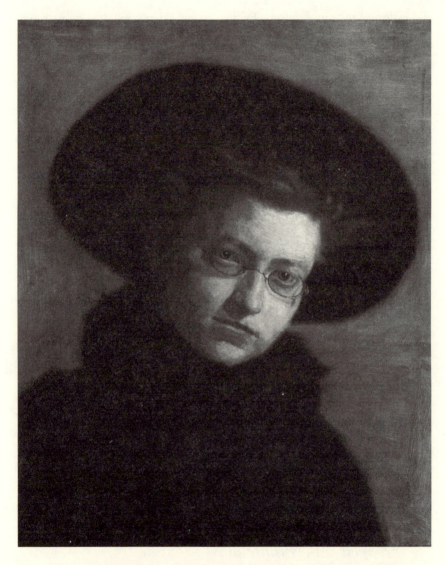

24. Thomas Eakins, *Girl in A Big Hat (Portrait of Lilian Hammitt)*, 1888, Hirshhorn Museum and Sculpture Garden, Smithsonian Institution, Gift of Joseph H. Hirshhorn, 1966.

Eakins abruptly halted work on this portrait after recieving a passionate and deluded love letter from the sitter, his student Lilian Hammitt.

was provoked by her dramatic instructions may be disappointed by these letters now that they have emerged, for they only tell a story—as Bregler said—of "sorrow and trouble," and incompletely at that. The most scandalous incident in the relations between Hammitt and Eakins is not discussed in these papers, and the truth about their friendship remains tantalizingly unclear.

Lilian Hammitt enrolled in classes at the Pennsylvania Academy of the Fine Arts in the fall of 1883, when she was eighteen years old.[3] She attended Eakins' classes until his departure in early 1886 and then joined his most loyal students in forming the Art Students' League that spring. A portrait specialist, she exhibited only once at the Academy's Annual in 1887. Susan Eakins used the page for March 23 in her retrospective diary to note that "This year we were familiar friends with Miss Lilian Hammitt (who went insane.)—1887." Susan's memory may have been jogged by rediscovering the first of Hammitt's extant letters to Eakins, dated March 4, 1887, which discusses the advisability of traveling to Europe with a Miss Connard, whose character Hammitt and Eakins had reason to question.[4] From Eakins' letter to Connard of March 2 (no. 124), we learn that she was one of the women students most responsible for the "infamous rumors industriously spread" during the previous year. What had been "a professional matter between me and Miss Searle and Connard"—perhaps dissecting-room policy, or the private studio practices, such as nude modeling by the students for each other's benefit—had been betrayed by their indiscretion.[5] Eakins invited Hammitt and Connard to review jointly "some papers relating to a criminal conspiracy against me," perhaps including the transcription of the Sketch Club exchange or the Crowell affidavit, which were also found in the company of these letters. To Connard, Eakins remarked that she might especially appreciate this enlightenment, as "you industriously made yourself somewhat conspicuous in an unjustifiable attack at the instance of someone more crafty than yourself." These words reiterate Eakins' observations elsewhere that his women students were manipulated by others, particularly Frank Stephens, who used their testimony to ruin Eakins' reputation.

Eakins did not discourage Hammitt from traveling with Connard, but her next extant letter came that summer from New Hampshire, not Europe. Her financial precariousness can be read in her admission to Sue that a woman from New York was helping pay her rent (20 Jul 1887, no. 126). The many strikeouts and illegibilities in another letter to Tom (n.d., [1887] from Keene, New Hampshire, no. 128) demonstrate another kind of instability.[6] If she felt more than admiration and gratitude for Eakins at this time, her feelings were expressed obliquely, in the guilty sentences to "Susie" that apologize

for having thanked Tom first for a photograph evidently sent by his wife. Mrs. Eakins' kindness to Lilian, acknowledged in both these letters, is demonstrated in her response to Hammitt early in the fall of 1887, at a time when Eakins was in the Dakota Territory.[7] Apparently Hammitt has announced her intention to marry—someone, anyone—for the sake of security. Mrs. Eakins recommended against this plan, but Lilian's insecure status as a single woman living alone must have made her contemplate such a strategy with seriousness. Hammitt's father was dead, her mother was frail, her family scattered and unhelpful. Eakins himself could demonstrate the difficulties in earning a living as an artist. The theatrical elements of her declaration of purpose can only be construed from hindsight; in her correspondence with Eakins that same year she seems optimistic and stable.[8] Mrs. Eakins' gentle advice—that Lilian should mix more with persons her own age, read less, and attend to her appearance—can only hint at Lilian's social maladjustment.

Hammitt wrote to Eakins while he was in the west and renewed her contact with him after his return in October of 1887. According to Mrs. Eakins' retrospective diary, her husband began to paint Hammitt's portrait (figure 24) a few days after Christmas 1887.[9] Eakins did not paint many portraits of his women students, so this picture must testify to their friendship as well as to Hammitt's frequent presence in the Chestnut Street studio. Work on this portrait was abruptly halted in early March of 1888, after Eakins received the first "inexpressibly" shocking letter from Lilian, evidently left in his box on February 29. This letter is now lost, but from Eakins' response we can imagine that Hammitt discussed their upcoming marriage and Tom's anticipated divorce from Sue.[10] Eakins' copy of his letter of March 2 (reproduced in full below) shows measured phrasing but genuine surprise. "You are laboring under false notions," he wrote, excusing her plans as "mental disorder" and reminding Lilian of her friendship with Susie as well as Eakins' "many expressions of devotion" to his wife that Hammitt had personally witnessed. He urged her to give up her studio and return to her "country home," where the surroundings of family and nature might calm her.

Perhaps Hammitt returned to live with relatives in Delaware County, Pennsylvania—the address she gave in 1887—or to her family's home near Dothen, then part of Henry County, Alabama. Mrs. Eakins' retrospective diary recorded that on May 21, 1889 "Lillian [*sic.*] Hammitt goes South," probably to nurse her ailing mother. Sue's recollection of this trip may confirm the moment when Eakins gave money to Hammitt for a trip to Atlanta; others interpreted this gift as a callous attempt to get her out of the way (L. B. Nelson to Charles Hammitt, 15 Jun 1890, no. 133). If Sue's date is

correct, however, the Eakinses tolerated Lilian's presence in Philadelphia for more than a year, intervening to assist her in at least one other crisis arising from similar delusions about another man (TE to Charles Hammitt, 5 Jun 1890, no. 131 reproduced below). Otherwise, her circumstances from mid-1888 until the spring of 1890 are unknown, except for her brother's later allusions to a "bad" reputation earned at home (near Dothen) about this time that made her return to Alabama in 1890 impossible (Charles Hammitt to Lilian Hammitt, 23 Jun 1890, no. 135). After her mother's death in January of 1890, Hammitt went to the nearest metropolis, Atlanta, where she supported herself first as a seamstress and then as a domestic servant. From there she wrote to "Brother Miller," soliciting his help getting a teaching position, confident that "my dear friend Mr. Eakins would I know be very glad to help."[11] About this same time she wrote again to Eakins, perhaps on this same topic of teaching but also on more "extraordinary" subjects recently discussed with her new employer, Mrs. L. B. Nelson. Eakins' brief and studied letter to Nelson (5 Jun 1890, no. 132) acknowledged receipt of bizarre letters from Hammitt (now lost), which he interpreted as manifesting "a form of insanity." By the same post he wrote to Hammitt's brother, Charles, in Alabama, alerting him to the worsening of her disorder, which had been "for some years a source of anxiety to my wife and myself" (TE to Charles Hammitt, 5 Jun 1890, no. 131 reproduced below). From his response we can imagine that Lilian had written another love letter to Eakins along the lines of her "shocking" missive two years earlier. This time she expected him to bring her back to Philadelphia and marry her. Eakins, although he could well remember the circumstances of her first such declaration, chose to suggest to Charles that the more recent strain of her mother's illness and death, in addition to her professional disappointments, had "accented" Lilian's "mental peculiarities" to bring on such delusions. "She has great talent for painting, artistic training and knowledge, and an intellect unusual in a woman," he wrote, hoping for Charles Hammitt's brotherly intervention on Lilian's behalf and casting his own relationship with her in strictly friendly, professional terms.

Mrs. Nelson, upon receiving Eakins' note, copied it for enclosure with her own letter to Charles Hammitt, whom she too hoped would offer Lilian assistance now that Nelson was leaving town. Nelson was not convinced by Eakins' cool letter. "I am sure he is the one responsible for her erroneous beliefs," she wrote to Charles on June 15 (no. 133). Having examined several of Eakins' letters to Hammitt (now lost), Nelson discovered "criminal propositions" on Lilian's part, met only by guardedness from Eakins. "I think it is his purpose in order to vindicate himself to carry the idea of insanity."

According to Mrs. Nelson, Lilian Hammitt was not so much insane as badly misled. Inspired by Eakins' suggestion, Hammitt had asked unspeakable things of Nelson's in-laws (such as posing nude?) that "almost [made] my heart stand still." Just as chilling to Nelson were Hammitt's questions to Eakins about the advisability of prostitution. Nelson knew that Eakins had warned Hammitt not to try the first unmentionable plan without her employer's approval, but she also felt sure that Lilian would basically do anything he advised. "She seems completely in his power," wrote Nelson. "Whenever she loses faith in this man there is some hope of getting her eyes opened to the truth."

After writing to Charles Hammitt, Mrs. Nelson gave Eakins a piece of her mind as well. This letter, now lost, can only be imagined from Eakins' tart response on June 19, 1890 (no. 134). Evidently Nelson assumed that Eakins felt responsible for Hammitt's expenses and also knew the name or names of other persons "morally responsible" for her behavior who could be blackmailed for "hush money" to prevent further embarrassing disclosures. "You mistake my character" and that of Lilian Hammitt," wrote Eakins. She is "mentally disordered" but also an honorable, talented, and intelligent woman thrown into difficult straits. Nelson might show her kindness by simply finding Hammitt a job. He understood too well "the difficulties in dealing kindly with her, sheltering her from the consequences of her many indiscretions" and the "ill-timed expression of her most eccentric opinions, but our sorrow at her condition has always outweighed our vexations." Eakins admonished Nelson for seizing Lilian's few "art treasures," apparently judged too profane and decadent: "Nothing could ever convince [Lilian], an old life class student, that there was obscenity in the beautiful body we are told was formed in God's image." Returning to Nelson a copy of her own letter for reconsideration, Eakins concluded with an ironic, old-fashioned flourish: "I have the honor to be, Madam, your most obedient servant." Hammitt had undergone in Atlanta the same trials that Eakins had suffered in Philadelphia, with additional pain wrought by loneliness, poverty, and the restrictions imposed by her sex. Deranged though she might be on personal topics, Eakins rose up to defend her identity as an artist.

If Eakins was annoyed by Nelson's hush-money schemes and narrow-mindedness, he must have been appalled by the reaction of Charles Hammitt. "Your affair with that Mr. Eakins—who claims to be a married man—is most astounding and ridiculous," Hammitt wrote to his sister on June 23 (no. 135). This man has "turned you *infidel,* and after *getting enough of you* now *casts you off* on the plea of insanity." To her brother, Lilian had "turned demon." He saw her as beyond reach, beyond even prayer. He closed his

house to her and refused to give financial support. Endorsed "your loving brother" without evident irony, the letter offered neither affection nor fraternal compassion.

Hammitt had received this dreadful letter and had been shown Eakins' letters to Nelson before she wrote to Eakins again on July 3, 1890 (no. 136). A week spent in a new job had ended with her employers leaving town without paying her wages. "I wonder that I am not really insane," she wrote, considering her bad luck. Things had taken a better turn, however, since she had found a job with friends of an Academy student, Eva Watson. In this "safer" and "calmer" situation, she denied telling anyone that Eakins was "anxious to take me away from Atlanta and marry me," even though her earlier letters to him must have said exactly as much. Feeling that her more general desire to be back in Philadelphia, in his company, had been misconstrued, she dismissed the perception of her insanity as the product of gender bias. According to Hammitt, she was no more "insane" than Eakins, but as a woman she was not allowed his liberty of speech and action. In attempting to be a painter on Eakins' terms, evidently Hammitt had only enhanced or confused perceptions of her maladjustment. She went on to describe Eakins as "my former teacher, my friend, and best counsellor," who has "filled the place of a father," yet inappropriate passion lurked in her wishful insistence on their mutual hatred of separation. "My love is always welcome [to you]," she wrote hopefully; "more than that—always returned." Her letter bore neither salutation nor signature, expressing her hope for a "calm, peaceful, quietly happy life" devoted to the study of art and free from the disturbances of the outside world.

This letter of July 3, 1890 is the last known item from Hammitt herself. From its text, full of both insight and self-deception, and from the veiled complex of earlier exchanges, wherein all parties expressed guardedness or prejudice, a picture of Hammitt's situation can only emerge between the lines. A misfit inclined to fantasize about men, she may have been attracted to the artist's life by the promise of freedom from conventional social relations. In Eakins' circle Hammitt found frequent, occasionally controversial study of the nude, which probably encouraged her imagination and her expectations. But ultimately Hammitt's dreams of sexual and professional satisfaction were equally frustrated, as her attempts to establish an identity as Eakins' wife, or as an artist in Eakins' mold, simply inspired rejection and drove her deeper into a spiral of maladjustment and delusion.

Within two years Hammitt was enjoying the tranquil, sheltered existence she desired, within the walls of a hospital in Pennsylvania. The last dated items in the Bregler papers are to Mrs. Eakins from Miss Maggie Unkle,

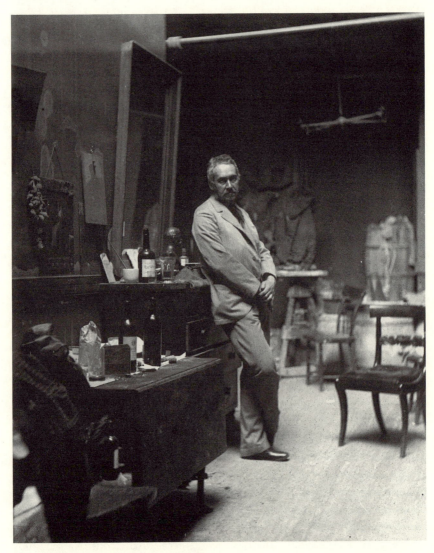

25. Susan Macdowell Eakins [?], Thomas Eakins in his studio, ca. 1891–93, modern print from a 4 × 5″ glass negative.

This well-known photograph depicts Eakins in the days of the Art Students'
League, when he was "the Boss" to admiring students like Charles Bregler, and a
sometimes disturbing mentor to women artists, including Lilian Hammitt and
his niece, Ella Crowell. Printed directly from the original glass plate, this
enlargement shows the full uncropped image and gives a freshly detailed and
informative view of the Chestnut Street studio, a few doors from the A.S.L.
rooms. Hendricks and others have speculated that Susan Macdowell Eakins took
this photograph and figure 29.

a friend who had, thanks to the Eakinses' gift, been able to visit the sanatorium in West Philadelphia where "Lillie" was contentedly resting.[12] Other friends were attempting to move her to the hospital in Norristown, a transfer that had been accomplished by the time of the second letter, on December 7, 1892 (nos.137,138). Hammitt had not wanted to leave West Philadelphia; according to a doctor, she wished to remain there "until she went to Paris." Perhaps she did have a sponsor who was willing to take her abroad; more likely her delusions were growing more elaborate. "I can't tell you how thankfull I am to you and Mr. Eakins for your kindness to Lillie," wrote Maggie, revealing, however incompletely, the Eakinses' continuing management of Hammitt's troubles through 1892.

No documents concerning Hammitt exist in the Bregler papers after 1892, although the worst crisis—surely the single "Hammitt incident" that Bregler recalled—was still to come. Sometime in the "mid-'90s" Hammitt was released from the hospital, only to be picked up on the streets of Philadelphia wearing a bathing costume. Interviewed by the police, she claimed to be married to Thomas Eakins—a story corroborated by Samuel Murray, who remembered Hammitt bursting into the Chestnut Street studio demanding the whereabouts of her husband. The sensational details of her arrest by the police were written up for a Philadelphia newspaper by Francis Ziegler, once the secretary of the Art Students' League and now a professional reporter. Ziegler came around to the studio for background information, but Eakins was out and Murray declined to comment. Ziegler went ahead and wrote the story, declining to exploit its lurid side (he said) but nonetheless infuriating Eakins, who wished the whole thing suppressed. When Ziegler returned to the studio he had the door slammed in his face by Eakins, who told him, "Never come here again."[13]

Eakins' unusually violent outburst was followed by a more studied letter of rejection. In Susan Eakins' handwriting we find the undated draft of a note:

> Mr. Eakins reproaching Mr. Ziegler with want of delicacy in exposing to the public the sad afflictions of a most unfortunate lady and requests him in consequence to discontinue his habit of visiting the studio. (Series II 4/A/14)

Eakins' anger on this final occasion, and his earlier interventions to help resolve Hammitt's problems, at least once by giving her train fare, can be imagined against a background of possible emotions: sincere concern and compassion, mixed with annoyance and impatience, dismay over yet another episode of notoriety, or perhaps guilt. Whether or not he had sexual relations

with Hammitt (as she told the police), Eakins must have felt somehow responsible for encouraging (or failing to discourage) an affection capable of fantastic extension. As another acquaintance remembered, all Eakins' "girl students were crazy about him,"[14] and the charged sexual atmosphere that surrounded his teaching, his art-making, and his scandal-ridden departure from the Academy surely did—as parents feared—put ideas into the heads of vulnerable young women like Lilian Hammitt. If Eakins did nothing to encourage such infatuations, his professional practices and reputation nonetheless attracted attention.

In measuring Eakins' involvement with Hammitt, two things must be remembered. The first is Eakins' own reputation for kindness and gentleness. Will Crowell, in his defense of Eakins' character in 1886, particularly stressed the tenderness and compassion in his brother-in-law's skill as a nurse (no. 161). Eakins' mother had died from complications brought on by "mania," and there seems reason to believe that, although alarmed by Hammitt's declarations of love and marriage, he responded with sincere concern for her happiness.

The second significant context for the Hammitt papers is the omnipresence of Susan Eakins. A friend and counselor at least as early as 1887, Sue was a source of support for Lilian throughout her troublesome episodes and hospitalization. Mrs. Eakins' entries in her own memoranda book record personal interest in Hammitt's course, and her draft of the letter to Ziegler illustrates her confidence in speaking for her husband on behalf of this "most unfortunate lady." Protecting all parties to the end, she insisted to Goodrich that the portrait of Hammitt be known only as "Girl in a Big Hat."[15]

Remembering Susan's intense involvement in Eakins' "trouble" in 1886–87, we can imagine that these signs of attention on her part indicate a lively sharing of correspondence and counsel between husband and wife. Mrs. Eakins, also well known for her generosity and kindness, can be assumed to have argued for patience and forgiveness beyond whatever might have been necessary to protect her husband's reputation. Motivated by more than a desire to "cover up," Susan must have perceived, along with Tom, that Lilian's desperate needs occasionally overrode questions of who was responsible for her condition or her future, or what might have been in the Eakinses' best interest. Their defense of Hammitt testifies to generosity of character, just as it shows a solidarity between husband and wife consistent with other descriptions of their marriage. Although it is possible that both women were deceived by Eakins, this seems unlikely. Simpler, and more plausible, is the opinion of Samuel Murray and Weda Cook, who found Hammitt "a poor, unhappy, demented girl."[16]

Ella Crowell's Suicide

Thomas Eakins' niece, Eleanor ("Ella") Crowell, shot herself and died on July 2, 1897, when she was twenty-four years old. Her father, William J. Crowell, blamed Eakins for corrupting, disturbing, and perhaps molesting Ella, who had studied painting with her uncle for several years in the early 1890s. Eakins was forever banished from the Crowell farm at Avondale, in Chester County, Pennsylvania. His nine other Crowell nieces and nephews, who had been a lively part of his own childless family life, were forbidden to speak his name. Even more bitter was the alienation of his sister Frances ("Fanny") and her husband Will, who had been comrades and supporters for years. And, perhaps most painful of all, Eakins again found himself caught up in a controversy arising from the environment, implicitly charged as sexual, that surrounded his professional practices.[1]

Perhaps because the dispute began within the family, there are no extant declarations from Eakins concerning his opinion of Will Crowell's charges. His surviving letters to the Crowell family at this time are terse, and they only assert some of his general principles—such as the importance of study from the nude—that are well known through other events and documents. The point-by-point response to his attackers was left to his wife, who was moved by events to record her own account privately, and at length. Mrs. Eakins, like her husband, remained publicly silent on this subject, pouring her outrage into a personal memorandum with no apparent intention other than a will to satisfy her soul by setting the facts down on paper. Her text (reproduced in full pp. 290–98),[2] full of strikeouts and emendations, seems to be a spontaneous draft that was never polished or recopied like other controversial statements in this collection that were made for distribution to others. It was simply written and saved in the interest of justice.

Susan Eakins' testimony has the drawbacks of any third-party account, and certainly she cannot be described as a disinterested observer. Since she was always fiercely partisan, her statements can be assessed in light of what we know about her character and her marriage, already discussed in respect to her role in the "Lilian Hammitt case." Whatever her biases, or however incomplete her story, Sue tells us much more about this unhappy sequence of events than is needed to comprehend her husband's passive response to the Crowells' charges. Inspired by more than guilt or discretion, his silence masked pain, disbelief, and the hopeless acceptance of betrayal.

The sting of rejection must have been sharpened by recollection of the warm reception Eakins had received at Avondale for two decades. Fanny

26. Thomas Eakins, the William Crowell family, ca. 1890,
mid-twentieth-century copy print, 8 × 10", acquired from the estate of
Gordon Hendricks, 1988.

This photograph of Tom's sister Fanny and her family posed on the steps of their farmhouse in Avondale, Pennsylvania was taken the year that Ella Crowell, seated on the second step at the far right, and her sister Maggie, seated next to her mother in the back row, began art studies with their uncle in Philadelphia. Later they were joined by their brother Ben, seated in the front row with the family's dog.

Eakins Crowell, a dedicated musician and an intellectual, was proud of her brother's accomplishment and supported his career; her husband, Will, Eakins' boyhood friend and companion in Europe, understood and respected the painter's work, even if he did not always approve of his manner and methods. Both Fanny and Will had been staunch supporters during the "trouble" in 1886, signing letters testifying to Eakins' good character.[3] The informal outdoor living and sympathetic company made the Crowell farm a refuge from the stuffiness of Philadelphia, and Eakins worked there with sufficient frequency to establish a studio at the back of the house. He brought his horses to the farm as well as his paints and his camera, and at an early age the Crowell children were posing, assisting, and receiving instruction from their Uncle Tom.

At the age of two Ella Crowell modeled for Eakins' *Baby at Play*, and she grew up with an interest in painting. By the summer of 1889 a career in art had been discussed—with some misgivings—for the two oldest children—Ella, who was then fifteen, and Margaret ("Maggie"), who was thirteen.[4] Benjamin Eakins Crowell ("Ben"), a year younger than Maggie, soon followed suit. All three children came to live in their grandfather's house at 1729 Mount Vernon Street, where they were tended by their Aunt Susie and taught—usually at the rooms of the Art Students' League—by their Uncle Tom.

Disputes arose even before the two girls arrived in Philadelphia on April 7, 1890. Fanny's letter of April 4, written with a mother's "anxious heart," reminded her brother that both children were "so innocent, and ignorant of the very existence of evil." Fanny wished they had better career opportunities, "away from the society of young men" and "the necessary Art surroundings" of the League. Lacking alternatives, she was at least assured that "there could be no better teacher in that line" than Eakins. She surrendered their welfare to him, begging that they be carefully held as *students* only, and never be asked "to pose nude, or even to strip in any way." She knew that, to save money, the students often posed for each other at the League, and Eakins had made it clear that he felt any life class member ought to be willing to undress in turn.[5] Full of apprehension, Fanny added that "I feel almost as if we were sending them to probable destruction" (no. 176).

Sue Eakins responded to Fanny's letter, following her husband's instructions. (n.d. [ca. 5 Apr 1890], no. 5) The undated draft of her letter told Fanny immediately that they could not agree to her conditions. Susan, for her part, remarked that if Fanny sensed destruction she should not send the girls at all, or insist that when visiting their grandfather the

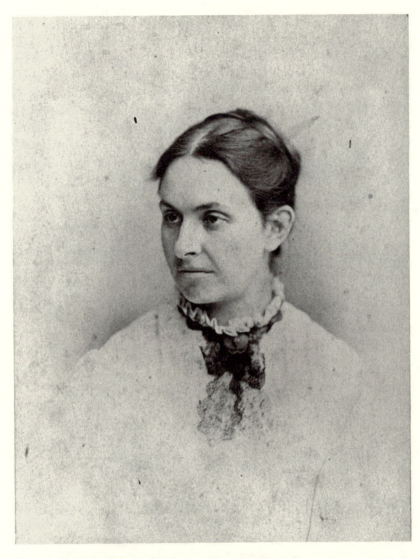

27. Frederick Gutekunst, Frances Eakins Crowell, 1880,
 albumen print, 5¹¹⁄₁₆ × 4¼", acquired from the estate of Gordon
 Hendricks, 1988.

Eakins' sister Fanny was one of his staunchest supporters in 1886, at the time of his dismissal from the Academy, but her ambivalence about his practices surfaced in the 1890s, when her own daughters entered the controversial environment of Eakins' teaching.

children stay out of their uncle's studio and away from his "art affairs." Her advice was not taken, for Ella and Maggie were already too determined to be thwarted.

Eakins wrote to Fanny when the girls arrived two days later. In a draft of a letter sent about April 7 (no. 95), he assured his sister "a watchful and loving care" for Ella and Maggie. The dangers she feared would not threaten them until later, when they were out "into the world"; for now, a sound education was the best foundation for later resistance to evil. He defended the environment of the Art Students' League as better than that of a girls' school and no worse than other training grounds for women seeking careers in music, nursing, typing, or store-tending ("Nursing would be my own choice next to art"). For Ella he anticipated a solid future as an animal painter perhaps remembering his friend in Paris, Rosa Bonheur. He noted, however, that this métier required thorough grounding in the study of the human figure. After basic skills had been mastered, life class studies would then need supplementary work at home, under Eakins' guidance, aimed at "closer observation of the joints & other machinery." In the pursuit of this study, the girls might well model for one another and "see any time any part of my body or Susie's, or any professional or private model." This is the method of all those in "constructive art," he wrote, requesting that Fanny abate her prejudice far enough to see that "the study of the naked figure is either wholly right or wholly wrong."

Fanny clung to the hope of compromise. When she responded on April 7 (no.177), the problems created by the "nude posing business" in 1886 were recollected. Fanny reminded Tom of the "trouble, estrangement, distress of mind and even disgrace" that had accompanied the use of women students as models in earlier years. Fanny also noted that his policy in the past had always required parental consent (which she was withholding), and remarked that secrecy in such matters had been shown to be impossible. Fanny feared that, like Alice Barber, her daughters might find their reputations ruined and their chances restricted for respectable employment outside the art world. She urged Eakins to use professional models and spare his nieces the risk of another scandal.[6]

Fanny's expression of the prevalent "prejudices" about artists and art school training makes a friendly and balanced presentation of the opinions held by "decent folk" in her day. Practical and informed rather than unduly prudish, her opposition to Eakins' practices seems reasonable, given contemporary standards, and her concerns real. She was worried about her brother, too.

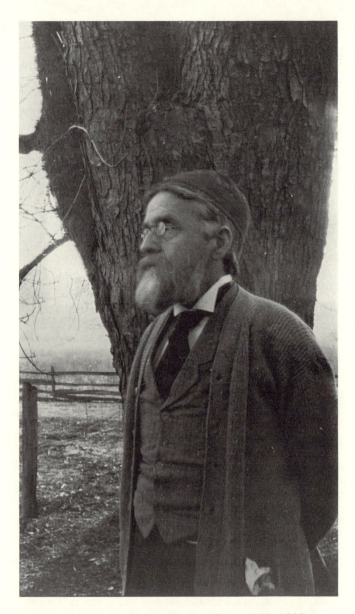

28. Photographer unknown, William J. Crowell, ca. 1890–1900,
silverprint, 4¼ × 2½″, Pennsylvania Academy of the Fine Arts,
acquired from the estate of Gordon Hendricks, 1988.

*Crowell, a friend of Tom's since boyhood, married Eakins' sister, Fanny, in 1872.
In 1886 Crowell wrote a lengthy affidavit in support of Eakins' character, which
was used to overturn the rumors circulating in the aftermath of Eakins' forced
resignation from the Academy. Crowell's reservations about Eakins' poor judgment
increased as he watched his eldest daughter, Ella, flounder emotionally while living
and studying with Eakins in Philadelphia. Ultimately Crowell blamed Eakins for
provoking the mental instability that led Ella to suicide in 1897.*

I thought you had given up girl students posing. Surely your experience with it was hard, and cost you dear. Think how it broke up two families, how we lost Caddie through it, the misery it cost Papa and all of us, yourself and Susie included. Nothing but evil came of it, sorrow and bitter feeling. A strong weapon which enabled your enemies to force you out of your high position and deal other hard strokes from which you are only just recovering.[7]

Still sensing trouble ahead, Fanny suggested that the girls be sent home.

The girls remained. In Susan's retrospective diary, she recorded on April 7, 1890 that "Ella and Maggy come to study."[8] When they did not return home, Will Crowell wrote on April 10 (no.178) that he assumed the Eakinses' acceptance of the children meant "at least a provisional waiver of your terms with reference to their personal posing." Despite, or perhaps in reaction to his earlier art training in Paris, Will approved of Tom's methods even less than Fanny, and he accused Eakins of setting up "the worship of the nude as a kind of fetich." A large section of Crowell's letter has been torn away, perhaps purposefully, but the information as well as the tone of his remarks tells much about the criticism Eakins received even from his best friends and closest relatives. Arguing that his "proselytes" came only from a class of young and impressionable persons, Crowell felt that Eakins' students "[run] riot in unjust denunciation & hatred of you" when they encounter the real world and feel that his teaching has deceived them. Like Fanny, he believed that Eakins had armed his enemies by making "unjustifiable assumptions." Nonetheless, Crowell had defended Eakins "at the time when every one known to me except your father & Frank Macdowell & Fanny seemed to justify or at least excuse the brutality of the treatment to which you were subjected," and he asked for Eakins' cooperation now in acknowledgment of his support then. With "small hope indeed that any of our children will ever attain a mastery of an art requiring such patience skill & industry," Crowell could only wish that they would avoid the more easily gained and "exceedingly offensive agglomeration of pettiness that is called 'Bohemianism.' " Crowell's list of the beliefs that he feared his children might learn from their "art associations," including faith in Eakins' "favorite Rabelais motto: 'Fay ce que vouldras' " [Do what you want], brought his letter to a bitter and self-righteous conclusion. His attitudes, already conservative by 1890, would not grow more flexible later.

The issue of nude posing was apparently resolved as long as the Art Students' League remained active, for the girls had ready access to models in the life class there. However, when the League dissolved early in 1893 Ella and Maggie "decided to work from one another as the most economical & easiest way to continue." (Memorandum, p. 295) According to Susan,

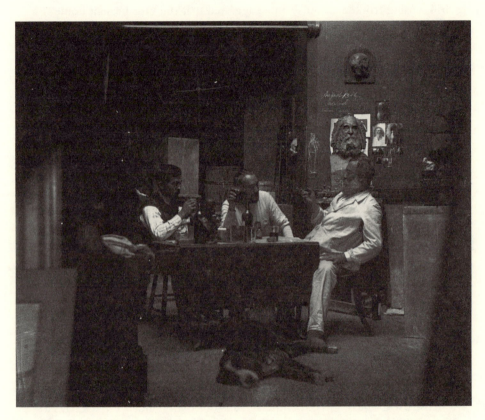

29. Susan Macdowell Eakins [?], Thomas Eakins, Samuel Murray, and William O'Donovan in the Chestnut Street studio, ca. 1892–93, modern print from a 4 × 5″ glass negative.

When his classes at the Art Students' League ceased in 1893, Eakins shared his studio with his nieces until 1895. This familiar image of Eakins from about this time is refreshed by the emergence of the actual negative in the Bregler Collection, which shows a wealth of detail cropped in extant prints. Now visible on the rear wall are the cast of a skull, the chalked reminder of an appointment with Weda Cook, and wonderfully clear details of the eight photographs of Walt Whitman adjacent to O'Donovan's bust of the poet.

Ella's "earnest and untiring solicitation" finally won approval of this plan. From phrases struck out ("only not to let their mother know") and the terms agreed upon ("not in this house"), it would seem that their mother's conditions were to be secretly overridden. Knowing her parents' strong feeling about this subject, the rebellious Ella must have felt guilty even as she enjoyed flaunting their wishes and winning her own way. According to her friend, the singer Weda Cook, Ella probably posed nude for her uncle, too, and this may have added another weight to her conscience.[9] Given her confessional style, Ella probably told her parents about these transgressions eventually in a manner much to her uncle's discredit. Her uneasiness about this independent study may explain why she gave it up not long after the League closed, and abandoned her career in art.

Eakins tried to stay out of his nieces' private arrangements and respect their parents' no-posing rule at least in regard to his own studio. His concessions came to an end on October 22, 1895. "I hold that the study of the figure is the foundation of good art," he wrote Fanny; "also that it is not right for one to profit by such study who is unwilling to allow his or her body to be seen." Because of the commencement of a major sculpture commission with Murray that would entail extensive study of nude models, many of them friends (who were "more interesting and more beautiful than the hired models"), Eakins found it both unfair and unwise to continue to allow his niece, a non-participant, the run of his private studio.

> To avoid all embarassments that might arise and explanations which would have to be made I decided that I would not invite Maggie to work with me. As long as I had a life class the children were entirely welcome to work there, but I am no longer teaching.[10]

The Crowells probably welcomed this logic, and Maggie—according to Mrs. Eakins—found his reasons just. She immediately enrolled in the life classes at the Pennsylvania Academy, where she continued her studies until the spring of 1899. In 1896 she was joined there by her younger brother Ben, who also came to live at Mount Vernon Street.[11]

While Maggie and Ben continued their art studies, Ella had taken a different course and entered university classes. At the end of the spring term in 1894 she returned to Avondale, helping Eakins with "the mechanical work on his sculpture," probably the figure of Grant's horse for the Brooklyn Memorial Arch, which he modeled at the farm from his own horse, "Billy." That fall Ella came back to Philadelphia with her uncle and, desperate to escape the boredom of the farm, offered her services to Susan as a house-

keeper. She took up music lessons (which she also abandoned), turning then to nursing, the career that her uncle favored "next to art."[12] On February 1, 1895 she enrolled in a two-year course at Presbyterian Hospital. According to Susan, Ella continued to spend her off-hours at the Eakins' home and once brought a group of her fellow nurses to the Chestnut Street studio. The crisis of her nursing training, never described by Mrs. Eakins, occurred when Ella mistakenly administered a near-lethal dose of medication to a patient; distraught, she threatened to shoot her friend Weda Cook, Eakins, and herself, and then swallowed an equally toxic amount of the same drug.[13] By August 1896 the Eakinses admitted they could no longer control Ella and her "wild plans," and they asked the Crowells to take her home; ten days later she was placed in a mental hospital. She was released after at least two months, but her improvement must have been short-lived.[14] The following summer she was confined at the farm until, escaping from her room, she found a gun and killed herself.

Eakins' relations with the Crowells, already strained by the restrictions on their children's study, broke at the time of Ella's hospitalization in August 1896. Fanny's first accusation of Tom came, according to Susan, three days before Ella was committed. Maggie, who had lived with the Eakinses through June of that year, first defended her uncle but was persuaded of his guilt by her parents. She and Ben aggravated the situation enormously by spreading tales of Eakins' seduction of Ella as a cause of her insanity. Susan was angry enough to write Fanny on October 18 condemning her "attitude toward Tom" as "detestable and outrageous" ("The Manuscripts of Susan Macdowell Eakins," no. 13).

> Maggie is freely talking at the Academy against her Uncle Tom. The stories are that her sister Ella's insanity was brought on by the wearing effect of unnatural sexual excitements practiced upon her in the style of Oscar Wilde. Such stories and behavior will injure her own reputation as well as Ella's.
>
> Fortunately I am able to record Ella's whole life here, and her trust in her Uncle Tom and her affection for him, have been remarked up to her last moments here.

Susan's (or Maggie's) reference to Oscar Wilde, whose sensational trials made headlines in the spring of 1895, adds further confusion to the charges made against Eakins. Wilde, the flamboyant writer and aesthete who went to prison that year for consorting with male prostitutes and newsboys, would seem to have little in common with "the style of" Thomas Eakins. From the tone of her remark, Mrs. Eakins thought the comparison was unjust, but Maggie's allegations deserve consideration, if only because they propose scan-

dalous behavior far different from the rumors circulated ten years earlier. Detailed courtroom testimony describing Wilde's liaisons appeared in print on both sides of the Atlantic, so it is possible that Maggie's reference was well informed and quite specific.[15] Her invocation of Wilde's name must make us look again at the parade of beautiful male bodies that passed across Eakins' canvases and in front of his camera. In 1974 Gordon Hendricks speculated about Eakins' closeness to his male students, his many nude photographs of men, and his affectionate relationship with the much-younger Samuel Murray, to propose at least an ambiguous sexuality for the artist.[16] Indeed, Eakins did seek the company of men and boys, admire the beauty of the male nude, and enjoy the spectacle of male athletes, both in real life and in Greek sculpture, as his earliest letters from Paris demonstrate. None of these behaviors were unconventional in Eakins' culture, but their linkage and, as seen in Wilde's case, their overly-enthusiastic practice, might draw attention. Such slender circumstantial evidence then raises the possibility, however unlikely outside the realm of rumor, that Maggie's story implicated Ella in a *ménage à trois,* or depicted her as a voyeur to her uncle's "unnatural sexual" acts with men.

The weight of testimony concerning Eakins' flirtatiousness with women when he was young, his zealous pursuit of opportunities to study the female nude, the heterosexual context of all his other scandals and—in spite of the preceding—his reportedly happy and stable married life, all tend to counterbalance innuendoes of homosexuality. However, the existence of such strong currents of appreciation of both male and female beauty confirms the presence of a powerful sexual awareness in Eakins that lay close to the surface of his art and his everyday interaction.[17] From his choice of profession, which mixed elements of anatomical study with painting, and the relentless emphasis on the figure in his art, Eakins had an unusual and compelling desire to "know" the human body, both male and female. That he might turn such interests on to culturally acceptable paths—such as painting the nude—does not deny the possibility of repressed curiosity or desire, or the reality of gratification from study itself. If Eakins had a bisexual or even "homo-erotic" inclination, as Hendricks suggests, such tendencies seem to have been channeled into conventional forms, such as figure painting or sports, or expressed in conventional relationships, such as his paternal and collegial affection for Samuel Murray.[18] Restrained within the bounds of acceptable activity—or standard heterosexual scandal—Eakins' energy and curiosity may have been enough to suggest to Ella "unnatural sexual excitements" of a vague and undirected order. If, in this same indeterminate way, Maggie made a naive association between Eakins and Wilde, her analogy might have been based

on the perception of youth corrupted by age, Eakins being about fifty and Ella twenty, while the "unnatural" aspect of their rumored relationship may have alluded to incest, a charge painfully familiar to Eakins from the Sketch Club proceedings. Mrs. Eakins' reference on her memorandum to "insinuations" of incest spread by Maggie and Ben Crowell may confirm this confused connection to Oscar Wilde and his boys.

Although it seems unlikely that Ella and Maggie were completely unaware of the homosexual implications brought forward in the use of Wilde's name, it is possible that he was simply invoked as the premier of criminally decadent artists. From this most distant, least informed perspective, Eakins and Wilde were united by their marginality. However different in personal style, they both occupied the far "artistic" fringes of their communities. To respectable neighbors in Philadelphia or London, each man exemplified Bohemian behavior in all the ways that Will Crowell had enumerated as degenerate. Relative to local audiences, they both represented every dangerous, ungodly, immoral, sexually liberated tenet of aestheticism. To say that Eakins was the Oscar Wilde of Philadelphia stretches a point, but only because Wilde occupied a place fundamentally off the map of Philadelphia's experience. Eakins, from his moral vantage, probably found Wilde's behavior silly, affected or decadent, and certainly he did not believe in art for art's sake or the theory of the avant-garde as did Wilde and his fellow aesthete Whistler. Nonetheless, in his advocacy of a painter's prerogatives and his willingness to confront popular opinion, Eakins was no less militant than Wilde, and his personal style was no less unconventional and mannered, in its own under-shirted way. Perhaps the style of his rebellion, with its component of sexual tension, can be better understood by analogy to an American literary giant, well known to both Wilde and Eakins, who shared the same marginal territory: Walt Whitman. Like Eakins, Whitman was drawn to nursing and to celebrations of the human body, male and female; in defense of his own homosexuality, he implicated himself in a string of heterosexual scandals. Eakins' sympathy for Whitman, read in his portraits of the poet, and Whitman's hearty approval of Eakins' work can only, like the mutual admiration of Whitman and Wilde, suggest a network of connected sensibilities, shared difficulties. Together, these men define a zone at the edge of late-nineteenth century Anglo-American culture where art and sexuality struggled for fresh expression.[19]

Will Crowell clearly believed in the Wilde analogy, although his accusations, contained in a letter of the same date as Susan's reference, have not survived.[20] He dated Ella's corruption by Tom to a period two years

30. Photographer unknown, William and Frances Crowell and
family, ca. 1900–1905, silverprint, 3⁷/₁₆ × 5¹¹/₁₆″,
Pennsylvania Academy of the Fine Arts,
acquired from the estate of Gordon Hendricks, 1988.

_Members of the family, joined by a tennis-playing friend, are posed in the steps of
the Avondale farmhouse in a reprise of the earlier 1890 family group by Eakins
(Fig 26), complete even to the newspaper held by Will Crowell._

earlier, when she had confessed scandalous intimacies between them. Crowell's claim, evidently extended later to include Eakins' responsibility for Ella's suicide, spurred Susan Eakins' retrospective memorandum in July of 1897. Her outline of events is dedicated to proving that both Eakins' nieces affectionately sought out his company, even during the period Fanny Crowell described as "Ella's flight . . . [from] Tom's approaches." Simultaneously, Susan wanted to record the fact that Will Crowell, if he did feel "rage and grief" over Ella's disclosures in 1894, did nothing to keep his children away from the corrupting environment of 1729 Mount Vernon Street, where at least three of them were happily residing through much of 1896. Mrs. Eakins assumed that Crowell's fiction was based on tales that Ella had told deliberately to enflame her father against her uncle. She concluded that Ella's instability was rocked by conflicting desires for love and approval from two father figures of diametrically opposed character.[21]

Ella's web of truth and fiction, somewhat unraveled by Sue's investigation but further knotted by the "insinuations" of incest spread (and then recanted) by Maggie and Ben Crowell, makes it hard to assess exactly what transpired between uncle and niece. Ella complained to her aunt of Eakins' "degrading touch," and she told her parents that he had forced her to touch his "private parts."[22] Given Ella's reputation as a liar, this may simply have been untrue. Perhaps this encounter constituted the full extent of the "unnatural sexual excitements." Regardless of the matter-of-fact explanations that Eakins might have given, in the fashion of his defense of his own nudity before Amelia Van Buren, such incidents (or tales) were clearly enough provocation for the unstable Ella and her grieving parents. Still, whatever happened must have taken place years before her death or "insanity"—since she stopped painting about 1893—making Eakins' behavior, however strange or ill-judged, an unlikely cause for suicide, particularly given Susan's account of Ella's cordial relationship with her uncle up to the last, and other accounts of her crisis at nursing school.

Left without the Crowells' specific complaints or any first-person testimony, we can only speculate about Eakins' opinion of the matter by reading his wife's guiltless response. Mrs. Eakins found the Crowells' charges "detestable and outrageous"—strong words from a normally soft-spoken and good-humored woman. She was angry, feeling that the loving and generous "sacrifice" that she and her husband had made for the Crowell children, who had lived for years in their home and benefited from their uncle's tutelage, had been shamefully betrayed. The Crowells' after-the-fact indictment, their failure to withdraw their children when (or if) they had signs of Ella's dis-

turbance, their poisoning of the children's trust and affection, their insensitive and "dishonorable" placement of their sons Ben and Willie as apprentices with Eakins' old enemy, Frank Stephens—all these counter-charges must be weighed against the Crowells' condemnation of Tom. While we might suspect that Eakins was not innocent of provocative behavior, his wife's memorandum must make us feel that the reality of his punishment far outweighed the substance of his "crimes."

Ella Crowell's story (like Lilian Hammitt's, and like the Academy and Sketch Club scandals) invites us to speculate again about the possible provocation behind all these similar situations involving Eakins and young women. Throughout his career Eakins attracted women students; he fell in love with one—Susan Macdowell—and married her, befriended a few, coolly ignored some, and violently alienated others.[23] Among all these students, at least two—Ella Crowell and Lilian Hammitt—found his presence dangerously stimulating and ultimately disturbing. Both students developed a powerful affection that inspired sexual thoughts: fantasies of marriage in Hammitt, revulsion and attack from Crowell. For such unstable and suggestible women, the environment of nude study, however businesslike, must have been provocative, and Eakins himself, who ever after 1886 moved through life with an aura of sexual disreputability, served as a lightning rod for personal anxieties and dreams that would never have been imposed upon an unflirtatious man in another line of work, or even upon an artist with a less well publicized reliance on the study of the nude. Eakins was more than just an exciting teacher; these relationships were more than student-professor flirtation or infatuation. For "so much smoke," as Eakins himself admitted, "what else can people think?" Was it just personal magnetism and the aura of illicit behavior that drew these women and these scandals?

The nature of Eakins' sexuality remains one of the real mysteries of Eakins' life, far less knowable than the "facts" of mental illness or physical contact, which are in themselves mutable according to the subjective testimony of different observers. We will never know exactly what kind of mixed signals Eakins conveyed to his women students, nor the degree to which he was conscious of the sexual messages lurking in his work and his teaching. Accounts of Eakins' classroom manner emphasize his disciplined, no-nonsense attitude; occasionally brusque, but generally good-humored and patient, he seems to have taken his cues from Gérôme's firm and kindly critiques at the École. He does not seem to have teased, bullied, or provoked individual students. "In all the womans' schools I have always conducted myself with the dignity which comes from serious thoughts," he told Coates in 1886 (15 Feb 1886, no. 65). Such

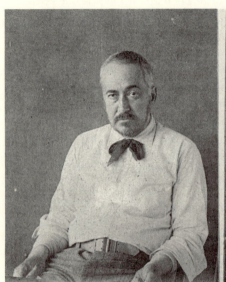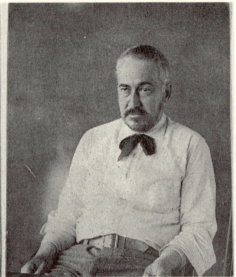

31. Photographer unknown, Thomas Eakins, 1890s,
 gelatin prints, 4¾ × 3¹⁄₁₆″ overall.

Two previously unknown images of the artist, who appears to be in his 50s, taken at the same sitting, were mounted side by side on a card. Eakins may be operating a shutter release with his left hand, making this a self-portrait session.

public statements always assert Eakins' professionalism and defend his methods as necessary to a craftsmanly pursuit of his work; when charged, he turned blame back onto his accusers, who saw immorality or lewdness where he found beauty, truth, and conscientious practice. Since this declaration of virtue and its attack by "Victorian" critics has become central to the Eakins legend, the possibility of ambiguity or simultaneity of such opinions within Eakins himself deserves consideration. Was Eakins really completely insulated by his own ideology? Wounded so often by the arrows of contemporary moral outrage, he must have been well aware of the conventional values of his students and the conflict created by his curriculum. Did he believe that his teaching would totally elevate the minds of his students, overriding the deep patterns of modesty, revulsion, or disapproval in his culture? Years of life class and dissection had surely made him less sensitive to the dilemmas of adolescent art students and too trusting of those who, like Ella Crowell or Lilian Hammitt or Alice Barber, for a time professed unreserved dedication to his methods. But Alice (and many others) turned against him, while Ella successfully betrayed him and Lilian, it seems, genuinely took him by surprise. If we accept these events at face value along with his own testimony, we are left again, as in the Academy "trouble," with a man of the very rarest idealism and ingenuousness, or one with deeply buried guilt and conflict who subconsciously provoked those around him to test his own identity. The letters and manuscripts propose these possibilities, but writing can hardly be expected to offer resolution. Necessarily, these papers are too hardened by the forms of language and the intervention of rational defenses to express the paradoxical, inarticulate reality of Eakins' mind.

Ella Crowell's death in 1897 and Eakins' silent acceptance of her parents' condemnation marked a watershed in his personal struggles. It was the last such controversy he would suffer, perhaps because he gave up teaching altogether after that year and left the provoking environment of the lecture hall and life class. The cumulative effect of the Drexel Institute uproar, the Hammitt scandal, and the Crowell suicide, all coming in these years around 1895, may have determined his retirement from teaching, for he was still young—only fifty-three—and otherwise fit. Free from the "impertinent interference of the ignorant" and bitter about the "misunderstanding, persecution and neglect" of the art establishment,[24] Eakins was in no way chastened. The last dozen years of his career spawned the majority of anecdotes about his "shocking" behavior with female sitters: wheedling women to pose nude, appearing half-dressed himself and, on one occasion, marching stark naked in front of a girl posing for Murray, announcing "I don't know if you ever saw a naked man before; I thought you might like to see one."[25]

In such stories, we see Eakins embracing the role of a confirmed impenitent. Perhaps he felt liberated by age to do exactly as he pleased; certainly he knew that his reputation could not be worsened. It seems that he enjoyed playing to expectations by caricaturing earlier stories, like the scandal of undressing before Amelia Van Buren—again a bit of theater "in the style of Oscar Wilde," in the spirit of Walt Whitman.

This bitter humor, supported by a few loyal friends and the first glimmers of official honor, carried Eakins through a decade of extraordinary portrait painting that culminated in his return to the theme of William Rush and his model. Now overtly autobiographical, the late Rush paintings reiterate Eakins' co-identity with the early nineteenth-century sculptor who dared to model from the nude figure of a society girl, and they confirm his victory over forces that would have made him more cautious and compromising.[26] Despite the costs, too easily reckoned from these new documents in the Bregler Collection, the nude model remained his goddess, his muse.

Eakins As a Teacher

A few manuscripts by Eakins in the Bregler Collection shed light on his methods and concerns as a teacher in addition to his emphasis on study from the nude. Several sheets of notes on human anatomy and animal locomotion illustrate his interest in the scientific understanding of weight, surfaces, and motion in the subjects he painted. The anatomy notes, written in French, are probably from the 1870s, when French was his language of internal discourse; his perspective drawings as late as the mid-'70s continue to show French annotations as well. The notes on animal locomotion must be later, perhaps from the period of his motion photography (ca. 1884–85) or—more likely—in preparation for his paper on the differential action of certain muscles in the horse, published in 1894. Also from the mid-'80s must be his notes and drafts on perspective drawing, which include drafts and variant exercises for his manuscript on drawing, now held by the Philadelphia Museum of Art. Because the Bregler Collection also contains the illustrations for this text, a separate publication reuniting Eakins' words and pictures, to make better sense of each, will be forthcoming as a joint production by the Pennsylvania Academy and the Philadelphia Museum of Art.

Eakins may have used the draft of his manuscript on drawing as a lecture guide, or perhaps his lectures to the Academy and the Art Students' League gradually consolidated into the chapters of his text, as we can read from Charles Bregler's notes. This suite of notes, with sketched diagrams, may date from

Reflections in the water

The calm surface of water reflects like a looking glass and we see reproduced upside down the images of the real objects The law of such reflection is very simple. It is that the angle of reflection equals the angle incidence

upright an object then will appear on the waters edge appear to be the same height up from the surface of the water as its reflection goes down deep Thus the reflection of the upright wharf. A.B is B.C. which is its equal and the bush height from the water E.D and its reflection E.F its equal

The reflection of a post sloping up towards a spectator would be longer on a picture plane than the post itself, but shorter if the post sloped up and away from the spectator

This then desposing of the reflection in calm water, we must examine reflection when the water is in waves

Each wave being curved has an infinity of planes which of course would not be examined separately, but some of these planes are more interesting than others and we may compleatly simplify our study of them by assuming the waves to be made of level planes.

1

32. Charles Bregler's notes on Eakins' lectures and manuscripts.
 Page headed "Reflections on water."

95 pages of Bregler's notes from Eakins' lectures at the Pennsylvania Academy of the Fine Arts and the Art Students' League have been preserved in the collection.

Bregler's years as a student (1885–87), although it is possible that he later copied them from Eakins' manuscript (figure 32).[1] Bregler's recollections of Eakins' teaching, which he published in 1931 in two articles in *Arts Magazine*,[2] remain the foundation of our knowledge of Eakins' classroom manner and his advice to students. Much of the material that appeared in *Arts* is also contained in the "Talks to Class" notebook, written in Susan Eakins' hand, that Bregler recovered from the floor of Eakins' studio in 1939.[3] Like another set of loose pages in Sue's writing titled "Remarks made by TE on the Law of Relief," these sheets demonstrate Mrs. Eakins' interest in perpetuating her husband's classroom statements. According to her own footnote, Sue copied this material from Bregler's notes, although it is not clear when. Oddly, some material relating to Bregler's articles on Eakins survived (see Chapter X, "The Life and Papers of Charles Bregler," and Fiche IV 12/D/13 to 13/E/1), but not his actual notes from 1885–87, so Mrs. Eakins' "Talks to Class" may be the only manuscript record of Bregler's experience.

Eakins Described by Others

Eakins' own manuscripts in the Bregler Collection are far outnumbered by the letters and statements of others, principally his wife, Susan Macdowell Eakins, and his student Charles Bregler. While his own words are the most engrossing, the recollections of others have great value, particularly when—as in the case of Bregler's lecture notes—Eakins' words are recorded so faithfully that, as Mrs. Eakins remarked, they sound like Eakins talking. But even less vivacious testimony has its worth. Susan's biographical statements (reproduced below, pp. 298–300) provided Lloyd Goodrich with a scaffold of dates and circumstances for his initial biography in 1933, and her papers afford a wealth of detail that supplements the record. Her diaries, while irregular and mostly from late in their married life, are full of household events, visitors, trips, and portrait sessions, shedding light on her own activities as well as her husband's. The context of these diaries and the character of her correspondence are discussed below in "The Life and Papers of Susan Macdowell Eakins."

Those studying Mrs. Eakins' papers to learn more about her husband need only one note of caution. Many of her statements and diary or record-book notations were made belatedly, sometimes long after Eakins' death. Her retrospective diary, which is a mine of useful lifetime dates, is written into a printed diary for the year 1913, and changes in the pen used, along with certain parenthetical glosses, make it clear that she went over the entries later, adding new recollections and editorial commentaries. "I'll bet it was

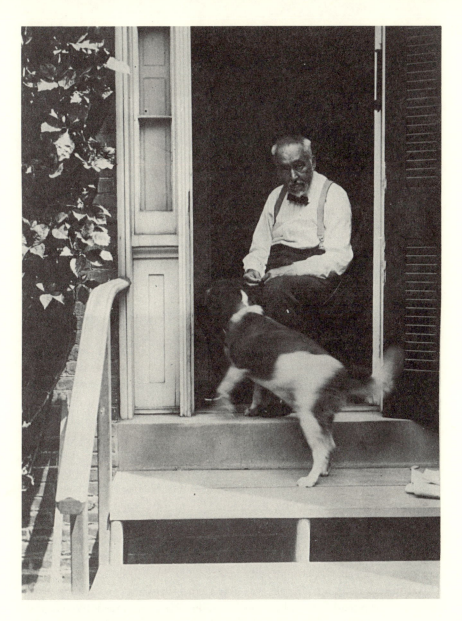

33. Photographer unknown, Thomas Eakins at about 70, ca. 1914,
 gelatin print, 4⁹⁄₁₆ × 3⁷⁄₁₆″.

*The Bregler Collection contains four unpublished images of the artist taken on this
day on the side porch of the Eakins home. These may have been taken by Samuel
Murray, or by Charles Bregler, who annotated one of the photographs in this series
as "the last photograph of Thomas Eakins."*

foolish," she wrote in 1931, speculating about a now-forgotten conversation with "Will" (Macdowell?), recorded on the page for April 25. There is also reason to suspect that some of these dates were suggested by manuscripts now in the Bregler Collection, since a few of Mrs. Eakins' entries appear on the date-pages corresponding exactly to dated items in the collection. We can imagine that a review of old letters jogged her memory and she compiled all such recollections in this one diary. Thus September 14, 1894, "Tom writes a kind note to Lid, offering friendship," may respond to a review of Eakins' letter to Elizabeth Macdowell of the next day (no. 97).

Certain omissions are noteworthy, too. On the first page—January 1, 1913—she titled this diary "Book of Events to Remember," and her own editorial discretion seems to have thereby eliminated all events she did *not* care to recall. Conscientious about births, marriages, and deaths, she did not choose to commemorate emotional upheaval: no dates are entered for the Academy, Sketch Club, Art Club, or Drexel "troubles," or for Ella Crowell's and Lilian Hammitt's actual moments of insanity.

Charles Bregler's papers are also a useful source of information about Eakins, although his memories are shaped by the confines of a more distant and idolizing relationship. His life, and the general character of his papers, have been discussed in the Introduction and below, in "The Life and Papers of Charles Bregler." Bregler's recollections of Eakins' teaching are unique and invaluable, of course, but other aspects of his experience, as expressed in his papers, deserve attention. A few observations, like his sketch plan of Eakins' studio on Mount Vernon Street, offer interesting new facts; a few opinions, like his hostility toward Thomas Anshutz, whom he blamed more than Frank Stephens for Eakins' "troubles" in 1886, make an interesting counterbalance to the testaments of others like Will Crowell. Bregler's assessment of Eakins' marriage, which he described several times as remarkable for its stability and tenderness, also helps us to judge the behavior of the Eakinses as they encountered crises like Lilian Hammitt's craziness, or Ella Crowell's suicide.

Bregler, a painter himself, was also a sensitive witness to Eakins as an artist, and his remarks about his master's methods bear attention. He proudly describes himself as having been present in the studio while Eakins painted Frank Hamilton Cushing, and he must have observed Eakins painting on many other occasions. This experience led him to dispute Goodrich's characterization of Eakins' method as slow, painstaking, and laborious, requiring many sittings.[1] While the testimony of many impatient sitters interviewed by Goodrich cannot be dismissed, Bregler's conviction about Eakins' ability quickly to grasp the main qualities of his subject needs to be assessed. According to Bregler, imagination and preconception formed an important part

of Eakins' method. Because he so powerfully visualized his intended effect in advance of actually painting, Eakins needed few studies beyond the broadly painted sketches that began most of his projects and rarely altered his concept dramatically after confirming his idea with an initial sketch. This sketch and the actual painting were done from nature, but the procedure Bregler describes places more emphasis on Eakins' artistic imagination than the usual rhetoric about his down-to-earth naturalism would allow. Bregler's observations, considered alongside Eakins' statement about "big painters" versus mere "coal scuttle realists" (06 Mar 1868, no. 38, reproduced below), makes us alert, exactly as we should be, to the subtlety of Eakins' creativity within the tradition of academic naturalism.

The voices of Susan Eakins and Charles Bregler are followed by many others in this collection, some heard only in a single manuscript. The remarks of other family members, students, friends, collectors, dealers, scholars—all provide fresh detail, new perspectives. Since the scope of this book has not allowed detailed annotations on every item or writer, much remains to be gleaned from these papers to enrich our sense of Thomas Eakins' life and work.

Notes

INTRODUCTION: A LIFE IN WORDS

1. SME to Peggy Macdowell, n.d., published in David Sellin, *Thomas Eakins, Susan Macdowell Eakins, Elizabeth Macdowell Kenton* (Roanoke, Va.: North Cross School, 1977), p. 62.

2. Goodrich I/x, and II/5–6, quoting Eakins' statement of 1893.

3. To Goodrich, n.d. [ca. Nov 1930], Philadelphia Museum of Art. Susan Eakins' statement will be appreciated by Michael Fried, whose recent work has analyzed the many uses of writing in Eakins' work, the "writing/drawing" emphasis in his earliest training, and the relation between writing and the realist style. Fried locates a tension in Eakins' art based on a conflict between the painterly, "pictorial" appreciation of the vertical surface of the painting and the opposing "graphic" sensibility, based on writing and drawing, which seeks to know more and more about the objects within the picture's illusionistic, horizontal space. See Michael Fried, *Realism, Writing, Disfiguration: On Thomas Eakins and Stephen Crane* (Chicago: University of Chicago Press, 1987.)

LETTERS FROM ABROAD

1. Eakins seems to have written to his father with respectful regularity, about every two weeks. The predictability of this pattern, as well as internal references in the letters, points to the loss of some letters, which may have gone astray in the mails then if they were not mislaid later. See 16 Jan 1867; 7 Mar 1867; [ca. 30] Nov 1867, nos. 12, 17, 33.

Numbers in parentheses after a cited letter refer to the Inventory of Eakins' correspondence. To read the full text of a letter on the Microfiche Edition, consult the Location Index for the Fiche Number. Letters reproduced in full in this volume are referenced accordingly.

The correspondents *to* Eakins in the Bregler Collection from this period are Frances Eakins, Emily Sartain and Joanna Schmitt; see "Letters Received 1868–1915" in the Inventory. Elsewhere, letters to Eakins in Paris from Benjamin Eakins and Charles Fussell are extant.

2. The nature of these transcriptions and Goodrich's use of them are discussed in the Introduction.

3. My tally of Eakins' letters from Paris is based on Elizabeth Milroy's list, appended to her dissertation, "Thomas Eakins' Artistic Training: 1860–1870" (University of Pennsylvania, 1986), discussed in the Introduction to this volume. Milroy notes the location of each letter and its status as a manuscript or transcript. Although her list contains a few errors and omissions, it is a convenient chronological roster of all the extant correspondence from 1866 to 1870. Whenever possible, Milroy acquired photocopies of these letters for inclusion in the Philadelphia Museum of Art's Thomas Eakins Research Collection.

4. The other half of his correspondence is directed to about ten different persons. Many of his letters are addressed to multiple names; others lack a salutation page, so the identity of the addressee can only be conjectured. The pattern in the Bregler Collection shows a higher percentage addressed to his father (65%) than is found overall, because the correspondence with Frances Eakins and Emily Sartain is concentrated in other collections.

5. The accounts in these letters usually duplicate entries found in his pocket notebooks; one is in the Philadelphia Museum of Art (the gift of Seymour Adelman), the other is the "Spanish Notebook" in the Bregler Collection, discussed below.

6. The theme of his "great anxiety" about spending too much money or taking too much time abroad appears often in these letters; see particularly no. 29; 20 Sep 1867. For Goodrich's characterization of Eakins' Paris correspondence with his family, see (1982), I/34–36.

7. This is true of his correspondence with Fanny overall; the three items to her in Bregler's collection are not among the richest examples of their letters, which tend to have been saved by her family. See also Homer (ed.), *Eakins at Avondale*, and *Thomas Eakins: A Personal Collection* (Chadds Ford, Pa.: Brandywine River Museum, 1980), cat. no. 77D, p. 72; and Goodrich I/38. It remains puzzling why—or how—Eakins acquired these three letters to Fanny.

8. My own master's thesis, "Paris and Philadelphia: Eakins and the Beaux-Arts" (Yale University, 1972), studied the impact of the European years, using transcripts from Goodrich of letters that have since been revealed in the Bregler Collection. Elizabeth Milroy's dissertation incorporated all the new Bregler material, as well as other letters recently come to light, in a thorough study of Eakins' experience in France and Spain. Goodrich's account of this period, although written before the emergence of the Bregler Collection, gives an excellent survey; see I, Chapters 2 and 3.

THE SIEGE OF THE ÉCOLE

1. According to Milroy (p. 343), Susan Eakins transcribed parts of the first letter for Goodrich, but evidently she condensed parts of the second one into the same text, leading Goodrich to attribute a quotation from the October 26–27 letter to the earlier one of October 13; see I/18. Goodrich's misunderstanding of the actual sequence of events leading up to Eakins' admission indicates that he never saw the full texts of these two letters. David Sellin's account of this same month, although written before the emergence of these letters, contains useful information about Eakins' peers in Paris who were also seeking admission at this time; see "Howard Roberts, Thomas Eakins and a Century of Philadelphia Nudes," in D. Sellin, *The First Pose* (New York: Norton, 1976), pp. 31–37; and Sellin, *Americans in Brittany and Normandy* (Phoenix: Phoenix Art Museum, 1982), pp. 10–13. Milroy's investigation of this moment has turned up new information about Eakins' later participation in the "concours des places" required for official matriculation at the École; see "Thomas Eakins' Artistic Training," pp. 146–48.

2. In the October 26 letter, Eakins describes an unnamed American who returned to the United States after waiting a year for admission to the École. See also Sellin, *The First Pose,*

pp. 31–37. Sellin, who does not posit a friendship between Howard Roberts and Eakins even though they were contemporaries at the École, will be interested to learn of the antipathy between them described in the letter of 13 Oct 1866. Given Roberts' wealth, it is not surprising that they moved in different circles. Eakins' role as ice-breaker is made clear in H. Barbara Weinberg's study *The American Pupils of Jean-Léon Gérôme* (Fort Worth, Tex.: Amon Carter Museum, 1984), pp. 101–108, which lists in chronological order the entrance of Americans into Gérôme's atelier. Eakins is preceded only by Lemuel Wilmarth, who enrolled on May 28, 1866 but was not present upon Eakins' arrival in October, when he described himself as the only English-speaking student in the atelier.

3. Little is known about Crépon although he seems to have studied at the Pennsylvania Academy in the 1850s. Eakins said in his letter of 20 Sep 1867 that Crépon had been in Paris 8 years. See Goodrich I/17, and Sellin, *Americans in Brittany and Normandy,* pp. 11–13. Eakins' friend may be the Louis Crépon or Crépin (1828–1887) who exhibited at the Pennsylvania Academy in 1866 and '67. An obituary for Louis or Lucien Crépon, written by John Sartain and filed in the Academy's Archives, noted his unfortunate death in 1879, at the age of 33. Sartain's kindnesses to Crépon, who supported himself as an illustrator, are mentioned in Eakins' first letters from Paris and implied in the obituary, but certain discrepancies in Sartain's account make it appear that there were two Crépons, perhaps related. Eakins' tone in referring to Crépon, as well as Sellin's account of Crépon's services to other Americans in Paris in 1863 (cited above), make it unlikely that he was younger than Eakins.

4. Milroy interprets Eakins' behavior as characteristic of his "tendency toward obsessive behavior" and "bull-headed arrogance." She also notes Eakins' sensitivity to class distinctions and suggests that his attitude may have been a reaction to his own sense of vulnerability in a hierarchy based on social position, wealth, or education. ("Thomas Eakins' Artistic Training," pp. 100–101.)

5. Even an invitation to travel to London with John Sartain was rejected on the basis of his antipathy for English culture; see 1 Oct 1866; 6 Oct 1866; 23 Dec 1866; 2 Aug 1867; [ca. 30] Nov 1867, nos. 2, 3, 9, 26, and 33 for examples of this all-inclusive prejudice. His remarks on Rubens are in the letter of 2 Dec 1869, reproduced p. 210.

6. Eakins' admiration for "big men" is the premise of Elizabeth Johns' important study, *Thomas Eakins, the Heroism of Modern Life* (Princeton, N.J.: Princeton University Press, 1983). She argues that Eakins liked to paint portraits of persons of expert accomplishment in many fields—sports, medicine, the arts—particularly when their achievement was representative of a new, "modern" occupation. Milroy develops this thesis to posit an almost obsessive fascination with figures of celebrity, which may be somewhat overstated if the everyday heroes of his letter of 12 Jul 1867 are considered. See Milroy, pp. 243–44, 246–47.

7. 21 Jun 1867, no. 22; see also [ca. 23–24] Feb 1868, no. 37. Eakins' Republican politics are made explicit in his letter of 1 Oct 1866, no. 2. The discovery of his bounty certificate in the Bregler Collection proves that Eakins' father purchased his son's exclusion from the draft lottery in 1864, but Eakins clearly sympathized with Northern, liberal politics and had nothing kind to say about "Copperheads" or Johnson. Milroy gives an excellent description of the circumstances implied by this bounty certificate (p. 65 and note 59). The Fiche Location Number for the bounty certificate is I 9/A/4.)

TOM AND EMILY

1. Their friendship, and its decline, are described in Goodrich (1982), I/41–43; see also Milroy, pp. 209–12. Sartain was an accomplished engraver who went on to head the Philadelphia School of Design for Women, a job that Eakins was happy to help her win; see his letter of 7 Mar 1886, listed in "Manuscripts Pertaining to Thomas Eakins in the Archives of the Pennsylvania Academy," no. 13.

2. Goodrich I/42–43. 11 Mar 1868.

3. As Cheryl Leibold has suggested to me, the condition of this letter suggests that it was balled up and discarded. There is no way of knowing whether Eakins actually sent a version of this text, or any letter at all. If not, it is interesting to consider how, or why, this draft was rescued from the wastebasket and retained among the few papers that Eakins himself saved from this period.

4. Very similar sentiments are expressed in a letter to his sister Fanny, written on the same date; see Goodrich (1982), I/43. Bill Sartain shared Eakins' opinion of opportunities in Philadelphia at this time, for he returned to Paris to study with Bonnat.

LEARNING IN PARIS

1. Goodrich (1933), p. 154. Goodrich mellowed his isolationist position in his revised monograph of 1982, although his credit to Gérôme remains grudging; see (1982), I/23. Like many others, Goodrich has had his eyes opened to the virtues of the Academy, principally through the work of Albert Boime, whose study *The Academy and French Painting in the Nineteenth Century* (New York: Phaidon, 1971) ushered in a revisionist age for "academic" painting. Gerald Ackerman's important article, "Thomas Eakins and His Parisian Masters, Gérôme and Bonnat," *Gazette des Beaux-Arts,* vol. LXXIX (April 1969), pp. 235–56, was an early statement of this new spirit; since then, his catalogue, *Jean-Léon Gérôme* (Dayton, Oh.: Dayton Art Institute, 1972) has done much to reintroduce Gérôme's virtues to America. Ackerman's early article was a starting point for my own master's thesis, "Paris and Philadelphia," which examined Eakins' training in Paris and its impact on his painting and attitudes throughout his career. David Sellin, who also understood Eakins as a "radical academic," expressed this theme in *The First Pose.* Since then, H. Barbara Weinberg has made an enormous contribution to our understanding of the role Gérôme and the École played in training American artists; see her *The American Pupils of Jean-Léon Gérôme,* which draws together much useful bibliography in addition to a sympathetic description of the various shades of academic naturalism popular in the period. Milroy's dissertation (1986), born in a world where it is no longer surprising to claim affinities between Eakins and Gérôme, describes the École experience with a thorough and liberal spirit.

2. For more of Eakins' opinion of Gérôme's appearance, see Goodrich I/21, quoting an SME transcript of a letter of 11 Nov 1866. A slightly later carte-de-visite image of Gérôme, probably purchased in Paris by Eakins, is in the Dietrich Collection; see *Eakins at Avondale,* cat. no. 61.

3. Goodrich I/25, quoting a letter of 11 Nov 1866.

4. Goodrich I/23 ff.

5. Goodrich (1933), pp. 16–17, from a letter of 17 Jan 1868. On Lecoq de Boisbaudran, see my "Paris and Philadelphia," p. 17; Milroy, pp. 171, 188 (note 79).

6. On Eakins' reference to Herbert Spencer, see Milroy's excellent discussion, pp. 229–33.

7. A technical description of these studies, in all their various forms, appears in Boime's *The Academy and French Painting.* The technique and vocabulary of the École, as relevant to Eakins' extant work, is discussed in my "Paris and Philadelphia," pp. 34–38; in Weinberg, pp. 28–38; and in Milroy, pp. 193–203. See also Fanny Eakins' description of her brother's work as seen in Paris in 1868 in Goodrich I/39.

8. See Goodrich I/50, for publication of other portions of this text.

9. Goodrich I/52, from SME's transcript of an undated letter, ca. Nov 1869.

CORRESPONDENCE WITH GÉRÔME

1. Goodrich I/113–14, 116.

2. Husson was painted by Eakins; later he served as one of his honorary pallbearers.

His authorship of the translations is recorded in Bregler's annotations on these documents. See also his letter to Mrs. Eakins, Feb 1918, "Inventory of the Manuscripts of Susan Macdowell Eakins," no. 108.

3. Goodrich I/113–19. Gerald Ackerman discussed this exchange in "Eakins and His Parisian Masters" (1969), but his account is confused by errors in dating these letters. I have examined the impact of Gérôme's advice in 1873–74 in "Makers of the American Watercolor Movement" (doctoral dissertation, Yale University, 1982), pp. 206–15, and in "Paris and Philadelphia", pp. 87–93.

4. McHenry, *Thomas Eakins, who painted,* pp. 39–40; Goodrich I/93, 320.

5. The circumstances at the Academy are related by Milroy, pp. 329–30. She notes the relationship between this letter and a similar one solicited from Bonnat by William Sartain, now in the Sartain Collection at the Historical Society of Pennsylvania. Bonnat's letter is published in translation in Sellin, *The First Pose,* pp. 57–58; the original text appears in Milroy, p. 328–29. Milroy has refined her account of this exchange with additional research. Apparently the Board threatened to close the life classes if enrollment fell below six (Minutes of the Committee on Instruction, 14 Feb. 1876), and they delayed opening such classes because of "incomplete . . . preparations" and hot weather. (Annual Report, 5 Feb. 1877). Such threats and foot-dragging must have alarmed Eakins and Sartain, but healthy student enrollment in the fall of 1876 eased their concern. The letters from Gérôme and Bonnat may have lent resolve to the campaign for more hours of daylight life study and the commencement of life classes in *painting,* solicited from the Committee on Instruction, 7 April 1877. Correspondence with Milroy, 27 Feb 1989.

6. James Wood was the son of Horatio C. Wood, who may have suggested Eakins' trip to the Dakota Territory; see "Adventures on the Ranch," below.

7. Linton to Charles Bregler, [n.d.] 1894; fiche series IV 5/G/2–3.

8. See Ackerman, "Eakins and His Parisian Masters," p. 244; Elizabeth Johns, *Thomas Eakins,* pp. 102–103; Weinberg, *American Pupils of J. -L. Gérôme,* p. 44; Darrel Sewell, *Thomas Eakins: Artist of Philadelphia* (Philadelphia: Philadelphia Museum of Art, 1982), p. 51.

LETTERS TO HIS FIANCÉE, 1873–1877

1. McHenry supplies most of the available information on "Katie" and her engagement with Tom; see *Thomas Eakins, who painted,* p. 29, recapitulated in Goodrich I/79. McHenry evidently saw the correspondence in Bregler's collection, which she describes as "rather gentle, formal little letters"; Goodrich reported these letters as lost. It seems likely that Eakins received these letters from Will Crowell or Kate's parents after her death. Typically, none of her letters to him have survived. See the Introduction to this volume.

2. The rail shooting picture was probably *Will Shuster and Blackman Going Shooting* (Yale University Art Gallery; Goodrich [1933], no. 104) or *Rail Shooting* (unlocated; Goodrich [1933], no. 105), his only two subjects in this line in 1876.

3. 21 Sept 1868, Wyeth Endowment for American Art; Goodrich I/44.

4. Goodrich I/222, notes Eakins' warm letter to "Susie" in September of 1879, not long after Kate's death, and speculates about the long engagement. According to Mrs. Eakins' retrospective diary, they announced their engagement on September 27, 1882, and were married January 19, 1884.

"TROUBLE" AT THE PENNSYLVANIA ACADEMY

1. Eakins' letter of resignation is in the PAFA Archives; see "Manuscripts Pertaining to Thomas Eakins in the Archives of the Pennsylvania Academy," no. 11. Both Coates' letter and Eakins' response are published in full in Goodrich I/286. His sister Fanny remarked the fall from his "high position" in her letter of 7 April 1890 (no. 177). In this same letter Fanny, like most members of the Eakins' circle, referred to the events of 1886 obliquely, as the "trouble;"

see also W. J. Crowell to TE (26 Apr 1886, reproduced below), Elizabeth Macdowell to TE (n.d., ca. 1894) and Bregler to Murray, (23 July 1939 reproduced below.)

2. No biographer of Eakins has failed to give the events of 1886 lengthy analysis. The best overview of fact and opinion is given in Goodrich I/281–95. Newspaper commentaries from the period are reproduced at length in Sellin, *Thomas Eakins,* pp. 35–36; many others are listed in Goodrich.

3. This event, cited as the cause of Eakins' dismissal in the newspapers, has been variously described, although Bregler Collection manuscripts confirm the circumstances as an anatomy lecture. Charles Bregler, who was enrolled at the Academy then, remembered the *cause célèbre* as involving the use of male and female nude models side by side; see "Thomas Eakins as a Teacher," p. 380; Goodrich I/335, note to p. 284.

4. Eakins' departure from normal or expected behavior in this instance may explain the charge by his instructors that his dismissal was the result of "abuse of authority." To Anshutz and others chafing under Eakins' firm hand on the school program, this wilful act may have exemplified the arrogance of his convictions.

5. See Goodrich I/287; TE to PAFA, 24 Apr 1879 (PAFA Archives); and Louise Lippincott, "Thomas Eakins and the Academy," *In This Academy* (Philadelphia: Pennsylvania Academy of the Fine Arts, 1976), pp. 162–87.

6. The first to formulate the economic rationale behind Eakins' dismissal seems to have been McHenry, *Thomas Eakins, who painted,* pp. 63–64. For Eakins' letter to the Board requesting his promised raise, see "Manuscripts Pertaining to Thomas Eakins in the Archives of the Pennsylvania Academy," 8 Apr 1885 (no. 10).

7. Goodrich reprinted the entire text of this "incredible document," addressed to James L. Claghorn from "R.S." on April 11, 1882; I/282–84.

8. See Sellin, *Thomas Eakins,* p. 32, for a discussion of the criticism of Eakins' curriculum by his students. It is worth noting that the liveliest discussion of oversights in the Academy's program came from Eakins' enemy, Frank Stephens.

9. Petitions calling for Eakins' reinstatement were signed by most of the students; see Goodrich I/287–88, and the petition (dated 15 Feb 1886 and signed by 55 students) listed in "Manuscripts Pertaining to Thomas Eakins in the Archives of the Pennsylvania Academy." The best contemporary response to Eakins' program appears in William C. Brownell, "The Art Schools of Philadelphia," *Scribner's Monthly,* vol. 18 (Sept. 1879), pp. 737–50; Lippincott comments on the reality of Brownell's description, see *In this Academy,* pp. 168–69 and note 16, p. 267. Most recently, Maria Chamberlin-Hellman's comprehensive doctoral thesis "Thomas Eakins as a Teacher" (Columbia University, 1982), treats the issues of his curriculum and student relations thoroughly.

10. See Coates to TE, 14 Jan 1886 (no. 149). Mary Searle attended Academy classes from 1884 to 1886. Records in the PAFA Archives indicate that she was born in Osborne, Illinois, in 1858. At one time she resided or held a studio at 1334 Chestnut Street in Philadelphia, two doors from Eakins. She exhibited at the Academy Annuals only once, in 1888, and later lived in Birmingham, Pennsylvania. Charlotte E. Connard enrolled in classes at PAFA in 1883, 1884, and 1886; in the fall of 1885 she won a "free ticket" for admission to classes and, like Searle, supervised the women's dissection sessions as "Anatomy Demonstrator." Connard exhibited in the annuals in 1889 and 1891, showing portraits. Her catalogue entries then indicate that she had studied in Paris and was, by 1891, living in New York. Her class card in the PAFA Archives adds the names of D'Orsini and von Rosenberg—perhaps married names. Jesse Godley (1862–1889) was also an Academy student from 1883–86, during which time he posed for many of Eakins' photographs and for oils and sculptures related to the Arcadian subjects and the *Swimming Hole.* Alice Barber (1858–1932) studied at PAFA in 1876–77 and 1879–80, by which time she was already a skilled wood engraver. She went on to develop a successful career as an illustrator and teacher. In 1890 Barber married Charles H. Stephens.

11. See TE to Charlotte Conard [*sic.*], 2 Mar 1887 (no. 124) discussed below in "The Hammitt Incident."

12. On Stephens' motives, see Sellin, *Thomas Eakins*, p. 37. Stephens' impulsive, extravagant style is also decribed in W. J. Crowell's affidavit, 5 June 1886, reproduced on p. and discussed below. Stephens (1859–1935) married Caroline Eakins (1865–1889) in 1885.

13. Undated draft, ca. 10 Mar 1886 (no. 66), full text reproduced below, pp. 216–18. See also TE to Emily Sartain, 25 Mar 1886, "Manuscripts Pertaining to Thomas Eakins in the Archives of the Pennsylvania Academy."

14. Goodrich I/286. This account in the Philadelphia *Press* evidently inspired a letter to the PAFA directors asking that the innuendoes of conspiracy be removed by an "official statement" of causes leading to Eakins' dismissal. Denying personal or professional enmity, the five signers were of course those with intense interest: Anshutz, Kelly, the two Stephenses, and Frank's business partner, Colin Campbell Cooper. See their letter of 12 Mar 1886, listed below in "Manuscripts Pertaining to Thomas Eakins in the Archives of the Pennsylvania Academy."

15. TE to Coates (12 Sept 1886, no. 70), reproduced below p. 239. Eakins wrote to Emily Sartain on March 25, 1886, declaring that "One of the women pupils, some years ago gave to her lover who communicated it to Mr. Frank Stephens a list of those pupils" who modeled for him (PAFA Archives, and Goodrich I/293). This line of transmission suggests Barber, who told her fiancé Charles Stephens. Will Crowell's affidavit of 4 June 1886 announces a slightly different sequence, placing blame on Caroline Eakins Stephens, who learned of the posing from "one of the participants" and told her husband. Alice Barber was probably the source in either event, since she seems to have borne the brunt of publicity on this matter. See FEC to TE, 7 Apr 1890 (no. 177), quoted below and at greater length in "Ella Crowell's Suicide," for additional retrospective commentary on "girl students' posing."

16. Lippincott, *In this Academy*, p. 177. The Committee of Instruction's directive was entered into the Minutes of March 24, 1884. His efforts to procure a better class of models began in 1877, see TE to the Committee on Instruction, 8 Jan 187[7], "Manuscripts Pertaining to Thomas Eakins in the Archives of the Pennsylvania Academy" (no. 1); Goodrich I/169–70, notes the misdating of this letter "1876."

17. The plum story, never told in full, is mentioned again in SME's account of TE's interview with Louis Stephens, 9 May 1887, discussed below.

18. TE to Coates, 11 Sep 1886 (no. 69). The personal dispute between Godley and Eakins inspired the letter to Eakins from the student's father, Henry Godley, 29 Apr 1886 (no. 158).

19. Eakins sent a set of these photographs to Coates, with remarks explaining their purpose; see Elwood C. Parry III, "Thomas Eakins' 'Naked Series' Reconsidered: Another Look at the Standing Nude Photographs Made for the Use of Eakins' Students," *American Art Journal*, vol. 20, no. 2 (1988), pp. 53–77.

20. Coates to TE, 13 Sep 1886 (no. 161).

THE ART CLUB SCANDALS: "MISREPRESENTATIONS AND FOUL LIES"

1. The principal account appears in Sellin, *Thomas Eakins*, pp. 37–41, which formed the basis of Goodrich's discussion I/292–94. Many of the documents in the Sketch Club's Archives have been filmed by the Archives of American Art, rolls 3919 and 3920.

2. From an undated memorandum by W. Moylan Lansdale (?), a lawyer and Club member; see Sellin, p. 41. Eakins' fragmentary letter of 13 Mar 1886 threatened legal action against his enemies, but evidently Will Macdowell talked him out of this. Lansdale's own account of the Club's history in 1886 conflicts somewhat with his more cautious memo, which makes it appear that the club's action was less strident (simply "censuring" Eakins and asking for his resignation) than an outright vote for expulsion (Sellin, p. 41).

3. Quoting a letter from Dunk to Sears; Sellin, pp. 39–40; Goodrich I/293.

4. Ibid.

5. The membership of approximately 50 persons included many who also belonged to the Sketch Club. They acknowledged only one honorary member: their professor, Mr. Eakins. See *American Art Annual* (1887), p. 131.

6. On Crowell's relationship with Eakins, see also "Ella Crowell's Suicide," below.

7. TE to FEC, 4 Jun 1886 (no. 67), reproduced below. Crowell did ask Dr. Duer for a letter, but as late as October 8, 1886 no response had been received. See WJC to TE, 8 Oct 1886 (no. 163).

8. TE to FEC, 4 Jun 1886 (no. 67). The Eakinses were horrified a decade later when the Crowells placed two of their sons in Frank Stephens' "shop," where anti-Eakins propaganda continued to circulate in the 1890s. The willingness of the Crowells to forgive the Stephenses' "treachery," or perhaps their gradual harmony with some of Stephens' opinions, contributed to the rift between the two households discussed in the section on "Ella Crowell's Suicide."

9. SME's notes are filmed in the microfiche series II, 4/A/6–7. Goodrich confirmed Eakins' predilection for direct speech and off-color humor, noting that "A woman friend told me that [Eakins] did not use euphemisms for bodily functions: 'he would always use the word.' He enjoyed improper stories and had a good memory for them." (Goodrich II/5) According to SME's notes, Charley Stephens was especially offended by the way that Eakins would bluntly ask the girls "if they want to pea."

10. On the transformation of this portrait, see Elwood C. Parry III, "The Thomas Eakins Portrait of Sue and Harry; Or, When Did the Artist Change His Mind?" *Arts Magazine* (May 1979), pp. 146–53; Goodrich I/224 and note, pp. 330–31; and Natalie Spassky, "The Artist's Wife and His Setter Dog," *American Paintings in the Metropolitan Museum of Art*, vol. II (New York: Metropolitan Museum of Art and Princeton University Press, 1985), pp. 613–19.

11. Lettie Willoughby was a student at the Academy in 1882–83. Her address in PAFA records indicates that she lived in Penlynn, Pennsylvania. Her married name seems to have been St. John.

ADVENTURES ON THE RANCH

1. On Wood's background and his role in Eakins' "camp cure," see Nancy K. Anderson, " 'Cowboys in the Badlands' and the Role of Avondale," in W. I. Homer (ed.), *Eakins at Avondale*, p. 21. Eakins' letters make it clear that he spent most of his time on the B-T ranch, or in the company of its people. He probably visited the Badger Cattle Company, near Medora, as witnessed by the two letters of introduction from Howard Eaton, the Badger Company's manager (dated 7 Aug 1887 [nos. 168 and 169]). Hendricks posits that his visit was mostly at this latter ranch, because it too was backed by a Philadelphian, also friendly with Eakins and Wood, but it seems that the visit with Eaton was actually brief. His ranch is mentioned only once in the extant letters (26 Sep, [no. 85]), although Eakins' accounts of the roundup at Medora are fragmentary. See Hendricks, *Life and Work*, p. 176.

2. Goodrich identifies the ranch manager as George Tripp, perhaps confusing him with his son, who is also mentioned in these letters. I am assuming that the "Mr. Tripp" referred to frequently by Eakins is Albert, who wrote to him on July 4, 1887 (no. 167); Goodrich II/16. Anderson identifies him as "Charles" Tripp (perhaps his brother?) (*Eakins at Avondale*, p. 21). McHenry recorded the memories of the young George Wood, who accompanied Eakins on his sketching rambles near the ranch; see *Thomas Eakins, who painted*, p. 82. George's older brother, Jim, mentioned in the letter of August 11, had been a student of Eakins at the Art Students' League.

3. Goodrich II/16–21. A discussion of these letters, with new research and many photographs taken by Eakins during this trip, can be found in Cheryl Leibold, "Thomas Eakins in the Badlands," *Archives of American Art Journal*, vol. 28, no. 2 (1988).

4. See Homer (ed.), *Eakins at Avondale*, cat. no. 771, p. 74.

5. See McHenry, p. 82. The extant Badlands sketches are Goodrich checklist nos. 225–29. Some of them may have been done on August 26, when Eakins actually recorded sketching "around the shack." Most of these sketches are now in the Philadelphia Museum of Art; see Siegl, (*The Thomas Eakins Collection*), cat. nos. 65–69.

6. Many previously unpublished glass plates from this trip will be featured in *Thomas Eakins Rediscovered*, the catalogue of the art and artifacts in the Bregler Collection (to accompany an exhibition at the Pennsylvania Academy in 1991), and in Leibold, "Thomas Eakins in the Badlands."

7. Several were evidently returned to Bregler in 1944 by Wallace's student George Barker. Typed copies of other letters, now mostly in the Wallace Collection at the Joslyn Museum in Omaha, also may have been given to Bregler by Barker. These typescripts are filmed among Bregler's papers, in Series IV.

8. See Anderson, in Homer (ed.), *Eakins at Avondale*, pp. 22–23.

THE "NUDE" AT DREXEL

1. The Drexel "incident," in the context of Eakins' other anatomy lectures after leaving the Academy, is thoroughly described in Goodrich II/303–309.

2. Arthur (1850–1914) was a Philadelphian who specialized in decorative painting and marines. Eakins painted Arthur's mother, Mary, in 1900 and inscribed the portrait "to my dear friend Robert Arthur."

3. Maynard (1843–1923), Low (1853–1932), and Turner (1850–1918) were all painters specializing in figurative subjects and murals. Both Maynard and Low had been responsible for bringing Eakins to lecture on anatomy in New York, at the National Academy and the Cooper Union.

4. On his lectures at the NAD, and later complaints, see Goodrich II/304–306.

5. See TE to Blashfield, 22 Dec 1894 (no. 98), and Goodrich II/305.

THE HAMMITT CASE: "A MOST UNFORTUNATE LADY"

1. Charles Bregler found this note with the Hammitt letters and papers concerning the "trouble" at the Academy. See the Introduction, pp. 9–10.

2. Bregler's letter on the "Hammitt incident" appears in Phyllis D. Rosenzweig, *The Thomas Eakins Collection*, pp. 128–29; Goodrich II/97. The complete text of his draft is published below on p. 333–34.

3. Her record, taken from the PAFA Archives, and her attendance at the Art Students' League, is summarized in Rosenzweig, p. 129. Her address in October 1885 was given as Norwood, Delaware County, Pennsylvania, a small town between Philadelphia and Chester.

4. On Charlotte Connard, one of Eakins' anatomy demonstrators, see " 'Trouble' at the Academy," note 10. On the nature of Susan Eakins' retrospective diary, see below, "Eakins Described by Others" and "The Life and Papers of Susan Macdowell Eakins."

5. Mary Searle, another anatomy demonstrator, apparently testified against Eakins to the Committee on Instruction; the linking of Searle and Connard in this reference may indicate their role in the "dissecting room business"; see " 'Trouble' at the Academy," note 10.

6. This second letter from New Hampshire has been dated 1887 because of the common topic (Sue's gift of photographic prints) and address. However, Hammitt's reference to Eakins' work on a portrait of "Prof. Clark" may date this letter to about 1893, when Eakins seems to have painted Professor Hugh A. Clarke. Since the Clarke portrait has disappeared and its date was only Goodrich's estimate, it is hard to confirm the date of 1893 for either the painting or the letter. However, the disorganized quality of this note, so unlike her orderly letter to Eakins

of 24 Aug 1887 (see note 8 below), may reflect Hammitt's disorientation following her hospitalization in the fall of 1892.

7. Susan Eakins' letter can be dated only by context, which implies that Thomas Eakins is not available to address her questions, and discusses events of the late summer and fall. It seems unlikely that Mrs. Eakins would have discussed marriage and advised Hammitt in this gentle tone following Hammitt's declaration of marriage to Eakins in February of 1888.

8. Hammitt wrote to Eakins at the ranch on 24 Aug 1887. He turned her paper over to use as stationery for his own letter to Sue on 28 Aug. Goodrich saw this sheet and transcribed both communications, but the page itself has been lost—while the earlier section of the letter, never seen by Goodrich, has emerged in the Bregler Collection. The transcript of the lost page, bearing Hammitt's letter, is now in the Philadelphia Museum of Art's Thomas Eakins Research Collection; the text discusses painting and summer travel plans in New England, without eccentricities. Eakins' complete letter is reproduced below, pp. 240–43.

9. SME's entry is "1887" on the page of 27 Dec. Elsewhere in her papers she dated this portrait to 1885 or 1886, (superimposing a 5 and a 6 in her date). The portrait itself (figure 24) bears no date; see Rosenzweig, cat. no. 65.

10. The loss of this letter and others sent directly to Eakins by Hammitt in 1890 creates a pattern that suggests the destruction of her most incendiary letters. As a result, her wilder statements are known only through the calmer reactions and descriptions of others. Although Susan Eakins set all these letters aside for destruction, she may have had a hand in the earlier disappearance of the most upsetting texts. See "The History and Character of the Manuscripts," note 14.

11. Nothing more is known of Miller. He may literally have been a step-brother, or perhaps a pastor. Many of the letters in this exchange seem to have been copied and passed around, which explains why Eakins eventually ended up with so many manuscripts, but the path of this one letter to Eakins is not clear. It is at least possible that "Miller" was Eakins' colleague Leslie W. Miller, principal of the School of Industrial Art in Philadelphia and a man Hammitt was likely to have known, and to have written to in hopes of employment. He may have forwarded this letter to Eakins for his comments.

12. Maggie Unkle may have been the daughter of Mrs. G. W. Unkle who is listed as the owner of Hammitt's painting, entitled *Portrait*, exhibited in the 1887 Annual Exhibition at the Academy.

13. The entire account of this incident is based on Goodrich II/97, who interviewed Murray, Ziegler, and Weda Cook Addicks in addition to Susan Eakins. The date of this incident (in the mid-1890s) comes from Ziegler's recollections. I have assumed his account is accurate enough, and that the incident follows Hammitt's earlier hospitalization, because the events must come after Ziegler's days in the Art Students' League, which broke up in 1893, and the commencement of his fulltime career as a journalist thereafter. Lilian Hammitt's fate after this last incident remains unknown.

14. Goodrich II/97.

15. Rosenzweig, p. 129.

16. Goodrich II/97.

ELLA CROWELL'S SUICIDE

1. Ella Crowell's story is told often in the Eakins literature, usually from testimony by close friends, such as Samuel Murray or Weda Cook Addicks, who had known her well. Goodrich's account II/91, 135–36, summarizes these sources, particularly drawing upon McHenry, *Thomas Eakins, who painted* p. 100, and other earlier opinions to develop a well-balanced, if necessarily unresolved discussion of the topic. Goodrich notes that Susan Eakins never mentioned the subject to him. Also interesting is Gordon Hendricks' version, based on his interviews with the Crowell children; see *The Life and Work of Thomas Eakins* (New York: Grossman, 1974),

pp. 194–6, 235–6. William I. Homer gave fresh attention to this crisis in "Eakins, the Crowells, and the Avondale Experience," in *Eakins at Avondale,* pp. 9–13. He drew on a recorded interview with Eakins' niece Fanny Crowell (1890–1971), conducted by Daniel Dietrich II in 1971. Fanny, like the other children who were later interviewed, was very young at the time of Ella's death; the children's accounts lack complexity, although they seem to have escaped their father's prejudice.

2. References to this document (SME's "Memorandum,") are to page numbers in this volume.

3. See "Art Club Scandals," above. Fanny Eakins (1848–1940), just four years younger than her brother, proved an understanding ally for many years, as demonstrated in her correspondence with him in Europe. Will Crowell (1844–1929) went to Central High School with Eakins, traveled with him in Europe in 1867, and studied art in Paris, although he returned to Philadelphia to become a lawyer. He married Frances Eakins in 1872, two years before Tom became engaged to Kathrin Crowell (1851–1879), Will's younger sister. Will and Fanny purchased the farm at Avondale in 1877 after a heart condition made it necessary for him to leave his job. Subsequently, as these papers show, he lived a "wretchedly unhappy" life of boredom and disappointment, supported by his wife's farm work and his father-in-law's money. Life on the farm with ten children is remembered in happier terms in Homer (ed.), *Eakins at Avondale.* If Eakins ever painted Fanny or Will after their marriage, the portraits did not survive the acrimony of the 1890s.

4. See WJC to TE, 10 Apr 1890 (no. 178). Margaret Crowell, named after her aunt Maggie (Eakins' sister), was referred to as "Maggie" and "Maggy" in these documents.

5. Eakins had written to Coates on 15 Feb 1886, remarking that "It seems to me that no one should work in a life class who thinks it wrong to undress if needful" (no. 65).

6. On Alice Barber and the "nude posing business," see " 'Trouble' at the Academy" and "Art Club Scandals," above.

7. "Caddie," Caroline Eakins Stephens, was "lost" to the family by her marriage to one of Eakins' most active enemies, Frank Stephens. See "Art Club Scandals," above. Caddie had died the previous fall, in November 1889.

8. Susan's retrospective diary may have been composed from review of old letters, many years later. On the character of her entries, see "Eakins Described by Others."

9. Goodrich II/91.

10. TE to FEC, 22 Oct 1895, no. 99; The letter is signed very formally "Yours Truly, Thomas Eakins." Susan Eakins was angry to learn that this letter was shared and misquoted among Eakins' enemies at Frank Stephens' shop. The project he was beginning with Murray that fall must have been the sculptures of ten prophets for the Witherspoon Building, although this commission is not otherwise documented until September of the following year. See Goodrich I/105–06.

11. Ben Crowell (1877–1960) studied at PAFA until 1900, returning for night classes in 1906–07. Like his sister Maggie, he became an artist. Their younger sister Frances ("Fanny" 1890–1971) also attended PAFA classes from 1911–14. As a result, all of these Crowells would have come in contact with Eakins' critic, Thomas Anshutz, who was the popular director of the school at this time.

12. It seems unlikely that Eakins pressured Ella into nursing, as W. I. Homer has suggested, since these papers reveal that, when asked, Eakins told Ella that her studies fitted her for "other directions" better. His letter to Fanny cited above (early Apr 1890) shows that he did have hopes for Ella as an animal painter, and perhaps the pressure of these expectations, added to the rigorousness of his teaching program, discouraged Ella, just as Homer proposes. See *Eakins at Avondale,* p. 13. Ella's decision to follow Eakins' second choice, nursing, a field where he also showed special aptitude (cf. Crowell's affidavit, 5 Jun 1886, no. 161), may have been another attempt at pleasing her uncle, and her failure at both art and nursing could not have helped her sense of self-respect in his company. See Memorandum, p. 296.

13. Goodrich (1982), II/327, note to p. 135; Milroy, "Transcript of Interview with Lloyd Goodrich," p. 45; Homer (ed.), *Eakins at Avondale,* p. 33, note 9. Ella's sister Fanny dated Ella's insanity to this episode. Although Susan noted that 1896 was the year "Ella goes mad," it seems odd that she failed to mention this episode, which her family felt was pivotal. Susan's notes do record that Ella disliked nursing; see Memorandum, p. 297.

14. The final pages of Susan's memorandum record Ella's visit to their home after release from the hospital, evidently in the spring of 1897. Susan remarked that even then she showed no signs of reluctance to be with her uncle, and sat in his lap when he examined a cut near her eye, suffered in a bicycle mishap. See p. 298.

15. Following a lecture tour of America in 1882, Wilde became a celebrity in the United States, and his rise and fall was followed closely in the press. I am indebted to Richard Ellmann's masterful biography for its rich and sympathetic account of Wilde's life; see *Oscar Wilde* (New York: Knopf, 1988). Ellmann notes that at least 900 sermons were preached against Wilde from American pulpits in the years 1895–1900 (p. 548), indicating that he had become a bogeyman of decadence to American moralists. Given this notoriety, it would seem unlikely that a young woman like Maggie, with six years experience in art circles, would have been unaware of Wilde's sexual preferences.

16. Hendricks, *Life and Work of Thomas Eakins* (1974), pp. 160, 221. More recently Michael Fried has imaginatively analyzed *The Gross Clinic* in Freudian terms and found a "family romance" at its core, based on Dr. Gross as a father figure that Eakins admired, feared, and ultimately subsumed into his own identity. This Oedipal structure, which Fried presents convincingly, coexists with a "paranoiac" scenario that proposes Eakins' co-identity with the passive nude patient on the operating table, and his participation in "the homosexual wish-fantasy of being sexually possessed by a man." Such fears are not evidence of homosexuality, but the strong sexual drama Fried detects in his analysis suggests subconscious tensions that contribute to the profoundly unsettling and original quality of this masterpiece. See Fried, *Realism, Writing, Disfiguration* (1988), p. 68. Corroborative speculation about Eakins' sexuality can be found in David Lubin's thoughtful study, *Act of Portrayal: Eakins, Sargent, James* (New Haven, Ct. : Yale University Press, 1985), discovered too late to be drawn into this discussion.

17. Goodrich tells many stories about Eakins' aggressive attempts to get his female sitters to pose nude; see II/90–98. He also discusses Eakins' sexuality candidly in his interview with Milroy, in which he dismisses the rumors of homosexuality; see "Transcript of Interview with Lloyd Goodrich," pp. 63–67. In this same text (p. 63) Milroy draws attention to Eakins' account-book records of visits to Parisian bordellos. Hendricks, taking another tack from his earlier speculations, suggests (with little evidence) that Eakins had an affair with Addie Williams; see *Life and Work of Thomas Eakins,* p. 244; and Goodrich, in "Transcript of an Interview," p. 66.

18. Like Goodrich, I interpret Eakins' attachment to Murray as basically paternal; see Goodrich II/109–10. It is worth noting that Frank Stephens, as he invented the most damaging interpretations of Eakins' behavior in 1886, implied lasciviousness with women students, incest and bestiality, but not homosexuality. See "Art Club Scandals," above.

19. On Whitman and Wilde, see Ellmann, *Oscar Wilde,* pp. 169–72. Eakins' friendship with Whitman has been often discussed; Goodrich gives the most complete account comparing Whitman's "expansive" sexuality to Eakins' more "repressed" style; see Goodrich II/28–38. I am grateful to Henry Glassie for his suggestion of the Wilde-Eakins-Whitman triad.

20. As with the Lilian Hammitt letters, the most heated documents in the series–such as Fanny's and Will's accusations–have disappeared, leading us to conclude that they were destroyed in anger almost immediately, or later weeded by Susan as too dangerous or misleading to be kept.

21. In diagnosing Ella's disturbance we are in murky territory, for—as with Lilian Hammitt—a psychological profile can be drawn only from secondary sources. Described by Murray and Cook as restless and tomboyish, Ella was characterized by Sue Eakins as "highly emotional" and "irresponsible." From her actions it is apparent that, like Hammitt, Ella was self-centered,

willful, and impulsive; prone to theatrical lies and confessions; poor at judging others; and anxious for the approval of men. She admired Eakins and was unwilling to threaten their relationship by admitting her anxieties or betrayals to him, but clearly she favored her father and catered to his supicions and jealousies. Ella seems to have enjoyed setting her family at war while seeking attention for herself. Her erratic behavior may be symptomatic of various "female disorders" characteristic of her repressed society, and it is worth remarking (as others have), that her grandmother died of "exhaustion from mania" the year before Ella was born. From such details, a more clinical description of her illness may be composed eventually by those with professional expertise. See Goodrich II/135.

22. SME's Memorandum, p. 296; the latter comment is from Hendricks, *Thomas Eakins,* p. 236.

23. On his women students being "crazy" about him, see "The Hammitt Case," and note 13. Eakins wrote to Coates that students were attracted to him because of his extensive experience "and not for personal reasons. My sad old face is none too pretty" (15 Feb 1886 [no. 65]). Never known as a ladies' man, Eakins repelled at least as many women as he attracted, so the issue of his charisma must have been more complex than just appearance and manners.

24. TE to J. L. Wallace, 22 Oct. 1888, no. 91; TE to Harrison Morris, 23 Apr 1894, quoted in Goodrich (1982), II/160. See "Manuscripts relating to Thomas Eakins in the Archives of the Pennsylvania Academy," no. 22.

25. Goodrich II/90–98. Goodrich takes the position that Eakins' attitude was a "strange naivete, an obliviousness to the realities of the society in which he lived—even a kind of innocence," which, in its "obsessive persistence may have had an element of conscious defiance of social conventions" (p. 95).

26. See Elizabeth Johns, *Thomas Eakins: The Heroism of Modern Life,* Chapter 4, pp. 82–114, for an excellent investigation of the "Rush" paintings and their meaning in Eakins' oeuvre.

EAKINS AS A TEACHER

1. These notes were filmed with Eakins' miscellaneous papers; see Fiche Location I 10/E/2 to 11/E/5. Eakins' manuscript was in Bregler's possession until 1944; for a description of its contents, see Siegl, *Thomas Eakins Collection,* cat. no. 56, p. 109. Siegl dates this draft to 1884. Bregler's notes are, on at least one page, annotated as being copied from the manuscript (not from lectures) and, as Elizabeth Milroy has reminded me, all of them are suspiciously neat and clean. Perhaps they are copies of earlier, rougher notes, now lost. See fig. 32.

2. See the Introduction, note 36, and the chapters on Charles Bregler. The articles are reproduced on the Fiche Series IV, 16/F/8 to 16/G/13.

3. See Introduction, p. 15.

EAKINS DESCRIBED BY OTHERS

1. On Cushing see CB to Theodore Sizer, 16 Jul 1940; on Anshutz as "ringleader" and "Judas" see CB to PAFA, n.d. (ca. 1951). On criticism of Goodrich (1933), p. 145, see CB to Frederick Sweet, n.d. [1940], and CB to Goodrich 30 Oct 1940, objecting to the "foolish procedure" Goodrich describes.

Inventory of the Manuscripts of Thomas Eakins

Every Thomas Eakins manuscript in the Bregler Collection has been listed in this Inventory. (See the chapter on "Editing and Filming Procedures" for details concerning the editing of the papers in the collection and the arrangement of this list.) An inventory of the papers of Susan Macdowell Eakins and a brief description of Charles Bregler's papers are included in the corresponding sections of this volume. This Inventory is organized as follows:

I. Letters sent, 1863–1869 (Fiche Location I 1/A/7–3/c/7)
II. Letters sent, 1873–1916 (Fiche Location I 3/C/8–5/E/2
III. Correspondence between TE and Philadelphia Sketch Club, 1886 (Fiche Location I 5/3/3–5/G/8)
IV. Correspondence with Lilian Hammitt and her family, n.d., 1887–1892 (Fiche Location I 5/G/9–6/C/1)
V. Letters received 1868–1915 (Fiche Location I 6/C/2–8/B/8)
VI. Other Eakins manuscripts, n.d., 1868–1916 (Fiche Location I 8/B/9–9/A/2, and 9/E/4–11/E/5)
VII. Printed matter, n.d., 1864–1916 (Fiche Location I 9/A/3–9/E/3, and 11/E/6–12/B/12)

Items marked R are reproduced below.

I. Letters sent, 1863–1869

Eakins' letters from Europe, now in the Bregler Collection, were seen by Lloyd Goodrich in 1930–32 and by Margaret McHenry in 1942–45. Their

use of this material, based on personal transcripts, notes, or copies furnished by Mrs. Eakins, has supplied scholars ever since. The entries below have been annotated with references to the original publication of this material by McHenry (1946) and by Goodrich, although his revised edition (1982), with its much more extensive quotations, has been consulted instead of his original monograph (1933). The majority of these references appear in Goodrich I/ 15–64. Other random citations in his book may not be indicated on the Inventory entry. Except for nos. 1 and 41, all letters from Europe are assumed to be received copies.

1. TE to Will [Sartain], 15 Oct 1863, Philadelphia.

"Do come to see me and bring some of the boys as I am again forbidden to leave the house after sundown."

1 p. [This may be a penmanship exercise.]

2. TE to CE 1 Oct 1866, "Atlantic Ocean 2 or 3 hundred miles from France."

recounts intense sea-sickness; describes life on the "Pereire," fellow passengers; meals.

8 pp., Goodrich I/15–16.

3. TE to CE, 6 Oct 1866, Paris.

first letter upon arrival in Paris; looking for a room and attempting to contact acquaintances, etc.

4 pp., initialed, McHenry 3.

4. TE to CE, 8 Oct 1866, Paris.

describes Paris life; eating habits of the French; birds in the park; geography of the city; men playing badminton or tennis; recounts how he found a room; inquires of home, is anxious to get their first letter.

4 pp., initialed.

5. TE to BE, 13 Oct 1866, Paris.

long description of his difficulties in seeing the American Mr. May, and Col. Hayes and Mr. Bigelow of the American legation about getting into the School; describes character of Dr. Hornor, a Philadelphian who has befriended him.

8pp., initialed, two satirical sketches of Col. Hayes, Goodrich I/18. [Goodrich claims to be citing this letter but the passage is really from the letter of 26–27 Oct; his apparent confusion was probably the result of SME's conflating of two letters in the transcriptions she made for him. See figs. 12 and 34.] R

6. TE to BE, 26–27 Oct 1866, Paris.

long letter recounting difficulties in getting into Gérôme's class; asks for news of recent U.S. elections; describes some boats on the Seine.

8 pp., initialed, author paginated, sketch of a fish, McHenry 1, Goodrich I/18 [incorrectly cited in Goodrich as 13 Oct, see note above]. R

7. TE to FE, 30 Oct 1866, Paris.

visit to the Louvre, the statues "of real marble" are better than the "miserable plaster imitations in Phila."; they are also stark naked; saw paintings as well as historical curiosities; note to Maggie asks about her school, exhorts her to good behavior.

2 pp., initialed, Goodrich I/27.

8. TE to BE, 1 Nov 1866, Paris.

tells of meeting with Harry Moore, a deaf and dumb student; Moore's entrance into Gérôme's studio; TE's first day in the studio—hazing by other students.

4 pp., initialed, McHenry 1–2, Goodrich I/18–21. R

9. TE to BE, 23 Dec 1866, Paris.

describes habits and bad behavior of Earl Shinn, a student who attends class rarely; mentions that "Roberts is in the modelling department and I have met him but once or twice."

2 pp., unsigned fragment, author paginated.

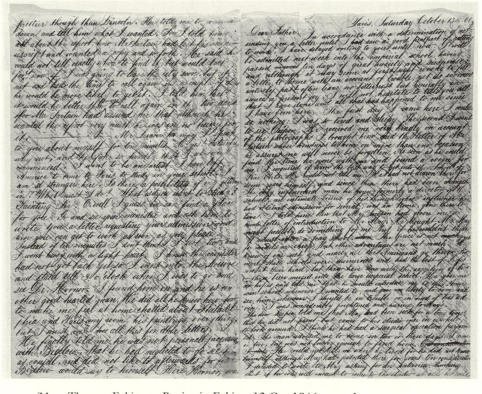

34. Thomas Eakins to Benjamin Eakins, 13 Oct 1866, page 1.

Eakins had so much to say that the first five letters from Paris are completely cross-hatched (lighter vertical lines of writing are laid over the first horizontal lines). Although legible, and a common economy of the day, it is clear that he stopped crosshatching his letters at the request of his family who probably found that the method precluded easy reading.

10. TE to [BE], n.d. [ca. 30 Dec 1866 or Jan 1867], [Paris].

describes the Imperial School; reassures his father that he has nothing to do with French politics; praises French Government system and French society.

2 pp., unsigned fragment, author paginated.

11. TE to FE, 8 Jan 1867, Paris.

asks for news of family; went to St. Sulpice to hear some music; describes seeing monks everywhere in Paris and how dirty they are.

2 pp., initialed.

12. TE to BE, 16 Jan 1867, Paris.

reassures his father that his trip to a place of "vice" with some students was purely educational; comments on inability to describe paintings or his feelings about them in words.

2 pp., initialed, Goodrich I/33.

13. TE to FE, 24 Jan 1867, Paris.

went ice skating in the Bois de Boulogne; sketches two kinds of French ice skates; had trouble with both but after some practice "showed them a few touches I guess they never dreamed of."

2 pp., unsigned, sketches of two kinds of skates.

14. TE to BE, 31 Jan 1867, Paris.

responds to news of friends and Philadelphia; mentions possibility of traveling during the summer; mentions that the big question of the day is the "Catholic or Pope" question.

2 pp., unsigned.

15. TE to [CE?], [late Jan 1867].

fragment of letter explaining recent expenditures; spent New Year's Eve at the Moores'.

1 p., fragment, initialed, McHenry 2.

16. TE to CE, 28 Feb 1867, Paris.

living expenses for Feb. itemized; attending musical concerts; dinner with Mr. Lenoir and family.

4 pp., unsigned.

17. TE to BE, 7 Mar 1867, Paris.

school closed for carnival preceding Lent; describes parades and floats; relates entry of a newcomer to the studio and his hazing by the students.

4 pp., unsigned.

18. TE to BE and FE, 21 Mar 1867, Paris.

spring has arrived in Paris; went to "Garden of Plants"; Gérôme says he can begin to paint; goes to gymnasium three times a week, does some wrestling.

3 pp., initialed, Goodrich I/23.

19. TE to BE, Margaret Eakins, and Max Schmitt, 12 Apr 1867, [Paris].

note to father re political troubles with the Prussians which are in all the papers; note to Maggie describing two hats he has bought, with sketches; often sees the Emperor and the Empress in the streets; note to Max in French re politics and French attitudes.

3 pp., initialed, sketches of two hats and a leaf.

20. TE to BE, FE, and Max Schmitt, 25 Apr 1867, [Paris].

describes political crisis between France and Germany, writes tongue-in-cheek letter to Max which compares France and Germany to highly unstable chemical compounds invented by Prof. Bismarck and Prof. Napoleon; mentions reading article on Philadelphia in the paper.

6 pp., initialed, Goodrich I/48.

21. TE to Caroline [sister] and Margaret Eakins, May [1867?], Paris.

tells of seeing a street entertainer with a dog and a monkey in the Luxembourg Gardens.

2 pp., unsigned, McHenry 5–6 [reading "Caddy" as "Daddy"].

22. TE to FE and BE, 21 Jun 1867, Paris.

to Fanny: a short note about verbs in the romance languages; to Father: sending Thomas Moran's picture via direct steamer to Philadelphia.

4 pp., unsigned.

23. TE to CE, 28 Jun 1867, Paris.

list of expenditures; praises Moore's understanding of his situation as a student; lent 5 francs to a hard-pressed Englishman who begged from him in the streets, later found out that the man has been begging in this manner for some time; trip to Versailles; list of accounts and bank withdrawals.

8 pp., initialed [p. 7 of the letter missing].

24. TE to BE, 12 Jul 1867, Paris.

describes meeting with Caleb Hallowell, who boasted of having spent great sums of money on his European tour, took him to the Louvre where Mr. Hallowell took copious notes; TE contemptuous of this and his cheapness.

5 pp., unsigned, sketch of three notes of music, McHenry 2 [half of final sheet missing].

25. TE to Aunt Eliza, 17 Jul 1867, Paris.

comments on women's fashions in Paris, says few fancy dresses seen in the streets.

2 pp., unsigned, McHenry 3–4.

26. TE to BE, 2 Aug 1867, [Paris].

has been to the Exhibition with Bill Sartain who now agrees that the English artists are inferior; plans to travel to Switzerland with him.

2 pp., unsigned.

27. TE to BE, 10 Aug [1867], Geneva.

about to start by steamboat up Lake Geneva to Villeneuve with Bill Crowell and Bill Sartain; describes Geneva, has been swimming; lists total funds received so far.

2 pp., unsigned.

28. *TE to BE, n.d., [ca. 15 Aug 1867], Zermatt, Switzerland.*

left Geneva, went to Mont Blanc and Chamounix, likes Geneva, hates Zermatt for its crude and dirty people; saw soldiers hunting for a murderer; read of Johnson's dismissing Stanton.

3 pp., initialed, McHenry 13–14, Goodrich I/34.

29. *TE to BE, 20 Sep [1867], Paris.*

speaks of high prices and fear of spending too much; does not feel homesick enough to come home; has procured a studio at 64 rue de l'Ouest.

2 pp., incomplete, last two lines have been cut out, Goodrich I/17, 24–25, 36.

30. *TE to [probably BE], n.d. [Oct 1867?], [Paris].*

fragment of a letter; sending list of photographs of works of art now available in Paris; recommends them highly; "Mr. Ravaisson proposes to make yet about 150 to complete the series."

2 pp., fragment, top half of p. 1 has been cut off; initials *T.C.E.* partially visible along cut edge of p.1. [The photographs are mentioned again in TE to BE, 30 Dec 1867—3 Jan 1868, and also see [ca. 30] Nov 1867, which references the miscarried or delayed letter.]

31. *TE to BE, 9 Nov 1867, Paris.*

describes a modern bicycle with which he is most impressed [two wheels of equal size]; enjoyed taking Mr. Sartain around the town; sees Earl Shinn.

2 pp., initialed, sketch of bicycle [*see* fig. 35].

32. *TE to BE, [mid Nov] and 22 Nov [1867], Paris.*

describes John Sartain's visit to Paris; describes events surrounding the expulsion of a student from the school; describes outing for breakfast with the students; excuses long letter recounting the "devilitries" of the French boys but it will serve to describe them.

8 pp., initialed.

Dear Father. Last week I got your press was Friday Nov 9, 67 place. The story of that velocipede is altogether impossible, & that of the Emperor's app decorating the fellow & that of fetching dirt to dump down in the gallery is very romantic but not true. They have though a very fine velocipede here which is very common. It is beautiful in its simplicity. It has only two wheels one right in front of the other & a steel spring on top of them on which is a saddle for the rider. The front wheel is turned to steer it by a cross piece in the hands & the rider makes it go by working his feet on two little pegs or cranks setting out from the front wheel.

The line from the cross piece to the saddle I didn't mean to make but can't scratch it out. The & the crankes are too long.

The man sits on the saddle but he has to set it going before he jumps on, by running or even walking or else he would fall right away. After he is on it seems to be under complete control. A bad rider makes a line like this ∼∼∼ but a good one like this ——————— & I saw one very skilful fellow go for a square in a gutter not faster than I can walk & then afterwards come out of the gutter & tear down the boulevard like a race horse. The alphaltum pavements are so hard & smooth there seems to be hardly a limit to their speed. It is becoming very fashionable & last summer early in the morning there were races by princes &

35. Thomas Eakins to Benjamin Eakins, 9 Nov 1867.

Eakins' letter to his father describes and sketches a new form of "velocipede" then all the rage in Paris. The easily legible writing is the result of his training from his father, a professional penman.

33. TE to BE, CE, Caddy, and Aunt Eliza, [ca.30] Nov 1867, Paris.

describes old and new studios at 64 Rue de l'Ouest; note to Caddy describing the public zoo; note to father thanking him for 100 francs, will try not to waste it; having trouble with an assignment for Gérôme, but otherwise optimistic; returned Moran's picture from the Great Exhibition.

4 pp., unsigned, McHenry 4–9, Goodrich I/25.

34. TE to BE and CE, 6 Dec 1867, Paris.

sends newspapers; negative comments on President Johnson; assisted an American named Richards who was ill; tells several humorous stories of life in Paris.

4 pp., unsigned. [Richards is Frederick de Bourg Richards, cf. fragment of letter dated Dec. 1867–3 Jan. 1868, and TE to BE, [Oct 1867?].]

35. TE to BE, 30 Dec [1867]–3 Jan 1868, [Paris].

Gérôme is in preparations for trip to Egypt; describes health and family problems of Richards; fears that BE never got the letter describing the photographs of works of art that he has recently seen—"Mr. Sartain will tell . . . how good they are."

2 pp., incomplete, unsigned, Goodrich I/40. [Earlier letter may be the fragment TE to BE [Oct. 1867?].]

36. TE to Bill [Crowell], FE, Margaret, and Aunt Eliza, n.d. [late Jan 1868?], [Paris].

mentions debt owed to TE by Bill, thanks him for an article; note to Fanny about her piano playing; note to Aunt Eliza describing a 3-penny outhouse with 5 seats; note to Maggie about gingerbread.

2 pp., unsigned.

37. TE to BE, [23 or 24] Feb 1868, Paris.

transcribes recent letter he received from Gardel and comments on how it reflects the man's goodness and generosity; note to Maggie on her skating; note to Fanny to keep up her skating practice; tells of going once or twice a week to Bonheurs'—enjoys evenings with them; has read Couture's book on art, recommends it to Bill Sartain; hears new organ at Notre Dame; anticipates President Johnson's impeachment.

5 pp., initialed.

38. TE to BE, 6 Mar 1868, [Paris].

entire letter responds to BE's arguments with others in Philadelphia about the role of the artist; uses boating metaphor to state that the artist should be modest and independent and should follow Nature; has been accepted into the sculpture studio of Dumont, describes the other students there.

5 pp., unsigned, Goodrich I/27, 30–31. R

39. TE to BE, 17 Mar 1868, Paris.

accounts since Jan 17; has attended five operas and a masked ball; purchased book by and photo of Couture, book by Rabelais; has begun sculpture classes; enjoys hearing the singing of Adelina Patti; feels more confident of painting ability—"I see color and I think I am going to learn to put it on."

5 pp., unsigned, McHenry 9, Goodrich I/33, 36.

40. TE to BE, n.d. [late May 1868], [Paris].

criticizes most of the work seen in the Salon.

1 p., unsigned [possibly a fragment of another letter].

41. TE to Emily Sartain, n.d. [ca. 20 Jul 1868], [Paris].

"touched by your loving interest in me"; answers her criticisms of his behavior.

4 pp., draft, unsigned [probably a response to her letter of 8 Jul 1868].

42. TE and FE to CE and Caddy, 24–26 Aug 1868, Munich and Mainz.

TE describes fleas for Caddy; TE to CE describes Munich, saw some nice Spanish pictures there; on reverse: note to Mommy from Fanny dated 26 Aug describing their visit to Heidelberg.

2 pp., unsigned.

43. TE to CE and FE, 30 Sep 1868, Paris.

describes bad behavior of Crépon's son; recommends *Les Misérables* for a description of Paris life; father and sister have sailed from Brest on the 12th; describes political cartoons of Gil.

4 pp., unsigned.

44. TE to BE, 29 Oct 1868, Paris.

asserts that he is working hard, learning a lot, may one day become rich through painting; Gérôme's advice not to finish one's student sketches too completely is sound; his training and skill is superior to Bill Sartain's; accuses Emily Sartain of interfering between him and his family; looks forward to the day when he will be independent.

4 pp., unsigned.　　R

45. TE to BE, 23 Apr 1869, [Paris].

describes scandal of the Prix de Rome competition winners—competition was annulled and a new jury appointed; criticizes corruption of the French art bureaucracy; had no trouble bringing his pistols into France; "send photographs of myself for the boys."

4 pp., unsigned.

46. TE to BE, 7 May 1869, Paris.

saw *Sheridan's Ride* by Buchanan Read, thinks it is a shameful picture by a bad artist; has heard bad things about American artists in Rome from Richards; impressed with the painting of May, an American in Paris.

4 pp., unsigned, Goodrich I/47–48.

47. TE to BE, 14 May 1869, Paris.

describes political unrest and street demonstrations; difficulties encountered by political candidates trying to speak in public; citizens of his district "have nominated Rochefort and will elect him"; intends to stay out of political activity.

4 pp., unsigned, Goodrich I/48–49.

48. TE to [BE], 3 Jun 1869, Paris.

has had dental work done; Bill Sartain goes to Bonnat's studio; describes at length a Japanese circus performance he enjoyed.

4 pp., unsigned; 3 small sketches of acrobats.

49. TE to CE, 18 Jun 1869, Paris.

stories of innocent persons arrested and imprisoned in the recent political troubles; short note to Fanny about a portrait of Gérôme; note to Caddy about dogs.

4 pp., unsigned.

50. TE to BE, 24 Jun 1869, Paris.

answers father's request for progress report on his studies, doing well— making progress in color—sure he could make a living.

2 pp., unsigned, Goodrich I/50. R

51. TE to [BE] and FE, 2 Jul 1869, Paris.

Paris monotonous and rainy; note to Fanny; explains that Bill Sartain chose Bonnat as his teacher because he thought he was the best one; news of other friends; note to Caddy in French encouraging her to study.

4 pp., unsigned.

52. TE to CE, 30 Aug 1869, [Paris].

entire letter concerns accounts; has bought photos of models, landscapes, Gérôme; has seen more operas; dental bills; attends circus; attending Bonnat's studio.

8 pp., unsigned, McHenry 10–12 [cited as 3 Aug; see fig. 36].

53. TE to [BE], 5 Nov 1869, Paris.

confident he can make a name as a painter; "I can construct the human figure now as well as any of Gérôme's boys . . . and I am sure I can push my color further so I keep working hard."

2 pp., unsigned, Goodrich I/53. R

36. Thomas Eakins to Caroline Eakins, 30 Aug 1869.

Throughout his student years Eakins sent regular reports of his expenditures to his parents. Usually addressed to his mother, they often contained information justifying specific expenses. Note the intriguing passage: "Loan to Bonheur / 40.00 [francs] / I could write you a whole French novel about that which I will do some time or other. He will repay me in September or October."

54. TE to BE, 2 Dec 1869, Madrid.

enjoyed seeing the "big painting" in Spanish museums; Velasquez most impressive; Rubens, even after seeing his best work in Spain, is still the "nastiest, most vulgar, noisy painter that ever lived"; finds Madrid clean and bright. "I have seen the Big Work ... and I will never forget it. It has given me more courage than anything else ever did."

4 pp., unsigned, McHenry 17–19, Goodrich I/54, 60–61. R

55. TE to BE, 7 Dec [1869], Seville.

arrival in Seville, threatens porters with his pistol; sees cigar factory; visits museum to see Murillo's painting.

4 pp., incomplete.

II. Letters sent, 1873–1914

Page references for Goodrich (1982) are given.

56. TE to [J. L. Gérôme], n.d. [1874].

draft in French of a letter to Gérôme describing two paintings and a watercolor TE is sending to him.

3 pp., draft. [Goodrich has full translation of p. 1 by Margaret McHenry; he says that this draft was lost by Bregler, cf. I/319–20, footnote 93:13–16.]

57. 11 letters to Kathrin Crowell, 24 Aug 1873, 22 Jul 1874, 29 Jul 1874, 19 Aug 1874, 22 Aug 1874, 20 Aug 1875, 19 Aug 1876, n.d. [8 Sep 1876], 29 Aug 1877, n.d. possibly 1875, n.d. possibly 1876.

primarily casual news of family and friends; occasional references to work on paintings.

20 pp., received copies. [Goodrich I/79 states that TE's letters to her do not seem not to have survived.]

58. TE to George McCreary, 13 Jun 1877, Philadelphia.

plans and hopes for the portrait of the President; would paint only the head if the President were impatient or pressed for time but would rather do the full figure.

3 pp., Goodrich I/141.

59. TE to the Board of the Pennsylvania Academy of the Fine Arts, 24 Apr 1879, Philadelphia.

criticizes conduct of George Corliss in attempting to eliminate *The Gross Clinic* from the loan exhibition of pictures by the Society of American Artists; accuses Corliss of being a "miserable and tricky partisan."

2 pp.

60. TE to James P. Scott, 18 Jun 1883, n.p.

defends his work and expenses on the knitting and spinning panels; lists expenses incurred; requests loan of the panels for the exhibition.

2 pp., initialed, Goodrich I/216 [letter found in Eakins' "wallet"].

61. TE to SME, 21 Jun 1883.

hopes she is having a good time; saw Mr. Scott but got little satisfaction.

1 p., received copy [letter found in Eakins' "wallet"].

62. TE to James P. Scott, 11 Jul 1883, 1729 Mt. Vernon St., [Philadelphia].

gives estimate for "finishing a panel in stone & putting it in place also the entire cost in place of a third panel representing an old man reading"; does not agree that a less finished work would do as well; recommends that he look at the Greek casts in the Academy.

3 pp., Goodrich I/216–17.

63. TE to James P. Scott, n.d. [1884], 1330 Chestnut St., Philadelphia.

requests arbitration to settle problem of whether and how two panels will go to Society of American Artists show in New York.

2 pp., Goodrich I/218.

64. TE to John Wallace, 27 Feb 1884, 1330 Chestnut St., Philadelphia.

news of the school classes, faculty, etc.

3 pp., received copy, Goodrich I/223. [Wallace gave the letters he had received from TE to his student, George Barker, who gave six of these to CB in 1944, and others to the Joslyn Art Museum (Omaha, Nebraska) in 1966. Barker's transcriptions of seven letters from TE to Wallace, including four in the Bregler collection, and others now in Omaha, are preserved in the Bregler collection.]　R

65. TE to Edward H. Coates, 15 Feb 1886, 1330 Chestnut St., [Philadelphia].

regrets his "agony" at their recent meeting; sorry that the public scandal is causing problems for his women friends, students, and family; defends use of the nude model; both Miss Barber and Miss Searle could have learned more if they had had the opportunity to study the nude.

3 pp. [If Coates received this letter, he did not file it at the Academy. Board members generally kept their correspondence at their place of business.]　R

66. TE to Edward H. Coates, n.d. [ca. 10 Mar 1886], n.p.

defends himself against charges; mentions having modeled the student Godley; mentions disagreement with female anatomy demonstrators.

2 pp., draft, initialed [probably TE's answer to Coates' letter of 18 Feb; filmed at end of Sketch Club letters].　R

67. TE to John Wallace, 23 Feb 1886, 1330 Chestnut St., Philadelphia.

thanks for the letter expressing confidence.

1 p., received copy, Goodrich I/291.

68. TE to FEC, 4 Jun 1886, n.p.

"cast down being cut on the street by those who have had every occasion to know me"; has learned that both Maggie and Fanny have now been brought into the affair; pleased with the affidavit of his father and Bill Crowell; wonders how it would look to the public if Frank Stephens were sent away for a while.

3 pp, unsigned.　R

69. TE to Edward H. Coates, 11 Sep 1886, Philadelphia.

compares the figure painter to a doctor in professionalism and attitude to the human body; points out that women medical students now receive the same training as men; defends education of women but says, "I do not believe that great painting or sculpture or surgery will ever be done by women, yet good enough work is continually done by them . . . "; mentions Miss Elizabeth Gardner, who now paints the figure almost exactly as Bouguereau does; she . . . "cannot at all times lead the conventional life"; has never been interested in students who were not judged to be professionally oriented; mentions "poor Godley . . . who was sent around by Frank Stephens to quarrel with me in the dissecting room."

8 pp., received copy [probably one of the enclosures returned to TE, cf. Coates to TE, 13 Sep 1886, no. 162]. R

70. TE to Edward H. Coates, 11 Sep 1886, Philadelphia.

retained copy of above-mentioned letter.

8 pp.

71. TE to Edward H. Coates, 12 Sep 1886, Philadelphia.

tells of a student, Miss Amelia Van Buren, who, having a question regarding a point made by TE in anatomy lecture, returned with him to his studio, where he stripped himself and demonstrated the point; defends his professionalism in handling the matter and their continuing friendship; wonders whether this incident might be the cause of the accusations against him.

3 pp., received copy [possibly one of the enclosures, see above, no. 69]. R

72. TE to Edward H. Coates, 12 Sep 1886.

retained copy of the above-mentioned letter.

4 pp.

73. TE to Secretary of the Academy Art Club. n.d., [late March 1886].

responding to note of 22 March from the Academy Art Club; criticizes the Club's acting in secret in expelling him.

1 p. [on reverse of Academy Art Club to TE, 22 March, 1886; see letters received, no. 155]. R

74. TE to Secretary of the Academy Art Club, n.d. [late March, 1886].
criticizes Club's acting in secret in expelling him.

2 pp. [appears to be the hand of Wm. G. Macdowell; same as text in TE's hand on reverse of
Academy Art Club to TE 22 March, 1886].

*75. TE to Samuel B. Huey, Esq., 5 Apr 1887, 1729 Mt. Vernon St.,
[Philadelphia].*
thanks for defeating the "ambitions of Mr. Stephens & Co."; is giving
Huey several pages to use at his discretion.

2 pp., copy.

76. TE to Louis Stephens, 9 May 1887, [Philadelphia].
sets up meeting with Mr. Stephens for that evening at which time TE will
present "The contradiction of some infamous lies regarding my personal
character"; welcomes the presence of Charley Stephens at the meeting.

1 p., copy [see description of this meeting in SME's hand probably dictated by TE].

*77. TE to Andrew C. Sinn, 10 May 1887, 1330 Chestnut St.,
[Philadelphia].*
asks for an answer regarding his question about rumors "against my
character" possibly circulated by Sinn's daughter, Fanny.

1 p., copy [in SME's hand].

*78. TE to Arthur B. Frost, 8 Jun 1887, 1729 Mt. Vernon St.,
Philadelphia.*
has wished for many days to "lay before you the falsity of some
outrageous slanders"; had wished to show him his marriage license to
quiet rumors that he was not married.

2 pp., copy [related to Frost to TE, 19 May 1887].

*79. TE to Miss Van Buren, 9 Jul 1887, 1330 Chestnut St.,
Philadelphia.*
defends his use of the nude model; asks her to write to him if she should
hear anything against him.

3 pp., copy [address amended from 1729 Mt. Vernon St. to 1330 Chestnut, and date
amended from 23 June to 9 July].

80. TE to Andrew C. Sinn, 12 Jul 1887, 1729 Mt. Vernon St., Philadelphia.

fears misdirection of his letter of May 10, includes a copy of it; asks that the contents be shown to Sinn's daughter Fanny.

3 pp., copy.

81. TE to SME, 31 Jul 1887, Medora, [Dakota Territory].

describes leaving Dickinson for the ranch; traveling to Medora for the roundup; town crowded with cowboys waiting for it to start.

5 pp., received copy, unsigned, rough map of the area included on p. 1; Goodrich II/16. [Goodrich mentions having seen 6 letters to SME. The first, dated 26–27 July, is in the Dietrich Collection. The remaining 5 are in the Bregler Collection.]

82. TE to SME, [early Aug] and 11 Aug 1887, n.p.

describes the roundup; thanks SME for sending him text of a letter from Gérôme.

2 pp., received copy, unsigned, half of one page has been torn off; Goodrich II/16–17. [Goodrich's transcription of this letter indicates that it was already torn when he saw it. See Leibold, "Thomas Eakins in the Badlands."]

83. TE to SME, 28 Aug 1887, n.p.

describes visits to neighboring ranches, hunting trips, meeting a young Indian; says will bring two horses back to model; has received a letter from SME in which she was doleful on account of her bad painting; he praises her work.

8 pp., received copy, unsigned. [From Goodrich's files it was learned that this letter was continued on a now-lost letter to TE from Lilian Hammitt dated 24 Aug. That continuation carried the passage quoted on p. 17 about Eakins having killed a rattlesnake. None of the contents of these first 8 pages of the letter are quoted by Goodrich. His transcription of the last page of the letter is in the Eakins research collection at the Philadelphia Museum of Art. See Leibold, "Thomas Eakins in the Badlands."] R

84. TE to SME, 7 Sep 1887, Dickinson, [Dakota Territory].

describes life on the ranch, impressed with the Indian fighters he has met and also with their tall tales; offered to pay room and board to Mr. Tripp, who refused to consider it.

4 pp., received copy, initialed, Goodrich II/17. [See Leibold, "Thomas Eakins in the Badlands."]

85. *TE to SME, 26 Sep and 9 Oct 1887, n.p.*

long story of a thief pursued and caught; continuation dated 9 Oct from Dickinson states that he is ready to leave for Chicago with a trainload of cattle owned by Howard Eaton.

18 pp., received copy, unsigned, author paginated, p. 15 has fragmentary map drawn over the text, p. 16 is on letterhead of the Kidder Hotel, Dickinson, Dakota; Goodrich II/17–19. [See Leibold, "Thomas Eakins in the Badlands."]

86. *TE to John Wallace, n.d., [late Sep and 9 Oct 1887], B-T Ranch, Dickinson, Dakota.*

about to start East with his horses on a cattle train.

2 pp., received copy, initialed, Goodrich II/19.

87. *TE to John Wallace, 14 Oct 1887, Chicago, Transit House, Union Stock Yards.*

waiting to leave Chicago with the horses, hopes to meet with Wallace before leaving.

1 p., received copy, Goodrich II/20 [incorrectly cited in several references as 4 Oct; Goodrich dates it correctly].

88. *TE to John Wallace, n.d., [8 Dec 1887], 1729 Mt. Vernon St., Philadelphia.*

horses arrived in Philadelphia and are at the Avondale farm; enjoys riding the horses; news of various friends.

4 pp., initialed, received copy, Goodrich II/20–21 [dated from Goodrich's reference to it; the envelope he saw in 1930 has not survived; he *incorrectly* cites the Joslyn Art Museum as the repository for this letter]. R

89. *TE to Charles Bregler, 15 May [1888?], n.p.*

cancels appointment with CB.

postcard, received copy [may refer to fixing CB's drafting board, see next entry].

90. *TE to Larry Philips, n.d. [1888], n.p.*

asks him to fix CB's drafting board and T-square.

1 p., received copy. [CB had this framed; note on back of frame states that TE fixed the board himself; dated via assumption cf. CB's reference to TE fixing his drafting board in his *Arts Magazine* article, Oct 1931, p. 35.]

91. *TE to John Wallace, 22 Oct 1888, 1729 Mt. Vernon St., Philadelphia.*

has been working with his negatives; hears that painting is no longer done at "our old Academy"; pleased with his own little school and the lack of "interference of the ignorant"; working on a cowboy picture.

3 pp., received copy, initialed, Goodrich I/296–97, II/23. R

92. *TE to Mr. Church [Frederick Stuart Church?], 25 Oct 1888, 1729 Mt. Vernon St., Philadelphia.*

"If I lecture at all upon anatomy I shall do so seriously"; necessity of using a nude model.

2 pp., copy.

93. *TE to E. Mitchell, 27 Oct 1888, 1729 Mt. Vernon St., Philadelphia.*

National Academy of Design has asked him to lecture; waiting for an answer to his terms; importance of the pelvis in anatomical understanding and the nude model in illustrating it.

3 pp., copy, Goodrich I/304 [text similar to TE to Mr. Church 25 Oct 1888].

94. *TE to the Secretary of the Treasury, 11 Mar 1889, 1729 Mt. Vernon St., Philadelphia.*

requests to be informed how he can get back from France some pictures he sent there, and also pictures he is sending to the Paris Salon.

4 pp., copy, Goodrich I note 119:26–27 and II/162.

95. *TE to [FEC], n.d. [early April, 1890].*

children have arrived all right; she should have no fears for them in his studio, wishes Ella to become an animal painter; they will need to study the nude model—"the study of the naked figure is either wholly right or wholly wrong."

4 pp., draft, unsigned [probably a response to FE to TE, 4 Apr 1890, no. 176].

96. TE to F. L. Schenck, 26 Jan 1894, 1729 Mt. Vernon St., Philadelphia.

answers apparent request for a loan; sends Schenck $5; on reverse a note from Schenck refusing the money and returning it.

2 pp., received copy.

97. TE to Elizabeth Macdowell Kenton, 15 Sep 1894, n.p.

his resentment at her having aided the conspiracy has cooled; wishes to be on speaking terms.

3 pp., copy [original of her answer to this is lost; TE made a copy but it carries no date; see letters received Sep 1894, no. 181].

98. TE to Mr. Blashfield, 22 Dec 1894, 1729 Mt. Vernon St., Philadelphia.

fragment of a draft letter concerning use of the nude model at a lecture.

½ p., draft [Goodrich I/305–306 refers to a *complete* draft of this date and quotes it at length].

99. TE to FEC, 22 Oct 1895, Philadelphia.

TE and Murray "are promised an order for some nude sculpture"; to avoid embarrassment he will not ask Maggie to work with him.

2 pp.

100. TE to SME, July–August, 1897, [Seal Harbor, Maine].

12 letters written while TE was staying at Seal Harbor working on portrait of Professor Rowland; describes sailing with Rowland, teaching him to ride a bicycle; daily updates on the progress of the work; chatty questions about home.

28 total pp.; 7 letters on letterhead of The Glencove, Lynam & Campbell, Proprietors; received copies.

101. TE to Robert C. Ogden, 7 Apr 1904, 1729 Mt. Vernon St., Philadelphia.

letter quoted at length by Goodrich II/229–30 concerning Ogden/TE dispute over the price of his portrait.

8 pp., copy. [More correspondence re this portrait is in letters received for 1903 and 1904.]

37. Thomas Eakins, *Professor Henry A. Rowland*, 1897,
 oil, 82½ × 53¾″, Addison Gallery of American Art,
 Phillips Academy, Andover, Mass. Gift of Stephen C. Clark.

*Eakins went to Professor Rowland's summer home at Seal Harbor, Maine to work
on this portrait. The Bregler Collection has revealed 12 letters he wrote to Susan
while at work on the painting.*

102. TE to SME, 8, 15, 16, 17 May 1905, St. James Hotel, Washington, D.C.

4 short letters recounting sittings and progress on the portrait of Archbishop Falconio.

1 p. each, received copies, unsigned.

103. TE to George Barker, 24 Feb 1906, 1729 Mt. Vernon St., Philadelphia.

"copy done Jan. 3, 1926"; response to request for advice on art study.

2 pp., Goodrich II/257, copy in SME's hand. [Original letter is in Wallace Collection, Joslyn Art Museum, Omaha, Nebraska.]

104. TE to Louis Cure, 9 Mar 1907, 1729 Mt. Vernon St., Philadelphia.

note of condolence in French on the death of Cure's son.

2 pp., Goodrich II/257–58. [Goodrich I/64 quotes from an 1871 letter from Cure to TE which he says was shown to him by SME; it is not preserved in this collection.]

105. TE to William H. Holmes, 19 Apr 1911, 1729 Mt. Vernon St., Philadelphia.

sending photo back to Holmes; Rothermel's daughter recognized it as T. Buchanan Read; also sending photo of his Rowland portrait; comments on its importance; believes it should be in a museum or public gallery.

1 p., copy in hand of SME.

106. TE to John A. Brashear, n.d., [1912], 1729 Mt. Vernon St., Philadelphia.

encloses photo of Rowland portrait; mentions Brashear's inventions in glass grinding, telescopes, etc.; wishes to paint Brashear's portrait but must wait for return of better health.

1 p., copy, SME's hand [see Brashear to TE, 9 May 1912].

107. TE to Mr. L[?], 24 Mar 1914, 1729 Mt. Vernon St., Philadelphia.

Starting Out After Rail was never purchased by Prof. Marks; would like it back; asks for whereabouts of Marks' portrait.

1 p. [probably a draft].

III. Correspondence Between TE and the Philadelphia Sketch Club, 1886.

The Philadelphia Sketch Club, an all-male association of artists and art students, was founded in 1860. Eakins taught at the Sketch Club in the 1870s, and his classes were apparently well attended. In 1886 the Sketch Club censured him as a result of the rumors circulating after his dismissal from the Pennsylvania Academy. He carefully preserved his correspondence from the Club, which is perhaps indicative of how deeply he was stung by the rejection. See pp. 79–90 for a discussion of these letters.

108. [Mar–Apr, 1886], "Copy of correspondence,"

transcriptions of 11 letters to and from the Sketch Club, copied by TE onto 3 folios; numbered 1–11; only nos. 6, 8, and 10 are not duplicates of letters described elsewhere in this list.

 #6: John Sears to TE, 3 Apr 1886; described below, no. 115.
 #8: Walter Dunk to TE, 7 Apr 1886; described below, no. 118.
 #10: TE to Sketch Club, 17 Apr 1886; described below, no. 120.

12 pp. R

109. John V. Sears to TE, 11 Mar 1886, Sketch Club.

committee has been organized to look into charges; members of the committee: John V. Sears, Walter Dunk, Henry Poore.

1 p., received copy [see no. 108, #1].

110. TE to John V. Sears, 13 Mar [1886], n.p.

asks why the Sketch Club should think to "constitute itself a tribunal to hear and try charges"; will not consider the subject further until full revelation of the charges has been made."

3 pp., draft, see Goodrich I/292 [original in Sketch Club Archives; see no. 108, #2].

111. TE to John V. Sears, 13 Mar 1886, 1330 Chestnut St., Philadelphia.

fragment of a draft containing only a few lines.

1 p.

112. John V. Sears to TE, 10 [13] Mar 1886, Sketch Club.

acknowledges TE's note, "the position you assume is perfectly just"; committee will do nothing until the "matter in question is formally before you."

1 p., received copy [misdated by Sears, cf. TE's note on dossier letter #3].

113. C. Few Seiss to TE, 13 Mar 1886

informs TE that an accusatory letter has been received by the Sketch Club and entered upon the minutes; text of the letter transcribed; Article V, Section III of the Club By-Laws transcribed for TE.

3 pp., received copy [see no. 108, #4, and no. 122].

114. TE to John V. Sears, 26 Mar 1886, 1330 Chestnut St., Philadelphia.

an action of expulsion from the Sketch Club cannot be in question since he was never a regular member; "It would be folly for me to appear . . . to answer an indictment the points of which I am not permitted to know in advance."

3 pp., unsigned, see Goodrich I/292 [original in Sketch Club Archives; see no. 108, #5, and no. 123].

115. John V. Sears to TE, 3 Apr 1886.

sets meeting for Wednesday next to hear charges, requests TE's attendance.

[item #6 on TE's 1886 dossier; location of original letter unknown.]

116. TE to John V. Sears, 7 Apr 1886, 1330 Chestnut St., Philadelphia.

again asks for specifics of the charges laid against him.

3 pp., copy, unsigned [see no. 108, #7].

117. TE to John V. Sears, 7 Apr 1886, 1330 Chestnut St.
draft of the above item.
2pp.

118. Walter Dunk to TE, 7 Apr 1886.
requests his appearance at the Sketch Club meeting.
[item #8 on TE's 1886 dossier; location of original letter unknown.]

119. C. Few. Seiss to TE, 7 Apr 1886, Philadelphia Sketch Club.
date fixed for final disposal of charges is April 17.
1 p., received copy [see also no. 108, #9].

120. TE to Sketch Club, 17 April 1886.
demands that all correspondence in the matter be read at the April 17 meeting.
[item #10 on TE's 1886 dossier; original in Sketch Club Archives.]

121. C. Few Seiss to TE, 19 Apr 1886, Philadelphia.
requests TE's resignation from the Sketch Club.
1 p., received copy.

122. TE to Chairman of the Sketch Club, n.d., [March 1886].
draft, in another hand, of the TE letter to John Sears of 13 Mar 1886.
1 p. [appears to be the hand of Wm. G. Macdowell].

123. TE to John V. Sears, n.d., [March 1886].
draft, in another hand, of the TE letter to John Sears of 26 Mar, 1886.
2 pp. [appears to be the hand of Wm. G. Macdowell].

IV. Correspondence with Lilian Hammitt and her family

Lilian Hammitt was an Academy student under Eakins from 1883 to 1886. The letters presented here were accompanied by a note in Susan Eakins' hand to Addie Williams: "The contents of this box destroy. You can look at them if you care to, but they are to be burned—destroyed completely" (6 May 1919, Figure 4). See "The Hammitt Case," pp. 95–104 for a discussion of these letters.

124. *TE to Miss Conard [sic.], 2 Mar 1887, 1330 Chestnut St., [Philadelphia]*.

has felt it necessary to advise Miss Hammitt of Miss Conard's character and recent attack [on him].

1 p. [not marked as a copy but probably the letter mentioned in the next entry].

125. *Lilian Hammitt to TE, 4 Mar 1887, n.p.*

has received the copy of the letter he sent to Miss Conard and encloses the message she herself has sent to Miss Conard—i.e., that the matter referred to in the letter will be entirely confidential.

1 p., received copy.

126. *Lilian Hammitt to SME, 20 Jul 1887, Keene, New Hampshire.*

has sent a note of thanks to TE for a photograph; is living in a better place now, but also a more expensive one, with financial help from a wealthy lady in New York.

1 p., received copy.

127. *SME to Lilian Hammitt, n.d. [ca. 1887?], n.p.*

is sorry that Hammitt feels compelled to seek marriage so out of the regular way; "my notion of marriage is the joining of two hearts and each would give up every worldly consideration that the other might be happy"; wishes Hammitt would stop thinking of "that serious step" and advises her to relax, enjoy herself and cultivate younger, livelier friends; she and her husband are "too dull and serious" to be companions."

4 pp. [filmed at end of Hammitt letters].

128. Lilian Hammitt to TE, n.d. [ca. 1887], [Keene, New Hampshire].

fragment of a letter apparently describing her current living arrangements; wishes him success with the portrait of Prof. Clark.

1 p., received copy.

129. TE to Lilian Hammitt, 2 Mar 1888, n.p.

was greatly shocked by the letter she left in his box; she must be aware of the "great love that exists between" him and his wife, and heard from him many expressions of his devotion to his wife; "That you should have consulted a lawyer as to my getting a divorce is so extravagant that I must excuse it on the suspicion of mental disorder"; is glad she has decided to stay away from his studio and has abandoned work on his portrait of her; advises her to return to the country to paint if financial troubles prohibit staying in the city.

2 pp. "Copy of answer to Miss Hammitt's letter of February 29, 1888." R

130. Lilian Hammitt to Bro. Miller, 12 May 1890, Atlanta, Georgia.

informs him of her mother's death and that she is in Atlanta sewing for a living; wishes to obtain a position teaching painting; is sure TE would use his influence to assist her.

2 pp., received copy.

131. TE to Charles Hammitt, 5 Jun 1890, 1729 Mt. Vernon St., Philadelphia.

believes Lilian's mind to be affected with delusions, the present one being that he is anxious to take her from Atlanta and marry her; she has had similar delusions with regard to other men; praises her talent for painting.

2 pp., copy. R

132. TE to Mrs. L. B. Nelson, 5 Jun 1890, 1729 Mt. Vernon St., Philadelphia.

has letters from Miss Hammitt relating extraordinary conversations between them; hopes that Mrs. Nelson's discernment is equal to her benevolence and that she will recognize a form of insanity.

1 p., copy.

133. Mrs. L. B. Nelson to Mr. Hammitt, 15 Jun 1890, Atlanta, Georgia.

is sure that TE is to blame for Lilian's erroneous beliefs; has read letters TE wrote to Lilian and was greatly shocked by what she read; believes he paid her way to Atlanta; hopes Lilian can be removed from Atlanta as soon as possible.

6 pp.

134. TE to Mrs. L. B. Nelson, 19 Jun 1890, 1729 Mt. Vernon St., Philadelphia.

she is mistaken in her belief that he is financially responsible for Lilian; the girl is intelligent and the best help anyone could give her would be a job; believes Mrs. Nelson has arrived at false conclusions and was wrong to confiscate all Lilian's "little art treasures."

3 pp., copy [in SME's hand].

135. Charles Hammitt to Lilian Hammitt, 23 Jun 1890, Kinsey, Alabama.

strong criticism of her conduct; cannot allow her to return to his home, nor will he pray for her any longer.

2 pp., received copy.

136. Lilian Hammitt to TE, 3 Jul 1890, 206 Spring St., Atlanta Georgia.

has seen the recent letters exchanged between TE, Mrs. Nelson, and her brother; will relate some of the things Mrs. Nelson has said to her; is quite disgusted with the actions of both of them; is living with a Mrs. Hills, who is a friend of Mrs. Watson and Eva; does housework and cooking; encloses text of her recent letter to her brother in which she praises the advice and the kindness towards her of both TE and SME; says that she did not realize how hard it would be to leave TE.

4 pp., received copy, unsigned.

137. Maggie Unkle to TE, 27 Oct 1892.

has heard that Lillie is contented; hopes she will get well soon; some of Lillie's friends are trying to get her into a mental hospital; is grateful for TE and SME's kindness to Lillie.

2 pp., received copy.

138. Maggie Unkle to TE, 7 Dec 1892.

Lillie is in Norristown State Hospital although she apparently had not wanted to go.

2 pp., received copy.

V. Letters received, 1868–1915

All letters are received copies unless otherwise noted.

139. FE to TE, 25 Feb [1868], Philadelphia.

mentions skating and the weather; asks TE to state definitively if he is going to marry Emily Sartain.

4 pp. incomplete, see Goodrich I/42.

140. Emily Sartain to TE, 8 Jul 1868, Geneva.

castigates TE for contemplating not traveling in Europe with his father and sister; regrets that they are parting and hopes that they will be close again one day.

4 pp. [TE's answer is probably that of n.d. [July, 1868]].

141. Joanna Schmitt to TE, 25 May [1870], Manheim, Germany.

she will not be able to meet him in Paris as planned.

2 pp.

142. Addie Williams to TE, 23 Sept 1870, Fairton, New Jersey.

thanks him for a gift of some fruit.

1 p.

143. Jean-Léon Gérôme to TE, 10 May 1873.

thanks TE for watercolor; compliments TE on his progress as an artist.

1 p. Goodrich I/113–14 [translation in CB's hand, location of original unknown].

144. *Jean-Léon Gérôme to TE, 18 Sep 1874.*

has received TE's pictures and has found a "very great progress."

1 p., Goodrich I/116 [translation in the hand of Louis Husson; location of original unknown].

145. *Jean-Léon Gérôme to TE, 22 Feb 1877, Paris.*

in answer to TE questions he believes students should begin with study of the antique casts and then progress to living models; "look what became of the German school to have neglected the truth . . . to have quitted the earth and plunging itself in empty ideals . . . "

1 p. [not referenced in Goodrich; translation of text in CB's hand; CB's note at bottom: "Translated by Louis Husson"; location of original unknown]. R

146. *Fairman Rogers to TE, 9 Nov 1883, Newport, Rhode Island.*

informs TE of his resignation from PAFA Board of Directors.

2 pp., Goodrich I/281.

147. *Edward H. Coates to TE, 27 Nov 1885, 116 Chestnut St., Philadelphia.*

praises the Swimming picture and requests the bill for it; proposes to take in its stead a picture more representative of TE's work for future addition to the Academy collection.

4 pp.

148. *Edward H. Coates to TE, 11 Jan 1886, Philadelphia.*

necessary to "treat the subject in anatomy just as has been generally done heretofore"; also of not "removing the band worn by the male model . . . until such change is decided upon by the Committee of Instruction"; "it is of great moment that at this time *you* should act in carrying out the wishes expressed above rather than the Directors should do so."

2 pp.

149. Edward H. Coates to TE, 14 Jan 1886, Philadelphia.

"During the few minutes when I saw you on Tues I omitted to say that it would seem to be best that the demonstration should be continued in the anatomy class by Mr. Godley, Miss Searle, and Miss Conard, as assistants, just as if nothing had occurred."

1 p.

150. Edward H. Coates to TE, 8 Feb 1886, 116 Chestnut St., Philadelphia.

asks for TE's resignation.

1 p. [this is the only one of the Coates letters referenced in Goodrich, cf. I/286. TE's letter of resignation is preserved in the PAFA Archives, #11].

151. Edward H. Coates to TE, 10 Feb 1886, Philadelphia.

best to continue teaching in class this week.

1 p.

152. Edward H. Coates to TE, 13 Feb 1886, Philadelphia.

accepts TE's resignation.

1 p.

153. Edward H. Coates to TE, 18 Feb 1886, Philadelphia.

fully appreciates the hardship of TE's position; recommends against TE's friends going to the press and the public in his defense.

2 pp.

154. Myra Radis Thompson to TE, 1 Mar 1886, Spring Hill, Tennessee.

was a pupil for a short time only but wishes to thank TE for the good teaching and friendship.

3 pp.

155. C. Few Seiss, [Secretary, Academy Art Club] to TE, 22 Mar 1886, Philadelphia

"It is my unpleasant duty to inform you that the Executive Committee of the Academy Art Club report an order that you be expelled from the Club"; transcribes Act VI, Sec. II of Club By-Laws, lists committee members.

1 p. [TE's answer on reverse; see no. 73].

156. Edward H. Coates to TE, 24 Mar 1886, Philadelphia.

recommends against any further steps on TE's part; asks if project for bronze medallions will go forward, he would like it to.

2 pp.

157. William J. Crowell to TE, 26 Apr 1886, n.p. [Avondale, Pennsylvania].

mentions TE's habit of going into the room occupied by Maggie, Caddy, and Aunt Eliza while he was getting dressed—"in your shirt tail"; thinks Frank Stephens may have exaggerated this all out of proportion; mentions "the nude posing business," implies that one or more of the sisters may have posed for TE.

4 pp., initialed. R

158. Henry Godley to TE, 29 Apr 1886, Philadelphia.

knows nothing of the dispute between TE and his son; refuses any involvement.

1 p.

159. William J. Crowell to TE, 4 May 1886, n.p., [Avondale, Pennsylvania].

says he cannot express "the indignation and disgust the story has caused us." Fanny and he have both written letters to William Macdowell on TE's behalf.

1 p.

160. The Art Students' League to TE, 1 Jun 1886, 1338 Chestnut St., Philadelphia.

statement signed by 16 students thanking TE for kindness and appreciation during the past school year; on reverse: short note in TE's hand about the Art Students' League and its purpose.

1 p., Goodrich I/296 [note about the ASL was probably part of a draft for a circular].

161. William J. Crowell to John V. Sears, 5 Jun 1886, Avondale.

affidavit of William and Frances Crowell defending TE and disputing charges against him; included are copies of letters of support from Mr. and Mrs. Crowell to William G. Macdowell; and statement of notarization.

23 pp., copy, author paginated. R

162. Edward Coates to TE, 13 Sep 1886, 116 Chestnut St.

returns TE's "enclosures" and wishes he had not left them as the matter is closed; defends the action of the Committee on Instruction.

2 pp. [cf. TE to Coates, 11 and 12 Sep 1886].

163. William J. Crowell to TE, 8 Oct 1886, n.p. [Avondale, Pennsylvania].

plans to send Fanny and several of their children to Philadelphia for the day and asks if the children can pass some time at the studio; Duer has not yet answered his letter—"he has a copy of your father's declaration".

2 pp., initialed.

164. Ellie [?] to TE, n.d. [ca. 1886?], n.p.

hopes that he will not think her "weak, bitter, and morbid" and that he will not speak "to others of me as changed"; "The sorrow from wrongdoing is sometimes hard to bear, and keeps me from having the spirit for things . . . "; glad that TE is beginning a new life.

2 pp. [Ellie may have been an Academy student; research produced a dozen possible names.]

165. *A. B. Frost to TE, 19 May 1887, Prospect Hill Farm, West Conshohocken, Montgomery County, Pennsylvania.*

does not know why TE wants to show him his marriage certificate; there never was any question about his marriage.

1 p. [related to TE to Frost, 8 Jun 1887].

166. *Horatio C. Wood to [Albert] Tripp, n.d., [June? 1887], 1925 Chestnut St., Philadelphia.*

letter of introduction for TE to ranch manager of the B-T ranch in Dakota Territory.

2 pp., Goodrich II/16.

167. *Albert Tripp to TE, 4 Jul 1884 [1887?], Dickinson, Dakota Terr.*

agrees to meet TE in Dickinson on July 26.

1 p., on letterhead of M. A. Sebastian, Sheriff of Stark County. [The date is likely an error by the letter's writer; TE did arrive in Dickinson on 26 July, 1887. This letter was filmed with 1884 letters received.]

168. *Howard Eaton to Lt. Macklin, Medora, [Dakota Territory], 7 Aug 1887, Medora.*

letter of introduction for TE who "wishes to see some of the sights around the Rock."

1 p., on letterhead of the Badger Cattle Company.

169. *Howard Eaton to Messrs. W. F. Douglas and Wm. McNiden, Medora, [Dakota Territory], 7 Aug 1887.*

letters of introduction for TE.

1 p., on letterhead of the Badger Cattle Company.

170. *William G. Macdowell to TE, 29 Aug 1887, Philadelphia.*

"I enclose draft on New York for one hundred Dollars which I obtained today to enable Sue to remit you that amount." Hopes TE is "having a good time & getting into first class physical condition."

1 p., on letterhead of Norfolk and Western R.R. Co.

171. William G. Macdowell to TE, 24 Sep 1887, 333 Walnut St., Philadelphia.

sending another $100 per arrangement with BE.

1 p.

172. Charles Cox [Secretary, Art Students' League] to TE, 13 Apr 1888, Philadelphia.

enclosed list of members wish to thank TE for services during School season of 1887–88.

1 p. [The list may be the one found with the ASL papers; p. 188.]

173. Rudolph Spiel [Secretary, Art Students' League] to TE, 23 Apr 1888, Philadelphia.

TE elected life member.

1 p.

174. Elizabeth Macdowell Kenton to Mr. and Mrs. TE, 8 Nov 1888, n.p.

"I regret the part I have taken in the attack upon Mr. Eakins, and it is my wish to separate myself from those connected with it. Being fully convinced of the error I now condemn it. It was characterized by misrepresentations and foul lies attacking the honor of Mr. Eakins, his father, and their home. I am glad to take this means of showing my disapproval and sorrow."

1 p.

175. William J. Crowell to TE, 3 Sep 1889, Pt. Pleasant, New Jersey.

recounts current problems with his father, who is trying to sell the house and go to Europe with the money.

4 pp.

176. FEC to TE, 4 Apr 1890, n.p., [Avondale, Pennsylvania].

sending daughters Ella and Maggie to TE for art study, worries about their exposure to the company of men; insists that they not be asked to pose nude.

3 pp. [TE probably answered this with his draft of early April 1890].

177. FEC to TE, 7 Apr 1890, n.p., [Avondale, Pennsylvania].

warns against using the girls as models; thought he had given up girl students posing; "surely your experience with it was hard and cost you dear . . ."

6 pp. [see above entry for more of this exchange].

178. William J. Crowell to TE, 10 Apr 1890, Avondale P.O. [Pennsylvania]

disagrees strongly with TE's insistence on using the children as models; says Fanny's decision is final—their children are not to pose; says TE has made a fetish of the posing.

5 p., incomplete, half of p. 3–4 torn off.

179. Franklin Schenck to TE, 31 Jan 1894, Smithtown Branch P.O., Suffolk Co., New York.

cannot accept his gift of $5; asks for acknowledgment of receipt of the money.

1 p., on reverse of TE to Schenck of same date.

180. John Boyd Thacher to TE, 23 Mar 1894, Washington D. C.

enclosing TE's award for the World's Columbian Commission.

2 pp., typescript.

181. *Elizabeth Macdowell Kenton to TE, n.d., [late Sept. 1894], n.p.*

"I shall be glad to act on your suggestion, but the statements in your letter call forth some comment. I never willfully invented stories against you— nor injured Maggie that I know of. I acted upon judgment though you know I confessed my mistake years ago. Both Maggie and your Father served in part as evidence for my convictions. You remember the people who turned against you were of your own choosing and I believe today they had no more intention of misrepresentation than I had. Your mingling of personal and business relations I still consider to have been most unfortunate and originated the trouble which ensued."

2 pp., copy in TE's hand [probably a response to TE to EMK 15 Sep 1894, no. 97].

182. *[J. R.?] Wilcraft to TE, 15 Mar 1895, Delair, New Jersey.*

congratulations to TE on his conduct in the Drexel affair from "all us Whitman fellows"; the human body is a divine creation and should be studied without embarrassment.

2 pp.

183. *Clifford P. Grayson to TE, 27 Mar 1895, 1 South 21st St., [Philadelphia].*

refuses to apologize for his actions in the Drexel affair; thinks an apology from TE would be in order; money for the lectures will be paid in full.

2 pp. R

184. *Robert Arthur to TE, 31 Mar 1895, 49 W. 32nd St., New York.*

letter of support for TE after the Drexel Institute affair. Showed Grayson's letter to Maynard, Low, and Turner, and all agreed it was "so pathetically silly an effusion."

1 p. R

185. *Laurens Maynard to TE, 23 Dec 1896, Boston.*

requests TE, as a friend of Whitman, to donate a set of his photographs of Whitman to the Boston Public Library collection of Whitman materials.

3 pp. [The Dietrich Collection contains a letter from TE to Maynard, 27 Dec 1898, thanking him for the present of the complete works of Whitman; cf. Homer, (ed.), *Eakins at Avondale*, p. 74.]

186. *Rev. Herman J. Heuser to TE, n.d. [1897], St. Charles Seminary, Overbrook, Pennsylvania.*

explains enclosed Latin text of inscription for a portrait [probably that of Dr. Charles Leonard]; mentions difficulty in translating the word "X-ray".

3 pp.

187. *Addie Williams to TE, 12 Feb 1897, 318 S. 15th St., Philadelphia.*

thanks TE for address of Lizzie Browell; would welcome a visit from TE.

2 pp.

188. *Henry A. Rowland to TE, 15 Sep 1897, Craig Stone, [Maine].*

thanks TE for gift of Japanese kites; gives permission for Schneider to see the portrait; gives opinions of several people who have seen it.

3 pp. Goodrich II/143. [SME apparently showed this letter to Goodrich, but not the 12 letters TE wrote to her while in Maine working on the portrait.]

189. *Fairman Rogers to TE, 19 Jun 1899, Lugano.*

thanks for the proofs of the new plate; asks for bill for them and that TE return the original picture to Earle and Sons.

3 pp. [refers to the oil copy of *The Fairman Rogers Four-in-Hand* which TE produced].

190. *William J. Crowell to BE?, 14 Aug 1899, n.p., [Avondale, Pennsylvania].*

asks for any part of Aunt Eliza's estate that may be coming to him as he is in bad financial condition; salutation is "Dear Mr. Eakins."

1 p.

191. *Mr. and Mrs. James W. Holland to TE, n.d., [ca. 1900], 2006 Chestnut St, Philadelphia.*

agrees to accept the portrait on his conditions, i.e., "that if at any time the trustees of the Jefferson Medical College may wish to purchase the picture, Mrs. Holland's ownership of it will not be a bar to selling it."

2 pp.

192. Fairman Rogers to TE, 30 Jun 1900, Vienna.

does not think it necessary to delay reprinting of the book in order to see more pages.

4 pp.

193. James P. Turner to TE, 31 Mar 1903, Philadelphia.

returns Bishop Conaty's letter to TE; Cardinal's portrait [Martinelli] has arrived; praises it.

1 p.

194. Archbishop Henry Moeller to Rev. James P. Turner, 17 Nov 1903, Cincinnati, Ohio.

asks that Turner request TE to execute a portrait of the Archbishop [Elder].

1 p., typescript.

195. Rear Admiral Charles Sigsbee to TE, 12 Dec 1903. Navy Yard, League Is.

thanks and praises for his portrait; his daughter will accept it.

4 pp., Goodrich II/208.

196. Frank W. Stokes to TE, 14 Dec 1903, 3 North Washington Square.

has succeeded in getting Ogden to consent to sitting for a portrait; offers use of his studio.

2 pp., Goodrich II/229. [TE's answer to this letter is #109a in Rosenzweig, along with two other letters to Stokes on the subject.]

197. Archbishop Henry Moeller to TE, 4 Jan 1904, Cincinnati, Ohio.

sends Latin inscription for portrait of Archbishop Elder [on reverse of letter].

2 pp.

198. Denis J. O'Connell to TE, 15 Mar 1904, Washington, D.C.

agrees to lend portrait of Cardinal Martinelli to the St. Louis exhibition.

1 p., typescript.

199. Robert C. Ogden to TE, 28 Mar 1904, New York.

has had a check drawn for the bill for the portrait; may ask Mr. Stokes to repeat "the conditions under which he consented to sit for the portrait."

1 p., typescript, Goodrich II/229 [more of this series is in Rosenzweig, pp. 198–201].

200. Walter Copeland Bryant to TE, 27 Apr 1904, Boston.

sends praises for his portrait he has received from Charles H. Davis, Tarbell, and others.

6 pp., author paginated.

201. Dr. William White to TE, 2 May 1904, 1810 S. Rittenhouse Square, Philadelphia.

very little time to sit for portrait—better to start fresh in the fall.

2 pp., initialed, Goodrich II/222.

202. Edward Redfield to TE, 23 Apr 1905, Centre Bridge, Pennsylvania.

cannot come to Philadelphia to collect portrait; please send it to him at Stockton, N.Y.

1 p.

203. William Balfour Ker to TE, 21 Jul 1905, 126 W. 104th St., New York.

he and his wife will be pleased to receive the portrait of Sigsbee; praise it.

2 pp., [the writer was Sigsbee's son-in-law].

204. John Singer Sargent to TE, 9 Feb [1906], 33 Tite St., Chelsea, London.

thanks for portrait of Dr. White.

2 pp., Goodrich II/223.

205. *Dr. William White to TE, 23 Feb 1906, 1810 S. Rittenhouse Square, Philadelphia.*

"I was surprised you had sent the portrait without taking another turn at it"; thinks it could have been improved.

1 p., typescript, Goodrich II/223.

206. *J. Carroll Beckwith to TE, 9 Sep 1907, Onteora Club, Tannersville, New York.*

sending his portrait to exhibition at the Carnegie.

12 pp.

207. *Charles H. Fromuth to TE, 18 Jan 1910, Concarneau, [France]*

returning home to America after 20 years for an exhibition.

postcard.

208. *John A. Brashear to TE, 9 May 1912, 1946 Perrysville Ave., Pittsburgh.*

second page of a letter about possibly sitting for a portrait.

1 p. incomplete, typescript [related to TE to Brashear, n.d., 1912].

209. *Frederick W. Coburn to TE, 26 Jan 1914, Boston.*

asks TE to submit a work to an exhibition of portraits by living painters to be held by the Copley Society of Boston.

1 p., typescript.

210. *William Sartain to TE, 28 Apr 1914, 130 W. 57th St., New York City.*

leaving for Paris; looking forward to being there as Paris is such a comfortable city.

2 pp.

*211. James Tyson to TE, 28 May 1914, 1506 Spruce St.,
[Philadelphia].*

thanks for photos of Gross and Agnew Clinics; will use them on his
consulting-room walls.

2 pp.

212. Library of Congress to TE, 4 Jun 1915, Washington, D.C.

requests donation of photographs of his artwork to Library.

1 p., typescript.

213. Library of Congress to TE, 21 Oct 1915, Washington, D.C.

acknowledges gift of photographs of 4 paintings.

1 p., printed form letter.

VI. Other Eakins Manuscripts, n.d., 1864–1912

1. Notes on art, 21 sheets
 3 sheets on human anatomy in French
 notes on animal locomotion, 2 pp.
 pencil notes and drafts, with sketches, on perspective drawing, 14
 sheets
 sheet headed "talks to Class, 1887, The Art Students League,"
 notes in SME's hand, 1 p.
 "Remarks made by TE on the Law of Relief," 3 pp., SME's hand
 draft on the horizon line in paintings, 1 p.
2. Notebook "Talks to Class," 8 pages
 dimensions: 7 5/8 × 5 1/8"; a small printed notebook with the
 first 32 pages torn out, pp. 33 to 43 contain notes in SME's
 hand headed "Thomas Eakins Talks to Class"; inscribed on flyleaf
 in CB's hand: "This book in the present condition was found
 on the floor on the 3rd floor of Eakins home . . . many of the pages
 were torn out no doubt by her sister Elizabeth Kenton. I found
 many others that had been destroyed."

3. Notes for specific paintings, 10 items

fragment of a draft concerning one or more episcopal portraits

Latin inscription from the Martinelli portrait on letterhead of the Augustinian College of St. Thomas of Villanova

inscription as above on plain paper

English text of the Charles Lester Leonard portrait inscription in TE's hand

Latin inscription from the Leonard portrait, typed on plain paper, with a note on difficulty of translating the term "X-rays"; cf. letter from H. J. Heuser to TE, n.d. [1897]

1-p. typescript headed "William Rush—Copy of Original Writing by Thomas Eakins"

2-p. holograph copy of the above Rush text

4. Financial/property notes

small notebook with 13 pp. of notes on mortgages, stocks, personal expenses in TE's hand

inventory of possessions dated July 1, 1911 in TE's hand, 1 page

receipt dated July 30, 1912 for $50 paid by Frank B. Williams for the Cohansey Fish House, signed "Thomas Eakins (Owner)"

5. Notebook ("Spanish Notebook"), 1868–80

"Spanish notebook" with expenses for 1868–69, comments on trip to Spain; notes on models ca. 1877–80. [Referenced in Goodrich I/59 and notes to that page; see fig. 13.]

6. Notebook (Exhibition Record), 1874–1916

pocket notebook containing exhibition record for 1874–1916. [Goodrich I/ix, 313 recalls two such notebooks. He references them as Record book 1 and 2; the other is in the PMA.]

7. TE's wallet [?], and its contents, 12 items

note in CB's hand, "This card case was made by me and presented to TE who used it during his lifetime. Recovered by me after his death and Mrs. E"

3 letters: TE to James P. Scott, June 18, 1883; TE to SME, June 21, 1883; SME to Gilbert Parker, June 24, 1918; [all transferred to manuscript collection]

3 photographs: albumen print of TE, cyanotype of SME, cyanotype of girl wading in a stream [all transferred to photograph collection]

pen-and-ink map of the Delaware Valley showing the Schuylkill and Brandywine Rivers

July 1. 1911

I, Thomas Eakins have a fine microscope made for me especially by Joseph Zentmayer as evidence of his mechanical skill. also a good telescope; Charley Boyer's gun made by Jim Evans. I have two good lathes and a forge. I have paintings. notably of Henry A. Rowland of the Johns Hopkins University of Baltimore. and of Prof. George Barker of the University of Pennsylvania I have two portraits of Admiral Melville. I have a large picture of boxing (Charley McKeever) lent to the Schuylkill Navy Athletic Club. I have in the Brooklyn Museum of Art & Science a large portrait of Frank Hamilton Cushing lent to the Museum by Prof. Culin. I have a portrait of Prof. Culin himself at my house. I have a large composition portrait of Mrs William Frishmuth the Collector. I have two pictures of boxing bouts with Billy Smith as principal. I have a painting of William Rush carving his allegorical figure of the Schuylkill. I have a Crucifixion lent to the College of St. Charles Borromeo at Overbrook. I have a good camera and lenses. I have many studies

38. Thomas Eakins, Inventory of Possessions, 1911.

sheet of verse in SME's hand, n.d.

2 TE calling cards

invitation to a lecture at the Alliance Française, n.d.

8. Notes compiled by CB from lectures by TE on
 Perspective, Drawing, Reflections, Law of Relief, Isometric, Shadows, and Mechanical Drawing, 97 pp.

VII. *Printed Matter*

1. Printed Matter saved by or relative to TE, n.d. 1864–1916

 Fifteenth Ward Bounty Fund Certificate, 1864, acknowledging Tom C. Eakins' payment of $24 towards the drive to free the ward from the Draft

 printed campaign ribbon, "General Grant/President," n.d.

 ticket in Spanish to an event, n.d.

 16 canceled checks, 1905–1909

 5 calling cards

 10 painting labels

 3 placards denoting medal winners from exhibitions

 Diploma accompanying award of Silver Medal from the Massachusetts Charitable Mechanics Association, 13th Exhibition, 1878

 Certificate of Honorable Mention, Exposition Universelle, Paris, 1900

 Certificate accompanying award of Gold Medal to TE, Pan-American Exposition, Buffalo, 1901

 Commemorative Diploma for the Louisiana Purchase Exposition, 1904

 Certificate announcing appointment of TE to the Advisory Committee on Art, Louisiana Purchase Exposition, 1904

 letter and Certificate accompanying award of Gold Medal to TE, Louisiana Purchase Exposition, 1904

 Award Certificate for Medal of the Second Class, Annual Exhibition, Carnegie Institute, 1907.

 newspaper clippings, 1879–99

 pamphlet: biographical sketch of Ellwood McCloskey, a boxer (He is the figure in green in *Between Rounds* (PMA), mentioned in Goodrich II/145, 149).

printed invitation card to the American Pavilion of the Roman Exposition, 1911

thermofax copy of TE's will

Circular of the Committee on Instruction, PAFA, 1879–80

receipt from PAFA to TE for sale of *Music* from the 1916 Annual Exhibition for $1500

program from presentation ceremonies for the portrait of Professor George Fetter at the Girls' Normal School, Philadelphia, 1890

2. Art Students' League printed matter, 6 items

 3 cards announcing the ASL seasons, 1887–88, 1889–90, 1891–92

 broadsides for Third Annual Riot, 1889; Sixth Annual Riot, 1891

 holograph student address list, 4 pp.

3. Photographs

 photograph of Professor Rowland with his ruling engine

 photograph by Wm. H. Rau of J. S. Sargent's *Portrait of Mrs. White* inscribed by Sargent: "to Thomas Eakins/from his admirer/John S. Sargent"

4. 20 theatrical playbills

 three are dated: 1890, 1906, 1907; one for Sarah Bernhardt in "Cleopatra" is annotated "the play was over at 1/4 after 12"

Selected Manuscripts of Thomas Eakins

[TE to BE]

Paris, Saturday, October 13th.66

Dear Father,

 In accordance with a determination of not sending you a letter until I saw a good prospect of getting to work, I have delayed writing to you until now. I will be admitted next week into the imperial school, having passed ten days of great anxiety and suspense; and although it may seem at first sight wrong to fill a letter to home with an account of trouble, yet as sorrows entirely past often leave no bitterness but generally enhance a present joy, I will not hesitate to tell you all that I have done and all that has happened to me since I have been here. The first day I came here I could do nothing; I was so tired and sleepy. The second, I went to see Crépon. He received me very kindly on account of the photographs I brought him, and the letter of Mr. Sartain whose kindness to him on more than one occasion he assures me will never be forgotten. As soon as he could find the time he went with me and found a room for me. I inquired of him the best way to get into the School of Fine Arts. He could not tell me. He had not drawn there for some years himself, and since then there had been changes. The only influential man he knew, formerly a director of the school, and intimate friend of his, through whose influence he had obtained admission for several, was in Rome, gone there to live. I told him then that Mr. Sartain had given me a kind letter of introduction to Mr. May. He thought Mr. May might possibly do something for me, but if he couldn't then I must enter a pay school. The price is not great for models are cheap, but other advantages are not much. He knew of

one such and nearly all the Americans go there. Formerly these schools were numerous and had the best of Professors at their head, but they have now with the exception of two or three been merged into the large imperial school. He gave me no hopes and told me that he would introduce me to this American school whenever I wanted to, and gave me liberty to come and see him whenever I should be in trouble or in need of his advice. I was considerably frightened and hurried to May's.

The doorkeeper told me that May had been sick for a long time, that he did not paint but came to his studio once in a while to look around. I think he had had a surgical operation performed. The man advised me to come in two or three days. I came in two but was not lucky enough to find him. He could not tell me where he lived for he did not know himself although May had painted there for years. On consideration I decided to write to May asking for an interview, thinking that if he was well enough to come to the studio at all he could see me for a few minutes. So I wrote "Dear Sir, I am very sorry to hear that you are not well, and knowing this I am again pained with the thought of troubling you but I stand so in need of a little advice that I cannot refrain from asking of you a short interview which I yet hope you will refuse me if you do not feel able to easily support it," and enclosing this in Mr. Sartain's letter of introduction, I left them both with the door-keeper. Just as I was about to leave a grand barouche drove up and Mr. May himself descended. The man called me back to tell me that that was Mr. May, and so taking up my letter again I introduced myself and being invited followed Mr. May up to his studio. He is a different looking man from what I imagined. I thought him young. He is old; and is tall and gray, and stiff and proud. He read the letter and then inquired coldly after Mr. Sartain's health and deigned to ask if Mr. Sartain painted a great deal and also if the daughter who traveled with him was married. He afterwards asked me how much money I calculated to spend. After he had done all his questioning I commenced. What chance is there of getting into the Academy. He then cried out to the young artist in the next room "I say! Saintin! there are no vacant places in the Academy! Are there?" No, says Saintin. Now says May you had better go into the private studio of Mr. So & So. He is a friend of Saintin's and Saintin will give you a letter to him. I next asked if he knew our minister, telling him I had a letter to him and also at what time I had better see him. He said he did know him and then gave me gratuitously to understand that he dined very very frequently with that illustrious man and was on the whole very intimate with him, and also that Bigelow was in the country and there was no knowing when he would come back. He was kind enough however to give me the address of the minister. He told me to come again in a week and he would get Saintin to write me a letter to this friend who kept a pay school and finally fixed the time at 4 o'clock on next Saturday,

that is today. I thanked him for his kind attention and took my leave. I dont like May at all. He may mean to be kind but you dont feel at ease in his presence. I fear he follows Couture his master in other things besides painting.

You may imagine that I was very low spirited and as I went home I stopped to see Doctor Hornor. Not at home. Come again. I did not feel sorry for it, I was almost afraid to see him, afraid to give up another letter, for the letters seemed to be friends to me. On my way home I thought I would execute a little commission for Mr. Sartain. There was an Art Report published in 1855. Mr. Sartain wrote the Report from America, and had lost his manuscript and wanted a copy of the Report. So he asked me as I was coming away to go to a Mr. Lenoir and see if he could not give me one, and wrote his direction on a little slip of paper. I got this out to see it, and it was this "A. Lenoir, secrétaire à l'École impériale et speciale des Beaux Arts", and then it popped into my head to speak to this man about the school. When I found the place I found it was the school itself. When I asked to see Mr. Lenoir I was passed through a whole suit of rooms, bureaus, entries and stairways by at least a half a dozen (one at a time) men dressed with uniforms and soldier caps and was finally ushered into the presence of Mr. Lenoir. He is a big, good-natured kind-looking man not a bit prettier though than Lincoln. He told me to come sit down and tell him what I wanted. So I told him all about the report, how Mr. Sartain had lost his manuscript and wanted a copy and so forth. He said he could not tell exactly where to find it, but would look for it now if I was going to leave the city soon, but if not and had the time to call again in a couple of days he would be more likely to get it. I told him that it would be better then for me to call again in the two days for Mr. Sartain had assured me that although he wanted the report very much he was in no hurry for it. ———Mr. Lenoir may I speak to you about myself for ten minutes. O yes! certainly, why not, and he spoke so kindly that I at once commenced. I want to be an artist. I have left America to come to Paris to study in your school. I am a stranger here. Is there a possibility of my getting in ? What must I do? What is it you want to study? Painting Sir. O well I guess we can find a place for you. Go and see your minister and ask him to write you a letter requesting your admission and then you can get to work as soon as you please.

Instead of ten minutes I dont think I took two, and I went away with a light heart. I knew the minister had not got back yet, so I went into the Louvre and staid till 3 o'clock when I was to go and see Dr. Hornor. I found him in and he is another good-hearted man. He did all he knew how to make me feel at home chatted about Philadelphia and Paris, my room,, his paintings, everything, but I must keep all this for other letters. He finally told me he was not personally acquainted with Bigelow, that he had neglected to go see him as consul and did not like to afterwards for fear Bigelow would

say to himself Here Hornor, you didn't come to see me when I was consul, and I wish you'd stay away now that I am minister. He said he thought Bigelow might be difficult to approach and offered voluntarily (for I had not even thought of asking) to put me in such a way that Bigelow would be sure to do all he could. He said he knew a physician an intimate friend of Bigelow's and in fact everybody that Bigelow knew and told me to come early next morning say at ten o'clock, before business time and perhaps he could also think of something else in the meantime. You may be sure I went. I thought I saw when I entered a look of disappointment on the doctor's face, but it passed immediately away and if you had seen us you would have thought we had known each other for years. As he said nothing about the minister neither did I, but just as I was leaving he followed me out and said, you had better go to Bigelow with your letter from Professor Rogers, and if he is not gentleman enough to do what you ask, but I am sure he is a gentleman, why wait till General Dix comes and he will do it for you.

I am sorry to have given Doctor Hornor any trouble, for I am sure he took upon himself considerable on my account and it proved of no avail.

I went then to the Minister's He was in the country. The servant said he would not be back until Saturday or Monday. (A lie.) I could see Colonel Hayes however.

Next day I must go and see about the Report. Mr. Lenoir had not yet been able to find it. He asked me if I had got my letter yet from the Minister. I told him no, that the Minister had not returned. Well said he, you cant depend much on Ministers, there is no knowing when they come and go. Go to his Secretary. He will give you one and that will be just as good and save time. Had you seen me going to the American legation you would have said I walked for a wager. I asked to see Colonel Hayes and after sending in my card and letter I was ushered into his august presence. Ah! Mr. Eakins I am happy to see you. So you have come to Paris to study? How do you like Paris? I answered all his questions and then told him what I was after. Oh Mr. Eakins I would be <u>delighted</u> (school-girl emphasis) to accord your request but there are no vacancies there, and if there were there are several applicants; some have been here more than a year and not admitted. I told him then that Mr. Lenoir had told me to come, and had promised to admit me. He said I must be mistaken for he had a letter from the Emperor's household which assured him there were no vacancies. Would he give me a copy of that letter or let me copy it to show Mr. Lenoir? No, but he would give me the substance of it. With this, he scribbled on the back of old envelope the following which is not good English nor good French nor a grammatical mixture of the two for there is no verb in his sentence. "A letter from the Ministry of the Emperor's Household and of Fine Arts dated Aug. 27th, declining to grant admission to the American students proposed by the U.S. Legation on the ground that all applications had been "ajournees jusqu'a

nouvel ordre" on account of the largely increased number of admissions."
Such an incomplete sentence might be a fine piece of disrespect coming from
some sources, but I am sure he was not capable of that. Why not I asked
write me the request and then let Mr. Lenoir refuse me. He did not feel at
liberty. The servant who heard the last of our discourse did not take the
trouble to show me out, but I found my way without him, thanks to the
kindness of a French cook into whose kitchen I wandered. I was again in
the depths of despair. What should I do? Had that young dandy lied to me?
Why didn't he let me see the letter? Should I appeal to May to write me a
letter to the Minister himself or take me to see him as he was such an intimate
friend. No, I was afraid of May. He may have private interests I thought, or
he may wish to advance someone else. Again, may it not be that there is
some truth about the letter of the French Minister. Roberts (a rich dis-
agreeable young man from Philadelphia, one who has without any apparent
reason seen fit to be my enemy) is now in Paris. I am sure he must be Colonel
Jackanape's dear friend, and if there is truth in the letter I may have brought
the first news of a vacancy, and the Colonel has refused to give me the request
to save time. He will go see Roberts & Co., and then put in requests for
them. I will go see Mr. Lenoir again the first thing in the morning.

As I went home, so nervous had I become that I even had fears of Mr.
Lenoir and Heaven forgive me those unjust sentiments. It is the vulgar talk
that French politeness is a sham. Is it possible I asked myself that Mr. Lenoir
has sent me to the Minister knowing that I will get a refusal, and will tell
me tomorrow that he is very sorry but he has done all he can? But mind I
did not believe it, I only feared it.

As I was now in great fear of losing time I wrote the following to Mr.
Lenoir which I would leave for him if he was not in. Mr. Lenoir, if I have
rightly understood you, you have promised to admit me into the Academy
of Fine Arts when I shall have obtained a request from my minister or his
secretary. I went yesterday immediately to Mr. Bigelow's. I found there a
young man who received me very politely and who said, "I would be delighted
to grant you your request, but they assure me that there is not place in the
school." I represented to him that Mr. Lenoir himself had told me otherwise.
He did not appear to believe that I was telling the truth.

Will you have the goodness to write for me what you have said to me,
that is, that there is room for me in your school, and sign your name.

Perhaps it has been necessary to exercise circumspection in the choice
of applicants. Perhaps there have been among them rich young men who
have entered your schools only to amuse themselves and pass the time. I am
not one of them. To study in the French School I have quitted and for the
first time my parents, my friends, and my country, and I have come alone
to Paris where I am a stranger.

I was assured there was no difficulty in entering the schools of France

that they were open to the world, and if I cannot enter how now can I write to my father, or the friends who told me to come here.

But if you will trouble yourself to write me the little note, the young man cannot I think then refuse me longer, and I will then commence my studies. I am sorry to give you the trouble but you will easily pardon it in considering that a word from you may perhaps determine the success of my life. Thomas Eakins.

Early next morning I went to the Academy again, and was shown into Mr. Lenoir's. Mr. Lenoir was not there, but there were two big Frenchmen there writing. One took my note from me and to my surprise opened it and read it through from beginning to end. They agreed that it was very good writing (I had done my best.) When he had finished reading it he looked at me a while and then said: What do you want to learn sculpture or painting? Painting. I guess I looked anxious for he said: Dont unquiet yourself (English have no inquietude) you shall obtain all this which you desire. Come here tomorrow at noon. I went and Mr. Lenoir being again out I saw the same gentleman who handed me a note from Mr. Lenoir addressed to Mr. Thomas Eakins, in which he tells me that he just written to the imperial superintendent that there is room in the school & says. You will therefore claim a letter from your embassy to sollicit the permission to study in the school, which he will accord to you on the presentation of this letter. As soon then as the Superintendent will write to us, I will cause your name to be inscribed on the list of the scholars of the studio you may choose. Meantime, you must see your professor who will give you a letter, and then you can commence your work, and to this interesting epistle he signed his name and title.

With this letter in my possession, I again went to the Legation. They asked for my card and sent back word that Mr. Bigelow was busy but to sit down and Colonel Hayes would come and see me. After an hour or so he came in but I didn't feel at all impatient. Good morning Colonel. Good morning Sir, is there anything new? Yes sir, I have the new order of which you spoke. It is in a private letter addressed to me. I will show it to you. I did so and he read it. There was no mistaking it or its meaning. Well said he changing his manner entirely, this is a most unaccountable thing. I have some friends who have been trying to get in for a long time. How did you come to get such a letter from Lenoir, Oh said I carelessly, it was only by chance. A friend of Mr. Lenoir's is also my friend. I didn't tell him how slim that chance had been. Hayes then explained to the clerks that I had had a private letter to Mr. Lenoir. I did not correct him. The mistake was only one of number. Mr. Sartain had made use of several letters in spelling the name and title. Hayes went back to Bigelow's room and came back after a while and said to me Mr. Eakins we feel we would be doing injustice to the other young gentlemen not to include their names. We never make a separate application for the candidates. We apply for all at once and they take in as

many of them as they have room for. We must however of course put your name first. I assured him that I would be *delighted* to render this assistance to my young American friends and I was sorry they had to wait so long. He asked me if I would like to see Mr. Bigelow, and telling him yes, I was conducted by him to Mr. Bigelow's Room. This gentleman impressed me very favorably. He talked with me a good while and gave me some excellent advice which I shall not forget. As he is a man of education none of it was of the soft kind. Hayes put in his penny whistle and said that the Americans students would look on me as their guardian angel, and a dozen other pretty compliments and so susceptible am I to flattery, that I forgive the puppy, but there was a time when I would have given a franc for a good kick at him. Sure enough Roberts is his friend. I thought so. Mr. Bigelow invites me to come and see him and his wife before they leave. As I went away Mr. Bigelow hoped I would make as good an artist as diplomat. The servant conducted me all the way, and as I passed him he made me a profound bow, for which I am extremely grateful. I bore with me a missive on gilt edge paper enclosed within an envelope about the size of a small window frame, the whole highly ornamented with seals & cunning devices. The following are the names. Thomas Eakins, Conrad Diehl, Earl Shinn, Howard Roberts, Frederick A. Bridgman. Next morning I saw Mr. Lenoir and thanked as well as I could his extraordinary kindness. He stopped me and taking one hand in both of his and told me to go and see my professor on Monday and be a good child (infant), and as long as I behave myself I feel sure that I will have a friend in Mr. Lenoir. In accordance with the appointment Mr. May had made with me, I have just gone to see him. Neither he nor his friend Saintin was there nor was any word left. I will not trouble them any further. I have now delivered all my letters except Mr. Gardel's one to Mr. Benneke. I dont think he is in Paris, at least I cannot find him. But Mr. Gardel has given me a still better introduction than Mr. Benneke's could have been, for he has introduced me to Mr. Lenoir and the whole French people. I have yet to encounter my first real difficulty in making myself understood. If you see Mr. Sartain thank him for his letters and that little slip of paper. I hope Mr. Lenoir will have soon found the report and then I will write to him myself. If you see Rogers thank him too. I gave his letter to Bigelow. And if you see Dr. Dunglison tell him I have found through his means a friend. I see I have space. I will write more about Horner. He is very fond of poetry, of his own, and very proud of it; but as a man is known by his work I will give you what he gave me of it. Lines on the 4th of July at Pre Catalan Paris 1866. We hail our nation's Natal Day. The Glorious Fourth, When Freedom's flag by patriot hands unfurld Enwrapped within her folds near half the earth, And form the State which since has awed the world. Content and Peace on all our borders smiled Earth sent her offerings to our thriving shore. Prosperity each ~~each~~ cheerful hearth beguiled & God did bless our basket & our store. But discord

reared its hydra headed form and brothers raised the swords their fathers gave. Against each other in a evil storm And dyed with crimson e'en a parent's grave. Four weary years our mothers sacrificed Their second aye their only *born* To shield our boon by fire and blood baptized Lest from that sacred scroll a leaf be torn. The waves of passion now have sunk to rest The anvil rings responsive to the flail The bow of promise gilds our glowing West, and commerce smiles as fills the swelling sail. Peace weaves again her garlands in our land! Heart beats to heart as we now gather here To pledge the memory of a martyr land, And sanctify the tribute with a tear.

The other piece he gave me is about the Atlantic Cable, & begins See yon ship majestic looming, Like some monster of the seas; How she cleaves the swelling billow, as her canvas clasps the breeze.

Be careful in acknowledging the receipt of what I have here written not to use the word trash as I want to show the letter to Doctor Horner. He was surprised that Dr. Dunglison had given me a letter. He says it is not often that Dunglison puts his name to such documents and judged right away that I must be a favorite of the Doctor's He is very anxious to know if Doctor Dunglison had received a letter from him by the hands of young Maury, and asked me to write to Dunglison. I told him I would write to my father and get him to ask Dr. Dunglison and that would save trouble. He sent Dr. Dunglison some of his poetry. Dr. Dunglison thanked him for it in a letter and then Doctor Hornor wrote a letter of thanks for the thanks of Doctor Dunglison. He dispatched it by young Doctor Maury, and it is this last letter he is so anxious about.

Doctor Hornor's wife is not well but as soon as she is recovered I am to come see them at home. The doctor is a great lover of pictures, and particularly of the low price at which he buys them; he is so sharp & such a good judge. Deception is wrong but the least is always the best of two evils and I think I would commit a sin not to affect to admire his Virgin Marys and other works of those great masters whose productions fill the dirty little shops of Paris especially when no harm can possibly come from the affectation.

Doctor Hornor is Mr. Pickwick in every sense. He even looks like him. Caddy would know him in a minute. You may judge how I value his friendship. His little failings increase as they always do towards the old, ones affection. I will go and see him and tell him I have dispatched my letter. I sometimes find now little scraps of news from America but they are only commentaries and put me in mind of the French lady who was surprised that Mr. Gardel could be an American & white at the same time. Tell me about the Union League fire. Have the accused been tried yet? Has the fire been proved the work of the Copperheads? What's Johnson doing? A paper here says that he is on good terms with the majority in Congress. But that is ridiculous. Write to me about all my friends. Tell Mr. Lewis I am sorry I

cant put in my vote. but I have a consolation; for, where my vote just lost to the Republican Party, the Copperheads have lost twenty, and I think that proportion was maintained throughout the whole steamship. I forgot to tell you in my first letter that those ill-mannered blackguards of whom I wrote were all Copperheads. However you have doubtless guessed it. I find I have yet room. I'll give you more of the poetry From her deck there comes a whisper Speaking plain as tongue can tell. Ship at ease with cable running and the work progresses well. Throbs electric still are beating Makes a thousand run or more Till it marks in fiery numbers We have reached the Western Shore! With the nervous pulse of commerce Quickning Wealth's arterial span. Science sends to hope her greeting Peace on earth Good will to Men. S.S. Hornor. Do you see Billy Crowell? How are his eyes? Can he use them? Do you have torch-light processions. Have you yet been with Charley after rail? How many did you shoot? Did you tumble overboard? Did you see old man Williams. Did he give you a concise history of the building of that wonderful house.

<div style="text-align:center">T.C.E.</div>

[TE to BE]

<div style="text-align:right">Paris, Friday night, Oct. 26, 1866</div>

My dear Father,

There is many a slip ~~between~~ twixt etc. You have received a week ago I suppose my letter of this afternoon telling you I am in, at last. You remember my letter about troubles entirely past. They were ~~only~~ ~~half~~ past but there were as many more yet to come, ~~and if~~

When I got Bigelow's letter to the Minister of the House of the Emperor I took it to the school and gave it to Lenoir who sent it to its destination. I talked with him a little while about my studies and we chose Gérome for my professor and as I had already lost much of my time & was anxious about the future Mr. Lenoir guessed there would be no harm in doing things a little backwards and to save time he permitted me to go see Gérome before I got my authorization from his Majesty's House. Gérome's studio the finest I ever saw is surely near one end of Paris. He was painting from a model. I told him my business. He must see my permit. I told him why I had come before getting it and showed him Lenoir's letter. He hesitated a moment, then put down his paints and wrote me

<div style="text-align:right">Paris the 15th Oct. 1866</div>
<div style="text-align:right">Mr. the Director,</div>

I have the honor to introduce to you Mr. Thomas Eakins who presents himself to work in my studio. I pray you will receive him as one of my scholars. Accept the expression of my most particular sentiments.

<div style="text-align:center">J. L. Gerome</div>

I hurried to the school. Too late. I must go the next day. I went and showed my passport. Call at 3 o'clock said they. I called and a man after asking my name said they had yet received no authorization from the House of the Emperor. He gave me back everything and told me to come in two or three days. I went and another man learned that the minister was not in Paris. Shall I come tomorrow? No. Next day? No. Come monday. I went and saw the big man who had read my letter to Lenoir and had told me to be easy. Any news? Not for you my friend. But an American has been admitted. His name is Moore. Then your Minister is returned. O Yes, some time. Can I speak to Mr. Lenoir. No you had better not, he has done all he can for you. I assure you he can now do no more than I can. What must I do then I asked, you see I am a stranger, to whom must I go? Could I see your minister? Dear me, no. I will tell you all that you can do, go to your minister and get him to push you. That would not be polite. It is not right to ask twice for a favor and he wont do it. Then there is nothing said he, and as the French nothing is shorter than the English word he repeated it three times. He told me he was very sorry and I'm sure he meant it. He could see no reason why I had not been admitted, and the thing was unexpected. There was a chance that the minister had not seen the document from Bigelow yet, but then again this American had been admitted and state papers are always examined in the order of the dates. So I came away. Once more I went. No news whatever. I tried to think why I had been refused and I concluded. Lenoir wrote the letter to me assuring me there was room in the school and the one to the Minister of the H. of the E. telling him the same thing. He wrote them at the same time. ("in this moment.") I ran to Bigelow's as Lenoir had told me and gave him the first intimation of a willingness to receive a foreigner long before he could possibly get it from the regular source this H. of the E. His precipancy and indelicacy of putting in five names has disgusted the Frenchmen, and they have not noticed the petition, but have hastened to respond to the more modest one for a single American, and I assisted by the kindness of Lenoir have opened for others a way which I cannot hope to enter myself. Besides I have placed everyone in a wrong light; Lenoir, for he has made me a promise which it hurts him not to be able to keep; my Minister, myself.

You may imagine how bad I felt and not the less when I thought of having to contradict my letter to you which said I will be admitted next week. (I must yet contradict the week.)

I could not lose time. Crépon appointed an evening to introduce me to a pay school where the students are all old men who having spent 40, 50, or 60 years copying the old masters have commenced the study of nature.

Saturday morning 27th.
and as there is no professor in the school and no one who can draw tolerably Crépon offered to criticize for me all my studies. Tell that to Mr. Sartain.

Crépon, said I, I am going to the Emperor's Palace and try to see his Minister. You cant see him says Crépon! You cant get near these big men; but try and you will rest easier perhaps knowing that you have left nothing untried. We thought over how I should try, and I concluded to write the man's name on a little slip of paper, I had acquired such faith in these little things. Crépon suggested a tremendous envelope. I accepted with rapture the amendment, hurried home endorsed one as follows "Mr. the Count of Nieuwerkerke, Superintendent of the House of the Emperor & of the Fine Arts" and went to the palace of the Tuileries.

What rows of soldiers & servants! Each one must know my business. I must see this Musheer I would say slowly and then I would point to my envelope and I resisted all efforts to take this from me. Such was my ignorance of the French language that I found it impossible to explain myself further nor could I understand those who doubted if I should be allowed to go on, but I easily comprehended however those who showed me still on. At last I rang a bell and then found myself in the reception room of the count. An old gentleman with a big chain around his neck came to me and I had then to tell my business sure enough, and gave him a glimpse of the letters of Prof. Gérome & Mr. Lenoir. He would take in my big envelope for me. Good Lord, thought I to myself what shall I do? A happy idea came. I put my modest little card in this tremendous envelope. I never saw a card look so little in my life, and although I was in such agony, I laughed to myself it was so ridiculous and I thought of the story of the little black monkey in the temple (Spectator Art. Hoops) and of the mountains in labor. In ten minutes or so the man returned. The count had found my card, and sent me word that he had not the pleasure of my acquaintance and could not therefore see me, but if I would write down what I wanted he would read it. I hurried home and wrote. Mr. etc. etc. I would not have dared address you this ~~petitio~~ supplication, but I feel so much of my success depends on your kindness that I cannot resist. In leaving my home I have made great sacrifices to come here expecting to be able to enter the Imperial School. My minister could not at first give me the request for he didn't know there were any vacancies in the studios. Then Mr. Lenoir gave me the enclosed letter & assured me I would be admitted. My Minister seeing this could no longer hesitate and he put in the request October 12. Mr. Gérome has accepted me as his pupil.

Would it be too much, to ask of you ~~to sign my application~~ , your signature without which I cannot commence my studies, Your obedient etc.

I felt that this letter would at least set everything in its proper light, and enclosing in it my letters from Lenoir & Gérome, I went again to the Palace. The count had left. The old man would give my letter to the count next morning. I must leave it there. Fortunately I had not sealed the envelope. I drew out my letters. Look said I to the old man, this envelope contains two letters of the utmost importance and I showed him the signatures of

Gerome & of Albert Lenoir Secretary of the School Imperial & Special of the Fine Arts, and he also saw the paper on which they were written stamped with the words School Imperial etc. Then I sealed them and gave them to him. He told me to come next day at 2 o'clock, and gave some orders about my being admitted & also took down my name & address. I had to print my name for him. He could not make out my English letters. Next day two o'clock found me again in the count's reception room. It was crowded. I waited till after three. The old man told me the count had been so busy all day he had not had the time to open my envelope. Could you come tomorrow at 3 o'clock? Yes, Sir. Next day I put Dante in my pocket & went to the Palace at 1 o'clock and determined to wait that day until I got some kind of a definite answer. The old man came to me and said "The count has read your letters and sent them to the Chief of the Bureau Mr. Tournoi, and he says your affair is now entirely with him. Where is he? You can find out by going first to Mr. Bassenet. Wont you be so good as to write these names down on a little slip of paper. (I have been fortunate & there's no knowing what I'll come to but if ever I'm a king I vow I'll right away create the "Order of the Little Slip of Paper" nor do I see why it will create less respect than that of a garter or a bath.) He did so & I found the first man who wrote the address of the second. Tournoi was harder to approach. When I got to his reception room they asked me what I was come for. Mr. the Count the Superintendent etc, has sent me here to see Mr. Tournoi. What for? To get an answer to some letters he sent here. The fellow considered. Have you seen the Count himself. He had to repeat several times and slowly. It will be an eternal ~~disgrace~~ shame to me that I couldn't understand such a simple question. I count only answer Mr t h e C o u n t t h e S u p e r i n t e n d e n t t h e etc. If Mr. Gardel had heard me it would have driven him almost crazy. Then he told me Tournoi couldn't be seen except tuesday & saturday at 2 o'clock, but with no better success. I only smiled and if there was a question asked & in such a tone as to leave no doubt as to its being a question that I commenced Mr t h e C o u n t t h e S u p etc. He despaired at last & asked me to write down my name. When I comprehended by words & signs what was necessary I hastened to comply. It was taken in. I was immediately sent for & ushered into the presence of Tournoi. Good day Mr. Eakins, I guess well what you are come for. I received your letters yesterday (It must have been soon after I left the count's.) I wrote to your minister and have just sent over to the school. You now have only to choose your professor but no I remember you have done that already. You may go to the school & get your card of admission. Please give me back Mr. Lenoir's letter; I prize it very much. I suppose so, I have sent it along with the other papers. I thanked him & left. I received afterwards another proof of his kindness. He next day answered my letter in writing and I'll send it to you. When I got to the school everyone was ~~pleased~~ glad & my big Frenchman

made out my ticket before my eyes that I might have the pleasure of looking at it. The director would sign it next day. I got it at 12 o'clock & was introduced to my fellow students.

I have done a month's hard work. It may be some of it was unnecessary, and I could have got what I wanted by patience, but I dont believe it. One man was here nearly a year trying to get in & then went back to America. Roberts has been here a long time & he is very rich and his father sent him to enter this school. Shinn has been trying his best.

Saturday night

On looking back at my month's work, I have certainly to regret that to get what I wanted I had sometimes to descend to petty deceptions but the end has justified the means and I cannot feel ashamed of them for they were practised on a hateful set of little vermin, uneducated except in low cunning, who having all their lives perverted what little minds they had, have not left one manly sentiment.

With men I believe I have always acted honorably and I trust I always will.

This pushing business is disgusting and although I find I can do it in dire necessity, I hope there will never again be occasion. I believe myself to have made three good friends already. Hornor, Crépon, & Albert Lenoir, Secretary of the Imperial School & Special of the Fine Arts, and as I shall make it a point never to ask them to do for me what I can do for myself; but will not hesitate to ask them for what is well worth doing & which I cant do for myself and which they see I cant do for myself I think I can always retain them.

My Paris life is benefitting me in the study of human nature for amongst strangers who do everything in a strange way, character is strongly marked for me, while at home the same amount of character springing from the same motives would make no impression.

How comfortable one feels in the company of the great men. They are kind, respectful, condescending. They listen with attention to any straight forward reasonable demand & grant it immediately when they can. They form a delightful contrast with those who have just authority enough to annoy their betters, Or mathematically

Gerome, Sartain, Dunglison, or Lenoir: Col. Jackanapes:: Charley Boyer's Brace: Paris lap-dog

or as an equation

Gerome, S., D., or L. X Paris lap-dog = C.B.'s X Col. Jackanapes. This will perhaps render clearer my observation. I saw Gérome again this morning & had quite a talk with him.

You have often accused me of being either in the garret or the cellar. Your remark had a fine application in Paris, and never were garrets so lofty or cellars so deep. But no sooner was I up in the garret that I was down

again. My cellar life has done me no harm though. It has set me thinking & planning for myself & has taught me patience. My hair is not yet turned gray, but this I attribute entirely to the moist atmosphere of Paris.

N.B. The above is all metaphysical for they never dig any cellars in Paris.

Dr. Hornor came to see me some time ago & left his card. I returned his visit this afternoon & found him just coming out. He was glad to see me & reproached me for not coming sooner. I told him I hadnt wanted to see him till I could tell him I had got to work. What! Had you any trouble about getting in? Any? thought I, and I answered yes some. Didnt Bigelow do the right thing for you. O yes but there a good many [*sic.*] applicants Then I told him I had written to my father to go see Dunglison. He was perfectly happy & nearly shook my hand off. I know that young Maury & I think I could lick him if he has not thought it worth his while for such a kind old man as Hornor to walk from 10th & Walnut to 11th & Girard.

It has been a long while since we have had news from the U.S., but when we had it was that the republicans had gained victories in 3 states but there were no figures. All yesterday & today I looked for a letter from home but none has come. How's Max of Mexico the First. I guess he'll be the last, for Napoleon's going to withdraw his troops. You get news in France from the editorials. They say, Max telegraphs his empire is flourishing. Let us then withdraw our troops, they are needed at home. These editorials all advise the reorganization of the army and all agree in thinking the army too small & the term of service too short & trust the government will see to it, and they make comparisons with Prussia. They all deplore with unfeigned grief the absorbsion of Saxony and those dear German states for which they have such tender sentiments. Every article in a French paper even a telegram must be signed by the writer, and as all the editors think exactly alike, they show a precision of judgement & harmony of sentiment never yet seen in America. The French Artists are all caricaturing Bismark. Poor man he's sick. I hope these drawings wont make him worse. Max's wife is gone crazy. The pope treated her uncivilly. Have you been gunning I hope you found everything in my drawer. The cleaning rod is in the closet. What luck had you? Has Dan been to see you? Did he tell you any story about a Frenchman? Did you see George Heyser? I liked to have forgotten the sporting news from Paris. I spoke to you of the thousands of fancy fishermen who fish in the Seine from morning till night. Well one has caught a fish. [sketch of fish] Natural size. I thought the man was going to throw it away but he wrapped it up & saved it. Larger fish could not live in the Seine. It is too dirty. They could not see to procure their prey. The animalcule fish find less trouble.

Bailly used to say water was good to wash yourself in. So it is if you are very dirty. Mr. Holmes used to admire it for navigation's sake. It is easy to see he is not from Paris. The steamboats here have neither paddle or screw.

The friction would be too great. They only have the axle of a paddleboat. There is a chain laid Turn back one page along the bed of the river. They lift this up and give it a turn around the axle. The chain pays out behind and drops for the benefit of the next boat. It is unnecessary to say that one turn is sufficient. It is sticky enough to prevent slipping.

This water is supplied to Paris by public hydrants. Men fill water carts from them & then drive about the streets retailing the water. There are wells too in the city but their water has the consistency of that of Charley Boyer's celebrated Mineral Spring, and the taste & smell is much worse. I'm too sleepy to write more.

<div align="center">T.C.E.</div>

[TE to BE]

<div align="right">Paris, Nov. 1st, 1866</div>

Dear Father,

I spoke to you about a fellow named Moore who got into the school. I met him the day before I got in. We remembered seeing each other in our Academy at Philadelphia. I never knew his name before or more likely I had forgotten it. We exchanged cards. He is deaf and dumb. This is the way he got in. His uncle went with him to see Gerome, and explained to Gerome that Harry had come a great ways to study with him, had set his mind on it, was almost frantic &c&. Gerome took such real interest in him that he promised to teach him. If he couldn't get him into his school he'd teach him anyhow, and then he wrote to the Minister & to the Inspector of the School. I beat him in though after all. I got my card Friday. He got his Tuesday. After leaving the studio Friday, it occurred to me that I had better go see Harry to give him some advice about the students.

Instead of finding him in the Latin Quarter he was in the American part of Paris near the Arch of Triumph. I supposed he had a little chamber. On ringing the bell a lady came to the door and spoke English and introduced me into a parlor full of company. The whole family is here. They received me very well. When they heard I had been admitted to the Imperial School they could hardly believe their ears. Harry was very downhearted and was afraid he wouldn't get in after all. I told him I thought he would and offered to go with him to the school. You cant imagine how glad his family were when they heard I would study with Gerome. Next day Harry came for me and we went to the school. They told me he would be admitted now as soon as he got the order from Gerome; so we turned back. He feared he was refused, and it was some time before he could find his paper & pencil. Then I wrote "admitted" as quick as I could, and we went to Gerome's together. We got the paper and I had another talk with Gerome who had not yet commenced his work. Then I took him round & bought all his things for

him. He would have found a great deal of trouble by himself for he knows very little of French. I also explained to all the students his affliction & begged them not to amuse themselves at his expense (and they have respected his infirmity), and then introduced him to them. So that he might commence at the beginning of the pose, the inspector wrote down for him an order, to last until his regular card of admission should be signed. Harry is a friend of the Waughs. Their families are acquainted.

When I got <u>my</u> card of admission the officers told me I could go now into the studio, and they seemed to have a little fun amongst themselves. Asking my way of the employees I was passed along & the last one looking very grave took me in. All the way that I went along I was making up a neat little address to Prof. Gerome explaining to him why I appeared so tardy. Unfortunately for French Literature it was entirely lost as is every trouble you take to imagine what you ever are going to say when such & such a thing arrives.

The man took me into the room & said, I introduce to you a newcomer & then he quickly went out and slammed the door. There was nobody in there but students. They gave a yell which would have lifted an ordinary roof up, and then crowded around me. Oh the pretty child. How gentle. How graceful. O he is calling us Musheers the fool. Is't he tall. Give us 20 francs. Half of them screamed 20 francs & the other half the welcome breakfast. When I could get them to hear me I asked what it was. Several tried to explain but their voices were drowned. They all pushed each other and fought & yelled all at once. Any one of them would have felt disgraced not to be doing two of these things at the same instant. Twenty auctioneers all crying twenty francs could not have said twenty francs oftener. Who must I give my twenty francs to? To me, me me me, etc. Oh you hogs said the rest. Dont trust them they'll steal etc. etc. , and a delightful interchange of courtesies and missiles. Where do you come from? England? My God no, gentlemen I'm an American. (I feel sure that raised me a peg in their estimation!) Oh the American ! What a savage. I wonder if he's a Huron or an Alonquin [*sic*.] Are you rich? No! He lies; he's got a gold mine. They began at last to sit down one by one. I was invited by one to do the same thing. I did so looking to see the stool was not jerked from under me. No sooner was I sat down than one of the students about 30 years old; a big fellow with heavy beard came and sat down with his face within a foot of mine & opposite me. Then he made faces & such grimaces were never equalled.

Zeph Hopper would be nowheres. If he had lived in Addison's time and had looked through the horse collar at the grinning match the first one, the Article in the spectator would have been spoiled for no one would have dared look through it afterwards. Each new contortion of course brought down the house. I looked pleasantly on and neither laughed nor got angry.

I tried to look merely amused. Finally he tired himself out, and then after examining me a little, said he You've got pimples on your face, what makes them? Pardon me I dont know. I'm not a doctor. Oh the droll etc. etc. etc. Then he insisted that I should put my bonnet on to see how I looked in it. Not being a model I resisted and wouldn't until I would be ready to go away. Can you speak German said a student. Some of them really did not know what was the language of the Americans. I saw he was no German so I answered him in German, and as he could not respond there was a laugh raised at his expense. I had determined to keep my temper even if I should have to pitch into them and to stay there and have as much of it through with as possible. When they got not quiet but comparatively quiet I took my leave. I thanked them for their kind attention and giving warning to the big fellow that I was now about to put on my bonnet I thanked him for his politeness and then left. I think the last was a good stroke and the first thing I did next day was to go make friends with the big booby.

I went Friday afternoon to see Crépon. I asked him about the twenty francs. Pay them said he by all means and conform to all their old customs as much as you can. They will let you work then. They had wanted me to bring my twenty francs next day Sat., but as I had to go to Gerome's with Moore I got back too late for breakfast time. I therefore went to them & demanded pardon & explained why I couldn't come. O that's nothing any time at all. Let's say next Saturday. The first day I worked there when we got through a fellow called me & offering me two cents told me to run get him some black soap. What! said I. Black soap. My hands are dirty. Yes but I'm no errand boy. O no! but you are the newcomer. It is the rule. You assure me it is the rule. Yes we all have done it. Then said I I beg your pardon. I took the two cents and went to hunt the soap. A student who knew I was going had posted himself at the door & he went out with me and then showed me where to get it. I have this business to do until a newcomer arrives. It is sometimes a little annoying when you are busy to hear a cry of New I want a penneth of milk to fix my drawing, or the like, but I always do it quickly and with as good a grace as I can & and they never forget to thank one. They are an ill-mannered set when together but easy to make friends with one at a time. I will be sorry if I ever have an enemy amongst them but I'm almost sure I wont. Whenever I meet the officers, with whom from my frequent intercourse I am as well acquainted perhaps as the rest of the students, they ask me how I am getting along with them. I say I find them a little lively, but that I have no trouble, and that they are a good hearted set of fellows, etc. They laugh and I'm sure think ten times more of me than if I should make a complaint. Their students are a pride with them. I can easily see now why Laurie got into trouble. He got into a big fight right away and they made the place so hot for him he had to run away. I have no doubt my assuming the protection of Harry has in a measure

protected me also. There is no one in all the studio who knows English, and I'm glad of it.

An employee told me there was an American in the school & and asked me if I had known him in America. He comes from Peru. I went to see Mr. Lenoir Tuesday for the first time since my admission. I told him it was entirely owing to him I was in, and that I should try to merit his goodness. There was a great deal of hand shaking. I am sorry he has not yet found Mr. Sartain's report. He has soon to rummage some old papers though and thinks it probable that he will come across it.

<div align="center">T.C.E.</div>

[TE to BE]

<div align="right">Friday, March 6, 1868</div>

Dear Father,

I will again be running out of money about April 15th when my rent day comes again. I will try make out my account next week, I have too much to talk about this time. When earnest people argue together it will generally be found upon reflection that they are all arguing on the same side of the main question with some misunderstanding in a trifle, and so I look on the argument between you on the one side and the crowd on the other against you, for I cannot conceive that they should believe that an artist is a creator. I think Herbert Spencer will set them right ~~for~~ on painting. The big artist does not sit down monkey like & copy a coal scuttle or an ugly old woman like some Dutch painters have done nor a dungpile, but he keeps a sharp eye on Nature & steals her tools. He learns what she does with light the big tool & then color then form and appropriates them to his own use. Then he's got a canoe of his own smaller than Nature's but big enough for every purpose except to paint the midday sun which is not beautiful at all. It is plenty strong enough though to make midday sunlight or the setting sun if you know how to handle it. With this canoe he can sail parallel to Nature's sailing. He will soon be sailing only where he wants to selecting nice little coves & shady shores or storms to his own liking, but if ever he thinks he can sail another fashion from Nature or make a better shaped boat he'll capsize or stick in the mud & nobody will buy his pictures or sail with him in his old tub. If a big painter wants to draw a coal scuttle he can do it better than the man that has been doing nothing but coal scuttles all his life. That's sailing up Pig's run among mud & slops and back houses. The big painter sees ~~Nature~~ the marks that Nature's big boat made in the mud & he understands them & profits by them. The lummix that ~~dont~~ never wondered why they were there rows his tub about instead of sailing it & where he chances to see one of Natures marks why he'll slap his tub into the mud to make his mark too but he'll miss most of them not knowing where to look for them. But if

more light comes on to the concern that is the tide comes up the marks are all hidden & the big artist knows that nature would have sailed her boat a different way entirely & he sails his as ~~well~~ near as he can to how nature would have sailed hers according to his experience & memory & sense. The stick in the mud shows some invention he has for still hunting these old marks a plomb line to scrape the shore and he flatters himself with his ability to tell a boat mark from a muskrat hole in the deepest water, and then he thinks he knows nature a great deal better than any one else. I have seen big log books kept ~~with~~ of the distances made in different tacks by great artists without saying a word about tide or wind or anything else the length of a certain bone in the leg of a certain statue compared to the bone of the nose of a certain other one & a connection with some mystic number the whole which would more mystify the artists that made them than anyone else. Then the professors as they are called read Greek poetry for inspiration & talk classic & give out classic subjects & make a fellow draw antique not see how beautiful those simple hearted big men sailed but to observe their mud marks which are easier to see & measure than to understand. I love sunlight & children & beautiful women & men their heads & hands & most everything I see & some day I expect to paint them as I see them and even paint some that I remember or imagine make up from old memories of love & light & warmth &c &c. but if I went to Greece to live there twenty years I could not paint a Greek subject for ~~I would~~ my head would be full of classics the nasty besmeared wooden hard gloomy tragic figures of ~~this~~ the great French school of the last few centuries & Ingres & the Greek letters I learned at the High School with old Haverstick & my mud marks of the antique statues.

~~I conceive I would do an immense service to~~ Heavens what will a fellow ever do that runs his boat a mean old tub in the marks not of nature but of another man that run after nature centuries ago and who the fools & historians & critics will have run his boat in the marks of an Egyptian boat that was after a Chinese + (a + b + &c) x ... Nature at last or maybe God like intelligence or atmospheric effect or sentiment of color lush or juice or juicy effect etc (see newspapers or Atlantic monthly magazine) No the big artists were the most timid of themselves & had the greatest confidence in Nature & when they made an unnatural thing they made it as Nature would made it had she made it & thus they are really closer to Nature than the coal scuttle men painters ~~like Meissonier~~ ever suspect. In a big picture you can see what o'clock it is afternoon or morning if its hot or cold winter or summer & what kind of people are there & what they are doing & why they are doing it. The sentiments run beyond words. If a man makes a hot day he makes it like a hot day he once saw or is seeing if a ~~delicate~~ sweet face a face he once saw or which he imagines from old memories or parts of memories & his knowledge & he combines & combines never creates but at the very first

combination no man & less of all himself could ever disentangle the feelings that animated him just then & refer each one to its right place.

I must go to school now. I got admitted yesterday to the studio of Dumont the sculptor in our school. I am going to model in clay every once in a while. I think I will thus learn faster. When I am tired of painting I will go to the class & be fresh & I will see more models & ~~have more choi~~ choose. The sculptors are not so noisy as painters. They are heavier duller looking boys proverbially. I was well received & spent 15 francs on them to give them the welcome. They tried to make the things pleasant. I can now talk good enough to understand all they say & make them understand me it is not like when I went into Gerome's first when I did not understand a word of slang which we always talk and very little French too. Love to all my friends.

[unsigned]

[TE to BE]

Paris Oct 29.68

My dear Father,

Your two last letters though intended to encourage me to keep hard working ~~as it~~ could not but dispirit me a little by showing me you were fearing perhaps that I was not in the right path or had stopped working or some such idea. I am working as hard as I can & have always the advice of a great painter who does all he can for his scholars & of boys ~~who~~ friends who can paint the figure as well or better than any man in America. I have made progress & can equal the work of some of the big painters ~~wh~~ done when they had only been studying as long as I have, & as far as I have gone I see in their works that they have had the same troubles that I have had & the troubles are not few in painting. I have got to understanding much more than I did & though I see plenty of work ahead yet I am not altogether in the dark now but see it plain & sometimes how to catch hold of it. If I live & keep my good health I am certain now of one thing that is to paint what I can see before me better than the namby pamby fashion painters. Whether or not I will afterwards find poetical subjects & compositions like Raphael remains to be seen, but as Gerome says the trade part must be learned first. But with or without that I will paint well enough to earn a good living & become even rich. There is a common mistake made by those who do not know drawing, and that it [*sic.*] that one should have the habit of finishing studies. This is a great mistake. You work at a thing ~~till you are as~~ only to assure yourself of the principle you are working on & the moment you satisfy yourself you quit it for another. Gerome tells us ~~often~~ every day that finish is nothing that head work is all & that if we ~~finished~~ stopped to finish our studies we could not learn to be painters in a hundred life times & he calls

finish needle work & embroidery & ladies' work to deride us. His own studies are rough quick things mere notes & daubs, but his pictures are finished as far as any man's, ~~but a man~~ therefore ~~we cant~~ one will take his advice quicker than ~~a b the~~ the work of a writer who knows nothing about painting such as Ruskin.

I do not look on Bill Sartain as my superior in any way but my equal. My chance of study is surely better than his for his teacher is not to be compared as a painter with Gerome, & I can compare my work ~~after~~ every day with the best work in all the world, & my associates in painting are despite Emily's great mind superior to her in their knowledge of their art & therefore leaving me & Bill out Geromes class is better than Schusseles as I truly believe & more numerous too. I can't help thinking that Emily has been talking to you about my affairs. Perhaps she would like me to ~~join their sweet little class & we we~~ leave Gerome & this naughty Paris & join their sweet little class & come & fetch her & see her home after it & we would drawey wawey after the nice little plaster busty wustys & have such a sweet timey wimey. I know she has had the effrontery to try interfere between Fanny & you. Maybe she would like to go farther, God speed the day that I can stop my studies long enough to paint a good picture & relieve you of your share of an anxiety which should be nearly all mine, which in depression is harder than death to bear but which disappears in the joy of every progress felt or discovery made.

I have not time to write more & I have written so hastily I dont know if you will understand all I have written. Please burn this letter right away for part of it looks so like boasting which ill befits me, but by which I have still hoped to reassure you a little. Please send Cope enclosed receipt.

<div align="center">[unsigned]</div>

<div align="center">[The word *Poppy* is written twice over page 3.]</div>

[TE to BE]

<div align="right">Paris June 24.69</div>

Dear Father,

You asked me how I was getting on with my studies. I am getting on as fast as anyone I know of. There are often awful sticking points but at last by a steady strain you ~~take~~ get another hitch on the thing and pass. When you first commence painting everything is in a muddle. Even the commonest colors seem to have the devil in them. You see a thing more yellow you put a yellow in it & it becomes only more gray when you tune it up. ~~The farther you~~ As you get on ~~some~~ you get some ~~our~~ difficulties out of the way and what seems trying is that some of the things ~~you took the gr~~ that gave you the greatest trouble were the easiest of all. As these difficulties decrease or are entirely put away then you have more time to look at the model & study,

& your study becomes more regular & the works of other painters have an interest in showing you how they ~~were~~ had the same troubles. I will push my study as far & fast as I can now I am sure if I can keep my health I will make better pictures than most of the exhibition. ~~Part of a ter~~ One terrible anxiety is off my mind. I will never have to give up painting, for even now I could paint heads good enough to make a living anywhere in America, I hope not to be a drag on you a great while longer. I tried to make a long letter of this & it has been troubling me some time but I cant think of any more to say. All I can do is to work.

[unsigned]

[TE to BE]

Paris Novem.5,69

Bill Sartain came to see me last night & he is well except a cold & I have a cold too that set me coughing today. I will try keep get it well. It has been raining now for two weeks every day & sometimes it pours & is very dark so that I feel anxious to get away. Bill Sartain in spite of his resolution to work through the winter at Paris is going away, probably starting off in the middle of next week. There is no news at Paris of any kind. Rain dampness & French fireplaces no color even in flesh nothing but dirty greys. If I had to live in water & cold mist I had rather be a cold blooded fish & not human. I made a good drawing at school this week & ~~today~~ if I can keep my health I think I can make a name as a painter for I am learning to make solid heavy work. I can construct the human figure now as well as any of ~~the~~ Geromes boys counting the old ones & I am sure I can push my color farther so I keep working hard & thinking of the reward of my troubles & long studies. My attention will now be much divided from my school work to making up sketches & compositions now that I am getting such a good start[.]

I have a good fire going that warms my back & I hold my feet up on a chair to keep them from the draught that blows in from under the doors & sashes & up the chimney. The French know no more about comfort than the man in the moon.

[unsigned]

[TE to BE]

Fonda del Peninsular, Madrid,
Thursday
Dec. 2, 1869

Dear Father,

I suppose & hope you got my last letter telling you of my progress my determination to come home to stay, early this summer, asking you for

another draft soon of not less than a thousand francs for Drexel refused to give me a note for less on his correspondence which makes me have to carry all my gold with me. I left Paris Monday night in a pouring rain of course. All my friends came to see me off & Billy Sartain will miss me very much like I miss him. I lent my studio to Cure & Sauvage. If it had not been winter time & if I had not known & feared the Atlantic voyage, not being well, I would have come home straight, but since I am now here in Madrid I do not regret at all my coming. I have seen big painting here. When I had looked at all the paintings by all the masters I had known I could not help saying to myself all the time, its very pretty but its not all yet. It ought to be better, but now I have seen what I always thought ought to have been done & what did not seem to me impossible. O what a satisfaction it gave me to see the good Spanish work so good so strong so reasonable so free from every affectation . It stands out like nature itself, & I am glad to see the Rubens things that is the best he ever painted & to have them alongside the Spanish work. I always hated his nasty vulgar work & now I have seen the best he ever did I can hate him too. His best picture he ever made stands by a Velasquez. His best quality that of light on flesh is knocked by Velasquez & that is Rubens only quality while it is but the beginning of Velaquez's.

Rubens is the nastiest most vulgar noisy painter that ever lived. His men are twisted to pieces. His modelling is always crooked & dropsical & no marking is ever in its right place or anything like what he sees in nature, his people never have bones, his color is dashy & flashy, his people must all be in the most violent action, must use the strength of Hercules if a little watch is to be wound up, the wind must be blowing great guns even in a chamber or dining room, everything must be making a noise & tumbling about, there must be monsters too for his men were not monstrous enough for him. His pictures always put me in mind of chamber pots & I would not be sorry if they were all burnt.

~~Yesterday morning I~~ Tuesday ~~night~~ afternoon at 2½ o'clock we started into Spain. It was still rainy. The night was very cold in the mountains. At daylight we were crossing mountains with snow covering them all, at 10 minutes of seven we commenced descending. The sun got up in a clear sky a thing I had not seen for a very long while & at half past nine we were in Madrid. I was pretty weak & sick from my diarrhea but the sight of the sun did a great deal to cure me & now I feel right well & almost as strong as ever. The sky here is a very deep blue the air is dry mountain air & the temperature 40 Fahrenheit. The people all cover the nose & mouth & wrap themselves very warm & I do the same thing. My appetite which I had lost entirely is as entirely ~~come~~ back again. Tomorrow night I will start to Seville where I will try to stay some time. Madrid is the cleanest city I ever saw in my life. The ladies walk the promenades with long trails like in Philadelphia & just as rich dresses what is never seen in Paris, & I dont think they are much more soiled when they come home than if they had been to a ball.

The hotels are clean the privies are large commodious & built on the American not French pattern & the floors are everywhere covered with carpet or thick matting even in the picture galleries.

The peasants & muleteers have very bright pretty colored dresses sometimes though they are dressed entirely in skins with the wool left on or worn off by age. There are a great many ink shops in Madrid where a man sells a great many kinds of things he still advertises & pays most attention to his ink. What in the world the Spaniards want with ink I dont know unless for their generals to write pronouncements & proclamations with. I went to church this morning to hear mass. The music on the organ is the queerest I ever heard. It is the quickest dance nigger jig kind of music then its echo in the distance. Then another jig & it comes so suddeneach time or you cant get accustomed to it. The whole cathedral floors are covered with thick matting & there are no seats. The people all keep on their knees men & women & from time to time fall their face on the ground like a Hindoo sticking the backside up in the air and then back on the knees again.

Friday afternoon

The ladies of Madrid are very pretty, about the same or a little better than the Parisians but not so fine as the American girls. A good many of them are fair but the proportion is not so great of fair ones as in America. The country women are often course with that ugly hanging of the eye that is often supposed to represent the whole Spanish type. I have been going all the time since I have been here & know Madrid now better than I know Versailles or Germantown & tonight I leave for Seville. I have seen the big work every day & I will never forget it. It has given me more courage than anything else ever could. The cooking is very nice here with one exception I dont like stinking fish cooked in garlic egg & oil with fresh lemon juice squeezed over it although the Spaniards even the delicate ladies seem very fond of it. The Spaniards as far as I have seen them seem to be a very good average sort of people, with good ideas or none at all.

I would not tell anyone about my coming home. Bill Sartain thinks best too. I would not want anyone to make plans hanging on my coming, & I do not care for Schussele or the young artists to know of it.

[unsigned]

[Jean-Léon Gérôme to TE]
Copy of Gérôme's letter to Eakins. Paris Feb 22–1877

My dear Eakins,

Just arrived from Italy and found your letter brought to me by your friend letter to which I had already answered, [*sic.*] but it appears that my answer did not reach you. did I put the wrong address is it my fault or the

Post office I do not know. then I answer a second time to your point of interrogation

You know what is the system of the French education because you have made your studies a Ecole des Beaux Arts, [*sic.*] and I believe the system is good. If I judge by the results obtained in the past also at present

I think that the youths should begin with relatively easy subjects that is to say, with some antique plaster. whom are useful to form the spirits of the pupils [*sic*] and do show them how to interpret nature but after first studies are accomplished it is necessary to continue and apply it to the living models . it is only direct from nature, that it is possible to form the artists and by constand [*sic.*] study from the nude that the painter arrives to be really strong, deep and true . look what become from the German School for to have neglected the truth, for to have quitted the earth and plunging itself in empty ideals entirely foreign to the plastic arts .

To search the truth, is only the reasonable way and other roads carry you to the abyss

please receive my dear Eakins my cordial salutation. I assure you of my best feeling.

<div align="center">

Gérome
translated by Louis Husson friend of Eakins

</div>

[TE to John Laurie Wallace]

<div align="right">

Feb. 27th, 1884
1330 Chestnut St.
Philadelphia

</div>

My dear Johnny,

I have just received today your second letter, and I am mortified to think how I have delayed answering you, for I myself know well the pleasure of a letter from home when away. Of course you are very much missed by the whole gang.

Wagner became our prosector and chief demonstrator of anatomy on your retirement, and gave satisfaction to all the school. Dr. Keen having commenced his lectures so early this year finished sooner, that my course might commence & I am now already on my third lecture on perspective and composition. The school is fuller than ever. There was a great deal of careful work on the horse made in the dissecting room this year. Tommy Anshutz Harmer Godley, MacLean & McCormick working every night. A good class worked from the live horse in the modelling room & we will follow up the horse with a cow as last year. A new life modelling class has been started at night for the girls on the boys' painting nights & we have at

last our still life class going in the little room. There is solid work going on there all day. I am glad to say the oldest & best pupils patronize it largely, and they are painting from eggs to learn nicety of drawing & from pure colored ribbons & muslins the range of their colors.

Sue & I are married and we live in Frost's old rooms on Chestnut St. We are very comfortable so far, and will be happy unless sickness should overtake us.

I have been carpentering & tinkering ever since I have been here but hope soon to get at pictures again. Sue sends you her love with mine and although I approve very much of the course you have marked out for yourself, that is to earn money at portraits, yet I still hope you will pay us an occasional visit & when you do there is no place barring your mother's where you will find so hearty a welcome as here.

<div style="text-align: center">

Yours truly,
Thomas Eakins

</div>

[TE to Edward Hornor Coates]

<div style="text-align: right">

1330 Chestnut, Feb. 15, 1886

</div>

Dear Mr. Coates,

I hope that you yourself will not mistake the agony you saw me in at your examination, for any shame at what I have done, but simply as it was, to having to tell things which were a surprise to people unprepared to understand.

The public could still less understand. It was asked incredulously could refined ladies do such and such things, and the strong doubts reflected on my dear Susie and others of Maggy's friends who to me are sweet and refined above all others. The thing is a nightmare. My heart breaks for them, yet how can I defend them from the vicious attacks of those who should never have known what was [a] private professional matter. It seems to me that no one should work in a life class who thinks it wrong to undress if needful. About the hazard, that is another matter. Was ever so much smoke for so little fire? I never in my life seduced a girl, nor tried to, but what else can people think of all this rage and insanity.

For years Miss Barber studied with me with enthusiasm and induced others, and with motives as pure as my own. She was quick and talented, poor and expected to earn her living, friend to my friends. I have taught her all she knows. It is my fortune or misfortune to have studied longer and to more purpose than most artists the naked figure: and that is why my instruction is sought by so many, and not for personal reasons. My sad old face is none too pretty.

I never took pay from pupils and only selected such as I conceived the most talented and who were to be professional to ever let come to my studio

and work from my models or from each other. It is not a rare ambition in a painter to want to make good pupils.

My dear master Gérôme who loved me had the same ambition, helped me always and has to this day interested himself in all I am doing.

Miss Searle came to me in despair. She had done what she could and was not improving, and begged help. She seemed so earnest it was pitiful. If I had been using the naked model at the time, I would have invited her alongside of me, but I was not, and advised her to get a private model or comrade and come to me for correction only. Now what bad motive should my worst enemy impute. She seemed from her remarks to feel the risk and decided to take it. She is no child but a grown woman. She was shortly to leave forever.

They were two together and my wife was another safeguard. Why should she denounce me and try to hurt me, but that others have used her as in the dissecting room matter.

I once told ~~a coarse st~~ very apropos a coarse story not a lascivious one to two girls (not in school) many years ago. No offense was intended or taken. I am not accustomed to doing such things: yet this is brought against my personal character repeated through the school ad nauseam to any who will stop to listen. To have told it I do not excuse, but I excuse still less the retelling with malice.

I began dissecting twenty-four years ago. If there is a place in all the world where seriousness should reign and the little affectations of this life have no place it is there in the dissecting room and the mutilation of the male subject for the false modesty is to me revolting.

In all the woman's schools I have always conducted myself with all the dignity which comes from serious thoughts.

And now that I am out of the school, what shall be done with the now hot-headed majority [of] men and women?

I sent one of them to you this morning to quiet him, for I feared his indiscretion.

It seems to me now that the whole rebellion was a little one, worked from a little spot outside the school, and I never suspected it till Miss Searle's inconsistency.

The law of New York in the recent case of Lefarge has decided the right to privacy of a figure painter's studies, in his case from a Society-lady.

I hoped at one time you would see Flory. Now you were wiser than I. I am glad you did not trouble her. Nothing can stop them. Must the public have every detail?

I have done nothing myself, have seen no one but let them have their swing. They are carrying it outside of the school.

I am not in society nor skilled in the world's ways like you and Will Macdowell. My life has been spent with doctors and life students. If I am

giving you trouble or have given you more than I ought, it is because I cannot keep everything to myself, and I hoped much from your power in appeasing wrath or making people see reason.

Yours truly

Thomas Eakins

[TE to Edward H. Coates, n.d. ca. 10 Mar 1886] [This transcription does not reproduce every passage or word of the original since there are numerous changes and illegible passages.]

My dear Mr. Coates,

Your last letter to me of the 18th Feb told me you would regret misfortune to me, that you fully appreciated the hardship of my position and advised me to allay the feeling and excitement that my supporters were creating which advice I did all in my power to follow, but when you tell me that my friends are the ones who will be most to blame for unpleasant consequences I must differ. [illegible sentence]

And it is small comfort to me that you suppose the facts in the case remain with the committee who have made no statement whatever. No sooner was I out of the school than your same informers repeated even to new scholars in the school, and to outsiders that I had made photographs of my female pupils naked. and that I was a libertine, which is a lie, but they pointed out said that I had been turned out of the Academy for my bad character by the directors who were honorable men & *would make* no mistake, and the news was also carefully sent to New York, where I heard it. It seems that Stephens had been bragging some time of his power over me, that he could put me out of the school and out of the city and out of any other school, and all this while living in my family & professing great friendship & admiration for me. I have been very blind, ~~and the blow was well prepared & struck me from behind.~~

And it is small comfort to me if the facts had remained with the committee who certainly had no right to them. ~~Is there no professional dishonour~~ came by them through professional dishonour and as to the ~~supposed~~ facts themselves I now have reason to believe they are not facts; as I have heard lies & so has my father.

~~Through all this business Of all persons[?] I have probably most studied the naked figure.~~ Your committee ~~could~~ will judge if they wont re-hire me.

The public & your committee are not fit to judge of the requirements of good figure study, but I have looked upon you yourself as one broad enough to respect consider at least the views of one who has made the figure his special study so many years as I have. and ~~to no~~ not without end; as ~~you yourself have noticed.~~ My figures at least are not a bunch of clothes with a head & hands sticking out but more nearly resemble the ~~living body that~~

strong living body's [sic] than most pictures show, & my subjects have always been decent. You probably know that for months last year I was modelling young Godley after the Greek methods of relief not on any order or hope of reward but merely to study & gain knowledge & strength; and so has my whole life gone in hard study & painstaking. ~~and who I which is not without its showing in my pictures.~~

And I have always helped my pupils as far as my means would permit, and most of them men & women remain very ~~have been extremely~~ grateful to me.

~~With such study~~ And in the latter end of a life so spent in study, you at least can imagine that painting is with me a very <u>serious</u> study, ~~as serious at least as medicine itself. in those who should be about it~~ that I have but little patience with the false modesty which is the greatest enemy to all figure painting. And it would not seem strange to me if you would have shared my disgust at the conduct of the female demonstrator who not a wayward child but a full grown woman, could seek out and discuss violently right & left with young men & women delicate things the female medical student immediately accepts without an impure thought. ~~I did not then~~ She is not yet quiet in the school.

I told her plainly that I considered her influence in art education a very bad one and that I regretted having given her a few days previously under a mistaken impression a strong recommendation as teacher. Her reply was that she did not value a recommendation from such a person as myself when I told her that if not used she could then return it and we would both be satisfied. This I did with conviction and not with spite. The reason I speak of it now is that I hear among other New York rumors that you had been angry with me for my apparent change of opinion. ~~My opinion of the woman changed not my opinion of the art.~~ My opinion of art principles did not change not influenced they are above personal things, but my opinion of the woman only as you could surely divine, from her capricious conduct ~~influenced as I now know from outside~~

~~All the harm that can be done is probably done and I am only quiet to spare as much as possible. The injury~~
~~Those most interested in my supporting talk~~
Where Stephens expected to do me the most injury, with my father, my father-in-law, my wife's brothers, he unexpectedly injured only himself & and brought them still closer to me & injured himself irreparably and I hope that someday you too may think it worthwhile to take time clear up [sic] with help any doubts or misunderstandings that may rest in your mind as regards myself, for I have cared so much for you that I can not but believe you too care for me.

I myself see many things clearer now than I did when in my first surprise I was stabbed from I knew not where and half remembered or wholly for-

gotten things brought forth perverted. It was a petty conspiracy in which there was more[?] folly than malice [,] weak ambitions and foolish hopes, and the actors in it are I think already coming to a sense of their shame. My conscience is clear, and my suffering is past.

<div align="right">Yours,
T.E.</div>

[TE to Academy Art Club, March, 1886]

Sir—

Your note of 22d is at hand. As it announced my expulsion from the Club I was uncertain as to the need for answering it. For some reasons it may not demand any reply but in its effort to throw discredit upon me, the Club has proceeded in so puerile a manner and its action has been so devoid of the most ordinary principles of honest dealing that in its own interest I deem it wise to point out what must be considered either as childish impetuosity or else reckless malice. As the Club saw fit at one time to make me an honorary member without my solicitation I presume it may be at liberty, when it so desires, to withdraw the Compliment but I do not see how the revocation of a compliment can be construed into an expulsion, which involves the abolition of duties and privileges that I have at no time been subject to or enjoyed.

Further than this however the By-Law quoted in your note requires your President to direct your Secretary to notify in writing the member whom it is sought to expel, of the Executive Committees report upon the subject. If no appeal be taken within two weeks thereafter a conclusion is then arrived at. In the first place it is an outrage upon justice that your Executive Committee should be permitted to act in secret in resolving to report a member for expulsion no matter whom or for what cause but it is also a violation of your own rules, that I should never have been advised of your contemplated action. Up to this time your note advising me of my so called expulsion is the first intimation of any kind that I have received in relation to this matter. With the hope that this explanation may enable your Club to aquit itself with more Credit in any similar case that may hereafter arise I remain

<div align="right">Thomas Eakins</div>

[TE's dossier of Sketch Club correspondence, 1886]

1.

Copy of correspondence

Mr. Thomas Eakins Present,

Sir: In accordance with resolution duly adopted John V. Sears, Walter M. Dunk, and Henry R. Poore have been appointed a committee to inquire

into certain charges appearing against yourself on the minutes of the sketch club. The committee will meet at the club on Saturday 13th. inst. at half past seven P.M. for the purpose of hearing your reply to said charges.

By Order
John V. Sears
Chairman.

Sketch Club
Thursday Evening
March 11th. 1886.

2.

March 13.

Dear Sir,

Your favor of the 11th was received yesterday. It seems hardly possible that the Sketch Club could have been ignorant of the extraordinary character of its communication to me.

I know of no circumstances in relation to which any person or persons have a right to make charges against me to the sketch club, nor of any right of the Sketch Club to constitute itself a tribunal to hear & try charges. The action of the Club in advising me as it has done without stating the charges or by whom they are preferred is so inconsistent with the principles of fair dealing, that I can only regret that the Club has permitted itself to be placed in such an equivocal position.

It is evident that there is an organized movement to do me mischief. The methods pursued are such as can proceed from only private motives seeking their expression through malicious acts. They who are active in this course are answerable to me before other tribunals than that which it is now sought to set up by your club.

The character of the Club's action is such that I should not have replied to it were I not willing to call your attention to the stultification involved in it.

Until a full submission is made of me of the statements against me, with an equally candid advice of the names of persons making and discussing the charges I must decline to consider the subject further.

If your club deems it proper to attempt this rectification of its course, and will place me in complete possession of the facts and names, I shall then decide whether or not further action on my part will be needed.

Yours respectfully
Thomas Eakins

to John V. Sears
Chairman.

3.

<div align="right">
Sketch Club

Phila. Sat. March 10/86

(Error in date, should be Sat. Mar. 13)
</div>

Mr. Thomas Eakins.
no 1330 Chestnut St
Sir:

Your note to Sketch Club Committee duly received. The position you assume is perfectly just and right. The members of the Committee desire to state that they appreciate the Soundness of your argument and the propriety of your conclusion.

The lack of notice the Committee understands was an inadvertence on the part of the club. Until assured that the matter in question is formally before you, the Committee will take no step therein.

<div align="right">
For the Committee

John V. Sears

Chairman.
</div>

4.

Mr. Thomas Eakins.
Dear Sir,

At the regular business meeting of the Phila. Sketch Club, held March 6th. 1886, the following communication was read, entered upon the minutes, & filed: "To the President & Members of the Phila. Sketch Club,
Gentlemen,

We hereby charge Mr. Thoms Eakins with conduct unworthy of a gentleman & discreditable to this organization & ask his expulsion from the club.

<div align="right">
Resp

Thomas P. Anshutz

G.F. Stephens

Charles H. Stephens
</div>

As the club will be governed in this case by Article V. section III. of their ByLaws, I have been authorized to send you an entire copy of it.

Any member may be expelled for improper conduct by a vote of two-thirds of the members present at a stated or special meeting.

Charges of improper conduct shall be made to the Club in writing by any active member or by the Executive Committee at a stated meeting.

When charges are made the Secretary shall forward to the accused a correct copy of them with a notification that the Club will pass upon them, four weeks from the date of their submission to the club; provided that the club may fix any date for the hearing and determination of the charges, of not less than four weeks nor more than three months from the time of their presentation.

The Secretary shall also notify all the active members of the club that charges have been preferred and of the date when the club will be called upon to pass upon them. The accused shall have the right to be heard in his own defense in person or by counsel.

<div style="text-align:right">

Respectfully
C. Few Seiss
Secty' Phila. Sketch Club
Phila. March 13th. 86.

</div>

5.

<div style="text-align:right">

1330 Chestnut St.
Philadelphia.
March 26th. 1886.

</div>

Mr. John V. Sears,
Sir:

After considering carefully the letters from yourself and the Secretary of the Philadelphia Sketch Club in rectification of your previous proceedings, I beg to submit what follows.

In this reply however, I do not in any way manner admit the jurisdiction of the Club in regard to my own affairs, but I am desirous of looking into the matter in question sufficiently to determine whether circumstances will warrant further attention from me.

In making me a so-called honorary member, the Sketch Club presumably wished to convey a compliment which I did not seek. The compliment did not in any sense constitute me a member of the club, my relations to which are the same as if I had never heard of it. An action of expulsion cannot therefore be in question. The only action possible could be one withdrawing the previous action by erasing the compliment. Anything further would be gratuitous and malicious.

In relation to the communication which is the cause of the clubs' action, I submit that the statements made by it are indefinite and ~~vague~~ could not in any ~~sense~~ event properly furnish a basis for proceedings. It would be folly for me to appear before your committee to answer an indictment the points of which I am not permitted to know in advance: and it is an injustice on the part of the Club to proceed against anyone by calling ~~on~~ him to appear at a stated time to answer injurious charges which are not to be stated until the time at which the answer is to be made.

I could come to no conclusion until something specific is placed before me in the form of a written statement properly signed, giving the detail of occurrences as to times, places, and persons witnessing the same, and who are expected to give evidence as to the matter alleged against me.

It is useless to waste my time or that of the Committee in dealing with

vague statements of opinions which it is an affront to the Club to present and an affront to me to consider.

<div align="right">Yours Respectfully
Thomas Eakins</div>

6.

Mr. Thomas Eakins
no 1330 Chestnut St.

Sir:

The Investigating Committee of the Sketch Club acknowledge receipt of your note of 26th ult:

Referring to your remark as to being desirous of looking into the matter in question" the Committee have to say, they are anxious to afford you the first and fullest opportunity so to do. The Committee have deferred the hearing of specific charges because of suggestions made, as they judged, in the interests of peace and quiet. At a meeting held this evening an appointment was made for the hearing of such specific charges on Wednesday next. Preliminary inquiry as to the character of these charges induced the committee to decide that they should be presented orally rather than in writing.

Pursuant to instructions the Chairman hereby requests your presence at the rooms of the Sketch Club on Wednesday evening next at eight o'clock April 7th. to meet & traverse such specific charges if any are then and there made. Should the Committee find the matter requiring further attention at their hands, reasonable time will be extended at your request in order that you may take whatever action seems to you fitting.

<div align="right">By order of the Committee
John V. Sears
Chairman</div>

Sketch Club Rooms
Philadelphia
Saturday P.M. April 3d. 1886

7.

<div align="right">738 Sansom St. Phila.
April 7th. 1886.</div>

Mr Thomas Eakinss
Dear Sir,
Having had some conversation with Mr. W.G. Macdowell in relation to your

7.

1330 Chestnut
April 7th. 1886.

Mr. John V. Sears
Chairman.

Sir:

I have from you still another communication from you dated April 3, 1886 which acknowledges the receipt of mine, bearing date March 26, but of which you appear to have ignored the most important part.

I cannot understand, presuming honest motives, how, when I, whom it is sought to injure, ask for specific charges properly signed, you again show an inclination to return to the curious methods of examination first proposed by you, and of which you have acknowledged to me in writing the impropriety.

It seems to me that the concern for the interests of peace & quiet inducing the committee to have the charges "if any" presented orally rather than in writing had better have prevailed before your club saw fit to record on its minutes a personal expression of my character injurious to me.

For fear you have overlooked the most important part of my last communication I copy,

"I could come to no conclusion until something specific is placed before me in the form of a written statement properly signed giving the detail of occurences as to times, places, and persons witnessing the same, and who are expected to give evidence as to the matters alleged against me. It is useless "to waste my time etc"

I am entitled to such a presentation of the matter, being otherwise unwilling to consider it, and I respectfully caution the club against taking action upon any less sufficient basis.

Thomas Eakins

8.

738 Sansom St.
April 7th. 1886

Mr Thos. Eakins
Dear Sir:

Having had some conversation with Mr. W. G. Macdowell in relation to your case now before the Sketch Club Committee I urged upon him the importance of you appearing personally before our committee, and I now write this note to you to ask you to reconsider your decision regarding the communication sent you by Mr Sears requesting your appearance this evening

as a note from Mr Macdowell this morning infers that you will not come without the charges being detailed to you in writing.

You have already had the charges in writing in a condensed form that covers them entirely. The details will be given you when you appear to receive them. As a member of the Committee, I am more than disposed to treat your side with all the judicial fairness at my command, and will regret very much if any actions on your part will do away with the friendly relations heretofore existing between us.

The Committee have a very delicate and uncongenial duty before them and I regret to say that if you refuse to appear before them on account of the technicality which you set forth that your actions in so doing cannot fail to produce a feeling in your disfavor.

There is no doubt that being an honorary member or otherwise you are answerable for such action as you are said to be guilty of and it is only fair that you should make your friends fully informed of your side of the story as soon as possible not only to try and make your case right before them, but to lighten their labors of a very burdensome duty.

Our Committee has been appointed as much for your benefit as for that of any one else and I think you are certainly acting against your own interests by refusing to appear.

Hoping that this note will be received by you in all friendliness, I remain
<div style="text-align:center">Very truly
Walter M. Dunk.</div>

(Not answered.)

9.

<div style="text-align:right">Phila. Sketch Club
Wed. April 7th. 86</div>

Mr Thomas Eakins
The date fixed by resolution for a final disposal of the charges brought against you, is Saturday evening. April 17th. 86.
<div style="text-align:center">C. Few Seiss.</div>

10.

<div style="text-align:right">Saturday April 17. 86</div>

To the President and Members of the Phila. Sketch Club
Gentlemen,
I have received notice of the date for the final disposal of the charges brought against me. Before any action, I desire that all the correspondence between me and the committee appointed to inquire into certain concealed charges be read.

I have in vain endeavored to get at a proper presentation of these charges; but from the character of the correspondence with the committee, from rumor, and from the irregular, secret action instigated by the same party in another club, I easily conclude the whole affair to be a dastardly attempt to injure me, and to use the club as a cat's paw to further the injury.

Yours truly
Thomas Eakins

(N.B. The above correspondence was not all read to the club, but suppressed.)

11.

Mr. Thomas Eakins
Sir.

At the meeting of the Phila. Sketch Club held April 17th. 86 a *vote* of *censure* was passed upon you accompanied by a request that you tender your resignation as an honorary member of the Club.

C. Few Seiss
Secty

Phila. April 19th. 86.

[William J. Crowell to TE]

April 26th/86

Dear Tom,

I showed your letter to Fanny as there seemed to me no sufficient reason for keeping it from her, even if she had not made her regular daily inquiry if there were no news about the trouble. She is indignant at the idea of your resting quiet under such an outrage. I think that your father and the other members of his family ought to do what can be done toward tramping out a lie of such infamy. If Frank is using his wife's big belly as a rampire behind which to wage such a warfare in security, the nature of his protection might at least be made public which would check his operations, if he is not stark mad. This your father and we could do. But is there no chance of mistaken construction somewhere. I have myself heard Maggie more than once speak very strongly against your habit while dressing of walking back and forth in your shirt tail from your room to that occupied by her and Aunt Eliza & Caddy, regardless who was present. Sally Shaw often being there—and she did name that as one reason for giving Caddy the other room (the private one) when we left it to move to the country—the chief reason for not taking it herself being her unwillingness to leave Aunt Eliza with no one but Caddy at night.

Something of this sort may have got to F. or C. and being by them magnified and reflected in the style of filthy innuendo characteristic of them both, has later been differentiated in the disgusting manner you mention.

We *know* that Frank was not in Maggie's confidence as to the nude posing business. Caddy first told him of that (she said) one afternoon the summer following Maggie's loss when they were together with the children over at our barn. Fanny and I were both much surprised, as we had supposed that his animosity against you which had been almost if not quite as marked before Caddy's revelation to him as afterwards, had to do with that matter.

When Fanny was lately in town Caddy asked her with an air of horror whether she would allow our little girls to stay all night at your house. Fanny puzzled said of course she would if there were any occasion for it & you had room. Maybe some such idleness was in her mind then.

If there is any testimony, private or public, sworn or other, we can give—either of us—in your behalf we shall be only too glad to give it. I can say for my very own part that during our long intimacy of nearly thirty years, I never even suspected much less knew of any act of lewdness or immorality on your part. Even during our antagonism—going 14 years ago—I should never have thought of accusing you of such.

As to the expediency of many of your methods, I differ strongly with you even where (as in great measure I do) agree with you in the speculative right or wrong of questions.

<div align="center">W. J. Crowell</div>

If Mr. W. G. Macdowell can spare the time to give Fanny his understanding of this latest calumny with some detail she would regard it a favor. She wants me to write to him but I hesitate to do so, preferring to ask you to tell him of her wish if you think it proper.

<div align="center">W. J. C.</div>

[TE to FEC]

<div align="right">June 4, 1886</div>

Dear Fanny,

For some days I have been quite cast down being cut deliberately on the street by those who have had every occasion to know me, but who evidently can no longer reconcile Frank's longer stay at home with the honor of our family. It is now I believe since last Christmas that he has been confidentially whispering his lies, and yet it was only last Sunday I learned that Maggy had been brought in actually and by Billy's letter yesterday that he had made use of Billy's confidence to bring you in, and then I saw Frank's statement yesterday for the first time and it sickened me.

Yesterday I was cut by a lady one of my most active friends until quite recently.

Now although I think the affadavit my father signed today & Billy's letter with his & your affadavit will do much good as undoing some of Frank's harm his life's work would not go far towards undoing it all, so I should little consider his comfort in the matter.

It seems to me indeed about necessary that he should be sent away temporarily at least. No amount of good painting on my part can have the least effect in removing the stain cast on the family, but Frank's being sent away now that Caddy's child is born, will again put doubt in the minds of those who wanted to doubt before, and then they will inquire or be easily approached.

If things were not so unhappy it would best please me to remain in my own little home which I shall keep & where I have been very happy, but Aunt Eliza should not be left alone, neither should my father in his old days, so if Frank goes, I should prefer to go back & try to make things as comfortable all around as possible.

The only consideration that I could have in the matter & the only one I believe that my father could have, would be for Caddy; yet I really think it would be best for her too that she & Frank should go out now into the world and learn something [sic] charity at least.

If trouble befell her she could go back again.

I propose to see Dr. Duer & get from him an affadavit as to Maggie's love & confidence as evinced in her last illness.

Will Macdowell is very cheerful now, & I too, knowing for the first time the utmost depth of the iniquity, and naturally horified find comfort in the fortunate testimony.

If Fanny & Poppy had been dead think how the mischief might never have been stayed.

[unsigned]

[Affidavit of William and Frances Crowell]
COPY

Avondale, June 5 / 86

Mr. John V. Sears.
My dear Sir,

In again bringing to your attention a subject of which you have perhaps had a surfeit, I recognize the risk I run of being regarded as an intruder upon your time and patience.

I am nevertheless impelled to try in this manner, to say to you, and to every person present at the meeting on Saturday evening, (29th. ult.) at 1729 Mt. Vernon St. Philada. what I was unable to give proper expression to at that time and place.

Considering that even my opinions, as those of one very intimately

acquainted with the characters and environment of the parties to this unhappy business, are entitled to respect. I wish to say that I sincerely believe the true and only source of the proceedings which have been taken to ruin the life of my brother-in-law, Thos. Eakins, is nothing higher nor deeper than an intense—I may fairly say—insane, resentment in the minds of Mr. and Mrs. G. F. Stephens, of slights or incivilities some, no doubt, real, (and which I do not excuse) others, fancied, to which she (Mrs. S.) has, as they conceive, been subjected. Incivilities, which their super-sensitiveness, and ignorance of life, exaggerate into indignities.

A circumstance that confirms me in this view is that when I first became acquainted with Mr. Stephens, the summer following the loss of Miss Maggie Eakins, when he, in company with his present wife, was visiting us,—at a time, when, as he afterwards admitted to my wife and myself, he knew nothing of the nude posing at the studio at 1729 Mt. Vernon St.—(a matter, which through its injudicious communication to Miss Caroline Eakins, by one of the participants shortly after the elder sister's death, and by her, Miss Caroline to Mr. Stephens, during a later visit to us, has been made such a terrible weapon)—at this time, I say, there was an extravagance of hostility in their expressions concerning Thomas Eakins, but little less than that they have ever since displayed.

Beyond the fact that, by the advice of a physician, and at the request of Mr. B. Eakins, (as he, Mr. B.E. afterwards told us) he had shot a diseased pet cat belonging to Miss Caroline, without consulting her, no definite charge was ever made or hinted at.

They inveighed against his "wolfish looks", "his boorish manners", "his brutal talk", and the like.

I well remember my astonishment upon an occasion, more than a year later (Nov./84) when I met Mr. Stephens at Eakins's studio on Chestnut street, not long after listening to such invective, at my own house for the greater part of an evening, to find that he came to ask an important favor, which he did in a quiet, respectful manner, much at variance with what I would suppose to be that of a gentleman towards a "boor" and a "brute",—much more, towards one whom, if he now speaks the truth, he must have known to be guilty of all the nastiness, he now claims to have learned from Margaret Eakins, at that time (Nov.1884) for nearly two years in her grave.

I observed,—as you doubtless also did,—that on Saturday evening last Mr. Stephens claimed to have received his information about "not only the posing", but also the actions on which the charge of bestiality was founded from Miss Maggie.

My wife and myself can both testify to the fact of his admission to us, that he knew nothing of the posing at least, until six months after her death.

He furthermore admits that fact in a letter of his in my possession dated

March 29, 1886, wherein he says: "Three years since when this trouble about the girls posing, came to my knowledge,".

The letter indeed claims an acquaintance with the subject longer by several months, than the truth warrants.

As to the grosser charges, (which, perhaps, I should ask pardon for alluding to,) in asserting that they were confided to him by Miss Maggie Eakins, both my wife and myself are sure that he does not tell the truth.

I have very often heard my deceased sister-in-law talk about Mr. G. F. Stephens, still oftener heard my wife repeat her sister's talk about him.

Miss Maggie Eakins always spoke of him with extreme kindliness and liking, mixed with amusement, at what she seemed to consider his extravagant ways of acting and talking and thinking; and very frequently too, tempered with a humorous, halftroubled sense of the oppressiveness of his juvenile, personal devotion to her—It was habitual for her to say that she felt like a mother toward him, and to speak of him as a large child.——I think there was only some six years difference between them in age; vastly more in judgement.

Is it likely she would have made a confidant in such matters,—supposing such to be,—of a young person whom she so regarded?

Is it not likely—is it not sure,—that in her frequent visits to her elder sister, my wife, between whom and herself there was a degree of love and confidence, unusual even with sisters,—or that in some of her very frequent letters, she should have made some allusion to this terrible "family skeleton"?

These letters came at least weekly from the time we left Philadelphia until her last sickness—they were very often written upon large sheets of foolscap paper, and made up a transcript, a sort of continued story of the joys and sorrows, plans and prospects, doings, troubles, and difficulties of herself and the other members of her father's house-hold.

Yet you are asked to believe that she hid this skeleton from her elder sister and entrusted the key of its closet to the youthful Mr. Stephens, and the very young lady, now his wife, the impulsive extravagances of the one and the dainty affectation of the other of whom, she so often amusingly, (tho' in perfect kindliness and good nature) described and mimicked.

Now, with regard to Thomas Eakins who, I will observe, was nearly twenty-one years old when Miss Caroline was born,——

When I learned, no earlier than Saturday morning last, that his adversary's presence was to be suffered at the meeting for discussion of the scandal, and that he himself had not been invited to attend; and that the scope of the meeting did not include the vindication of his personal character except as incidental to the refutation of a grisly calumny against the honor of the family, living and dead, I, at once, telegraphed to him, requesting him, if he did not expect to go to the meeting, to come stay overnight at my house, for security of my wife and our six little children (the elder two girls,) so as to allow me

to come to Philadelphia, hear the discussion, and be at hand for cross-examination, if required.

As Mr. G. F. Stephens, at the meeting, distinctly disavowed any intention of conveying the hideous charge which Messieurs Sartain and Van Ingen distinctly inferred from his statements to them, that matter might perhaps be dismissed from consideration; carefully observing however, that Mr. Stephen's equally distinct admission (made with an almost unaccountable display of truculent insolence and defiance) of the substantial accuracy of Mr. Frank Macdowell's statement, amounts, in effect, to an assumption of the paternity of the scandal; in as much, I submit, as no male person of mature age and judgement would interpret his words in a sense different from that in which the New York gentlemen received them.

As Mr. Stephens also said that he "didn't know for sure", but "might" have told these things—these alleged domestic improprieties to the Academy Directors: an admission at least as conclusive (to my mind) as would be his express avowal of having done so;——as I am credibly informed upon the authority of a female student at the Academy of Fine Arts, that one of the Directors had said that the true reason for Eakins's enforced resignation was not that semi-publicly assigned,—as, upon the same authority, I have learned that scandalous gossip affecting the family of Mr. Benj. Eakins was current among the members of the Academy classes, some of whom professed to credit it, as coming from, or supported by Mr. G. F. Stephens;——I conceive it to be surely my duty to do whatever I may, in the way of contradicting, and perhaps to some extent checking this atrocious wrong.

My acquaintance with Thomas Eakins began twenty nine years ago, and has continued uninterruptedly from that time until the present hour.

With a notable exception, to which I shall recur, my relation to him, during all these years, has been most intimate and friendly.

For six weeks I shared his lodgings in Paris, and for an equal period traveled with him in France and Switzerland; for six years after my marriage, I lived in the same house with him; for two or three years before my marriage, I was almost a daily visitor at his father's house, where he then lived.

During all this long period, in which I have come, as I believe, to understand his character pretty thoroughly, there has never been so much as a suspicion in my mind of impure conduct or depraved sentiment on his part.

My opportunities of judging have been such, that if ever one man can be justified in saying that he <u>knows</u> another, I may say of Thomas Eakins that I <u>know</u> he is not, nor ever has been lewd, profligate, or depraved.

I own that he sometimes uses coarse expressions in his talk;—that he is apt not fitly to respect the periphrases in which society has decreed that certain notions shall be enveloped; that his manner is, at times, unpleasant to the fastidious and super-sensitive, too often, perhaps, to those also who

cannot justly be called super-sensitive;—that he is often openly contemptuous of the opinions and sentiments of others, thereby exposing himself to just resentment; that he occasionally disregards the conventional proprieties of life to an extent that I consider injudicious and dangerous; of which injudiciousness and danger no better proof could be asked than the present case affords, where the knowledge of some harmless, or at worst, annoying breaches of conventional decorum has enabled a shallow, vindictive enemy, armed with a glib tongue, and ready cunning, to deal most damaging blows to reputation and happiness.

All this I know and understand, but find in it no reason to modify my opinion of his essential uprightness and integrity.

I am now constrained by the treachery of Mr. G. F. Stephens to me personally, to refer to a matter, allusion to which otherwise without excuse, in the actual circumstances, I assume is justified.

Nearly fourteen years ago there was a breach in the friendship between Thomas Eakins and myself, which immediately before the final settlement of the trouble (fourteen years ago next winter) had bred in me such an intense hostility toward him, that I confess having said to him, in the presence of his father, that if it were possible to confine the consequences of the act to our two selves, I would take his life.

The nature and particulars of the trouble between us I have not mentioned from that day to this, to any living person, and do not intend to go into them now. Only two other persons besides ourselves, were, so far as I know, fully cognizant of them, and these two have been in their graves for years.

It was a purely personal affair growing out of hasty, unconsidered words, spoken in anger and dropped out of memory, and falling in fruitful soil, but in the hottest of my animosity I never thought of accusing Thomas Eakins of personal impurity or immorality.

No part of the difficulty had any relation whatever to the ideas and suggestions which have formed the ostensible basis of Mr. Stephens's enterprises.

Three years ago, the coming autumn, wearied to disgust by the ceaseless invective of Mr. Stephens and his sweetheart against Eakins, any attempt on our part to deprecate which, was invariably met by them with a juvenile arrogance of superior wisdom and knowledge of character, attributing our indifference to the trivialities which they chose to regard as grievous wrongs, and our failure to sympathize with them, to our remoteness from the scene of action and want of experience of similar treatment, I deliberately, but I fear very foolishly, gave to Mr. Stephens in express confidence, a glimpse of the earlier relations (then more than eleven years in the past) between Thomas Eakins and myself; but without explaining or even alluding to the origin and particulars of the trouble.

I told Mr. Stephens, distinctly, that my sole reason for doing this, was that he and Miss Caddy might see that our peaceful counsels were not mere gratuities; that there had been a time when we, too, were sufferers from Tom's want of considerateness and that, too, infinitely more than they.

I now learn from two persons, one, an entire stranger, whom I never saw before last Saturday night, and the other a recent acquaintance, that Mr. Stephens has not only betrayed my trust in him, by publishing my confidential communication, but has also perverted it to the service of his sinister purpose against my wife's brother by representing me, to strangers as sympathising in his antagonism to the extent of having threatened Eakins's life.

Guilty, as I know him to be, of betrayal and perversion of my own confidence in him;

Guilty by his own admission on Saturday night last, of the authorship and circulation of statements, to reasonable and disinterested men importing a horrid charge, but which he now says he did not seek to convey;

Guilty, as we are in condition to prove, by his own admissions, oral and written of having falsely boasted of a confidence he did not possess; this, namely, that his alleged acquaintance with certain methods, or accessories of Art study, by him assumed to be indecent, was the result of a confidence in him by the late Margaret C. Eakins, whose memory he now, perhaps unconsciously, assails in the letter of March 29,/,86, (before mentioned) wherein he claims that the burden of some assumed outrageous offense against common decency, must be borne by her and some ladies of the Academy of Fine Arts, as the only alternative of the position that her only brother and constant associate, is, and for years has been a beast, and the debaucher of the minds and manners of his pupils.

Guilty, as he appears to me, on all these counts, I submit that Mr. G. F. Stephens's assumption of the role of conservator of morals and manners, champion of modesty, factotum to Divine Retribution and Almighty Justice, is not justified by anything observable to those who are in a position to criticise his character from the rearward side, a field of discovery, perhaps, even yet not fully explored.

As to the gentlemen who have been Mr. Stephens's co-adjutors in the Academy proceedings, all of them entire strangers to me, I have no unkind word to say. For myself I never entertained, for a single moment, the conspiracy hypothesis; but I should much like to know, whether, supposing it possible for these gentleman [*sic*.] to wholly divest their minds of every impression received from Mr. G. F. Stephens, any one of them would venture to apply the favorite epithets "gross and vile" to the character of the man, Thos. Eakins, whether, unsupplemented by Mr. Stephens's rhetoric, he would think any worse of Thos. Eakins, than that he is a man whose notions of decorum are unpractical, impracticable and inexpedient; and whose language and manners frequently violate the accepted canons of good taste.

I should gladly say something about my brother-in-law's many good and noble traits; such, for instance, as his unwearying gentleness and perfect skill as a nurse of the sick, mention of which, irrelevant tho' it may appear to some, it is to my mind distinctly and highly relevant, because, as any earnest, thinking man knows, these qualities are incompatible with the possession of a depraved nature.

I cannot forbear referring in this connection to Mr. Stephens's treatment upon one occasion of an allusion by my wife to an incident illustrative of her brother's unselfish humanity and kindness of heart.

Breaking in upon the half-told story, and snapping his fingers impatiently, he exclaimed:

"I dont care one cent for a <u>mere animal</u> thing like that" . . .

The term "merely animal" might with equal justice have been used to characterize the conduct of the Good Samaritan in the New Testament parable, a story somewhat resembling, in its details, the incident my wife was trying to relate.

I fear I have wearied you; and yet our own intense interest in the subject and the knowledge that you have heretofore been willing to share in its investigation lead me to hope that you have favored me with your attention.

Altho' I have written in very great mental agitation, which my wife shares with me, I have yet kept in view from the start that I proposed to append to this letter an affadavit of its truth; a sanction which, unnecessary, I trust, to its credibility among the few who know me intimately, has acted as a check upon intemperateness of expression, and will perhaps give it an additional weight among strangers.

I will now conclude, first adding copies of the letters written by myself and Mrs. Crowell to Mr. Wm. G. Macdowell, which we wish to include in our affadavits.

"Avondale P.O. May 24/86.

Dear Mr. Macdowell,

I return with this the copies of Wm. Sartain's and Frank Macdowell's letters. The statements contained in them upon the reported authority of G. F. Stephens, are atrocious falsehoods—a horrible calumny, hardly intelligible upon any other hypothesis than those of insanity or devilish malignity in the authorship.

I speak not only from my knowledge of Tom's character, got during an intimacy almost life-long; but from daily observation of his home life in his father's house (where I too lived for six years after my marriage), from Maggie's conversation during frequent visits to our house in the country, occasionally accompanied by Tom and from Maggie's letters to my wife weekly from the time we left Philada. up to her last sickness.

No charge of immorality or impurity was ever uttered, or as I believe,

conceived against Tom, by myself, or my wife, or her sister Maggie. No ground for any such charge, as we believe, exists, or ever did exist.

<div align="center">

Sincerely yours
(signed) Wm. J. Crowell".
</div>

<div align="right">

"May 24/86
</div>

Dear Mr. Macdowell,

During all my life I never heard of any act of immorality committed by my brother Thomas Eakins.

I never heard of any such act being even charged against him. There was never any suspicion of him in either my own mind, or in that of my deceased sister.

At the time of my leaving home, more than eight years after my brother's return from Europe, my sister Caddy was but a child of thirteen years, and her removal to my vacant room was in no sense occasioned by any dread of immoral conduct towards her from her brother.

<div align="center">

(signed) Frances E. Crowell
</div>

I need hardly add that I consider Frank's charges most infamous, false, and cruel.

<div align="center">

(signed) F. E. C."
</div>

<div align="center">

Very respectfully yours
(signed William J. Crowell.
</div>

Commonwealth of Pennsylvania
County of Chester L.L.

Before me, a Justice of the Peace, residing at Avondale in said County, this fifth day of June A.D. 1886, personally appeared William J. Crowell of this vicinity, who, being duly sworn deposes and says that he is the writer of the foregoing letter of thirty six pages (in this copy twenty three and a half,) addressed to John V. Sears of Philadelphia; that the statements therein made, including those in the copies of letters dated May 24, 1886, so far as they lie within the deponents knowledge, are true; and that those matters which are therein stated on information and belief, are true, according to the best of the deponents knowledge, information and belief, and that he verily believes them to be true.

Deponent further says that the said letter was written, and this deposition is made of his own free will and accord, and without the suggestion, persuasion, or solicitation of any person whomsoever.

<div align="center">

(signed) William J. Crowell
</div>

Sworn and subscribed before me the day and year aforesaid.

<div align="center">

(signed) Lewis A. Lipp
J.P.
</div>

Before me, a Justice of the Peace of the Commonwealth of Pennsylvania residing at Avondale in Chester County, personally appeared Frances E.

Crowell, wife of William J. Crowell, above deposing, who, being duly sworn, deposes and says that she has carefully read the foregoing letter, dated June 5,/86, and deposition of her said husband, and that she verily believes the statements therein contained to be true; and desires to re-iterate under the ~~statements of~~ sanction of an oath the statements made in her own letter dated May 24, 1886, addressed to William G. Macdowell, a true copy whereof is embraced within the said letter of her husband to John V. Sears; further that she makes this deposition voluntarily and of her own free will and accord, and without any persuasion, solicitation, or constraint by her said husband, or any other person whomsoever.

<div align="right">(signed) Frances Eakins Crowell</div>

Sworn and subscribed before me this fifth day of June, A.D. 1886

<div align="right">(signed) Lewis A. Lipp
J.P.</div>

[TE to Edward Hornor Coates]

<div align="right">Philadelphia, Sept. 11/86</div>

Dear Mr. Coates,

The careful consideration I have always had from you of my written matter, induces me to lay before you some opinions, in which if you do not agree with me, for there are all shades and degrees of even the same opinions, I yet trust I will at least make you understand me; for I have been fearfully traduced and I think even by you sometimes misunderstood: nothing is to be more feared I find than hasty judgement on real facts distorted and purposely deprived of circumstance.

If for instance, I should be in a railroad accident, and escaping myself unhurt, should on looking around me, perceive a lady bleeding most dangerously from the lower extremity; then and there I should try to find the artery and compress it, perhaps tie it if any bystander had the stomach to aid me: and for this I might well receive both her gratitude and that of her folks.

Now if years after, some evil disposed person would run busily about and whisper that I was a filthy person, that I had lifted up a lady's clothes in a public place, that on account of it, there was a great scandal at the time (when there was none), that I was near being killed, I should have upon me at once more than I might ever hope to fully contradict, except to a very few friends, and of my few friends, some would sympathize with me, but would wish I wouldn't do unconventional things, and some would tell me that it is always bad to have dealings with strange women anyhow, and others with much worldly wisdom that no motives can ever be understood by the public except lechery and money-making, and as there was no money in the affair I should not have meddled, as if my chief care should be the applause of the vulgar.

Again, a man could easily be accused of lewdness, and his actions be truthfully described in fearful terms; yet if the explanation were once listened to that he was an obstetric physician practising his calling he might rest blameless.

The long study of the man, and his skill have given him the right to do whenever necessary unconventional things; and the more civilized the community, the more its members differentiated, the more are such rights respected and understood. So the figure painter may be accorded privileges not allowed to the rabble, and must be if his work is to be worthy.

Although professional privileges are more tardily accorded to women than to men, and with reason, yet there is a decided advance making with respect to the education of women especially in America.

And if women are to be taught at all I think they should have good teaching.

I once knew a lady physician of some renown and large practice, whom I admired and greatly respected. She got a little troublesome sore on her master finger but did not recognize it as a venereal chancre, and delivering and examining many patients, she introduced the syphilis into a great many families who never deserved it, and died herself after great suffering from the effects of her ignorance.

But within the last few years the young women medical students attend the same clinics as the men. The most dreadful diseases are shown them, described, and operated on, much to the safety of those families who are afterwards to employ these students become physicians.

And while students, these young women spy into each others' piddle with a microscope and do a hundred other unconventional things, from which the novelty now being worn off, even mild derision can hardly be excited against them.

I do not believe that great painting or sculpture or surgery will ever be done by women, yet good enough work is continually done by them to be well worth their doing, and as the population increases, and marriages are later and fewer, and the risks of losing fortunes greater; so increases the number of women who are or may be compelled at some time to support themselves, and figure painting is not now so dishonorable to them.

Miss Elizabeth Gardner who studied the nude at Paris (with young men) while I was a student there, paints the figure now almost exactly like Bouguereau, and her pictures sell so well that she must be rapidly accumulating a fortune, and I could name many other women both painters and sculptors who are honorably supporting themselves; and even if marriage should be contemplated by them, they are at least in a position from their education to decline ineligible offers.

But no woman could ever hope to paint like Miss Gardner or Miss Clementina Tompkins and live at all times the conventional life.

She must assume professional privileges. She must be the guardian of her own virtue. She must take on the right to examine naked men and women. Forsaking prudery, she locks her studio door whenever she wishes, and refuses admittance on the plea that she has a model. And without these privileges, she could not hope in any way to compete with men nor with the intelligent of her own sex, and a certificate of prudery would not in this age help sell a figure piece by a young lady.

Under the chairmanship of Mr. Rogers, the aim of the Academy schools was to give the advantages of the best instruction possible to men and women who were to become professional painters and sculptors. The result hoped for was the possible development of ~~some great~~ talent which would repay in honor by great work, the careful thought expended in the direction of the methods of study, ~~and the generous money supplied for the maintenance~~

I need not perhaps tell you how earnestly I seconded his efforts.

I most carefully watched the progress of every intelligent student, and supplemented school work whenever possible by the advantages of my private studio.

Being the only artist in the city habitually using the nude model, I have often had my best students with me while making my pictures, and have freely advised or aided them in the making of their own, and I believe much of the success of the figure work by graduates of the school has come from supplementary work on my part.

And right here I shall tell you that I never gave these special advantages to any student man or woman, who did not show in my judgment the best talent in the class, or who did not intend to be strictly professional.

I see no impropriety in looking at the most beautiful of Nature's works, the naked figure. If there is impropriety, then just where does such impropriety begin? Is it wrong to look at a picture of a naked figure or at a statue? English ladies of the last generation thought so & avoided the statue galleries, but do so no longer. Or is it a question of sex? Should men make only the statues of men to be looked at by men, while the statues of women should be made by women to be looked at by women only? Should the he-painters draw the horses and bulls, and the she-painters like Rosa Bonheur the mares and the cows?

Must the poor old male body in the dissecting room be mutilated before Miss Prudery can dabble in his guts? Such indignities anger me. Can not any one see into what contemptible inconsistencies such follies all lead? and how dangerous they are?

Take the case of ~~our~~ poor Godley who by his actions and words during years admitted of no impropriety in the exposure of the living male form even to female eyes, yet was sent around by Frank Stephens to quarrel with me in the dissecting room matter, saying with words put into his mouth that he must draw the line somewhere. So he drew his line of propriety between

the living and the dead body, and getting with the young women on the foolish side of the foolish line, they discussed obscenity.

Such inconsistencies brought to the attention of a thinker interested in art education should arouse some very serious thoughts.

If the exposure of the naked body for study purposes is improper, life classes should be shut up, but I maintain that art is refining rather, and I should have very little respect for any figure painter or sculptor man or woman who would be unwilling to undress himself if useful; yet by his presence in a life class would encourage a model to do it, holding it either a sin or degradation.

The class room with the distant model forms but a part of the education of a master painter or sculptor.

I believe I have the courage of my convictions. I am not heedless. My life has been full of care and thought, and governed by good moral principles, and it is very wicked and unjust to misfit my doings to motives which a very little consideration would show did not govern them.

<div style="text-align:right">Yours truly
Thomas Eakins</div>

[TE to Edward Hornor Coates]

<div style="text-align:right">Philadelphia Sept 12/86</div>

Dear Mr. Coates,

Having given you in fragments some account of Miss Van Buren's studies with me I am moved to write it fully. She is a lady of perhaps thirty years or more, and from Detroit She came to the Academy some years ago to study figure painting by which art she hoped to support herself, her parents I believe being dead. I early recognized her as a very capable person. She had a temperament sensitive to color and form, was grave, earnest, thoughtful and industrious. She soon surpassed her fellows, and I marked her as one I ought to help in every way. Once in the dissecting room she asked me the explanation of a movement of the pelvis in relation to the axis of movement of the whole body, so I told her to come around with me to my own studio where I was shortly going. There stripping myself, I gave her the explanation as I could not have done by words only. There was not the slightest embarrassment or cause for embarrassment on her part or on mine. When next year she arrived at the Philadelphia school, I was using a nude man, and I had her come around and model alongside of me that I might give her more particular advantages of which she profited for some weeks. I also directed her choice of classes at the Academy and method of study.

Our social relations were what would be natural anywhere between kindly decent people.

She staid to lunch two or three times when it stormed for her health

was not good, and I think she came to tea once and spent the evening with us.

She was taken sick that spring and went early to the sea-shore. She asked my advice about the summer work, and I told her if she gained strength enough to want to work, then to make color studies of outdoor effects, and to model in wax with her companion from one anothers' bodies, and said that I would correct their work in the fall of they would bring it to me: which she intended to do.

When back in the fall, improved somewhat in health, she told me that although they had taken my advice about modelling, they had done but very very little. I supposed it was on this account they did not bring it to me for correction.

If it had been advanced enough to gain by criticism I do not believe she would have hesitated to undress herself before me any more than before her family physician; but as it was I never saw her undressed, and she never saw me undressed but the once, because no other occasion arose to require it.

The lady has been quite an invalid at home. After the Academy trouble, she wrote us a letter, (but without mentioning the trouble, although she had most abundant means to hear of it through my enemies), thanking me again for the interest and kindness I had always shown her.

Except yourself, I do not think Miss ~~VanBuren~~ Cald. knew or cared for any Academy Director. She paid her money and took what the school provided.

I have spread out this history at length as it is the one to which I had always supposed before your denial that your question referred, as to whether I thought it right to undress before a person who did not want to see me.

The lady would hardly like to ask to see me, yet she was glad to do so. I think indeed she might have been embarrassed, if I had picked up a man on the street and endeavored to persuade him to undress before the lady for a quarter, while with me and Mrs. Eakins there was no danger of misunderstanding, or misapprehension of any kind.

Now if the Academy Directors wished to enquire into my private or professional affairs in order to act upon what seems to me did not concern them, I think they should have at least investigated them, and if any thing suspicious appeared to them, they should have told me just what it was, and have asked of me the explanation. The whole conspiracy against me was so secret that I could only guess at my accusers and of what they might have accused me, nor would any one enlighten me. The subsequent action of the Directors was to my mind cowardly cruel and dishonorable.

Yours truly
Thomas Eakins.

[TE to SME]

Sunday, Aug. 28th, 1887

Dear Sue,

As I was very anxious to join the round up and we did not know where it was, we started last Monday after dinner for Dickinson to get some news of it. We put up at Loomis's on the Green River some distance above the trail. Loomis's is 15 miles from Dickinson. Little George Wood had become a little tired of the ranch and wanted to get to a friend's at St. Paul to shoot chickens and fish till his father came so he went along.

Loomis is a farmer. They call farmers grangers out here & is our nearest neighbor, 30 miles, except Arnets who live only 16 miles. I was over at Arnets day before yesterday. They have a lot of beaver dams right alongside of the house where trappers cannot disturb them. When we got to Loomis's & picketed our horses & eaten supper Mrs. Loomis mentioned incidentally that seven cowboys had been there to dinner. This made Mr. Tripp very anxious to get back & he would have started back next morning if we had not had George with us. If we could have borrowed a good saddle horse of Loomis Mr. Tripp would have gone to town himself and left me to drive to Dickinson & back. But Loomis had no good horse and we took an early start to Dickinson, bought what was necessary and left George at the depot; we hadn't time to see him off and started back home. On the way home we stopped at Pryor's for dinner, another granger on the Green River. Our dog Ponto made a rush for the little tame antelope tied to a string and caught him by the hind leg but Mr. Tripp saw him and yelled at him in time. The next bite would have been at his throat. It was not the dog's fault. He is accustomed to catching wounded deer & antelope & thought he had a prize that we would be glad to see him get. Fortunately he did not hurt the little thing much, only frightened it, and the little girl that owns it. It is very pretty playing and skipping about, and is allowed to run loose most of the time. A cowboy ran it down & caught it when little with his lasso and brought it as a present to little Gracie Pryor.

After dinner we hitched up & drove home & the Pryors hitched up & came with us because they wanted to gather a couple of bushels of wild plums in the bad lands to make preserves for the winter.

~~Next day~~ When we had got ready to go Monday morning the horses were off as usual & we went to hunt them. We found them after a short ride of 12 miles all but the ones he wanted. I offered him mine as I wanted to see it driven to harness & he went in with us over the prairie & bad lands hard travelling to Loomis 30 miles & next day to Dickinson & back to the ranch 60 miles in the one day, & we brought from Dickinson 300 pounds of shorts to feed hogs with. The horse alongside of him was a colt only 4 years old, Mr. Tripp's best horse. They didn't appear the least bit tired but trotted along the last part of the road the fast-

est. Then we watered them & turned them loose. They do not eat oats or grain only grass. The horses here have great endurance. One day we started out to find our horses and hunt antelope & we rode 60 miles, a good part of it on a fast lope and some of it a full run from one hill to another, and he did not appear at all tired, so I took him next day to look up the horses again & we found them after riding only 30 miles altogether, part of that pretty fast to keep the ponies from running out of the trail sideways, or rather rushing after them and driving them in whenever they did. Dave Foote, a cattle owner, rode out to our place next day being very much interested in the approaching round up & he & Mr. Tripp rode 70 miles to find out something about it. They only found some newly branded calves but couldn't find the round up & so Dave went home again next morning. I couldn't go with them because I had to get ready my photograph snap, the waterproof cloth having worn out also the seat of my breeches which I wanted to mend. They were an all day job & by night I was all ready packed for the round up. It hasn't come yet & only yesterday afternoon we got trustworthy news from the return of one of Arnet's men past our place bringing home his string of tired horses & one of ours lame. The round up had split & changed its course & our horses & man will be home in about 4 days & there will be no round up here for two weeks until Jeffries cattle are shipped east.

This will hinder me from seeing the Indians. We met one in a wagon with two squaws coming out to hunt deer in the bad lands. His young son a lad of 14 or so was riding a pony. He wore a straw hat. Loomis was out in the bad lands cutting some wood & staid all night but his partner Hall brought home the load of wood & had seen the same indian. The indian had come up through the thick brush without making a sound & touched Loomis on the shoulder and said how? for how do you do. The indians take pride in making no noise. There is no longer danger of indians here but a few years ago a man never went from his house to his barn without his Winchester. Do you remember the little cow-black-birds that keep around the cattle. There are lots of them. One day I was helping herd cattle. A bird left the herd & came on to my horse's head. I had my leg across the pommel of my saddle and pretty soon he ran down the horse's neck after flies and directly he jumped up on my knee. My leather breeches were slippery & he would slip & then have to open his wings to keep from falling. He ran up & down my leg balancing himself running against my hand and then back to the horse's neck if he saw a fly there.

I guess he played there a quarter of an hour until I had to go chase in a steer. You would laugh to see these birds riding horse back. When the horses go too fast the birds fall off & then they fly back & scold & get on again. The horses & cattle don't mind them a bit. I guess they like them. They are very pretty shaped birds and look very knowing. When one gets

on a cowboy's hat, the cow boy shoos him off so that he won't do his job on his hat.

Afternoon.

We had the first frost 6 days ago the night we spent at Loomis's. When we got our horses before sunrise, the picket rope was icy. Old man Hall took a pail of water and a broom to sprinkle his cucumbers to thaw them out, but the water froze on them, so he came back concluding he was doing more harm than good. Up here on much higher ground than Green River there was a frost but not enough to hurt vegetables. This morning we went out to hunt horses. I now have a whole string of horses to ride and rest mine. We scoured the country but there are still 6 missing.

I am going to bring my own horse back with me for a model. He is a broncho, a very beautiful and a good type of cow boy horse, also a mustang, a small Indian pony, the ugliest you ever saw but a fine cow horse. This Indian pony is exceedingly tough, funny, and good natured and is for Fanny and the children to ride and drive. I bought him from little George Wood after he was done with him. The broncho is a gray & looks something like the Susie horse I once took down to the farm. If I can sell any cow boy pictures at all they will be a good investment for me. If you see Fanny, perhaps you had better tell her, as the two horses might make some difference or there might be a chance to sell or trade off the lame horse they have. But it must be kept from the children for fear of some accident preventing me getting it to them. Mr. Tripp is sure of getting me to Chicago at less price than I would buy my own ticket. The cattle men will box up a part of a cattle car for my horses and send me to take care of them free. I thus pay only my share of a car. I will also probably take care of my car of cattle, and see that they are properly fed & watered. A cattle car goes as fast as a passenger train only I shall keep on my cow boy rig & bunk in the caboose with cow boys. ~~The only part~~ So I am pretty sure of getting to Chicago which is half way, and Tripp thinks he can influence other cattle men to get me from Chicago to Philadelphia. I meet a good many cattle men and like them very much. Many of them are very rich.

Tuesday evening
Dickinson
Aug. 30

Yesterday we concluded to come to town again & bring Mrs. Tripp to send her to St. Paul. She is sick of the ranch. She likes neighbors to talk to but don't like her husband. We found a bunch of horses & caught them up yesterday morning, and got an early dinner, mounted good horses & went to look after 6 missing horses that have been gone a week. We did not find them and did not get home till dark having gone over 60 miles part in the bad lands & very fast. The last 20 miles I carried behind my saddle an antelope We killed going. It was a young one & we will have its meat several days. It

is very good, but they seem almost too pretty to kill. Today we came to Dickinson.

Wednesday morning

I only found one letter from you and that one a little doleful on account of your bad painting. All painting is bad but yours is very good compared with other people's. I saw the train come in & thought there was probably another one on it but there wasn't because it is only a week since I have been here before.

I like my horse very much. He is so gentle & bright & intelligent. You ought to see him prick up his ears when he hears me coming to give him water or change his picket pin to a good place with plenty of blue gumbo grass. It would not take long to have him follow me around like a dog. Send me Johnny Wallace's Chicago address in E. Washington St. next time you write. Mr. Tripp hates rough riding horses & he says mine is the roughest on the ranch but I like his movement very well & fit into it as well as into any other ~~gait~~ of their horses. George Tripp says he wouldn't have him

[Eakins continued this letter on the back of a letter he had just received from Lilian Hammitt. The text of the continued section is known only through Lloyd Goodrich's transcription, now in the Philadelphia Museum of Art and reproduced here with permission.]

for a gift if he had to ride him all day. I do not get stiff or tired riding. I can ride all day and not feel it, but I get sleepy as soon as night comes and sleep right through till daylight. I wish Charley Boyer was here. He would have great times shooting chickens and the grass plover are thick all over the prairie. The chickens are nearly as big as tame chickens. They must be grouse. They are bigger than the prairie chickens of Illinois. They have feathers down the legs and cluck like tame chickens I have no good shot gun so I don't go after them, but if we are out of deer meat I often shoot their heads off with my rifle. George Tripp can shoot them flying with his rifle.

I killed a big rattlesnake the other day and will bring home the rattle for Ella. My horse is the fastest of all those on the ranch, and the Indian pony is next to one the fastest with light weight George Wood on him, but he carries a heavy man very well. Two winters ago he carried George Tripp who is as heavy as I am 60 miles from sunrise to dark night part of the time through snow drifts. It would not hurt him to carry me a hundred miles in a day if he rested the next. He has split ears because he is an Indian pony. I send you Miss Hammitt's letter to give you news of her and because I was short of paper in Dickinson and the stores were not yet open. The time is more than half gone now. How happy I shall be to see you again.

[unsigned?]

[TE to John Laurie Wallace]

n.d.,[Dec. 8, 1887]
1729 Mt. Vernon St.
Philadelphia

Dear Johnny,

One neglect brings on another, and the real reason I have not written before is that I intended to go up & see your mother with Susie before I wrote. The days are short & one thing or another put off our visit and so I just didn't write. I had a splendid time coming on meeting with no accidents & no unpleasantness except a little delay around Baltimore. I was entirely comfortable, more so than in a sleeper. I could lie down or go back into the caboose or climb up on the top of my car to enjoy the scenery. I came through as pretty a country as ever I saw especially around Harper's Ferry that I passed soon after sunrise.

The delay around Baltimore was probably fortunate for I arrived home in the middle of the night. If I had got in when school was out, I fear I would have been as bad as a circus coming down Mt. Vernon St. on my broncho, leading the mustang packed with my blankets & traps.

My trunk had arrived long before with my clothes, so I stabled the horses & then went into the bath tub & to bed & next day rigged out in a boiled shirt etc.

On Saturday I got my father to ride down in the cars to Media & wait there for me to pass through on my way to the farm 40 miles down the road W.S.W. from Phila. where my sister's husband's farm is. I started down on the broncho leading the pony. At Media where the prettiest country begins my father got on Baldy & we had a delightful ride down to the farm. At Kennett Square six miles this side of the farm we met Susie on horseback and all the little children & their father in the wagon coming out to meet us. Then my father got in the wagon and little Ben got on the pony, and little Ella on Susie's horse & we scampered home like cowboys.

Little Baldy is ridden every day to school by one of the children at least an hour before school & then the school children are allowed to ride him by turns until Mr. Crowell returns with the milk wagon. Then he leads Baldy home unless another child coming in the milk wagon rides him home & in the village he is met by another crowd of children who would like to ride him as far as the farm. So I have been a public benefactor with the little beast besides giving the children the greatest happiness they have ever had. Nor is the pleasure confined to the children only. My sister is very fond of the little beast and often rides him in the afternoon when she has finished her work & Susie rides him whenever we go down to the farm.

The other horse the broncho had a bad cold the first week he was here but got over it alright. He has the sweetest disposition that a horse ever had.

He follows my sister around & the greatest trouble is to keep him from coming into the house after her. When the door is shut he puts his nose against the panes in the kitchen window. They wheel the baby coach under his nose for the baby to play with him.

Although so rough gaited the children ride him too, but not so much as little Baldy the mustang. I hope when you come on you will find time to go down to the farm for a day or so & we can ride over to see Benny McCord the farmer artist or any where else.

Fromuth came to see me last week and I am going up to his house soon to see some work he wishes me to see a little later. Wag has been to see me several times but misses me. Harry McCarter is doing very well financially with his sketches for the Press and counts on going abroad. Miss Haskell it appears is in Paris studying at Juliens with Miss Dohn, Miss Sinn, Miss Conard, and Miss Trotter and other Academy girls. Come see me as soon as you get home.

Yours,
T.E.

[TE to Lilian Hammitt]

March 2nd, 1888

Dear Miss Hammitt,

I was inexpressibly shocked to read the letter you left in my box.

You have through your companionship with my dear wife seen the great love that exists between us and heard from me many expressions of my devotion to her.

You are laboring under false notions and will surely injure your reputation if you give expression to them.

That you should have consulted a lawyer as to my getting a divorce is so extravagant that I must excuse it on the suspicion of mental disorder.

There is wisdom in your decision to stay away from my studio now for a long time, and I have abandoned my portrait of you and taken up other work. I am sorry that I cannot help you in your money affairs.

I still advise you if you cannot pay your rent, to give up your little studio especially as the spring opens, and go home and work there, and study and struggle as many other young painters are doing. You are strong in many ways, and in your little country home, you have around you the sky, the animals, land-scapes, a wealth of beautiful materials to choose from.

I sincerely trust that time will calm your troubles and that I may again be ~~able to~~ useful to you in your painting.

Yours truly,
Thomas Eakins
Copy of answer to Miss Hammitt's letter of February 29th, 1888.

[TE to John Laurie Wallace]

1729 Mount Vernon St.
Philadelphia
Oct. 22, 1888

Dear Johnny,

I declare I am ashamed to think how long it has been since I have written to you. The days slip by and soon count up into weeks and months. I got a photograph of you on my return from the country last summer.

The negative must have been very beautiful before it was retouched. However I was very glad to get the print and like it very much.

I had my negatives out the other day and was printing some. The sight of those old things brought back many a pleasant recollection and made me long to see you again. When are you ever coming back to Philadelphia to see us.

I send you a print at Mrs. Eakins's suggestion because it is a favorite with us. I think though you have one in platinum.

I do not forget ever that you expect a study or sketch some time.

Harry McCarter has gone to Europe, and Fromuth expects to go in the winter or spring.

I hear that at our old Academy they do not paint at all any more. They only draw outlines and shade them up occasionally.

My own little school has gone into good quarters at 1816 Market St., and is exempt from all impertinent interference of the ignorant.

I have nearly completed a little cowboy picture, and hope to make more. The subject cow boy subject is a very picturesque one, and it rests only with the public to want pictures.

Lat. Brown goes over with McCarter to Paris. I have not seen him for ever so long. Harry came up to see me before going & told me.

Miss Hurlbut is right well. She is going West soon and will pass through Chicago. She took your address and is coming to see you.

Tell me what you are doing in the way of work? Are you painting portraits or pictures or both?

I got a letter from Harry McCormick some time ago. He is in Chicago illustrating a sporting horse newspaper. You must already have met him.

T.E.

[TE to Charles Hammitt]

COPY

> 1729 Mt. Vernon St.
> Philadelphia, Penna.
> June 5, 1890

Mr. Charles Hammitt,
Dear Sir,

The condition of your sister Lilian has been for some years a source of anxiety to my wife and myself. Her mind is affected by delusions.

The most dangerous one at present is that I am anxious to take her from Atlanta and marry her. She has had similar delusions with regard to other men, but we were so fortunate in one case as to prevent trouble, and the delusion disappeared.

The knowledge of her condition now much worse, should I think be confined to as few persons as possible in the hope she may entirely recover.

She has great talent for painting, ~~thorough~~ artistic training and knowledge, and an intellect unusual in a woman.

Her hard study, her sorrows, the nursing of her mother, the death, the disappointments at not earning in Philadelphia at her art a compensation somewhat proportionate to its merit have probably accented ~~peculiarities~~ mental peculiarities or obscure physical disorder.

> Yours truly,
> Thomas Eakins

[Clifford P. Grayson to TE]

> 1 South 21st Street
> March 27th, 1895

Thos. Eakins, Esq.
Sir,

I have just been told that you think it strange that I have not been to see you since your dismissal from the "Drexel Institute". As that dismissal was the inevitable result of your own silly behavior a visit and apology from you to me would be in better taste. The money for your course of lectures will be paid in full, although you have only delivered four of them. You will have no occasion therefore to sue the Institute. In view of your weakness for cheap notoriety, this no doubt, will be a sad disappointment to you.

> Yours truly,
> Clifford P. Grayson

[Robert Arthur to TE]

<div align="right">

March 31st /95
49 W. 32nd Street
New York

</div>

My dear Eakins,

If some enemy of Grayson's had concocted a letter for the purpose of proving him a donkey he could hardly have been more successful. I showed the letter to Maynard, Low, Turner, who, of course, were amazed that Grayson should write so pathetically silly an effusion. Suspect that Grayson has had a hauling over the coals in the Drexel Institute and was trying to take it out on you.

Your portraits are tolerably well hung—better than usual tho' not so well as they deserve—at the north end of the "West Gallery"—They have been highly praised in all the preliminary notices. Between them is a big cattle picture by Howe with a bellowing bull.

Am glad to know that there will be no suit and that the "Drexel Institute" admits, by paying the money, that you did not break your promise and contracts as charged at first by Macallister.

<div align="right">

Sincerely your friend,
Robert Arthur

</div>

Chronology of the Life of Thomas Eakins

1844	July 25, born in Philadelphia
1861	Graduated from Central High School
1862	Registers for antique class and anatomy lectures at PAFA
1863	Registers for life class at PAFA
1866	Sails for France, enrolls in the atelier of J. L. Gérôme at the École des Beaux Arts
1867	Summer trip to Switzerland with William Crowell and William Sartain
1868	His father, Benjamin Eakins (b. 1818) and sister Frances (b. 1848) visit Europe, travel with TE in summer; December, TE returns to Philadelphia
1869	March, returns to Paris; late summer spent in atelier of Léon Bonnat. November, trip to Spain
1870	In Seville until June; revisits Paris; returns to Philadelphia by July 4. Studio established at 1729 Mt. Vernon Street
1874–76	Teaching evening classes at the Sketch Club
1874	Engagement to Katherine Crowell (1851–79)
1875	Paints *The Gross Clinic*
1876	New PAFA building opens; volunteers as Christian Schuessele's assistant and demonstrator of anatomy; Centennial Exhibition opens
1877	Teaches at Art Students' Union when assistance to Schuessele denied
1878	Volunteers again to assist Schuessele; first illustrations for *Scribner's Monthly*
1879	Death of his fiancée. Death of Schuessele. Appointed Professor of Drawing and Painting at PAFA
1880	First perspective lectures; first experiments in photography

1882	Teaching at Brooklyn Art Association; becomes Director of PAFA School; death of sister Margaret (b. 1853)
1884	Marriage to Susan Hannah Macdowell (1851–1938); studio at 1330 Chestnut Street
1885	Sister Caroline (1865–1889) marries his student George Frank Stephens; teaching at Brooklyn and Art Students' League, N.Y.
1886	February 9, resigns as Director of PAFA schools; Art Students' League of Philadelphia formed
1887	Summer Trip to B-T ranch
1888	Anatomical lectures at National Academy of Design, New York
1889	*Agnew Clinic;* death of sister Caroline
1891	Resigns from Society of American Artists, following rejection of *Agnew Clinic* and other paintings; Samuel Murray joins him in Chestnut Street studio
1895	Dismissed from anatomical lecturing at Drexel Institute
1896	One-man exhibition at Earle's Galleries, Philadelphia
1897	Suicide of niece Ella Crowell; conclusion of teaching; PAFA purchases *The Cello Player*
1899	Death of his father, Benjamin, and of Aunt Eliza Cowperthwait
1900	Mary Adeline Williams joins TE and SME at 1729 Mt. Vernon Street; leaves Chestnut Street studio; top floor at Mt. Vernon Street converted into new studio
1910–12	Poor health and failing eyesight gradually bring painting to a stop
1916	June 25, death at age 71
1917–18	Memorial Exhibition at the Metropolitan Museum of Art and PAFA
1944	Centenary exhibitions at the Carnegie Institute, Pittsburgh; Knoedler Gallery, New York; and Philadelphia Museum of Art

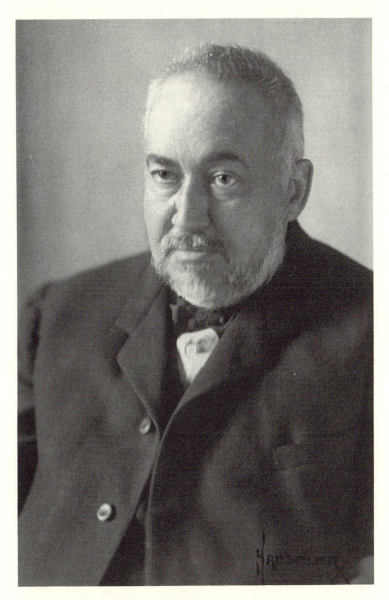

39. Conrad F. Haeseler, Thomas Eakins at about 65, ca. 1910,
platinum print, 6¹⁄₁₆ × 4″.

_This formal studio portrait shows the artist a bit heavier than in any of the other
images. It has been mounted onto a 3-layer ornamental mount. The photographer,
Conrad Haeseler, exhibited in three of the Photographic Society of Philadelphia's
Salons at the Pennsylvania Academy of the Fine Arts from 1898–1900, and he
continued to work in Philadelphia after the turn of the century. His relation to
Eakins, and the circumstances of this portrait sitting, remain unknown._

Genealogical Chart for the
Eakins Family

Family Tree for Thomas Eakins

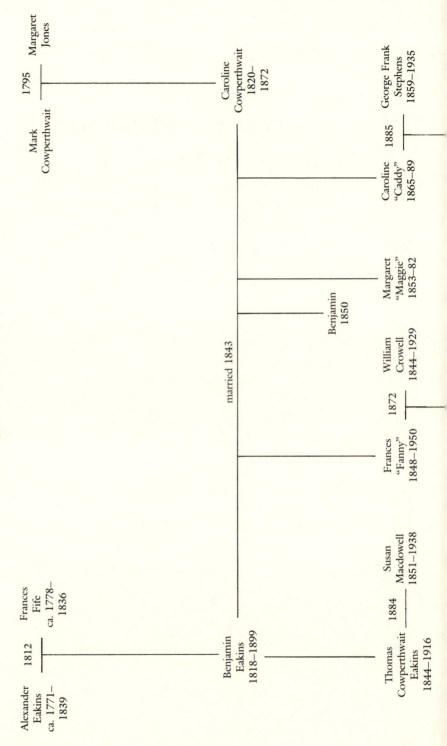

Roger
1889

Donald
1887

Margaret
1886

Caroline
1893–1972

Frances
"Fanny"
1890–1971

James White
1888–

Kathrin
1886–99

Thomas
1883–1964

Arthur
1881–1969

William
James
1879–1975

Benjamin
1877–1960

Margaret
"Maggie"
1876–1920/24

Eleanor
"Ella"
1873–97

The Manuscripts of
Susan Macdowell Eakins

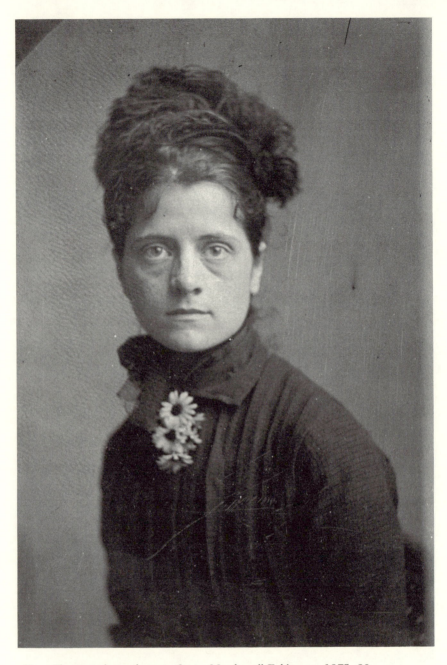

40. Photographer unknown, Susan Macdowell Eakins, ca. 1875–80, tintype, 3 7/16 × 2 5/16".

The Bregler Collection contains both a profile and a full-face version of this image of Susan taken by an unknown commercial photographer. The feathered hat and the bunch of daisies at her throat give a very artistic look to the young painter some years before her marriage.

The Life and Papers of
Susan Macdowell Eakins

CHERYL LEIBOLD

Almost every published work on Thomas Eakins mentions the lifelong ded-
ication of his wife, Susan Macdowell Eakins. She was an accomplished artist
in her own right, but her life and work have long been overshadowed by
her husband's fame. To date only one work on Susan Eakins herself has
appeared: the 1973 catalogue of an exhibition of her work held at the Penn-
sylvania Academy of the Fine Arts. With the acquisition of Charles Bregler's
Thomas Eakins Collection, the Pennsylvania Academy now holds material
that will allow art historians to reevaluate her life and career.

Biographical Facts

There are few biographical landmarks in the life of Susan Macdowell Eakins.
Born in 1851, she grew up the fifth of eight children in a large family headed
by William H. Macdowell, a well-known engraver. More than one of her
siblings showed an interest in art, although none so pronounced as Susan's.[1]

 She studied at the Pennsylvania Academy from 1876 to 1882, distin-
guishing herself by winning prizes in two of the Annual Exhibitions, both
awarded for the first time. In 1879 she won the Mary Smith Prize for the
best painting by a resident female artist in the Annual and in 1882 the Toppan
Prize for a work by an Academy student. The Bregler Collection has revealed
a reproduction of her 1882 Toppan prizewinning painting, *The Old Clock
on the Stairs,* a heretofore unknown work inspired by the Longfellow poem

of that name. It was quite an ambitious composition depicting a young couple chatting at the base of a flight of stairs. (See figure 41.) A news clipping reveals that the work was commissioned by Fairman Rogers. While still a student Susan showed work in six Annual Exhibitions: 1876, 1877, 1878, 1879, 1881, and 1882. (Until about 1890, it was common for students to exhibit in the annuals.)

Although Susan's first meeting with Thomas Eakins predated her Academy studies, she surely got to know him better during her student years. She was active in student affairs, and with her lively mind and artistic talent, the friendship must have surprised few who knew them.[2] In January of 1884, they were married, taking up residence at Thomas' Chestnut Street studio. In July 1886, they moved to the Eakins family home at 1729 Mount Vernon St, where they would both remain until their deaths.

Although the marriage was childless, they were devoted to each other, and to the life of art and music that they preferred. Much has been made of the fact that Susan apparently abandoned her own promising painting career to support her husband's career. She exhibited with the Philadelphia Society of Artists in its first two exhibitions in 1879 and 1880 (both held at the Academy), and one last time in its second Sketch Exhibition in November of 1883, just prior to her marriage.[3]

After 1882 she exhibited only once more in the Pennsylvania Academy Annuals, a portrait of her old Academy teacher, Professor Schuessele, in 1905. In 1898, she exhibited a photograph in the First Philadelphia Photographic Salon, an act indicative of her interest in this medium and of her continuing participation in the world of art and ideas. During the years of her marriage Susan painted only sporadically, but she assisted her husband on at least two of his works.

Susan's biographer is hard-pressed to come up with additional specific events in her life. After her husband's death, she remained in the Mount Vernon Street house, committed to placing his works in important collections, disseminating information about him, and continuing her own painting. She lent 44 works and assisted Gilbert S. Parker in securing other loans for the 1917 retrospective of Eakins' work at the Metropolitan Museum of Art. The exhibition appeared with additional works at the Pennsylvania Academy in 1918. She cooperated with several New York dealers in mounting smaller exhibitions of Eakins' work, notably at the Joseph Brummer Gallery in 1923 and the Babcock Gallery in 1927, 1929, and 1930. Sales from these exhibitions were minimal. In 1936 she organized an exhibition of 85 works by Charles Fussell, David Wilson Jordan, Charles Bregler, Samuel Murray, Elizabeth Macdowell Kenton, herself, and Thomas Eakins at the Art Club

41. Frederick Gutekunst, *The Old Clock on the Stairs*,
by Susan Macdowell Eakins, 1882, phototype, 8¾ × 6⁷⁄₁₆″.

*This photoreproduction of Susan's Macdowell's Toppan Prize-winning painting,
shown at the Pennsylvania Academy in 1882, illustrates her style two years before
her marriage to Eakins. At this time she shared his interest in early nineteenth-
century subjects and also his patrons, for this picture (now lost) was commissioned
by Eakins' friend Fairman Rogers.*

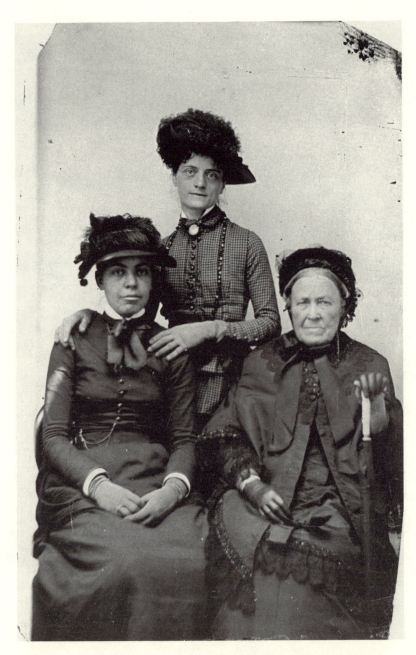

42. Photographer unknown, Susan Macdowell Eakins, Margaret Eakins, and Mary Trimble, ca. 1880–82, tintype, 3¹³⁄₁₆ × 2⁷⁄₁₆″.

Susan's sisterly pose, with her hand on Maggie's shoulder, demonstrates the closeness of the two families even before the marriage of Tom and Susan.

Gallery in Philadelphia. She included 19 of her own works, the largest group she ever showed in public.

Her work, mostly portraits, did increase in quantity in the last two decades of her life, although it lacked the strength of her early years. The Bregler Collection contains two fine self-portraits from these later years, both of which reflect Susan Eakins' strong, intelligent character (see Figure 43). Her letters to Charles Bregler and her diaries contain passing references to works in progress or to techniques, but on the whole scholars hoping to find here a significant new cache of information about her painting will probably be disappointed.

During these years her income from her husband's estate and that of her brother, William G. Macdowell, left her without financial worries. She was able to devote herself to her painting and to her concern for Tom's artistic legacy. She died, in her 87th year, after a brief illness, on December 27, 1938.

The Manuscripts

The manuscripts of Susan Macdowell Eakins preserved in the Bregler Collection form an uneven assortment, much of which seems to have been saved in an attempt to document her husband's career. While valuable insights into her life are indeed provided, it is also clear that much has been lost. When the house was cleared in 1939 a good deal was destroyed (see the Introduction). Bregler's notes frequently refer to material that is now lost, and there are many references in Lloyd Goodrich's book on Eakins to manuscripts that Susan Eakins showed him but that have not surfaced in this collection. We shall probably never know the full story, but it is likely that Elizabeth Macdowell Kenton, Susan's sister, destroyed or removed manuscripts and possibly photographs before she left Philadelphia. The correspondence and personal papers listed below will provide researchers with a wide variety of insights and information from which the first comprehensive study of Susan Eakins' life and work can be undertaken.

Personal references to Eakins in these letters, while not uncommon, are not particularly revealing. One notable exception is Mrs. Eakins' draft of a letter, probably written in 1936, to Alton O'Steen, an Eakins admirer in Minnesota. Reprinted below, it contains several fine passages describing her husband. On the reverse of this scrap of paper is a draft of a letter to George Barker (the Omaha man who received some famous advice on art study from Eakins in 1906). Mrs. Eakins states that Eakins "never left the Met. Museum

43. Susan Macdowell Eakins, *Self-Portrait*, ca. 1935–37,
 oil on linen, 20 × 16″.

without finishing his visit with a contemplation of the Fates and the splendid torso of a man. . . . "

Several of Susan's letters, particularly those exchanged with her sister-in-law, Fanny, relate directly to events in Thomas Eakins' life. There are also interesting letters to and from Amelia Van Buren, and one from her brother, William G. Macdowell. Discussion of these materials has been incorporated into the commentary on the manuscripts of Thomas Eakins by Kathleen Foster elsewhere in this volume.

With the above-mentioned exceptions, Susan Eakins' surviving correspondence is primarily concerned with business matters regarding sales or loans of Thomas' works. Far more useful for the study of her or her husband's life are the diaries. They consist of a full diary for 1899 (see Figure 45), various loose pages from diaries no longer extant, and a "retrospective" diary in which she recorded the date of many important events in their lives (see Fiche Locations II/4-G-13 to II/7-G-6).

The hundreds of brief entries in these diaries provide a wealth of information on topics such as paintings commenced or finished (mostly Thomas'); social events or gatherings; friendships with other artists such as Samuel Murray; deaths, births, marriages, trips, and vacations; and many others. Among the more intriguing or interesting items in the diaries are the following:

"I try on rich stuffs to tempt Tom to paint" (diary 16 Feb 1899).

"I write of wretched conditions among the poor, and it is printed to my surprise" (retrospective diary page 1 Oct 1913; clipping of her letter-to-the-editor enclosed).[4]

"1901 Signora Gomez d'Arza instructs us in cooking spagetti and kidney Neapolitan style" (retrospective diary page 9 Oct 1913).

"This year we were familiar friends with poor Miss Hammitt (who went insane) 1887" (retrospective diary page 23 Mar 1913).

"Mr. Goodrich comes to see paintings—a young honest looking gentleman, he wants to write an Eakins article. . . . " (loose pages, printed page headed 27 Sep 1895 [1929 entry]).

Letters to Charles Bregler, 1917–1938

Another source of information on Susan's life is the collection of 117 letters and postcards she sent to Charles Bregler between 1917 and 1938. Bregler's papers have not been described in detail in this volume, although the bio-

graphical essay devoted to him summarizes the content of his correspondence and a selection of typical letters has been reproduced.

The fact that Bregler seems to have saved every note or letter that Susan Eakins sent him, a habit that is indicative of his reverential attitude toward the Eakins family, has fortunately provided a whole new perspective from which to view *her* life and ideas. Though there is no evidence to suggest that Bregler was particularly close to Susan before about 1920, they had surely known each other for some time. Charles Bregler claimed to have known her for "fifty years" (i.e., since the late 1880s), and Susan's diary for August 16, 1899 reveals that Miss Bregler (probably his sister) did seamstress work for her at that time.

Most of Susan's cards and letters to Bregler are quite brief, giving mundane instructions for errands, including the framing and cleaning of paintings. Her note of August 15, 1934, reproduced here, is typical of these messages. Occasionally she addressed a longer, more substantive letter to him in which she commented on contemporary art or artists, or her impressions of recent gallery or museum shows (see the letters of 18 Oct 1934 and 19 Dec 1929). Most of her remarks reflect a conservative taste, praising traditional figurative work and poking fun at the "crimes" of modern art. Daniel Garber and Edward Redfield seem promising to her; Yasuo Kuniyoshi is "either a fool or a knave." Her comments on Mary Cassatt (8 May 1927) reflect her strong feelings about artistic sincerity: "Out at Memorial Hall they have an exhibition of Mary Cassatt pictures—I have always felt interested in her work—it's honest, I think and so I went out yesterday afternoon and looked carefully at all her work, she makes some bad mistakes, but it is all plainly an honest effort to do intelligent work . . . some most beautiful feeling in beautiful subjects."

"Intelligent work" is a phrase that recurs throughout Susan's letters. It surely reflects her preference for friends and activities that challenged her mind. She read books, kept up with current affairs, and continued to try to grow in her art until the very end of her life. Painting was a form of "study," as she wrote to Bregler in February 1927: "All the time I can give to study, I am trying to see quickly the simple construction of form and color, and the difference of character." Again, on July 3, 1933 she wrote: "two beautiful models came to see me and I will study from both of them."

Comments on her own painting, or on technique, are relatively rare, the longest passage being found in the letter of July 18, 1934. Her statements about lighting effects for a landscape or cityscape are interesting coming from a painter who seems to have attacked these subjects only rarely, but they seem to address issues central to Bregler's painting at this time. Bregler seems

to have taken her suggestions to heart, for the effects she describes occur throughout his landscapes in this decade.

Susan Eakins constantly encouraged Bregler to continue his painting, not to lose heart or give up. Her charity to him is clearly documented in these letters.[5] On several occasions she sent him money when no service had been performed, or an amount that even she recognized was more than the work would warrant. It is clear that she grew to rely on him not just as an odd-job man but as a friend who shared her feelings about Tom and his work. In the 1920s, she turned to Thomas Stevenson to restore Tom's paintings, while Gilbert S. Parker and Clarence Cranmer acted as her agents, but by about 1930 it is clear that Bregler was doing much of this work. Bregler's opinion on authentication was sought and heeded by Susan on many occasions.

Although Susan Eakins clearly respected and liked Charles Bregler, their background and education were not similar enough to make them truly close. She almost always addressed him in her letters as "Mr. Bregler" or "Charles Bregler"; only twice does she begin a letter "Dear Charley." She rarely wrote to him of her interest in books, never of her love for music, and she saved only two of his letters to her. Her mind was really much more in sympathy with the much younger Seymour Adelman, with whom she shared a love of books, ideas, history, and current events. Her letters to Adelman, now in the Bryn Mawr College library, contain a wealth of information about her ideas, interests, and activities.

The picture we get from the Bregler correspondence of the last years of Susan's life is one of a slowing pace, a time of relaxation and thought. She refers frequently to "sorting and weeding out" the things that had accumulated in the house over the years (to Bregler 5 May 1930). She seems to want to see fewer and fewer people and to make the most of time spent in social engagements (to Bregler 27 Jul 1936).

The most vivid impression of Susan Eakins provided by this collection is that of a woman with a wonderfully keen mind right up to the last days of her life. Ten days before her death she wrote to Bregler: "I am glad I sent you word not to work on that Russel Smith canvas. I would rather it would be presented in the shape it was when Smith gave it to P. F. Rothermel" (December 13, 1938).

The critic Carl Van Vechten, who was interested in the Eakins works still owned by Susan, visited her in March 1938. On this occasion he took the striking photograph of her reproduced in Figure 44. The body may have been frail, but the mind, so patently sound, speaks to us despite the passage of time.

Notes

1. Academy records reveal that her siblings attended classes as follows: Elizabeth in 1879–83, Mary in 1880–81, and Frank in 1881.

2. A letter preserved in the Hirshhorn collection dated September 9, 1879 reveals that Tom and Susan were already quite friendly by that date. See P. D. Rosenzweig, *The Thomas Eakins Collection of the Hirshorn Museum and Sculpture Garden* (Washington, D.C.: Smithsonian Institution Press, 1977), pp. 86–87. The only published work on SME is Susan M. Casteras, *Susan Macdowell Eakins, 1851–1938* (Philadelphia: Pennsylvania Academy of the Fine Arts, 1973).

3. Her participation in the 1883 Sketch Exhibition is documented in S. R. Koehler (ed.), *The United States Art Directory and Year Book* (New York: Cassell, 1884).

4. Susan's letter to the editor of the *Philadelphia Record* begins: "A woman, once rich, now poor, asks that the editor . . . will print the following: Of necessity living where I see greater poverty and distress than my own, having personal experience of a hapless struggle against existing conditions, I ask you . . . to call attention in your own way to the conditions I try to describe." She goes on to decry public expenditures on civic embellishments rather than on housing and sanitation improvements.

5. Her charity to people other than Bregler is also well documented in numerous passages where she reveals to him that she has given money to artists and friends in need. The most significant example of this generosity is surely her continuing support for the artist Samuel Salko and his family. The Bregler Collection contains 34 letters from Salko's family acknowledging her support and keeping her informed of the family news.

Inventory of the Manuscripts of Susan Macdowell Eakins

The list that follows enumerates every letter in Susan Eakins' preserved correspondence, with two exceptions: 1) letters written by her to Charles Bregler; and 2) letters written by Tom to Susan, which are enumerated in the chapter on *his* manuscripts. In each case they refer in detail to a project he was working on. (See TE to SME, 21 Jun, 1883; 6 letters written in 1887 from Dakota Territory; 12 letters written in July and August 1897 while he was at work on the Rowland portrait; and 4 letters written in May 1905 while he was working on the Falconio portrait.) Except where noted, letters sent are retained copies or drafts. Following the list of correspondence is a listing of other personal papers of Susan Eakins preserved in this collection. See the chapter on "Editing and Filming Procedures" for details on the editing of the papers and the arrangement of this Inventory.

This Inventory is organized as follows:

I. Letters sent, n.d., 1886–1937 (Fiche Location II 1/A/4–1/D/7)

II. Letters exchanged with Horatio C. Wood over the ownership of his portrait by TE, 1917 (Fiche Location II 1/D/8–1/E/10)

III. Letters and documents, 1929–1933, re gift of art to the Pennsylvania Museum (Fiche Location II 1/E/11–1/G/10)

IV. Letters exchanged with the Salko family, n.d., 1934–1938 (Fiche Location II 1/G/11–2/E/12)

I. Letters sent: Susan Macdowell Eakins, n.d., 1886–1937.

Where no place of origin is given, 1729 Mt. Vernon St., Philadelphia is assumed.

1. SME to [unknown], n.d. [1916].

thanks for condolences on the death of TE.

1 p., draft.

2. SME to [unknown], n.d. [1931].

note concerning selection of a TE painting for the Louvre.

1 p., draft.

3. SME to Caroline Crowell, n.d. [1938].

concerns SME's ideas about existence of heaven; problems with and treatments for constipation; one page on problems with high-heeled shoes.

2 pp., draft. [Caroline Crowell was SME's niece, the youngest child of Fanny & Will Crowell.]

4. SME to Caroline Crowell, n.d. [1938].

thoughts on beauty of the human body and wisdom of the Creator.

1 p., draft.

5. SME to Caroline Crowell, n.d. [1938].

same text as above with additional thoughts on the female body.

1 p., draft [cf. Caroline Crowell to SME 6 Jan 1938].

6. SME to Cardinal Hayes, n.d.

[See following entry.]

7. SME to Father Charles E. Coughlin, n.d.

two letters asking questions concerning the sanctity of marriages between "unfit" persons (with mental or physical problems); also thoughts on the Catholic Church and its wealth.

1 p. each, drafts.

8. SME to Mrs. Gustave Ketterer, n.d.

women can help with social problems by not crippling themselves with high heels.

1 p., draft.

9. SME to Lilian Hammitt, n.d. [ca. 1887?].

advises against seeking marriage "so out of the regular way, that is, the meeting with some one, to whom you are drawn by his agreeable traits"; "my notion of marriage is the joining of two hearts and each would give up every worldly consideration that the other might be happy"; advises her to seek out friends of her own age and to work hard.

4 pp. [located in the file of correspondence with Hammitt and her family in TE's papers].

10. SME to Amelia Van Buren, 9 Jul 1887, 1729 Mt. Vernon St., Philadelphia.

will she please pass this letter on to Miss Willoughby to read; informs Miss Van Buren of the conspiracy against TE and asks her to refrain from misjudgment through the influence of Miss Willoughby; accuses Willoughby of being a conspirator against TE.

3 pp., copy.

11. SME to J. L. Wallace, 28 Jul [1887], dated via postmark, 1729 Mt. Vernon St., Philadelphia.

has sent his note to TE on to him [in Dakota] but doubts it will reach him quickly.

2 pp.

12. SME to FEC, n.d. [ca. 5 Apr 1890].

says TE does not agree to the conditions FEC has set regarding Maggie and Ella's studies; SME unwilling to accept any responsibility for FEC's children.

2 pp., draft.

13. SME to FEC, 18 Oct 1896.

"The attitude toward Tom I think detestable and outrageous"; has told her father-in-law that she will no longer live in the house if FEC's children are allowed to stay there.

2 pp., copy.

14. SME to FEC, 1 Nov 1896.

"It has reached our ears . . . that Maggie is freely talking at the Academy against her Uncle Tom . . . that her sister Ella's insanity was brought on by the wearing effect of unnatural sexual excitements practiced on her in the style of Oscar Wilde. . . . I am able to record her whole life here."

2 pp., copy.

15. SME to Mrs. Beckwith, n.d. [Mar 1918].

wishes to know her preference for disposition of Mr. Beckwith's portrait now that it is returned from PAFA exhibition.

1 p., draft [answered by Mrs. Beckwith, 1 Apr 1918].

16. SME to Gilbert S. Parker, 24 Jun 1918.

apologizes for having perplexed and annoyed him.

1 p., copy [letter was in the Eakins "wallet"].

17. SME to Addie Williams, 6 May 1919.

"The contents of this box destroy. You can look at them if you care to, but they are to be burned—destroyed completely."

1 p., received copy. [Goodrich II/97; this note accompanied the TE/Lilian Hammitt and family correspondence, see the Introduction and fig. 4.]

18. SME to Prof. Edgar F. Smith, 13 Jul 1919.

background on the painting of the Agnew Clinic and portraits of Gilbert Parker & Mrs. Frishmuth.

2 pp., copy, Goodrich II/39:15–22 note; also II/175:5–8 note. [Probably SME's reply to his of 7 July 1919. Note that the correspondence concerning *The Agnew Clinic,* referred to in Goodrich II/47–48, has not surfaced in the Bregler Collection even though shown to him by SME.]

19. SME to Bryson Burroughs, n.d. [Nov 1929].

surprised that Mr. Babcock had visited him; she never asked him to do so.

1 p., draft [dated from his letters to SME 22 and 27 Nov 1929].

20. SME to Carmine Dalesio, 22 Nov 1929.

sending photos & pamphlets on TE including photos of animals by Henry Schreiber, who was a close friend of TE. "The photo of [him] full-length in the yard of 1729 is rather faded, but shows plainly the character of figure, it was taken when Mr. Eakins was about 35 years old."

1 p., draft.

21. SME to Reginald Marsh, n.d. [Dec 1929].

thanks him for his interest in publishing a book of illustrations of TE work; doubts that TE pictures will be popular and thinks that the book would not be a success.

1 p. [draft of the letter referenced in Goodrich I/vii–viii].

22. SME to Bryson Burroughs, n.d. [Apr 1931].

thanks for his interest in "the choice of Eakins picture for the Louvre"; is interested in getting one of the Museum's TE paintings for the same purpose.

1 p. [incomplete].

23. SME to Fiske Kimball, 23 [?] Mar 1934.

saw a copy of the portrait of Arthur B. Frost in a bookstore, presented as if it were the original.

1 p., draft.

24. SME to Charles H. Sawyer, Curator, Addison Gallery of American Art, 19 Jan 1935.

very dissatisfied with their photographs of "Elizabeth at the Piano"; doesn't want them published.

1 p., draft.

25. SME to Alton O'Steen, 9 Jul 1936.

describes her husband; he was a philosopher, yet a man of few words.

1 p., draft [answer to O'Steen's of 1 Jul 1936; on reverse of SME to George Barker, n.d.] R

26. SME to George Barker, n.d., [Jul 1936].

recommends he look at Phidias' *Fates:* TE "never went to the Met. Museum without finishing his visit with contemplation of the _Fates_ and the splendid torso of a man..."

1 p., draft [on reverse of SME to O'Steen, 9 Jul 1936]. R

27. SME to Henri Marceau, 23 Jan 1937.

damages noted on the William Rush painting; asks return of the studies for it.

1 p., copy in CB's hand.

II. 28–38. Correspondence to and from SME, Horatio C. Wood, and Samuel Murray re dispute over ownership of TE's portrait of Horatio C. Wood, March–April 1917. 10 items.

III. 38–63. Correspondence to and from SME re SME's gift of paintings by TE to the Pennsylvania Museum, 1929–33. 25 items.

IV. 63–98. Correspondence to and from the Salko family, n.d., 1934–38. [Samuel Salko was an artist to whom SME gave financial support.] 35 items.

V. Letters received, n.d., 1886–1936.

Letters from TE to SME are listed with TE's papers. All letters from Bryson Burroughs, Edwin Robinson, and H. W. Kent are on letterhead of the Metropolitan Museum of Art, New York City.

99. Unknown to SME, n.d., n.p.
fragment of a letter possibly from SME's mother; mentions Fanny.
1 p.

100. Minnie Van Buren to SME, 14 May 1886, Detroit.
thanks for hospitality and kindness when in Philadelphia; mentions that her health is improving.
4 pp.

101. William G. Macdowell to SME, 15 Oct 1886, Philadelphia.
expresses sympathy for her troubles; urges caution and patience; she may have misunderstood the motives of others.
4 pp.

102. Lilian Hammitt to SME, 20 Jul 1887, Keene, New Hampshire.
has received a print from a negative from Mr. Eakins.
1 p. [located in the file of correspondence with Hammitt and her family in TE's papers].

103. FEC to SME, n.d. [before 1892], n.p. [Avondale, Pennsylvania].

tell Mary she is welcome to come down to the farm any time for a rest; this would get her away from Frank's influence.

2 pp. [dated via reference to Mary Treacy, who worked as a housemaid for the Eakinses until 1893].

104. Charles Adamson to SME, 7 Jun 1916, Ogunquit, Maine.

condolences on death of TE.

1 p., typescript.

105. "Pythagoras" [Franklin Schenck] to SME, 20 Sep 1916, East Northport, Long Island.

affectionate letter from friend and ex-student of TE.

4 pp.

106. Carroll Beckwith to SME, 12 Sep 1917, Tannersville, New York.

glad to have his portrait in the [Metropolitan Museum of Art] exhibition; writes of his extremely high regard for TE.

2 pp.

107. Bryson Burroughs to SME, 12 Dec 1917,

may have suggested too low valuations for the pictures; the day will come when they will be competed for at great prices; take less from a museum or permanent place than from private people.

2 pp.

108. Louis Husson to SME, 17 Feb 1918, n.p.

cordial letter describing an army banquet in Kansas where he was attached to the U.S. Army.

4 pp.

109. Bertha Beckwith to SME, 1 Apr 1918, Great Northern Hotel, New York.

accepts her offer to take care of the Beckwith portrait.

4 pp. [answer to SME's note of Mar 1918].

110. Edgar F. Smith to SME, 5 Jul 1919, Philadelphia.

asks that SME give TE's portrait of George F. Barker to the University of Pennsylvania.

2 pp., typescript [SME replied 13 July].

111. Charles Bregler to SME, 11 Sep 1920, n.p. [Philadelphia].

transcribes statement on TE by Gertrude Whitney from Sept. *Art and Decoration.*

postcard.

112. Bryson Burroughs to SME, 9 Dec 1921.

glad to finally have a TE painting; thanks for SME's "generous offer"; is sending some copies of the TE Memorial Exhibition catalog; was thrilled to be able to "pull off" the TE show.

3 pp.

113. Bryson Burroughs to SME, 13 Dec 1921.

glad to have *Retrospection* for his personal collection.

2 pp.

114. Bryson Burroughs to SME, 20 Dec 1921.

has passed SME's Christmas greetings on to Foy, who thinks highly of her; is anxious to get his picture.

1 p.

115. Bryson Burroughs to SME, 27 Dec 1921.

the picture [*Retrospection*] has arrived. "How shallow and superficial every day work looks in comparison with its depth and restraint."

1 p.

116. *Bryson Burroughs to SME, 20 Jul 1923.*

his son wants to meet with SME; Burroughs has been asked to write on TE for *The Arts*.

2 pp.

117. *Edwin Robinson to SME, 23 Nov 1923.*

thanks for loan of two TE watercolors to the Metropolitan Museum of Art.

1 p., typescript.

118. *Joseph Brummer to SME, 26 Nov 1923, 43 E. 57th St, New York.*

has showed her small painting to several people; all praise it; hopes she is working.

1 p., typescript. [In the spring of 1923 Brummer's gallery had featured an exhibition of work by TE.]

119. *Robert Henri to [SME], Dec 1923, [Madrid].*

Christmas greetings.

postcard. [Henri had written an appreciation of TE earlier in this year for the checklist of the exhibition of TE works at the Joseph Brummer Gallery in New York.]

120. *Bryson Burroughs to SME, 20 May 1924.*

Metropolitan Museum of Art will buy *John Biglin in a Single Scull* for $600.

1 p., typescript.

121. *H. W. Kent to SME, 24 May 1924.*

thanks on behalf of the Metropolitan Museum of Art for the statement on the John Biglin painting.

1 p., typescript.

122–125. Bryson Burroughs to SME, 6 Jun 1924, 1 Apr 1925, 9 Apr 1925, 28 Apr 1925.

Four letters on getting several TE watercolors to augment the Metropolitan Museum of Art watercolor collection.

7 pp.

126. Bryson Burroughs to SME, 30 Mar 1927.

will she allow a photograph of a TE work to be made; Burroughs and Ivins had admired her portrait, "how cheap it makes the Sargent look!"

1 p.

127. Bryson Burroughs to SME, 31 May 1927.

delighted to have the TE portrait of her for the Metropolitan Museum of Art, will call it *Lady with a Setter Dog* since rules prohibit exhibition of "portraits of living people."

2 pp.

128. Francis W. Shaefer to SME, 15 Dec 1927, New York.

thanks for gift of TE painting; praise for TE's skill, etc.

3 pp. [Academy student in 1890s].

129. Reginald Marsh to SME, 9 Nov 1928, 67 Hillside Ave., Flushing, New York.

thanks for two paintings of TE.

1 p. [letter of 17 Dec 1929 references the two paintings as *Archbishop Falconio* and *General Grubb*].

130. Francis W. Schaefer to SME, 30 Mar [1929], New Milford, Connecticut.

The Veteran is hanging in good condition in his cousin's home; the pride of his collection.

2 pp.

131. Joseph Brummer to SME, 12 Apr 1929, 27–29 E. 57th St., New York.

wishes to buy *Katherine*.

1 p., typescript.

132. George D. Barrow, 27 Jun 1929, 321 N. Ocean Ave., Daytona Beach, Florida.

former student expresses his admiration for TE and his work.

2 pp.

133. George D. Barrow to SME, 11 Jul 1929, 321 N. Ocean Ave., Daytona Beach, Florida.

thanks for information on some of the "former League boys."

1 p., typescript.

134. Carmine Dalesio to SME, 11 Nov 1929, 5 E. 57th St., New York.

sends catalog of TE paintings on exhibit.

1 p., typescript.

135–136. Edward Babcock to SME, 22 Nov 1929, 25 Nov 1929, 5 E. 57th St., New York.

Two letters dealing with his attempts to get TE paintings on behalf of the Metropolitan Museum of Art.

1 p. each, typescripts. [Babcock's New York Gallery held exhibitions of work by TE in 1927, 1929, and 1930.]

137. Bryson Burroughs to SME, 22 Nov 1929, 27 Nov 1929.

Two short notes about Mr. Babcock: Babcock had visited Burroughs, claiming to be SME's representative in attempting to increase the Metropolitan's holdings of TE works; Burroughs then acknowledged SME's denial of Babcock's claim.

2 pp.

138. Carmine Dalesio to SME, 17 Nov 1929, 5 E 57th St., New York.

comments on the TE work currently in the Babcock Gallery; encourages her to donate TE works to the Metropolitan Museum of Art.

2 pp., typescript.

139. Clarence W. Cranmer to SME, 5 Dec 1929, The Poor Richard Club, Philadelphia.

his opinion on the Babcock/Burroughs misunderstanding is that it doesn't mean much; don't worry.

3 pp.

140. Clarence W. Cranmer to SME, 6 Dec 1929, The Poor Richard Club, Philadelphia.

glad to see that the Pennsylvania Museum has taken the collection; he will go ahead and try to sell her other TE works.

3 pp.

141. Reginald Marsh to SME, [17 Dec 1929 postmark], 67 Hillside Avenue, Flushing, New York.

happy to say that plans to publish a book of reproductions of TE work will go forward.

2 pp. [SME answered Dec 1929].

142. CB to SME, n.d. [ca. 1929], n.p.

gives advice on terms of proposed donation to the Pennsylvania Museum.

1 p.

143. Stephen C. Clark to SME, 21 Jan 1930, 149 Broadway, New York.

is a collector and would like to see her collection of TE works.

3 pp.

144. Stephen C. Clark to SME, 23 Jan 1930, 149 Broadway, New York.

will call on her when visiting Philadelphia for the TE show at the Museum.

1 p.

145. Stephen C. Clark to SME, 5 Feb. 1930, 149 Broadway, New York.

has bought four TE paintings; only one, *Catherine,* has arrived; has located and is trying to buy *Cowboys in the Badlands.*

2 pp.

146. Charles Bregler to SME, 12 Jan 1931, n.p.

sends amended second page of manuscript; does it meet with her approval?; hopes *Arts* will publish it.

1 p.

147. Walter Pach to SME, 6 Mar 1931, Paris.

news of progress in his attempts to get the Louvre to accept a TE painting; asks for better photographs.

4 pp.

148. Bryson Burroughs to SME, 4 Apr 1931.

advice on which TE work to give to the Louvre; suggests asking PMA to give one of theirs to the Louvre.

3 pp.

149. Bryson Burroughs to SME, 9 Apr 1931.

will discuss the matter with Kimball; prefers the *Clara* or the *Bohemian.*

1 p.

150. Clarence W. Cranmer to SME, 15 May 1931, The Poor Richard Club, Philadelphia.

passes on news from Lloyd Goodrich regarding several TE paintings.

1 p.

151. Frank [Weger?] to SME, 27 Mar 1932, n.p.

at the request of Mr. Stokes is sending text of a passage from a book about old Pennsylvania trees in which TE is mentioned.

1 p., typescript.

152. Arthur Colen to SME, 5 Jan 1933, Modern Galleries, Philadelphia.

receipt for consignment of four TE paintings with prices.

1 p., typescript.

153. Fiske Kimball to SME, 23 Mar 1933, Philadelphia.

plans to exhibit TE collection in Memorial Hall.

1 p., typescript.

154. Fiske Kimball to SME, 28 Mar 1933, Philadelphia.

asks to see her; note in SME's hand stating that he called to propose that the Museum sell three TE paintings; she agreed in principle.

1 p., typescript.

155. Clarence W. Cranmer to SME, 13 May 1933, the Poor Richard Club, Philadelphia.

thanks for her gift; glad the Eakins collection [at the museum] is enriched with "that fine trio"; discusses several other TE paintings; says he posed for *Wrestling*.

3 pp.

156. Fiske Kimball to SME, 26 Jun 1933, Philadelphia.

meant to "bring you the Schuylkill picture" but has been ill.

1 p., typescript.

157. Donald B. King and Francis G. McGee to SME, 2 Apr 1934.

for the Estate of Harriette B. Macdowell, Philadelphia. explanation of disbursement of money from the estate to SME; $70 enclosed.

1 p., typescript.

158. Donald J. Bear, Director, Denver Art Museum, to SME, 9 Apr 1936.

returning two portraits which they have decided not to buy.

1 p., typescript.

159. Estelle Horn to SME, 9 Jun 1936, 96 5th Avenue, New York City.

has a picture that she thinks is by TE; apologizes for bad photographs of it; wants to bring it to Philadelphia for SME to look at.

2 pp.

160. Alton O'Steen to SME, 1 Jul 1936, New York City.

thanks for TE plaque [relief] of a boy playing the pipes; treasures it greatly; relates how he first came to know the work of TE after a visit to the Metropolitan Museum.

5 pp. [cf. SME answer (draft) 9 Jul 36].

161. Alton O'Steen to SME, 12 Jan 1937, 2456 Beverly Rd., St. Paul, Minnesota.

has hung his "boy (plaque)" in his office; hopes she is painting again.

2 pp.

161. M. W. Ketchum to SME, 8 Jul 1937, Philadelphia.

thanks for help in her charitable endeavors.

2 pp., typescript.

162. Walter Pach to SME, 16 Dec 1937, 148 W. 72nd St., New York.

best wishes for her health.

postcard.

163. Caroline Crowell to SME, 6 Jan 1938, Austin, Texas.
cordial letter to Aunt Susie; her fond memories of their time together; she is now a physician at the University of Texas; comments on the shallowness of contemporary youth.

2 pp.

164. Frances Crowell to SME, [20 Jan 1938, dated via postmark], n.p.
cordial letter to Aunt Susie; news of her brother Jim, her house, etc.

8 pp. [also see two letters from SME to her niece Frances, 30 April and 5 May 1938, in the Crowell family papers at the Pennsylvania Academy].

165. Carl van Vechten to SME, 27 Feb 1938, 101 Central Park West, New York.
is anxious to examine TE work which she owns.

1 p., typescript.

166. Alton O'Steen to SME, 21 Sep 1938, 60 E. Patterson Ave., Columbus, Ohio.
still enjoying his plaque; has been exhibited several places.

1 p., typescript.

167. Donald Stephens to SME, 15 Oct 1938, The National Arts Club, 15 Grammercy Park, New York.
trying to sell painting of *Ella Playing with Blocks* for Aunt Fanny; needs photograph of it.

4 pp. [Donald Stephens was Caroline Eakins Stephens' son.]

168. Sadakichi Hartmann to SME, 22 Oct 1938, Banning, California.
thanks for her thought and help.

1 p., typescript.

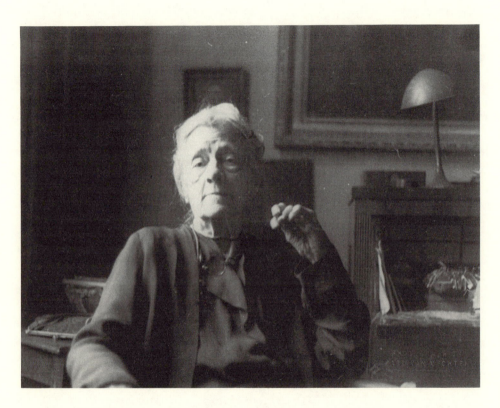

44. Carl Van Vechten, Susan Macdowell Eakins, March 3, 1938,
 gelatin print, 7½ × 9¹⁵⁄₁₆″.

_Charles Bregler was present when the critic Carl Van Vechten visited Susan eight
months before her death to see her collection of works by Thomas Eakins. Van
Vechten also took this striking photograph of Mrs. Eakins surrounded by paintings,
in a setting often described by visitors to her home._

169. Donald Stephens to SME, 24 Oct 1938, The National Arts Club, 15 Grammercy Park, New York City.

thanks for negative of TE painting of Ella; has had good prints made and has sent them to several major museums.

1 p., typescript.

170. Susan Baily [Mrs. Joseph H. Ireland] to SME, n.d., [1930s], 3608 Atlantic Ave., Atlantic City, New Jersey.

conveys praise for a picture.

2 pp.

VI. Susan Macdowell Eakins—Personal Papers, n.d., 1879–1938

1. Biographical notes on TE by SME, long and short notes, several appear to be the same text; pages addressed to Mrs. Lewis R. Dick are reproduced in this volume. 15 items.
2. Lists of paintings and prices, various lists, most undated; some just scraps of paper. 25 items.
3. SME diary for 1899; some references to TE paintings in progress, occasional outings with TE, visitors to 1729 Mt. Vernon, a few references to her paintings; several entries for the first few days of January 1900. See fig. 45.
4. SME loose diary pages (26 printed diary pages) from different years, with notations for various years (one headed "Books I Have Read 1929"); numerous loose scraps of paper with transcriptions by Bregler of selected entries from diaries both extant and non-extant.
5. SME "retrospective diary" of important dates; in a diary book SME recorded important events in her and her husband's life over many years.
6. SME Memorandum on Ella Crowell, 11 pages, draft of a history of the Eakinses' relations with Maggie and Ella Crowell; discusses Ella's residence at 1729 Mt. Vernon, her insanity, her relations with the family, the accusations against TE and the break in relations between the two families; full text reproduced in this volume, pp. 290–98.

Wea. FRI. FEB. 24, 1899 Ther. Wea. SUN. FEB. 26, 1899 Ther.

Wea. SATURDAY 25 Ther. Wea. MONDAY 27 Ther.

45. Susan Macdowell Eakins, page from 1899 diary.

Susan's only complete diary in the collection is that for 1899. There are many references to Tom and to friends or family. Other fragments have been preserved, but it is likely that much was destroyed by well-meaning friends after her death.

7. Notes and miscellaneous writings, notes on a variety of subjects. 17 items.
8. Printed ephemera re SME, PAFA student card and prize certificates, Christmas card, calling cards. 6 items.
9. SME; newspaper clippings on various subjects. [It is *assumed,* on the basis of the subjects and dates, that these were clipped by SME.]
10. Collection of Japanese illustrated books, wood block and fabric prints; [several references in her diaries testify to her interest in this subject].

Selected Manuscripts of Susan Macdowell Eakins

[SME's memorandum re Ella Crowell, 1897?]

On Sep. 2nd 1894 Ella Crowell came again to live with us, she had finished her course at the University the spring previous, and after the summer months at home, during which time she had helped her Uncle Tom with the mechanical work on his sculpture at Avondale; she arrived here ~~in company with her uncle~~ with him and represented to me that so great was her desire to be in the city that if I were willing she would help me with the housekeeping in her grandfather's house. ~~in those same reasons for remaining in the city~~ During the period of the housekeeping & afterwards while taking lessons in music she confided to me at great length ~~about~~ the condition of her farm home. She commenced by asking me if I knew that her papa intended putting Ben in Frank Stephens shop I did not and found it so, on asking Tom who had not informed me for obvious reasons. Ella ~~then~~ asked me what I thought about it. I said "do not like it, and am sorry" She ~~then~~ told me she had earnestly endeavored to prevent the dishonor, crying about it and arguing with her parents, but without effect. She then went onto criticize in all ways her home at Avondale & its occupants. Her parents were without honor her father not entirely dulled was so weak, idle & hopeless, a melancholy, unhappy, and disappointed man, his condition was pitiable, he longed for city-life, but despaired of ever making a change, partly through his lack of spirit and through consideration for his wife, who was contented in the country, so long as she had her children & her wishes for them gratified. Her mother was she said unable to consider the honor~~ableness~~ of an act, ~~except as it affected the welfare of her children and her husband She exampled to me~~ For in-

stance, ~~that~~ her mother calmly listened to her violent opposition to Ben's being placed under the influence of a man whom they had denounced ~~as dishonorable without being affected~~, yet took offense afterwards when Ella complained that the milk was often sour. Further she said that dissatisfaction was felt by her father mother & grandfather at the manner in which we conducted her grand-father's house, that they had often talked together of the advisability of the grand-father's move to a smaller house to reduce the expenses which I made un-necessarily heavy. If Tom and I would leave her grand-father's house her parents would willingly come to the city, her mother not liking the plan but willing, as her father was so hopeless & wretched in his present state, also as it was thought ~~considered~~ we were neglectful of Aunt Eliza and Mr. Eakins, it was her duty to come. With regard to her father she knew his secret thoughts best that her mother could not understand him. From her childhood he had confided to her, and that often, so intense was the sympathy between them, after listening to his confessions, she would be so exhausted that she could hardly drag herself from the room. She told me particularly of the idle life her father led, describing it as every morning spent in the village reading the newspapers, the afternoons either at useless instruction of the younger children or despairing over their idleness. The trouble on the farm was that the children needed the example of industry from their father, and never getting it, had no respect for his complaints. I did not encourage ~~these~~ her confidences, and said ~~to her~~ that I feared she would be sorry for talking so fully of her home affairs, she said it relieved her ~~mind to open her heart to some one~~ to talk of what was continually on her mind.

She had already expressed her mortification to her Uncle Tom, at the de-cision about Ben, and had criticized her parents severely although not to the great length that she did to me, also she did not tell him that she had enraged her father against him. This she told me on the occasion of the second confidence, what she said was foolish in the extreme and she almost immediately acknowl-edged it so. And then proceeded to discuss her Uncle Tom after a fashion that made me think her great love for her father & apparent contempt for his manner of life, brought about a desire for find faults in her Uncle, for whom at the same moment she acknowledged a great admiration ~~for~~, ~~and~~ assuring me that his teaching had been more valuable to her than any she had ever had. I remember her saying to me, "Aunt Susie I love my Uncle Tom but I love my father better" ~~This was when she was staying with us after she left~~ This just before she went to the Presbyterian Hospital; and seemed As though the conflict of emotions aris-ing from a great love for two entirely different natures was distressing her. Shocked and yet not fully trusting Ella's talk my first impulse was to write a full account of it to ~~Will &~~ her parents, but, on maturer thought believing that if Ella really had made serious complaint against Tom, they undoubtedly would in-quire into it or withdraw their children from our society, I decided to wait and when Ella returned home at Christmas, wrote to Fanny that I understood that

she and her grandfather had discussed the propriety of making changes in his house, and I thought it best that Tom & I should go else where to live. Answers, which I have, from both Fanny and Will Crowell dated Dec. 30th, 1894 express sorrow that I desire to leave Mr. Eakins house, and so that no discussions what ever had declare that no discussuions had ever taken place, Fanny writes, "I feel sorry to find that you have been led to think that my father and I should have discussed the making of any change without consulting you, and I find that Ella is responsible for that impression". In Will Crowell's letter dated Nov. [?] st, 1896 states the statement, "When, in the first excess of rage and grief that Ella's disclosures (now near two years ago) brought me" is a mistake, intentional I believe because of the misrepresentation which has been carried on as I have evidences of other misrepresentation by them. He had his information before Sep. 2nd, 1894 and permitted Ella not only to reside in the home with us during the five months elapsing between Sep. 1894 & Feb 1st 1895 when she started her course for nursing at the Pres. Hospital, but allowed her to accept a gift from her Uncle Tom, of a violin cello, & Ella declared he played on it, This occurring after said disclosures to her father & before she had confided to me. Tom & I at the time entirely ignorant of the secret behavior. In this same letter he declares Ella's inability to lie.

A letter written by Fanny Crowell to her father of the same date Nov. 1st, 1896 describes Ella's entrance to the Pres. Hospital as "Ella's flight to the hospital driven there to escape Tom's approaches". Ella was with us the five months previous to her starting her studies for nursing, first helping me at housekeeping & afterwards taking piano lessons from one of the teachers at the Spruce Street Conservatory, stopping before the first quarter was finished, because she was affected by her teacher's manner to an unbearable extent.

During these five months I knew she went home at least once and that was the occasion of my writing to her parents, the Christmas holidays. During those five months her father never entered Mr. Eakins house, gave us no information with regard to his feelings toward us and trusted his daughter Ella and son Ben, to reside with us, afterwards his daughter Maggie came to again reside with us and to pursue her studies in music & painting. During Ella's term at the Pres. Hospital from Feb. 1895 until Dec. 1896 she was accustomed to spend her off duty hours either at her grandfather's house or at her Uncle Tom's studio. The visits to Tom's studio being entirely her own choice. As often our knowledge obtained through her talk her parents letters Tom decided not to offer further advice or service to her in any direction, except she solicited it, which she did before entering the Pres. Hospital. She several times brought other nurses to her Uncle's studio. (a) Oct. 22nd 1895) I have a short note written by Fanny Ella's mother, & to Tom wanting to know why Maggie cannot paint in his studio follows, I have a copy of Tom's answer and have positive evidence that since then his answer was misquoted, and made a topic of conversation at Frank Stephens shop. This desire to have Maggie pursue her daily studies in painting at her Un-

cle Tom's s[t]udio, and be of course in his almost constant company, was written over a year after, Will was asserts he had information from Ella that gave him unparalleled provocation quoted from his letter Nov. 1 1896 against Tom. Maggie considered her Uncle Tom's refusal to have her work at his studio as entirely just, so she expressed herself. Maggie remained in her grandfather's home and consequently under in the same house with Tom & me until the late spring 1896. As late as June 19th going out with Tom & me to hear a musical entertainment, a small gathering of people to hear the result of electricity applied to the piano. The company being composed of Mrs. Charles Town, Miss Trimble Mr. & Mrs. Addicks, Mr. & Mrs. Douty Mr. Murray and Miss Murray, Dr. Hugh Clarke Tom myself Maggy and myself. After the musical it was proposed we should have some refreshment but Maggy feeling sick, Tom & I refused to & hastened home Maggy being chilled, Tom helped her to bed & rubbed her until she slept. The next morning she appeared at the breakfast table cheerful and declared herself quite well again. During the time elapsing between Sep 1894 and to the present day Will Crowell has never come to Mr. Eakins house, never apparently taken the slightest precaution against the continuance of abuse of his daughter Ella [illegible passage] did not fear similar persecution of his daughter Maggie & son Ben. Fanny Crowell has at distant and short periods been to the house but never at any time expressed concern for her children's mode of life in our company. Ella was with us for a short visit, having ridden from Avondale & Phila in in the summer of 1986 and returned home Aug. 22nd 1896 during this visit she was continually expressing indignation at her father's attitude against her Uncle Tom, she told me that her father desired Mr. Murray Tom's partner to come to visit him believing he could break the friendship existing between them, by his exposure of Tom's true character, Ella declared she had defied him so that I believed at the time there were [illegible word], intense quarrels and excitements being kept up between Ella & her father [illegible word] a short period of her confinement in the [illegible word] hospital. During this visit Ella went to her Uncle Tom's studio and on one occasion affected him greatly by saying the tears running down her cheeks, Oh Uncle Tom, I wish I was at work with you again like in old times. Will in his letter says that for nine years Tom persecuted Ella. Aug. 21st, 1896 I wrote to Will Crowell that he must caution[?] to get his daughter Ella home, Tom & I could no longer control her and we feared, she would carry out some of the wild plans she was initially forming. Ella was put in the Insane Hospital Aug. 31st, 1869. Aug 28, 1896 Fanny Crowell gave me the first information that they considered Tom to be responsible for Ella's condition saying there was no use of discussions Ella had said certain things & they were true, also she said Maggie had been her Uncle Tom's friend declaring he had never harmed them & that both Ella & Maggie considered Tom to have been their constant benefactor.

After Ella's confinement reports came to us that Maggie was spreading tales about her Uncle Tom which injured both injurious to both Tom & Ella

and of course to herself, as on my instantly writing to her parents, they ~~returned~~ answered in the two letters already quoted from Nov. 1st, 1896 ~~acusing saying~~ accusing Tom through me as an innocent instrument, of trying to ruin their daughter Maggie's reputation ~~at the same they~~ afterwards Maggie wrote a denial, & in the same note confessed she would not be sorry if such rumors had hurt him. So that between June 1896 & Nov. 1896 her parents had prevailed on her to believe her Uncle Tom to have been a wicked persecutor of innocence instead of her ~~devoted~~ benefactor & loving Uncle. Since then Maggie has tried through Ben, to obtain ~~information as to who was~~ the name of our informant, that she might further deny the objectionable reports. This information we could not give her. having been given us by a friend who did not believe the reports knowing the constant tenet imposed on us by her parents and had requested us not to tell her name. Only a few days ago from this date July 1897 I was told ~~from an entirely~~ by an other friend ~~who does not in any way~~ that an Acad. student had given the information ~~informed her?~~ of charges made by Maggie against her Uncle Tom, charges that created the most indignant protests and denial from my friend. ~~I now~~ I have Maggie's denial, but I believe now that she did circulate stories as injurious to her Uncle Tom's character as her newly acquired sentiments toward him could instigate.

Just before the report of Maggie's utterances, I was told by a friend that Ben had gone to Mr. Quinn, an old friend of Tom's, and had by his utterances ~~given~~ insinuated that Ella had been seduced by her Uncle, ~~and she found also had attracted she~~also had uttered told a lie which being immediately ~~found~~ proved, made his whole statement doubtful. Ben declared he had not intended such information indeed had not ~~understooood~~ meant that his Uncle had really injured Ella at all, as an explanation of his behavior he declared that for four years he ~~not~~ heard ~~other than~~ nothing but abuse of his Uncle Tom, ~~from his father~~ and he felt it was his duty to show people what a dangerous man he was. Ben retracted what he had said, by letter, and if it had not been for the fear, that the ~~act of~~ refusal to allow any of the children to live with us hence forth, would ~~distress and~~ add to Ella's distress if she should become well again & seek us as she had always done before we would have sent him from the house, afterwards at Mr. Eakins earnest solicitation. I consented to Willie's ~~coming here~~ being [illegible word] here, this was not acceptable, he was sent to live with Frank Stephens. While Ben was acting the spy & Tom & I were ~~caring for his grand fathers house, for Aunt Eliza~~ looking to his comfort in his grandfathers house and apparently trusted by his parents at least as far as his welfare was concerned. As of up to five or six weeks of Ella's death which occurred July 2, 1987 he has lived here without ~~his~~ either father or mothers presence, even for ~~a day~~ an hour.

What I have now written is the most important evidence of against these people. I propose to write more fully as there are many incidents that illustrate

the confidence & trust existing between Tom & Ella & Maggie, also curious facts concerning Ellas highly emotional and hence irresponsible nature. This, [illegible word] that after Tom's school the League, was closed, the children Ella & Maggie desiring to continue the study of the naked figure, ~~but could not~~ decided to work from one another as the most economical & easiest way, to continue ~~retain remain studies their Uncle Tom's instruction in a life class~~, the study. and that Ella declared it was only by the most earnest & untiring solicitation on her part that consent was given ~~to them to work as they pleased only not to let her mother know~~. Tom distinctly refusing to furnish this study in the house without their parent's ~~mother's~~ consent. ~~Another~~ On the occasion of our insistence that Ben should behave himself honorably, his father wrote ~~advising~~ admonishing him not to let us bully him.

I ~~have been~~ was unutterably shocked and grieved at the ~~mischief that has~~ result of our sacrifice for the children of Will & Fanny Crowell, but not surprised. I always believed that any complaint of what ever character ~~may be~~, presented by the children to the parents against us would be nursed by the father & and at least resented without question by the mother. I have contended more than once against accepting them at the house here, to him[?]not that I ~~blamed~~ disliked the children but I doubted the judgement of the parents, have always held that they know absolutely nothing of human nature, and could tolerate nothing but their own ideals; added to this the ~~many~~ repetitions by the children of remarks made by father & mother as opposed to their Uncle Tom made me suspicious of the sincerity of their friendship. Tom while believing them narrow minded and aggressively sure of their own perfections, did not believe them capable of dishonor up to the episode of Bens ~~entrance~~ entering the Stephens work shop.

[on reverse of last page:]

It stands as indisputable evidence of their trust in Tom, while secretly desiring to injure him.

[continuation of Crowell memorandum, on different paper, perhaps written at a different time]

All the children were dissatisfied and wanted to come to the city. They were disobedient and careless. That their father considered them the most disobedient and impudent of children, her comment on this was that he had no right to expect any thing else as he had taught them to think and act for themselves. That she never obeyed orders from father or mother if the order seemed unwise to her. That she had undertaken the housekeeping for her

grand-father because he had complained of Tom's and my extravagance, and that in the country we were considered to be extravagant and neglectful of Mr. Eakins and Aunt Eliza.

The second occasion of confidence much of this was repeated, and telling me of her annoyance at the touch of her Uncle Tom's hand saying she did not entirely trust him, she seemed to feel degraded. I asked her how the hand she had accepted all her life could degrade her, and that if her Uncle Tom knew she did not trust him, ~~it could not~~ all familiarity would cease instantly between them. I then asked her what her purpose was in smiling to his face while she stabbed him in the back. I did not use this expression but what I said amounted to that, and I planted the first seeds of remorse for the contemptible part she was playing. Her expressions [illegible word] often were of regret & fear for for the mischief she had brought to her Uncle Tom. Although all was freely forgiven by us, During her last winter here at the University I remember distinctly two notable instances, once her assertion that she had yet to see a man whom she was afraid of. The other, an occasion of some musical affair, her Uncle Tom refusing to accompany her, the night being stormy. After long coaxing she ended by reproaching him with loosing his interest & spirit, & so on. Before going to the Hospital she asked Tom's advise, he advised against it saying her studies fitted her for other directions and

[verso; text not continuous due to portion torn off]
was allowed unrestrained until she became violently insane.

Her parents then attributed her insanity to the persecutions endured from her Uncle Tom.

A notable instance of her poor self-government was the occasion of her parents refusing permission for her to ride horse-back to the city a distance of forty miles, she got on one of the horses and at a furious rate rode around the farm until the beast was exhausted, then betaking herself to the meadow stream remained in swimming until exhausted herself, this followed by sickness. The exhausting her strength as a vent to her passionate rebellion against restraint was a usual practice. Ella's first showing of other than ordinary feeling, to me was on the occasion of her return from the country, where she had gone after completing her studies at the University. She returned in company with her Uncle Tom. I was lying on the parlor sofa, ~~preceeding Tom,~~ she came quickly to me and throwing her arm about me kissed me, I was surprised, affected and embarrassed too, so that I lay quiet for a moment, only laying my hand on her arm I smoothed it, and then presently told her I was glad to see her, and remarked that she wore the dress I had helped her to make.

The next day she confided to me her dissatisfaction and unhappiness at having to remain in the country. She was determined to be in the city,

and would like to keep house if I were willing. Two other occasions during her effort at housekeeping she confided to me, ~~her~~ distresses, the first time dwelling on the misfortunes of her country home, saying the farm was going down, worsening every year, her mother was the only one who did any work, her father was idle, spending his time reading newspapers and talking about politics and morality until they were all sick of it, and listened only to the amused

[continuation of Crowell memorandum, on different paper, perhaps written at a different time; text not continuous with previous sheet]

her youth and inexperience, made the life and dreadful sights she would see there unfortunate for her. After being there some weeks, on an occasion of his ~~taking~~ seeing her safely back to the Hospital, having spent the evening at her grandfather's house, she told him she already regretted going to the hospital, that it did not suit her, she was tired of it, and her reasons for going there were that it was necessary for her to earn her living and she saw no other direction where it would be possible, and then told him the same that she had told me of the hopelessness & unhappiness of the country home.

Ella's preference was always to be in the city in the last few years her studies being finished and no particular reason for her remaining in the city, she still preferred to stay here, by returning to the country she could have avoided her Uncle Tom, he does not go there. All through the years of study Ella was always the reluctant one to return home, although by returning home she could have avoided her Uncle Tom. During the summer that Tom worked upon the horse sculpture, Ella confided to him her dissatisfaction of her country home. Complaining of the hopelessness of every thing and her great desire to stay in the city [.] About this time some questions arose

[verso; text not continuous]

the propriety of leaving, the fine bridle which Tom had bought for Billy, in the country, the children were careless with it. Ella urged her Uncle Tom to carry it to the city, saying it was outrageous that the children were allowed to abuse it, and on no consideration should he let it remain in the country.

Ella gave me the first information about Ben being employed by Frank Stephens, and asked me how I felt about it. I said I was sorry to hear it. She then went on to describe her shame and mortification and indignation against her parents, saying her father was weak, and her mother absolutely unable to consider any argument but the one that procured advantages for her children. I remember her saying, Mama was hardly touched by my bitter reproaches yet was offended the next morning when I complained the milk was often sour.

The night of the bicycle accident, which occurred after Ella left the Hospital, she came into the sitting room where Mr. Murray, Tom, and myself were, and sitting sat on her Uncle Tom's lap that he might more closely examine the wound near her eye, and then went with him to Dr. Leonard to have it ~~treated~~ sewed.

My memories are very vivid,

[SME's notes on TE, n.d. [ca. 1930?]]
To Mrs Lewis R. Dick

no 1

New Century Club, Philadelphia

This paper which, as you desired, I am sending you to be read to your Monday Morning Class, is a copy of an answer to a request from Alfred R. Mitchell asking me to give some information about the method of work pursued by my husband Thomas Eakins, for the benefit of the Art School of San Diego, California.

With a few exceptions, this writing is confined entirely to the method of work. Thomas Eakins wrote in answer to an inquiry of his life, the simple statement, which has been often quoted, as below [follows (written in Charles Bregler's hand)]

"I was born July 25th 1844. My father's father was from the north of Ireland of the Scotch Irish. On my mother's side, my blood is English and Hollandish. I was a pupil of Gérome, also of Bonnat and of Dumont, sculptor. I have taught in life classes and lectured on anatomy continuously since 1873, I have painted many pictures and done a little sculpture. For the public I believe my live [sic] is all in my work."

To Alfred R. Mitchell. Your questions about the method of study pursued by Thomas Eakins, I will try to answer simply and clearly. Before answering your questions about the pictures, it is best to describe the character of his mind. Always ready to receive instruction, but never satisfied, until he had investigated for himself the subject, independent and fearless. He studied anatomy, dissected, made casts of the human body and animals, getting knowledge of what caused the forms to move with freedom and beauty.

The plaster [written in Charles Bregler's hand] casts of the human cadaver, I have had cast in bronze, they cannot be destroyed. Eakins said "while most art students would not be interested to work in anatomy as I have done, if serious and sometimes puzzled about the meaning of the forms, they can find explanation in these casts.["]

Some year before studying anatomy, he was for a while a pupil in the Art school in Philadelphia, and made a splendid drawing of a naked nude model. Then in 1866—22 years of age, he went to Paris, entered the Beaux Arts where for three years he studied naked men and women. When weary

from class study, he would stop his painting in the school, and try to memorize the work he had been doing in the school, working alone in his lodging room. He considered this a good tax for the mind.

He said "Paint with your brain as well as your eyes" Also he said "A few hours intelligent study was far better than a whole day of thoughtless plodding". He considered the painter should model and the sculptor should paint. He was fond of all out-door pleasures, but did not allow these pleasures to interfere with serious study.

The picture "The Gross Clinic" painted 1875. At the Jefferson Hospital Eakins was permitted in the Clinic Room. Dr. Gross realized he was serious in his work, and gave him every opportunity to study the color, the positions of objects and general arrangements of a Clinic. Having arranged the composition on the canvas, he made studies of each person in the picture. The important figures, Dr. Gross and his assisting surgeons, requiring more finished painting, would give as many poses as possible, probably six poses of an hour each time in the pose of Dr. Gross, the other surgeons some what less time. The students in the background, probably one or two poses.

The same in the picture "Agnew Clinic" This determining the positions in the composition can be done more easily if the artist understands perspective., Positions absolutely secured, then by sketches for color, of light and shadow, where light comes from, then the picture can be carried forward with confidence, to finished painting.

His manuscripts on Anatomy—Perspective—the science in making a relief in sculpture, the cause and movements of man and animals, all illustrated, have not been published.

Eakins only used a photograph, when impossible to get information in the way he preferred, painting from the living, moving model. He disliked working from a photograph, and absolutely refused to do so in a portrait. In an hour he would have enough material, unless he wished to carry the painting to a finish. His portrait of General Burd Grub was done in one sitting, of one or two hours, it is rough, but exact in character and true in color. Often in starting a portrait he would make a small sketch of the subject then with cross lines transfer it to the large canvas-as- by this means saving time for himself and for his sitter, sometimes the work on the small canvas would be so satisfactory, that the copy of it on the large canvas would be ready for final work.

A lady whose portrait he started, suddenly announced she was unwilling to pose, her <u>maid should pose for her</u>. The portrait was quite a large ~~canvas~~ composition, Eakins was interested in it. He laid the canvas aside and refused to go on with it.

You write in your letter—"Each person so wonderfully well characterized that you would know him if you met him". You will understand, I think, that this would result from his methods of work.

In the picture "The Swimming Hole" Eakins modeled the diving figure in wax and then painted from it, making sketches on the spot, for color of flesh, the green, the water and the sky, on a sunny day. In the picture of oarsmen, they are all painted in the same method, constructing everything to be absolute in position, true in proportion, the oarsmen the ~~true~~ real men, who were then between 1870 and 76 the professionals in boat racing on the Schuylkill river. The reflections in the water, not guess work, but worked out by perspective, so that they are true.

In "Between Rounds" every person in picture posed for him. The interior was the Hall used by the fighters. With perspective and color studies, no photographs, all the result of his untiring observation and study.

Mr. Mitchell in his letter tells, when a student in the Phila. Acad. of Fine Arts, He heard the artist Joseph T. Pearson say—"Everything in the picture "Between Rounds" was painted in such a way that one could construct the whole spirit and character of the time from this picture, even the uniform of the policeman could be reconstructed from Mr. Eakin's picture".

The picture "Four-in-Hand" Eakins modeled each horse in wax before he painted them so that it was a likeness of each horse, the same as the likenesses of the passengers and coach men.

<div align="right">Susan Macdowell Eakins
(Mrs. Thomas Eakins)</div>

also made accurate studies of the coach, the landscape the color. light. so that the whole is a portrait of time and place [written in Charles Bregler's hand]

[SME to CB]

<div align="right">Friday [Feb 1927]</div>

Dear Mr. Bregler,

I guess Schenck will be comfortable now. I am very pleased with Boulton's letter, he was always a kind hearted fellow.

I doubt if Mrs. Ireland will be able to give time for painting before the latter part of May or beginning of June.

All the time I can give to study, I am trying to see quickly the simple construction of form & color, and the difference of character.

I never knew that about Renoir—it's a great idea isn't it, all the same I am glad we are not paralyzed—aren't you.

I have the Home Journal. The man just does not know, he makes his living by his writings, and he has just got to write something. Tom never was influenced by any painter. I remember his speaking of that to do great work you don't copy other painters. You pitch in & do the most intelligent work you are able to do, your own way.

I don't believe either Garber or Redfield copy any painter. I think both

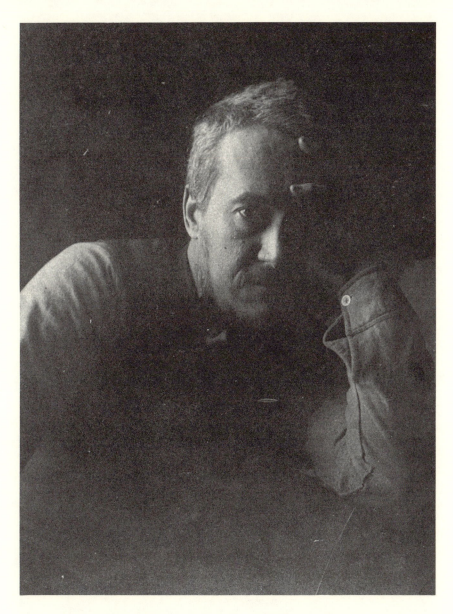

46. Susan Macdowell Eakins [?], Eakins at 45–50, ca. 1889,
 platinum print [?], 8¹⁄₁₆ × 6″.

 ―――――――

 The pose of the artist in this dark and moody photograph closely resembles his
 image in the portrait painted by his wife, now in the Philadelphia Museum of
 Art. Active as a photographer even before her marriage to Eakins, Susan
 exhibited a photograph in the first Philadelphia Photographic Salon in 1898.

these fellows try for the big construction of things as far as they can understand, but they are neither as strong as Tom or they would do better figure work, or not show it at all. So it seems to me.

I like to see what these fellows do, and I particularly hope that Garber will grow stronger rather than weaker.

> Best wishes always
> Susan M. Eakins

[SME to CB]

May 8, 1927

Dear Mr. Bregler,

If you can come, I would like to put up a few of the pictures—not the big ones I will have the hired men to come for those; after I see what I must do. The walls have been slow drying, but that I guess is a good thing in painted walls. It looks now as if bad weather will come, and I think you may be able to spare the time for my affairs, which can be done any kind of weather.

I have a letter from Cecil Boulton, Boulton's case seems indeed hopeless—I enclose her letter and you can bring it to me when you come— I had written lately to Boulton to Cecil's care, I thought he may be with her—but her letter explains.

Out at Memorial Hall, they have an exhibition of Mary Cassatt's pictures—I have always felt interested in her work—it's honest, I think and so I went out yesterday afternoon and looked carefully at all her work, she makes some bad mistakes, but it is all plainly an honest effort to do intelligent work—so I feel about it, and some most beautiful feeling in beautiful subjects.

I hope you & Elizabeth are both well.

> Sincerely,
> Susan M. Eakins

I am planning to have the old studio walls painted and made in good condition to place the pictures and other material interesting of Tom's works.

[SME to CB]

Dec. 19, 1929

Dear Charley,

I am enclosing two beautiful examples of modern art, when you come bring that lovely child back, I keep him as an example—for a while.

That Japanese [Yasuo Kuniyoshi] who photographed the Eakins pictures for Alan Burroughs article in Dec. 1923 is the wretch who committed the crime of "Boy Stealing fruit".

The still life is as usual in foolishness.

I am wondering if you could find time to frame those two watercolors I showed you. I have written to find when they propose to exhibit at the Museum, so I think there is plenty time, however as soon as you can.

When you come to help me put up the other canvases in the parlor we can arrange.

Elizabeth will enjoy the boy too, I know, it's beyond belief,—the fellow Kuniyoshi is either a fool or a knave. And he did not look like a fool. Also he is one of the few people I took an instant dislike to, when he came to take the good photos.

<div align="center">S.M.E.</div>

[SME to CB]

<div align="right">Monday
Dec. 7, 1931</div>

Dear Mr. Bregler,

Your letter today—I think one of my letters must have miscarried, I thought I had written—"as I was not sure of Sutton, that I engaged Mr. Kahler and the colored man William"—so we could do the work if Sutton did not come." Well it went pretty well, only some day I want to hang the Barker lower in the entry, where we decided to hang it that day. I'll arrange with you & Mr. Kahler some other time.

Sutton is unworthy, he has not paid me any attention at all. I am going to throw all my old picture wire away, and when you find it convenient, *no hurry,* will you get a coil of copper wire.

Yes I have seen the article in the Record—I always suspected Mrs. Whitney of being ordinary—she is sick and I guess sincere, as far as her mentality will permit. Tom's work cannot associate with this trash—so I will raise the price of the pictures. The "Champion Racer" will be $10,000. — also the Barker—the "Biglen Bros" one of the most beautiful works, I had decided $5000.—it should be more. It will probably be hopeless to sell but I won't belittle fine work, when such stuff is being bought.

I am enclosing the other check, wish I could make it larger.

Today a large paper—demonstration against the raise of taxes—asks us to hang it in the window, which I will do.

Yours truly with best wishes for Elizabeth and yourself.

<div align="center">S.M.E.</div>

[SME to CB]

Wednesday
July 18th, 1934

Dear Charles Bregler,

Your letter with Elizabeth's and your kind message received this morning.

Go right ahead with your own plans, I will let you know when I am ready to have you help me—and if you are busy at the time, it can be postponed. I am so engaged in trying to simplify my affairs, that I do not get much done, before I am tired, and I will not hurry. To tell the truth I am enjoying freedom from engagements—except one to the dentist Thursday morning. Don't even paint.

My idea about pictures—in the trying for odd effects I was looking at the views from our yard, for several sunsets, starting about 5.30, daylight saving—these sunny days every thing lit up from the strong light from the sun, the sky blue and a white cloud, just above the yellow plaster & red brick of the wall (very strong color). Then in the morning the same forms, but entirely, as you know, full of new life, everything even shadows reflected. How would it do to paint two studies one the morning light—the other afternoon light. I know you have painted both these effects in your sky studies but my idea is to have it from the ground, or low enough to introduce the wall of a house, or some shape that makes the study, as people may see it from the ground. I always think Whistler did these things, always odd and often true. This portrait of his mother, is the tamest, and one of his best things, but, the whole picture was so quiet, that it was long before it attracted attention, and then he was famous for his odd effects, so often I think the portrait only attracted because it had the name Whistler.

Of course these ideas are only suggestions, work no matter how odd, even startling, can be fine & true, all depends on the feelings of the good artist. Look at the run of really good painters, all different in the field they take, but all with the same understanding.

I certainly do not mean to suggest that you do meaningless things, in hopes you can attract the ignorant. I don't believe you could attempt it.

In city views I always want a wall or some still thing to make the city sky—in the country the trees do what the house does in the city.

You see I do not hesitate to give my ideas although I cannot do the work. Don't feel that I am discouraged, I am not, and before long I'll be trying again. I have got some ideas that I'll try out even if I know I'll fail—it's so happy to try.

Your "grandmother" would be good to show anywhere, but I thought presently when I hear again from Mrs. Hudson, I'll ask if the Milch Gallery would give an exhibition of your other things with your pastels, and meanwhile, whatever you can paint between this and autumn. You know I have

frames and some canvases if you need them. Did you hear from the paint & canvas store in 9th St in N.Y.—you said you would ask for sample.

I am no better acquainted with what is best than you are—it's easy for me to suggest, but how is the question.

But these days, the people everywhere are looking for thrills, so the more striking & odd the object, particularly well painted will appeal.

If you want to come here before 10AM to make a quick sketch of morning light, and another between 5 & 7 PM for late afternoon. If you see the chance, don't hesitate, just come—just say "I am going to make a picture in the yard. Don't ask if it's convenient for us, just come prepared and take chair from the summer kitchen & small easel from upstairs, or make a quick sketch to produce something larger from it. Do as you please, without any explanations—whether I or Addie are here. Gertrude is always interested & good natured. I was thinking of the canvases you already have

	1. Grandmother
If Milch Galleries	2. The Nephew
will not consent	3. Frank Linton
you might try on	4. (the sketch of blacksmith)
Chestnut St again	5. (the one you offered to Acad this year)
I can't think of	6. Portrait of Ritter
the name—you	7. the last portrait of Shriner
will know who I mean	8. the oil you gave me which every one likes, and
	I suppose others I don't know about.

I remember the portrait of Elizabeth Coffin was refused at the Carnegie—and while they may be somewhat humbled by the indignation that was aroused, by their giving the prize to that "Clown Suicide", still I doubt them. As soon as I hear from Mrs. Hudson I'll ask her about prospects and write you immediately. Couldn't you hire someone to give you a couple hours for a sketch. If you could get some sketches of people in effective compositions—just fine work, without finish, how about a striking still life. I can lend you things to group together.

You can depend on another check for one hundred in August.

After all, I do not plan anything, only suggest, I cannot count on your difficulties.

S.M.E.

[SME to CB]

August 15, 1934

Dear Charles Bregler,

I am glad to be able to send another check, so don't worry about it, it does not embarass me a bit. I am just careful, I never speculate never use

any money that I do not know is entirely safe. Of course you know what I mean by that, <u>safe as possible</u>.

I think I will not be ready for a quite a few weeks to have some work on pictures like cleaning & varnishing—and I will warn you in plenty time, I think other work too, but no hurry.

I have not heard from New York at all, if I do I will write you.

And I will not enter into any plans about the pictures, that do not show real interest.

I am not painting, just planning what to do for the future, and getting rid of accumulations that I realize cannot be useful.

I do not have a single engagement, just taking it easy these heavy August days. Really enjoying myself.

It was pleasant to see Elizabeth. I hope the Doctor could help her.

Have no news from Seymour Adelman, but I know he is constantly busy.

<div style="text-align:right">

With best wishes,
Sue M. E.

</div>

[SME to CB]

<div style="text-align:right">

Oct. 18. 1934

</div>

Dear Charles Bregler,

At the Art Club—lots poor—but Fred Wagner's Self-Portrait very fine. "A Boy's Will" by Thomas B. A. Godfrey very fine. "The Lone Gull" by George Gibbs, is fine to me. Redfield as usual good, but too hard—and Garber not so good as I see it.

The Franklin C. Watkins—called "Soliloquy" is so good that I wonder if he has been playing tricks on us. Not in any way resembling the "Clown Suicide". A little good painting by Charles Morris Young, like a good caricature, not foolish.

Afterwards I went to the Wanamaker show again—I find
21 pictures sincere, more or less, not at all bad.
1 To me the Charles Morris Young is fine "Harbor" Maine.
2 "Trolindern Norway" by Mary Butler is very impressive.
Two small canvases in a corner is "End of the Island" and
"Flower Study" by Marie Kawett.
"The Delaware" by K. Nunamaker
"The Clown Praying" should have had the prize I think, it is remarkable to me & so sad too.
Little picture "Rockford Harbor" by Gladys Winner is way off in a little space, at the end of big room. I would like to buy it.
"Little Mills Quarry"—Lathrop.
"Afternoon Reflextions" by Florence D. Bradway seems very true & real.

I was glad to look over the Exhibition again so pleased to find good work, sincere effort.

"Old Simplicity" I like so much.

Don't fail to hunt up "Rockport Harbor" it is so roughly painted, at a little distance seems finished & true. I would love to have it.

I meant to write more clearly, but is the best I can do.

It takes so much time to look over an exhibition—I determined to see both shows well today & did.

I hope Elizabeth feels much better,

<div style="text-align:center">Very truly,
S. M. Eakins</div>

[SME to Alton O'Steen]

July 9, 1936

Dear Mr. O'Steen,

I hope you will forgive

Please excuse my late answer to your very interesting letter of July 1st. I have your letter here on my table, and I hope to answer you as you desire.

There was a lot of sense in the remark of the guide, and I think he is the one who came to my house when they collected & carried to the Museum the pictures I selected to present.

Yes certainly my husband was a philosopher. A philosopher who did not depend much on talking, he believed in example, and if the student or observer was intelligent he or she would understand. He said, look at and try to understand ~~by seeing~~ what others have done, but do not copy, try to do good painting from the real object or scene, just as the great painters did, and try to do as good and better. ~~I am sure~~ He tried to do great work and it resulted in as great [illegible word] as has ever been done. I think Jerome said of him he ~~will not~~ a great painter or he will not paint at all.

You see I am known as an old woman—and probably, they say of course she thinks her husband the greatest. But that is a mistake. It delights me to meet up with fine work—so glad to know there are painters working with entire appreciation for the models nature has provided so generously.

I have some copies of Mr. Eakins remarks to his students, always not much to talk, but a few words to the point—Charles Bregler one of his students, a good painter now, as a young fellow wrote down his master's remarks—like "paint with your brain as well as your eyes". I think I can find a copy to send you.

~~He never belonged to any Clubs or societies,~~

I hardly know how to describe my husband—he was so simple, so unwilling to work for admiration, never a Club man or society man—and yet perfectly good natured if asked particularly to join occasionally in that

life. He was welcomed by men of science. Dr. Gross admitted him in his Clinic. He saw that the young Eakins interest was to learn.

[SME to George Barker]

[n.d. on reverse of
SME to Alton O'Steen
July 9, 1936]

Mr. Barker,

Your letter of July 5th came to me. I assure it was a pleasure to show the work I have in my house, to Mrs. Barker and you. I am glad to know your son is interested in Journalism. To be really interested in whatever course one pursues, it is half the battle. I am a very old woman—but the more I work at my painting, the more interested I am, hoping to improve my painting.

I am very glad to know that the interest is awakening in good knowledge of great painting. I have a photograph of Velasquez's Aesop—I love it. Also I love the Milo Venus. Also the Phidias "Fates"—I think the noblest of all. If you are not familiar with the Fates, you must see them the next time you are in N.Y. city. Mr. Eakins never went to the Met. Museum without finishing his visit with contemplation of the Fates & the splendid torso of a man, he has not feet or hands, but the understanding & modelling was most noble of all to my husband.

Perhaps I do not quite understand your method in teaching. It seems to me you are willing anxious [illegible passage] to help people to understand noble work. People without thought have accepted the most utterly meaningless daubs as masterpieces because some Art dealer has put the work on the market.

Mr. Goodrich published a most useful volume on Eakins, but how much he may have profited by his research I cannot say, when a man cannot understand the greatness of Gerome I cannot think he understands Eakins. (Goodrich never knew Eakins—Charles Bregler a student of Eakins & good painter knew & loved him and his work—and his <u>notes</u> on <u>Eakins is really the best writing</u>.

I will have to stop now as I write more, some time I will write again. What you write of your interest in good painting I like very much.

Chronology of the Life of Susan Macdowell Eakins

1851 born September 21, Philadelphia

1876 at age 25 first registers for classes at the Pennsylvania Academy; exhibits *Portrait* in the 47th Annual Exhibition

1877 continues her studies; exhibits *Portrait* in the 48th Annual Exhibition

1878 continues her studies; exhibits *Portrait of a Gentleman* and *The Picture Book* in the 49th Annual Exhibition

1879 continues her studies; exhibits seven works in the special student section of the 50th Annual Exhibition; wins the initial Mary Smith Prize for *The Rehearsal;* two of her works are engraved and published in a *Scribner's Magazine* article on the Academy Schools

 exhibits three works—*Portrait of an Old Gentleman, Portrait of Dr. J. H. McQuillen,* and *Fruit*—in the First Annual Exhibition of the Philadelphia Society of Artists

1880 continues her studies; exhibits *Thinking It Over* and *June* in the Second Annual Exhibition of the Philadelphia Society of Artists

1881 continues her studies; exhibits *Portrait of a Child* and *Portrait of a Gentleman* in the 52nd Annual Exhibition

1882 continues her studies; exhibits *The Old Clock on the Stairs* in the 53rd Annual Exhibition; it wins the 2nd Toppan Prize; becomes engaged to TE Sept. 27.

1883 exhibits in the 2nd Sketch Exhibition of the Philadelphia Society of Artists

1884 marries Thomas Eakins, January 19; they take up residence at his Chestnut St. studio

1886 the couple moves to the Eakins family home at 1729 Mt. Vernon St.

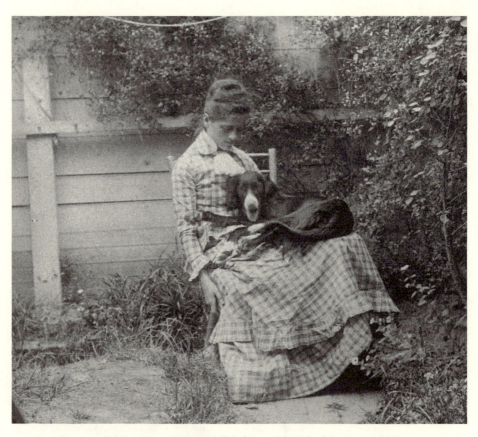

47. Thomas Eakins, Susan Macdowell Eakins with "Dinah" [?], ca. 1880,
 albumen print, 3½ × 4³⁄₁₆".

*Tom and Susan's marriage was childless, but they enjoyed a full life together,
devoted to their mutual interests in art and music. Both were fond of animals.
Susan is seen here about three years before her marriage with one of many beloved
setters they kept as pets. A wide variety of animals shared their home and Susan's
diaries record many births and deaths among their pets.*

1889	assists her husband in painting *The Agnew Clinic*
1893	exhibits *Reflections* at the World's Columbian Exposition in Chicago as Mrs. Thomas Eakins
1898	exhibits *Child with a Dog* at the First Philadelphia Photographic Salon
1905	exhibits *Portrait of Prof. Schuessele* in the 100th Annual Exhibition
1916	Thomas Eakins dies
1929	with Addie Williams gives large collection of works by Eakins to the Pennsylvania Museum.
1933	gives additional works to the Pennsylvania Museum
1936	organizes and shows nineteen works in a group show at the Philadelphia Art Club
1938	dies December 27 at the age of 87

Genealogical Chart for Susan Macdowell Eakins

Reprinted from the 1973 Pennsylvania Academy of the Fine Arts exhibition catalogue: *Susan Macdowell Eakins, 1851–1938*.

PARTIAL GENEALOGY OF THE MACDOWELL FAMILY

James John Macdowell (1844–1878)
 Married
Blanche Rothermel (1846–1922)

William Gardner Macdowell (1845–1926)
 Married
Elizabeth Sherwood (1844–1920)
 Married (2)
Harriet Baldwin (1855–1931)

Elizabeth Macdowell (1847–ca. 1855)

William H. Macdowell
 (d. 1906) Frank Macdowell (1849–1888)
 Married
Hannah T. Gardner SUSAN HANNAH MACDOWELL (1851–1938)
 (d. 1902) Married
 THOMAS EAKINS (1844–1916)

Mary Macdowell (1852–1916)

Walter Macdowell (1854–1930)
 Married
Rachel A. Cushwa (1852–1925)

Elizabeth Macdowell (1858–1953)
 Married
Louis Kenton (1869–1947)

The Manuscripts of Charles Bregler

The Life and Papers of
Charles Bregler

CHERYL LEIBOLD

Although no official record of his birth survives in city records, Charles Bregler's marriage certificate states that he was born in May 1864.[1] The brief biographical statement that accompanied his reminiscences of Eakins as a teacher, published in *The Arts* in 1931, noted that his parents were "very poor, but honest, clean, respectable" people from German emigrant families. His father, a Civil War veteran, died when Bregler was three years old, and young Charles "started to work at twelve and a half years of age, working ten hours of the six days of the week, learning the trade of a fancy leather goods worker. Not because it was my choice, but as a matter of *dire necessity*."[2] Throughout a large part of his mature life, Bregler sold paper and leather novelties, as well as art supplies, from his home. He also had a small shop in Asbury Park, New Jersey, for a number of years. Eakins' leather wallet, found in Bregler's collection, may well have been a gift made for his master by Bregler himself.

An early interest in drawing, documented in the many juvenile sketches now in the collection, led Bregler to the night classes at the Franklin Institute in Philadelphia, where instruction emphasized the mechanical, architectural, and ornamental applications of drawing. The fifteen-year-old Bregler won a scholarship there, but "left soon after" for night classes at the Pennsylvania Academy, perhaps because he desired the fine-arts orientation of the Academy's curriculum. He registered for the Antique Class in October of 1883, preparing himself for a traditional course of "several years" drawing from plaster casts of antique sculpture. To Bregler's "surprise" and delight, Pro-

fessor Eakins, then Director of the School, transferred the entire class into the evening "life" drawing session one month later. Bregler remained in this class, studying from the nude model, from the fall of 1883 through the fall of 1885.[3] During these last two years of Eakins' tenure at the Academy, his intense commitment to the use of the nude model in both male and female classes upset the conservative Academy Directors; ultimately they asked for his resignation. When he left in March of 1886, a devoted core of students went with him and formed the Art Students' League. Bregler was one of this group, and he continued his studies at the ASL until at least 1890, juggling his working hours so that he could attend day classes. At this time he probably took the notes that he would publish in 1931 in two chatty articles about Eakins' teaching.[4]

During these years, Bregler's respect and affection for Eakins took root. There is no evidence that Eakins returned anything like the same degree of esteem for Charles Bregler. Our only piece of correspondence between the two is a postcard dated May 15, 1888 from Eakins to Bregler. It reads: "Please dont come tomorrow as I have an engagement/come the next day Thursday if you can." This is probably related to the undated note from Eakins to Larry Phillips, a carpenter, asking him to fix Bregler's drafting board. Bregler had the note framed and wrote on the back, "However I did not take it there. Eakins told me to bring it to his home. When I had called for it I found he had made a new board." These items seem to confirm Bregler's story in his second *Arts* article that Eakins made him a drafting board.[5]

This and other incidents illustrate the respect, bordering on veneration, that Bregler felt for Eakins. One can imagine the framed note occupying a place of honor in Bregler's studio in his later years, along with small framed reproductions of works by Eakins or photographs by "the Boss" that were found in his collection. Perhaps the incident of the drawing board was the most intimate encounter he ever had with Eakins outside of the classroom. The manuscripts in his collection contain no further evidence about their friendship. No other reference to Charles Bregler appears in any of the letters from Eakins' hand in this collection.

Bregler returned to the Academy in 1894 after the demise of the Art Students' League, attending day classes in "life and head" for the school year 1894–95 and the fall semester of 1895.[6]

He first showed in the Academy Annual Exhibitions in 1892. Success never crowned his efforts, as he showed only five times in the Annuals between that year and 1934.[7] Though it is not known how many times he submitted work, letters from Susan Eakins to Bregler indicate that he was discouraged

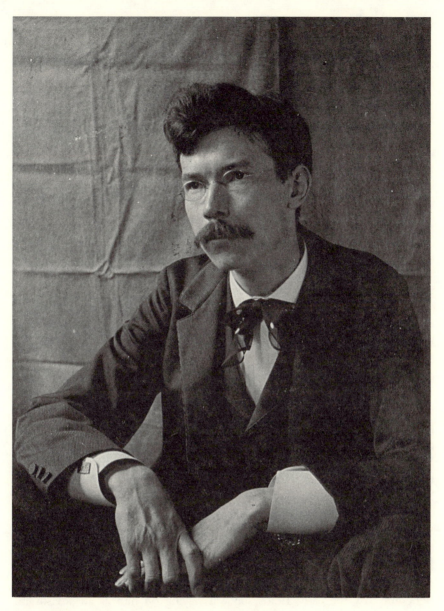

48. Thomas Eakins, Charles Bregler, ca. 1885–90,
albumen print, 3⁹⁄₁₆ × 2⁵⁄₈″.

*Charles Bregler began to study with Eakins at the Pennsylvania Academy in
1883. When Eakins left the school in 1886, Bregler was among those who
withdrew in protest to form the Art Students' League, where Eakins was invited to
continue his teaching. Bregler attended classes at the League until about 1890,
occasionally jotting down notes that he would publish in 1931 in his essays on
"Thomas Eakins as a Teacher". Bregler reproduced this portrait in the first of his
two articles, describing it as "a photo of myself taken by Eakins at that time."*

by his constant lack of exhibition success. Correspondence in his collection also indicates that his efforts to sell his work, especially in his favorite medium of pastels, were rarely successful.

The 1890s concluded with Bregler's marriage to Elizabeth Yohn in 1899. His devotion to "Lizzie" was complete. Her ill health began to be one of his major concerns, both emotionally and financially, as early as the 1920s. His wife's mental illnesss was probably a factor in his relative isolation from society during most of his life. Her death in 1944, following an accident, was a severe blow.[8]

Only a few other facts are known about Bregler's life. He joined the St. John's Lodge of the Masonic Temple in 1918 and remained a member until his death. He never held office and seems to have kept a low profile within the organization. He painted several portraits of lodge officers, although none of these has been located.

From all accounts Bregler was a mild, easygoing person, respected by everyone who knew him. Museum curators and collectors seem to have taken his opinions seriously and treated him well. His papers reveal a naiveté exemplified by his delight in light verse and aphorisms. Many clippings and copies of this type of material are among his personal memorabilia.

And what of Charles Bregler's relationship with Susan Eakins? Bregler wrote that he had known her for fifty years and was a constant visitor to her home for twenty. (Further discussion of their friendship can be found in the chapter, "The Life and Papers of Susan Macdowell Eakins".) Their close association began in the 1920s, after Thomas Eakins' death. At about this time Susan's concern for the many Eakins paintings in the Mt. Vernon Street house began to manifest itself in a desire to conserve them, and place them with prominent museums or collectors. The many letters and notes from Susan to Bregler reveal that he was indeed a very frequent visitor to the home. She employed him to clean, reback, frame, and revarnish many of Eakins' works. She paid him generously for these and other services such as photography, packing, and delivery, and also sent him many checks as outright gifts. By the early 1930s she was relying on him as an advisor in authentication, pricing, and dealing with collectors. (See letters reproduced in the chapter on Bregler's papers to Stephen C. Clark, and Dean Everett Meeks.)

Bregler's two articles on Eakins as a teacher, published in 1931, established his authority as an expert, and it is clear that Susan Eakins approved of his work and valued his opinion. Their friendship was based on a shared concern for Eakins' oeuvre and reputation, and their fond recollections of the man himself. Her letters to him are rarely very intimate. They shared

only the world of art and a few mutual friends such as Samuel Murray. (See "The Life and Papers of Susan Macdowell Eakins" for a selection of her letters to him.)

The papers of Bregler and Susan Eakins indicate that he "conserved" most of the paintings sold from her collection before her death in 1938 and in the settlement of her estate thereafter. Although we may deplore with hindsight the relative crudity of Bregler's conservation attempts, it is safe to say that he did no major damage and was, to his eternal credit, instrumental in preserving the works for posterity.

After Susan's death, Bregler was asked by the executors to prepare a comprehensive inventory of all the paintings left in the home. He stated that this took all of his time for six months. In addition to preparing the inventory he cleaned and varnished most of the works. During this time he apparently also acted as a peacemaker between Addie Williams, the family's guest of many years, and Elizabeth Kenton, Susan's sister. The cause of this friction is not clear, but in June of 1939 Addie Williams, who had been greatly distressed by the death of her friend, was strong enough to leave Philadelphia for Washington in the care of her niece.

The house was closed up, and plans were made to sell it. It must have been at this time that Bregler cleaned out the "leftovers" from the Eakins home. Sometime after the major paintings were removed for sale or distribution to the heirs, he gathered up the letters, photographs, glass negatives, drawings, oil sketches, and plasters that we now prize so highly.[9]

Mrs. Eakins had given him some of the items before she died, and during the remainder of his life other friends of Eakins did the same. George Barker wrote in 1944, "I am parting with my Eakins letters . . . and sending them to you as 'keeper of the gate.' You have been the most faithful, of any of his pupils."[10]

For the next twenty years, until his death in 1958, Bregler surely spent many hours lovingly reading and sorting through these materials. He showed them to relatively few visitors. He may have made prints from Eakins' glass negatives, and he made many copies of Eakins' photographs. He assembled a photograph album of Eakins paintings. Another album, possibly assembled by Mrs. Eakins, containing photos by, and of, Eakins and his family was annotated and expanded. He annotated and transcribed letters, diaries, and notes.[11]

Bregler's correspondence documents his loans to various Eakins exhibitions, particularly at Knoedler and Company, the Philadelphia Museum of Art, and the Carnegie Institute, as well as his attempts to sell some of his manuscripts and sketches. In 1944 (at the age of 79) he sold a small but

significant part of the collection to Joseph Katz, a Baltimore collector. The sale was handled through Knoedler's, and at that time it was thought that Bregler had sold the bulk of his collection.[12] We now know that indeed he had selected only a small part of his holdings. Of the more than 200 drawings in his possession he parted with about 30. He held back almost 500 photographs, apparently unaware that of the over 200 glass negatives by Eakins there were many images for which no prints existed. He sold the three or four beautifully illustrated letters, keeping no fewer than 100 from Tom's hand. The sale brought him $40,000. In 1961, after Joseph Katz's death, the collection was purchased by Joseph H. Hirshhorn, who subsequently gave it to the Hirshhorn Museum and Sculpture Garden in Washington, D.C.

The sale must have brought Bregler a degree of financial relief. It is clear that he did feel secure, if only for a while. In 1947 he approached the chairman of the Pennsylvania Academy Board, Alfred G. B. Steel, proposing the establishment of a yearly prize of $100 for an Academy student's work in figure painting. The award was to be known as the *Thomas Eakins and Susan Macdowell Eakins Prize,* and Bregler considered an endowment of about $3000 for its continuance. Just why he never provided the endowment is not clear. He did give $100 in 1949 and 1950, and the prize was awarded, as he had requested, in the memory of both artists. In 1951 he informed the Academy that he could no longer afford the necessary contribution. A new donor was found and the official name of the prize amended to exclude Susan Eakins' name. The award continues to this day as the *Thomas Eakins Memorial Prize.*

Bregler was probably thrifty with his money. Years of financial stress induced him to bank the proceeds of the sale of his Eakins material. When he died in 1958, his estate contained $55,000.00 in savings and securities, plus his house.

In the late 1940s or early 1950s Bregler met Mary Picozzi. She was much younger than he (he was in his eighties, she in her late thirties). It was Mary Picozzi Bregler, the companion of his late life, who hoarded the collection for almost thirty years before selling it to the Academy in 1985.[13] Academy Board minutes in the late 1960s record unsuccessful attempts to secure the collection.

And what of Bregler's own achievement as an artist? He produced a large body of work, but both fame and sales eluded him. The collection contains over 500 paintings, drawings, and pastels as well as over 500 photographic prints and negatives by Bregler. His early work, before 1900, primarily figural, exhibits a strong Eakins influence. In later life, however,

Bregler turned more and more to pastels and to cloud studies and landscapes for subjects. With the exception of an occasional portrait commission, he seems to have made his living through his leather-working business. Perhaps his lack of success was because of his simple, unassuming personality. Samuel Murray wrote to him in 1927: "I wish you had a little, just a little, deceit and bluff. It seems so necessary with the general public. You have to be a wolf and prey on them. Ability with modesty don't count."[14] Whatever may have been his merits as an artist, Charles Bregler was respected by almost all who knew him for his honest, open manner and his devotion to the memory of Thomas Eakins.

Notes

1. Bregler's 1899 application for a marriage license, preserved in the Philadelphia City Archives, gives his birth date as May 28, 1864. However, at the time of his first exhibition at the Pennsylvania Academy, in 1892, the catalogue gave his birth as 1865. His own account of his art schooling (see note 2 below) states that he attended the Franklin Institute at the age of 15, but "soon after" transferred to the Pennsylvania Academy's classes (where the minimum age for enrollment was 15.) Since there is no evidence that he attended the Academy before October of 1883 he was either misremembering the age at which he first began classes or (less likely) his birth year was really 1868. Always youthful looking, he subtracted years from his age later in life, convincing his second wife, Mary Picozzi, that he was a decade younger than his actual age.

2. "Thomas Eakins as a Teacher," *The Arts,* vol. 17 (March 1931), p. 376.

3. Ibid., and p. 380; and PAFA Student Register for 1860–84.

4. "Thomas Eakins as a Teacher," *The Arts,* vol. 17 (March 1931), pp. 376–86; "Thomas Eakins as a Teacher: Second Article," (October 1931), pp. 27–42. Bregler apparently planned some kind of larger publication on Eakins which never came to pass. Many notes for such a project seem to have been preserved in Bregler's papers.

5. Ibid., October 1931, p. 35.

6. Bregler was given free admission to these classes by his own request (Faculty Minutes Oct. 11 and 24, 1895). He asked for and received permission to attend them again free of charge in February of 1897 (Faculty Minutes, Feb. 18, 1897), but there is no evidence in the Student Registers to suggest that he actually attended in that year.

7. Bregler exhibited in the Academy Annuals as follows: 1892: *Portrait of a Woman;* 1896/97: *Portrait Sketch of My Sister;* 1889: *Portrait Sketch of a Man;* 1903: *Portrait of a Young Man;* 1934: *Blacksmith Shop* (pastel). In addition, Bregler's *Portrait of a Woman* from the 1892 Annual was one of many works by relatively unknown Philadelphia artists selected for the Fine Arts section of the World's Columbian Exposition in Chicago in 1893.

8. Letters written in 1932 from Susan Eakins to Seymour Adelman, now in the Adelman collection at Bryn Mawr College, mention Bregler's wife's mental illness and the high degree of stress he was under at that time.

9. However, evidence from various sources shows that a good deal of material was destroyed at this time. Bregler wrote to Seymour Adelman on August 3, 1939: "I went to the Graphic Sketch Club. I thought to give the frames and modelling stands etc. and the relief of the horse. . . . Murray wanted to destroy it as he did all the fine life masks, hands, feet, etc." (letter in the Adelman Collection, Bryn Mawr College). In 1979 Seymour Adelman wrote: "The

reason Eakins' photographs of the female nude are now so rare is . . . scores of them were destroyed . . . by a well-meaning, but tragically misguided family friend" (Goodrich I/246). However, over 30 photographs of the female nude have survived in the Bregler Collection. Also see the Introduction to this volume.

10. George Barker to Bregler, July 30, 1944. Barker gave more Eakins/Wallace letters to the Joslyn Art Museum in Omaha, Nebraska in 1966.

11. A draft of a letter to Susan's sister Elizabeth Kenton, dated December 13, 1939, reveals that he sent her several pages torn from one of Susan's diaries, pages "which should not concern anyone but you." We will never know how many other manuscripts he destroyed, although it is likely that this act was not typical of his guardianship of the collection. He was very much concerned in 1939 about keeping in the good graces of Mrs. Kenton, since he was asking for her aid in securing payment for his inventory. (Also see the Introduction.)

12. Indeed, as late as 1982 Goodrich would write: "All these documents [shown to him by Susan in 1930–32] I copied in toto. Their present whereabouts, or even existence, are unknown." (I/viii). He wrote also, "In 1961 Mr. Hirshhorn acquired the paintings, sculpture, drawings, documents, and memorabilia that had been preserved by Charles Bregler" (I/xiii); and "Bregler placed most of his collection on consignment." (II/283).

13. For more on the condition of the collection at the time of its sale see: "An Important Eakins Collection" by Kathleen Foster in *The Magazine Antiques,* vol. CXXX, no. 6 (December 1986), pp. 1228–1237, and the Introduction to this volume.

14. Samuel Murray to Bregler, May 5, 1927.

The Manuscripts of
Charles Bregler

Bregler's surviving correspondence documents his life from about 1913 to a few years before his death. In most cases, Bregler kept only fragmentary copies of his outgoing correspondence. Many of these are undated and it is often not clear whether they were actually sent or were just a series of thoughts jotted down for his own satisfaction. His most frequent correspondents are Susan Eakins and the executors of her estate; Samuel Murray, Elizabeth Kenton, David Wilson Jordan, Stephen C. Clark, Seymour Adelman; Henri Marceau, and Fiske Kimball of the Pennsylvania Museum; Elizabeth Dunbar, George Barker, Walter Pach, Carmine Dalesio, Lloyd Goodrich and Frank B. Linton. Several letters are reproduced in this chapter, and a selective list of Bregler's received correspondence has been included. All art-related material is included in the Microfiche Edition. For details concerning the editing of the papers and the arrangement of the Microfiche Edition see the chapter on Editing and Filming Procedures.

Apart from his relationship with Susan Eakins, two specific events in Charles Bregler's life are fairly well documented in this collection. His part in the settlement of Mrs. Eakins' estate in 1939 and 1940 can be traced in over 70 letters to and from the executors, the heirs, and the bank. It was only after repeated pleas and reductions in his bill that he was finally paid five hundred dollars for his services in cataloging the works of art left in the Eakins house. There is also a significant amount of material relating to the 1944 sale of a part of his collection through M. Knoedler and Company.

In addition to correspondence the collection contains hundreds of other documents relating to Charles Bregler. Among the most interesting are:

- Notes kept by Bregler on his visits to 1729 Mt. Vernon Street, e.g., "April 8, 1937, went to the Eakins house this afternoon to work on the Beckwith portrait . . . Mrs. Eakins was in very good humor. She confided in me that she had sent T. Eagan a check for $300 as she felt he needed it . . . ". Most of these notes are from the period in 1939 when Bregler visited the house almost daily to work on his inventory.

- Bregler's biographical notes on Susan Eakins; his summary of her character appeared in her obituary in *Art Digest,* Jan. 15, 1939. Several drafts and notes for this reflect his regard for her. He wrote: [She had a] "sympathetic and a most understanding nature which showed itself unobtrusively in so many ways . . . modest, self-effacing, shrinking from any form of publicity or desire to bask in the shadow of her husband's merited fame . . . beloved by all who came into contact with her."

- Bregler's inventory of the paintings left in the house after Mrs. Eakins' death, including works by Thomas, Susan, and other artists.

- Bregler's notes and drafts for his magazine articles on Thomas Eakins. In addition, there are many pages of notes that do not seem to be directly related to the two 1931 articles.

- Memorabilia from Bregler's leather novelties business, including small leather-bound blank books, hand-colored postcards, and business cards, e.g., "Bregler's / The Original Little Art Shop". A charming photo shows Bregler standing in the shop door, and 3 panoramic photos of Asbury Park, New Jersey document the location of his shop as well as the town's main street around 1910 (see Figure 49).

Charles Bregler's Correspondence and Personal Papers, Fiche Location IV 1/A/5–16/G/14

Correspondence, n.d., 1894–1958

1. Letters and drafts sent [?], n.d., 1894–1951.
2. Letters to and from CB re estate of SME, 1939–1940.
3. Letters to and from Knoedler & Co., 1944.
4. Letters to and from Philadelphia Museum of Art, 1944.

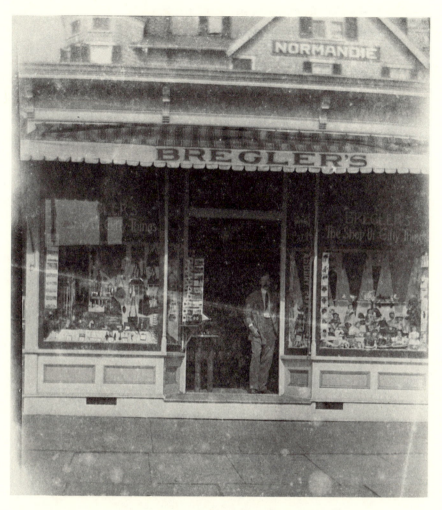

49. Photographer unknown, Charles Bregler standing in the
 doorway of his shop in Asbury Park, New Jersey, ca. 1900,
 modern print from a 3¹⁄₁₆ × 2⅝″ film negative.

*Bregler sold his leather work and other novelties from his home in Philadelphia or
from "Bregler's the Shop of Gifty Things", in Asbury Park. His shop was in
operation in the years around 1900, but it seems to have closed sometime before the
mid 1920s. After Eakins' death in 1916, Susan employed Bregler for various odd
jobs, gradually entrusting him with the conservation of her husband's work, and
eventually allowing him to use the studio for his own painting.*

5. Letters received from SME, n.d., 1917–1938.
6. Letters received from other persons, n.d., 1894–1955.

Personal Papers, Diaries, Notes

1. "Diary" type notes on his visits to 1729 Mt. Vernon St.; and biographical notes on SME.
2. Notes on TE and TE paintings; manuscripts for his articles on TE; (his notes on TE lectures and manuscripts can be found with Eakins' papers).
3. Inventory of works of art at 1729 Mt. Vernon St.
4. Personal papers and printed matter (receipts, programs, lists, membership cards, Academy and Art Students' League admission cards).
5. Miscellaneous notes.
6. Condolences on the death of his wife, 1944 (unfilmed).
7. Letters to the Breglers from family, 1905–1944 (unfilmed).
8. Correspondence re CB's business, 1909–1937 (unfilmed).
9. Letters to Elizabeth Bregler (from Elizabeth Kenton (1), from Jane Murray (2), from Samuel Murray (1) (unfilmed).

Printed Matter Relating to TE

1. TE exhibition catalogs
2. Published articles about TE
3. Newspaper clippings about TE (not reproduced on microfiche)
4. CB's scrapbook of TE clippings (not reproduced on microfiche)
5. Reproductions of TE paintings (not reproduced on microfiche)

Personal Ephemera Unrelated to TE
(not reproduced on microfiche)

1. Miscellaneous nineteenth-century art-related book and pamphlets
2. Two German exhibition posters ("1904/05. Deutsche Malerzeitung Die Mappe. Zeitschrift fur die gesamte Malerei. Detailbogen No. 284. Pause zu Tafel 45." Also "Detailbogen No. 282")
3. Masonic order printed matter
4. Miscellaneous printed matter unrelated to art
5. Copy of lecture, "The Mechanics of Painting," by Emil Carlsen, PAFA, 1914

6. Data collected for the portrait of James Logan
7. Notebook entitled "Photographic Information" (notes on photography by the same person who annotated the circa 75 glass negatives—not by Eakins—in Inventory #87.25)
8. Miscellaneous twentieth-century art books and pamphlets

Photographs Made by or Owned by CB
(not reproduced on microfiche)

1. Photographs of TE Letters
2. Photographs of purported TE works denied by CB
3. Photographs of TE works of art
4. CB copies of TE photographs
5. Photographs of Elizabeth Bregler, Mary Bregler, and other unidentified persons (Bregler-related)
6. Photographs of CB paintings, or in preparation for paintings
7. Photographs of SME paintings

Brief List of Charles Bregler's Received Correspondence

This very abbreviated list illustrates the character of Charles Bregler's received correspondence, which contains over 500 letters, many from dealers and collectors.

DATE	SENDER	CONTENT
n.d., 1894	Frank B. Linton	enjoys Paris; saw Quinn
17 Jun 1913	Samuel Murray	sorry he missed CB
30 Apr 1914	Emil Carlsen	on some painting problems
12 May 1914	Mathilde Weil	on photography
7 Jul 1914	Henry Ritter, M.D.	on oils used in painting
15 May 1919	Samuel Murray	recommending CB for a portrait
13 Aug 1919	———	sympathy for CB's problems with Logan
24 Oct 1919	———	promised "that spinning plaque to Linton"
1 Dec 1921	———	has seen Quinn
19 Mar 1925	———	saw "Thief of Bagdad"
7 May 1926	E. W. Boulton	speaks of Schenck
5 Jan 1927	David W. Jordan	friendly greetings
8 Mar 1927	Samuel Murray	speaks of Schenck
5 May 1927	———	life as an artist; his Provost Smith statue

9 Feb 1930	David W. Jordan	friendly letter
21 Aug 1930	Samuel Murray	friendly letter
2 Feb 1931	David W. Jordan	CB should see TE show in New York
Nov 1931	Stephen C. Clark	wants to buy a TE work
7 Feb 1933	Seymour Adelman	will keep CB's pastels in the gallery
8 Mar 1933	Lloyd Goodrich	$85 fee for CB's notes
17 Mar 1933	Seymour Adelman	Sympathy for lack of sales; tired of the art business
30 Mar 1933	EMK	praises CB pastels
31 Mar 1933	Seymour Adelman	gave CB pastels to Milch Gallery
3 Jan 1934	Robert Gwathmey	thanks for photo of TE sketch
1 Jun 1935	Frank B. Linton	friendly letter
14 Jan 1936	Henri Marceau	regrets Art Club's refusal of CB work
5 Nov 1936	A. J. White	interested in a book on TE
12 Nov 1936	Stephen C. Clark	will not buy 2 TE works
24 Mar 1937	Macbeth Gallery	considering buying an unnamed TE work
22 Jun 1937	Elizabeth B. Johnson	leave her portrait at Milch Gallery
2 Jul 1937	Henry Ritter, M.D.	thoughts about Art Club show
9 Aug 1937	Elizabeth B. Johnson	sale of her portrait
28 Dec 1937	Adele K. Smith	can she borrow a TE
3 Jan 1938	———	arranges to receive 2 watercolors
24 Jan 1938	———	copy of her offer for TE painting
6 Mar 1938	Carl Van Vechten	sending photos of SME
24 Mar 1938	Lloyd Goodrich	asks CB's opinion of a possible TE
27 Mar 1938	Elizabeth Dunbar	describes Peking
21 Apr 1938	Kitty Horstick	when will CB finish Husson portraits
8 Sep 1938	Elizabeth Dunbar	More on life in China CB should have faith
11 Dec 1938	———	tells of life in Peking
4 Jan 1939	Susan B. Ireland	warm feelings for SME
5 Jan 1939	Elizabeth Dunbar	life in China
16 Mar 1939	Saul Gurevich	are his pictures ready
19 Mar 1939	Margaret Pach	asks re SME estate and discord at SME house
21 Mar 1939	George Barker	asks for copy of CB's article
4 Apr 1939	———	has his TE mementos stored well; has talked to Wallace
7 Apr 1939	Samuel Murray	wants to go to TE home
11 Apr 1939	George Barker	has hung TE souvenirs given by CB; recounts talk with Wallace
12 May 1939	Mark Lutz	saw TE show in N.Y.
16 Jun 1939	Seymour Adelman	wants to get TE home appraised; asks CB's advice
18 Jun 1939	Samuel Murray	wants to end argument
11 Sep 1939	Seymour Adelman	re TE house
12 Nov 1939	Walter Pach	sympathy for problems re TE house
18 Nov 1939	George Barker	problems getting his book on *The Gross Clinic* published
21 Nov 1939	Seymour Adelman	spoke with PAFA about TE house
10 Feb 1940	Wm. G. Macdowell	can do nothing about CB's fee
10 Mar 1940	EMK	sympathy as above

13 Mar 1940	Babcock Galleries	re sale of the Rowland portrait
13 Oct 1940	Seymour Adelman	sympathy re CB's problems with restoration of *The Gross Clinic*
30 Jan 1942	Jane Murray	asks for copy of CB's article on S. Murray
4 Jan 1942	John Laurie Wallace	answers CB questions re TE motion photos
30 Jan 1943	Henri Marceau	asks for TE letters for Archives of Amer. Art
14 Jan 1944	———	asks to visit CB with Julius Bloch; is readying TE show
31 Jan 1944	A. Hyatt Mayor	re sale of TE photos to Met. Museum
30 Jul 1944	George Barker	encloses TE letters
19 Feb 1945	Beatrice Fenton	thanks for card she sent to TE many years ago; wishes TE was alive to enjoy his fame

Selected Letters of Charles Bregler

See "Selected Manuscripts of Susan Macdowell Eakins" for a selection of letters written by her to Charles Bregler.

[CB to Stephen C. Clark]

Phila. June 11–31
COPY

Mr. Stephen C. Clark
149 Broadway
New York
Dear Mr. Clark,

You know and I know that Eakins' pictures are selling far below their value. When one compares the price paid for Winslow Homer, Inness, Sargent, without mentioning some of the Modern French painters.

There are several reasons why Eakins who is far superior to those mentioned had been neglected. I will endeavor to point out some of them in an article for publication this fall.

In my insurance I have placed a value of $10,000 on Eakins picture and a like value on my painting of my Grandmother. I feel confident when this psychological depression is in the background there will be a decided advance in values. also the diminishing supply. However I think and believe from the choice which you have made that your motives are not speculative. That you are [illegible word] solely by an appreciation and love of beautiful work.

And it is for that reason why I should rather see this gem the best of all of Eakins portraits of women go into your possession. If I let it go at this time at $8500 does this interest you?

<div align="center">[unsigned]</div>

[CB to Samuel Murray]

<div align="right">July 23 [1939]
Copy, to Murray</div>

Dear Sam,

Thinking I did not make myself clear over the phone [I] thought it advisable to send these few lines, to prevent any misunderstanding as [to] that very painful one to me about the statuette.

I have not been in or near 1729 since the day they left for Washington which is about three weeks.

I did want to be there last week when they removed the things, but I failed to get the letter which Morgan mailed me, and knew nothing about it until I received his letter on Friday.

I do hope they have not carted away [any] thing Mrs. E. had given me and which it was my plan to preserve for the Eakins room at the Museum which some day will become a reality.

Some things I did not put my name on. [I] had hoped to be present when they did remove the things. Among them was the chair up in the top studio. It was all covered by me. This was one of the things plan[n]ed for the Eakins room.

I have decided to keep those reliefs and the horses during my life time, and then pass them on to some Museum out side of this city.

The same with the Boss['s] perspective drawing which Mrs. E. gave me more than 15 years ago, some of which I mounted other[s] I shall try to save if possible as the paper breaks unless great care is taken.

These are all for future student[s] that is the thought and hope that prompts me to care for them.

The letters I have were taken solely to keep them safe. They will all be turned over to the executors. If I had not acted when I did they probably would have gone elsewhere, as many of them did. In the course of years I wrote Mrs. Eakins many letters. But I did not find a single one. The executors have the most important letters, and lists of the money loans etc. she made to various people.

In a box I found letters relating to the trouble at the Academy, and the Miss Hammit case, with a note by Mrs. Eakins that they were to be completely burned.

I was surprised to find them, But glad they were discovered before they fell into strangers hands.

The Gerome drawing which you and I know the Boss had. I had asked Mrs. Eakins about these, for several years, But she always told me she knew nothing about them. After her death I searched every drawer [and] closet in the hopes to find them, but without success. And there were other things I failed to find. Also, if they were taken by some person during her life time without her knowledge, one can only surmise.

The life class drawings, up in the top studio are by Rothermel. I was careful these would not get out and passed off as Eakins. They are the property of Carrie Macdowell and she asked me to give them to students who may be interested. This I promised to do.

These past months I have learned much seen, heard much. It's a sorrowful and tragic ending. You know all this as I do.

Believe me as ever sincerely copy mailed
 Charles Bregler July 23–39

Sunday eve

[CB to Mary Butler, President of the Academy Fellowship]

Mrs Butler, [1939?]

I have just received word from Mr Adleman. He had an interview with you in regards to the Eakins home and the thought came to me.

What a splendid opportunity for the Fellowship to secure a permanent home. if it could be realized it would accomplish a two fold purpose a memorial to Eakins and a home for the Fellowship a caretaker who would for his or their service have good living quarter and a good studio to work in it would provide a meeting place for the Fellowship. There are two Studio ~~the original one could be kepted~~[?] I know nothing [illegible word] could or would have pleased Mrs E or met with her approval if this could be brought about.

To think it was here where the Gross, the Crucifixion, Chess players, Katherine, Eakins first sweetheart, all the rowing and sailing pictures were painted so many others—too numerous to mention. Here he lived this entire life from the age of two and where he passed from this life and only recently his beloved Sue.

It is unthinkable that this house should be used for any other purpose.

When one thinks of the many famous men and women who enter the door of 1729, and the possibility of these rooms that hold so many sacred memory [*sic.*] of America['s] greatest genius Thos E [?] to be desacrated[?]

by a rooming house or maybe a house of prostitution, heaven forbid. I know of no one who has worked harder for all that the fellowship stands for and who wields a greater influence among Artists and are lovers of Phila. and it is for this reason that my thought is conveyed to you for your consideration. I wish that the years had not taken their toll[?] and had not the care for years of Mrs B. I should devote them [five illegible words]

[unsigned draft]

[Seymour Adelman to CB]

n.d. [1939]
Friday night

Dear Mr. Bregler,

Don't worry that you were unable to wait for me this afternoon, as it's perfectly all right. I had to be in Phila. anyhow, and it was no trouble for me to stop in at your house. I know you'll be glad to have that November issue of the "Magazine of Art." Please keep it, because I have another copy for myself.

I received a reply from Miss Butler this morning, in regard to the Fellowship taking over 1729. She writes that it is impossible, as the maintenance would be far too costly for the Fellowship. She is sympathetic and wishes me success; but nevertheless she says that the whole idea seems hopeless.

So during the afternoon I went to the Record and had a long talk with Miss Dorothy Grafly. She also, at first, said that the venture appeared hopeless to her. But after a while she conceded that perhaps it <u>might</u> be possible to save the house, after all. (The problem of future maintenance bothers her most of all.) Finally she promised me that she would support the campaign in the Record, <u>providing</u> some prominent organization would start the drive first. She phoned the publicity director of the Academy of the Fine Arts, and made an appointment for me at 2 P.M. on Monday. So maybe something will work out of that.

I'd like to have your opinion of one or two ideas regarding 1729. There is a slight possibility that I'll have to be in Phila. tomorrow (Saturday). If so, I'll try to stop in to see you. <u>If I'm not there at 1 o'clock,</u> don't wait for me any longer—I'll see you on Monday after instead.

With kindest regards to you and Mrs. Bregler,

Cordially,
S.A.

No word from Atwater Kent so far.

[CB to Dean Everett Meeks]

May 2—1940
COPY

Mr. Dean Everett Meeks
Yale School of Fine Arts
New Haven, Conn
My dear Mr. Meeks

Having in our collection the original sketch by Eakins for his picture "Counting out" and as Yale has this painting of which this is the original conception showing the 3 figures as in the painting it is ruled by squares as was his custom for transfering to the large canvas.

We thought it would prove of ~~great~~ inestimable value for students giving them a graphic illustration of his method of procedure.

With these thoughts in mind these few lines are addressed to you to inquire if Yale would be interested in acquiring this sketch of Eakins.

This is the first time it has been offered for sale, and Yale is given the first opportunity, it having the large painting and are therefore to be given this consideration.

Respectfully your
Charles Bregler

The writer of these lines was a pupil of Eakins, and a close intimate friend for 50 years.

The author of "Eakins as a Teacher" published in the Arts Magazine, from which Mr Goodrich quoted ver-batem, including personal information given him for his book "Thomas Eakins his life and works".

Charles Bregler 4935 N. 11th St Philadelphia, Penna

[unsigned draft]

Chronology of the Life of Charles Bregler

1864	Born, Philadelphia (his marriage license application lists date of May 28, 1864; PAFA Annual Exhibition catalog of 1892 gives 1865)
1883	First recorded attendance at the Pennsylvania Academy of the Fine Arts
1884	Attends Pennsylvania Academy in March, April, October, November, December
1885	Attends Feb. to Dec.; and Jan. of 1886
1886–90	Attends classes at Art Students' League
1892	First exhibits in the Academy Annual Exhibition subsequently exhibits in 1896/97, 1898, 1903, and 1934.
1893	Exhibits at the World's Columbian Exposition, Chicago
1894	Returns for more classes at the Academy, registers for day courses in Life and Head; attends both semesters of 1894/95
1895	Continues day course, Fall semester of 1895/96
1899	Marries Elizabeth Yohn, October 11
1918	Joins St. John's Lodge (Masonic order)
1920s	Begins close association with SME
1931	Publishes 2 articles on Thomas Eakins in *The Arts*
1936	Exhibits in group show at Art Club Gallery organized by SME
1943	Publishes brief *Magazine of Art* article on Eakins' motion photography
1944	Wife, Elizabeth Bregler, dies on February 4
1944	Sells a part of his collection to Joseph Katz
ca. 1950	Meets Mary Picozzi
1958	Bregler dies on September 24, without issue

50. Thomas Eakins, William H. Macdowell, ca. 1884,
 albumen print, $2^{11}/_{16} \times 2^{3}/_{16}''$.

*Eakins took at least five photographs of his father-in-law and painted several
portraits of the striking looking gentleman, who was a distinguished Philadelphia
engraver.*

The Papers of Benjamin Eakins and the Macdowell Family in Charles Bregler's Thomas Eakins Collection

Benjamin Eakins (1818–1899), Thomas Eakins' father, was a well-known and widely respected Philadelphia writing master, who taught at the Friends' Central School for over fifty years. He and his son were very close. Eakins painted his father's portrait or included him in a figure composition on numerous occasions. Letters written to Benjamin by Thomas are listed in "The Manuscripts of Thomas Eakins."

BE to Eliza Cowperthwait, n.d.
asks her to tell him whether he should write long or short letters to her.
1 p. [probably the sister of his wife, Caroline Cowperthwait].

Henry F. Huttner to BE, 29 Jan 1867, San Francisco.
has received a letter from Tom in Paris; remembers how he was strongly opposed to going abroad; is sure that he will do well there; asks for some samples of paper from an area mill for his brother who is starting out in the business.
3 p.

BE to Henry Huttner, 29 July 1874, Philadelphia.

glad to have a letter from his old friend; "Fanny lives with me still, and I hope will as long as she finds it comfortable;—she has a little daughter about six months old which makes it seem a little like old times. . . . Tom last fall had a serious attack of "Malarial Fever" which kept him in the house for 10 or 12 weeks, since then he is all right, painting away—. . . he will be able to make a living, that is all any of us get. This is a fast age and I hope it will not prove with him as it did with many of the old Master, [*sic.*]—receive great honors a hundred years after they had starved to death".

3 p.

Macdowell Family Letters and Personal Papers

The Macdowells lived at 20th and Race Streets in Philadelphia, just a few blocks from the Eakins home. The patriarch, William H. Macdowell, was a distinguished engraver. Several of his eight children displayed artistic leanings, but none so pronounced as Susan's. Elizabeth, the youngest (1858–1953), painted and gave instruction in painting. She married Louis Kenton in 1904. William G. Macdowell, the second son (1845–1926), was very close to Susan and was particularly supportive and concerned during the period of Eakins' dismissal from the Pennsylvania Academy of the Fine Arts.

> Bill for groceries to Wm. H. Macdowell, 1857
> Wm. G. Macdowell to [James Macdowell], n.d. [Civil War], 4 pp., illustrated
> Newspaper account of 49th graduation of Central High School with mention of William G. Macdowell, 13 Feb 1863
> Receipt for violin lessons for William G. Macdowell, 1869
> Mary Kirkham to William H. Macdowell, postcard, June 1875
> Business card of Elizabeth Macdowell: "Painting Classes/2nd Quarter/January 14th/2018 Race St.," n.d.

Manuscripts Pertaining to Thomas Eakins in the Archives of the Pennsylvania Academy of the Fine Arts (Other Than the Bregler Collection)

In addition to the Bregler Collection, the Archives of the Pennsylvania Academy contain other documents relating to Thomas Eakins or to members of his family. These consist of four series.

I. Letters and documents pertaining to Eakins' tenure as faculty member and Director of the School, or to works of art submitted by him to the Academy's Annual Exhibitions, or on other matters, 1876–1916.

II. Letters from Thomas Eakins to Emily, William, and John Sartain, 1866–1871 and 1886. Gift of Paulette van Roekens and Arthur Meltzer as executors of the estate of Harriet Sartain, 1959. 14 items.

III. Letters from Benjamin Eakins to Emily and Paul Sartain, source as in Series II above, 3 items.

IV. Documents relating to various members of the Eakins and Crowell families, acquired 1988 from the estate of Gordon Hendricks. 10 items.

Series I: Letters and Documents Pertaining to Eakins' Tenure as Faculty Member and Director of the School or to Works of Art Submitted by Him to the Academy's Annual Exhibitions, or on Other Matters, 1876–1916

The Pennsylvania Academy of the Fine Arts reopened in the spring of 1876 after almost 6 years of limited operation (or no operation) during the construction of the Academy's building. Eakins was appointed professor of drawing and painting in 1879 and served as Director of the School from 1882–86. In addition to the Eakins correspondence listed here, the Pennsylvania Academy Archives house many other manuscripts that document the history of the School during the period of Eakins' tenure. These include:

> Minutes of the Committee on Instruction
> Reports submitted to the Committee on Instruction
> Registers of student attendance
> Student petitions and letters
> Incoming correspondence from various persons
> School catalogues
> Clippings

(Additional documentation for Eakins' tenure and dismissal can be found in the Bregler Collection, especially the letters exchanged between Eakins and Edward H. Coates.)

Eakins exhibited in the Annual Exhibitions at the Pennsylvania Academy from 1876 to 1916. Additional information on the exhibitions can be found in:

> Minutes of the Committee on Exhibitions
> Exhibition catalogues and their published indexes
> Registers of Works Received for Exhibition
> Correspondence
> Clippings

Many of the materials mentioned above have been filmed by the Archives of American Art and are available on microfilm via Interlibrary Loan.

Letters from Eakins are all autograph unless specified otherwise. Letters written to him from the Academy Secretary/Managing Director, (Harrison

S. Morris, John A. Myers, or John E. D. Trask) are press copies from bound letterbooks. The letterbooks of Harrison S. Morris are still intact. Those of Trask and Myers have been dismantled. All other letters are autograph. Pagination has been calculated by the editor. The word "transcription" before the summary indicates a letter that has been fully transcribed in the entry. Editorial comments are in brackets.

The Committee on Instruction, a subcommittee of the Board of Directors, was responsible for the running of the School. The Secretary/Managing Director was charged with the day-to-day operations of the institution and acted, to a great extent, at the discretion of the Board. The major figures in the correspondence listed here were:

George Corliss (1839–1908), Secretary of the Academy 1877–1891

Harrison S. Morris (1856–1948), Secretary and Managing Director of the Academy 1892–1905

Fairman Rogers (1833–1900), member of the Committee on Instruction 1871–1883

Edward Hornor Coates (1846–1921), member of the Committee on Instruction 1881, 1882, 1884–1889

John E. D. Trask (1871–1926), Assistant to the Managing Director 1897–1905, Secretary and Managing Director 1905–12

John A. Myers (1863–1938), Secretary and Managing Director of the Academy 1913–1938

1876–1886: CORRESPONDENCE PERTAINING
TO THE PENNSYLVANIA ACADEMY OF
THE FINE ARTS SCHOOL

1. TE to Committee on Instruction, 8 Jan 1876.

Asks that female models of respectability be advertised for in the *Public Ledger*. They may be "accompanied by their mothers or other female relatives. Terms $1 per hour," and may wear masks. Hopes thus to get beautiful forms instead of the coarse, flabby types formerly obtained by bargaining with inmates of brothels.

1 p. [It is unlikely that this advertisement was ever run. No responses to it are preserved. Since the Academy School did not re-open until the Fall of 1876, this letter must have been written in January 1877 and misdated by TE.]

2. TE to Board of Directors, n.d. [early March 1878].

Offers to assist with the teaching as the classes are increased, as per request of the Committee on Instruction.

1 p. [At its March 20 meeting the Committee formally agreed to invite Eakins to assist Prof. Schuessele, although the matter had also been discussed on March 6 and 11.]

3. TE to Committee on Instruction, 16 Dec 1878.

Begs the favor of a life class ticket for Miss Lizzie Macdowell. Believes her ready to receive great benefit from the study of the living model.

1 p.

4. TE to George Corliss, 9 Feb 1879.

Caught two students ("Sovy & Co.") casting antique gems from casts he suspects belong to the Academy's collection. Try to catch them in act or "they will probably steal or destroy those they have injured"; saw one of "Leda and Jupiter," the original of which they must produce or be prosecuted. No loss if Sovy should leave school.

2 pp.

5. TE to George Corliss, 27 Apr 1879.

Gives Miss Franklin permission to copy her picture of Judge Mitchell any morning before the admittance of the public to the exhibition.

1 p. [Miss Mary Franklin, a student, showed 3 paintings in the Annual Exhibition of 1879.]

6. TE to James L. Claghorn, 28 May 1880.

Considers it inexpedient to have daytime lectures on anatomy as students need daylight for painting. Anatomy lectures at night are well-attended and popular.

2 pp.

7. TE to George Corliss, 26 Jun 1880.

Please send school circular to Miss Mary C. Dwyer of Port Huron, Michigan.

postcard.

8. TE to Fairman Rogers, 14 Apr 1881.

Is going to N.Y. next day to see exhibitions. Therefore excuses himself from Committee [on Instruction] meeting, but on return will give his opinion on any drawing [students applying for admission] about which the Committee might be in doubt. Offers to give a course of perspective lectures in the evenings.

1 p.

9. Elizabeth Macdowell to TE, 31 Jan 1882.

Requests that the women's days in the dissecting room be reserved exclusively for women. Boys working there have destroyed the subject by cutting off its head—the rest is dried up. Some boys are noisy and rude.

2 pp.

10. TE to Board of Directors, 8 Apr 1885.

States that while his salary as Director of School was fixed at $2,500, he had been asked to serve temporarily at a much reduced rate. Has never received full amount although the school is full and its reputation widely known. The promised salary was a large factor in his remaining in Philadelphia.

2 pp.

11. TE to Edward H. Coates, 9 Feb 1886.

Tenders his resignation, in accordance with request, as director of the Academy schools.

1 p.

Two often-quoted and important documents concerning the dismissal of Eakins from the School, although not from his hand, are listed here for the convenience of researchers:

*PAFA students to the Board, 15 Feb 1886.

petition signed by 55 students expressing "confidence in the competency of Mr. Eakins" and asking that he be retained on the faculty.

4 pp.

**James P. Kelly, Colin Campbell Cooper, Charles H. Stephens, T. P. Anshutz, and George Frank Stephens to PAFA, 12 Mar 1886.*

Protest from a group of instructors inspired by rumor in the press that Eakins' dismissal was result of malicious conspiracy; while in fact it was due to abuse of his authority.

2 pp.

1879–1916: CORRESPONDENCE RELATING TO THE ANNUAL EXHIBITIONS, SERVICE ON JURIES, OR OTHER MATTERS.

12. TE to George Corliss, 4 May 1879.

instructions to ship *The Gross Clinic* to the Jefferson Medical College.

1 p.

13. George Corliss to file, 4 Jun 1879.

note in Corliss' hand on the bottom of TE's letter to him of 4 May 1879, re the arrival of *The Gross Clinic* at the Academy.

1 p.

14. TE to George Corliss, Oct 1881.

Asks that invitation be sent to Day, who has a good little picture he wants the Committee to pass on.

1 p.

15. TE to George Corliss, n.d., [1 Mar 1885].

Requests that the Academy give Mr. Haseltine the painting *The Meadows* (landscape).

1 p.

16. Pennsylvania Academy to TE, 17 Dec 1885

Receipt for 3 paintings by TE: *Swimming, Portrait of Wallace,* and *Portrait of Reynolds.*

receipt.

17. TE [per SME] to George Corliss, 14 Jul 1886.

[transcription] Please let the bearer have the picture by Thomas Eakins entitled "Ecce Homo" for James S. Earle & Sons, collectors for Charles M. Kurtz, Director of Art Depart., Louisiana Ex./ and oblige.

1 p. [This letter was written for TE by his wife. His dismissal a few months earlier had probably left him too bitter and unhappy to write to the Academy himself. It is not until 1891 that he again personally contacts the institution.]

18. TE to George Corliss, 9 Jan 1891.

Portrait of Professor William D. Marks, belonging to the University of Pennsylvania, which he offered to exhibit on invitation of committee of artists, was not collected. Will make arrangements for its collection.

2 pp.

19. TE to Committee on Exhibitions, 16 Jan 1891.

Offers to add to interest of his exhibit by sending *Portrait of a Poet,* owner, Walt Whitman; and *Portrait of a Student,* owner, Samuel Murray.

calling card.

20. TE to Edward H. Coates, 6 Feb 1891.

Thanks Coates for putting into writing a conversation they had. Recent controversy concerning the Hanging Committee was not handled very well.

2 pp.

21. TE to Pennsylvania Academy, 12 Mar 1891.

"Please deliver to Chas. Haseltine the portrait of Prof. Wm. Marks."

1 p.

22. TE to Harrison S. Morris, 23 Apr 1894.

Gives biographical data, names of instructors, and length of teaching term and ends with "My honors are misunderstanding, persecution and neglect, enhanced because unsought."

2 pp.

23. Harrison S. Morris to TE, 13 Dec 1894.

is expecting the Beckwith portrait from Mr. Beckwith and the Fussell and Lippincott portraits from TE [for the Annual Exhibition].

letterbook, 1 p.

24. Harrison S. Morris to TE, 20 Dec 1894.

[transcription] Many thanks for your prompt attention to Mrs. Eakins' portrait of Schuessele. Mrs. Krupp was an old friend of mine & I hope she will be friendly about it. When you learn all the details, please send us the address where the picture is to be collected. Merry Christmas to you & Mrs. Eakins, and believe me,/ Yours very truly/

letterbook, 1 p. [see also no. 66].

25. Harrison S. Morris to TE, 23 Feb 1895.

please let him know where the bronze relief *Washington Crossing the Delaware* is to go at the end of the exhibition.

letterbook, 1 p.

26. TE to Harrison S. Morris, 25 Feb 1895.

The address for the bronze panel is Maurice J. Power, Founder, 218 E. 25th St., New York.

1 p.

27. TE to Harrison S. Morris, 6 Dec 1895.

Sent his picture of Frank Cushing to the Academy today without its frame, which is at his house.

1 p.

28. TE to Harrison S. Morris, 16 Feb 1897.

"I shall be very busy all day tomorrow at the Tioga studio but can stop in to see you the next day. Purchase of my *Cello Player* would be a very simple transaction if you have my price." Would not think it at all fair to quote one price and take another.

2 pp. [The Academy purchased the work the next day, the first painting by Eakins to be acquired.]

29. *Harrison S. Morris to TE, 11 Oct 1897.*

[transcription] The plaster cast of your tablet for the Trenton Monument is still here, and I wonder if you would now care to have it sent to your studio. If so, kindly let me know and it will give us pleasure to return it whenever it is convenient.

letterbook, 1 p.

30. *Harrison S. Morris to TE, 26 Mar 1898.*

[transcription] While we have no desire to get rid of your portrait [Prof. Rowland] from the exhibition yet Duckstein tells me that you asked him to notify you when we were ready to deliver it. We are now ready, and I take this occasion to thank you for letting us have it.

letterbook, 1 p.

31. *Harrison S. Morris to TE, 7 Apr 1898.*

[transcription] Your note is at hand and I will do the best I can about retaining the picture here.

letterbook, 1 p.

32. *Harrison S. Morris to TE, 8 Dec 1898.*

[transcription] Your entry blank is at hand this morning and I am delighted that we are to have the *Prize Fighter,* but unless you have directed Chicago to send it to us we shall fail to get it in time without an order such as we enclose. Please sign and return the order and oblige,/

letterbook, 1 p.

33. *TE to Board of Directors, 17 Oct 1899.*

Asks permission to send his picture of *The Cello Player* to the Paris Exposition.

1 p.

34. *Harrison S. Morris to TE, 8 Nov 1899.*

[transcription] You were kind enough to promise the head of Chase now at Pittsburgh. Please sign the enclosed order, thus enabling me to get it from Pitt. I thought they looked swell in their good positions out there./ P.S. It is the new boxing picture in your studio I especially want.

letterbook, 1 p.

35. *Harrison S. Morris to TE, 6 Dec 1899.*

Thanks for the order; expects an entry blank for the boxing picture.

letterbook, 1 p.

36. *TE to Harrison S. Morris, n.d. [1900].*

Picture you want is at the New York Athletic Club, have written secretary there to let you have it.

1 p., unsigned.

37. *TE to Harrison S. Morris, 9 Jan 1900.*

Mr. Miller, the secretary, will get together at least a quorum of the Park Commission to act on the matter of the belated contribution.

2 pp.

38. *TE to Harrison S. Morris, 29 Jan 1900.*

has decided not to change the price of *Between Rounds,* leaving it at $1600.

1 p.

39. *Harrison S. Morris to TE, 2 Feb 1900.*

encloses reproduction of *Between the Rounds* from a Syracuse newspaper

letterbook, 1 p.

40. *TE to Pennsylvania Academy, 29 Jul 1900.*

After careful consideration feels he must decline invitation to serve on jury.

1 p.

41. *Harrison S. Morris to TE, 21 Sep 1900.*

sincerely hopes he will serve on jury; Mr. Coates also "earnestly desires this"; "In view of your Paris medal it is more than ordinarily urgent to take your allotted part in the big movements of American Art. You received . . . among the largest number of votes and even were this not the case, we should want you to serve because we have already the assent of 11 Paris medal winners. . . . "Now do be nice and give us your consent . . . !"

letterbook, 1 p.

42. *Harrison S. Morris to TE, 24 Oct 1900.*

when he fills out entry blank "do not forget to enclose *The Man in Black*, husband of Miss McDowell, also Portrait seated of the Inventor. But you are on the Jury and can send what you wish. I write this only as a suggestion."

letterbook, 1 p.

43. *Harrison S. Morris to TE, 1 Nov 1900.*

has seen the full-length portrait in Pittsburgh "and it looked extremely well. All the newspaper fellows praised it. We want it for the exhibition here, you know. You also promised that small picture of Miss McDowell's husband, an inventor, I think. What else have you?"

letterbook, 1 p.

44. *Harrison S. Morris to TE, 10 Dec 1900.*

[Letter illegible because of condition of the letterbook. 3 or 4 sentences long.]

45. *Harrison S. Morris to TE, 8 Jan 1901.*

[transcription] I showed the letter of Mr. Gest to Mr. Coates who seems to think that unless the Committee of the Fairmount Park Art Association meets and approves of the Bust of Mr. Windrim, Mr. Coates would be powerless to admit it on behalf of the Fairmount Park Art Association to the exhibition. On behalf of the Academy he is not only willing but anxious to have it come provided the FPAA agrees. Perhaps it would be just as well to send the bust here and maybe Mr. Coates or you can get the Committee of the Art Association together.

letterbook, 1 p.

46. Harrison S. Morris to TE, 2 Apr 1901.

invites TE to serve on Stewardson award jury. Gives time and place for the competition. "It is thought of especial importance that you, who were a valued friend of the young sculptor in whose name the foundation has been made, should serve.

letterbook, 1 p.

47. Harrison S. Morris to TE, 20 May 1901.

reminder of the time and date of the Stewardson jury meeting.

letterbook, 1 p.

48. TE to Harrison S. Morris, 5 Jan 1902.

recommends that the jury select a work of Mr. Burbank's for the exhibition; "a couple of his little Indian studies which are surely good enough to raise the average of an exhibition"; gives his address.

2 pp.

49. Harrison S. Morris to TE, 6 Jan 1902.

wishes it *were* possible to review the work of Mr. Burbank as TE has kindly suggested. Also "public exhibition in Philadelphia renders an artist's work ineligible for the show."

letterbook, 1 p.

50. Harrison S. Morris to TE, 13 Jan 1902.

will arrange for invitations to be sent to those persons whom TE has named.

letterbook, 1 p.

51. Harrison S. Morris to TE, 13 Jun 1902.

Mr. W. W. Carr asked for some names of painters who might copy some family portraits for him. "had I supposed that you would want to do this work I should have headed the list with your name. If you think it worth while you might call or write" to him.

letterbook, 1 p.

52. Harrison S. Morris to TE, 11 Sep 1902.

asks him to serve on jury for the 72nd Annual Exhibition.

letterbook, 1 p.

53. TE to Harrison S. Morris, 16 Sep 1902.

agrees to serve on jury.

1 p.

54. TE to John E. D. Trask, n.d. [1903].

please send portrait of Father Henry, the translator, to the Catholic High School Board.

1 p.

55. TE to Harrison S. Morris, 8 Feb 1903.

will not be able to come to the Academy tomorrow.

1 p.

56. Harrison S. Morris to TE, 12 Nov 1903.

likes the *Oboe Player* very much and wants it for the exhibition. "Won't you please sign the enclosed card . . . and be good to us?"

letterbook, 1 p.

57. TE to John E. D. Trask, 15 Jan 1904.

requests complimentary invitation for the Annual opening to owner of *Archbishop Elder,* the Most Rev. Henry Moeller, and also one to the Rev. P. R. McDevitt of Philadelphia.

2 pp.

58. Harrison S. Morris to TE, 15 Jan 1904.

will send an invitation as he requests.

letterbook, 1 p.

59. TE to John E. D. Trask, 25 Jan [1904].

Asks that one or two catalogues containing reproduction of *Archbishop Elder* be sent to Most Rev. Henry Moeller, the owner of picture.

1 p.

60. Harrison S. Morris to TE, 13 Feb 1904.

Temple Gold Medal has been awarded to him for the portrait of *Archbishop Elder*.

letterbook, 1 p.

61. TE to Committee on Exhibitions, n.d., late Feb [1904],

acknowledges receipt of Temple Gold Medal.

2 pp.

62. Harrison S. Morris to TE, 3 Mar 1904.

please inform where to send pictures for the exhibition; would like to give him the Temple Medal "if you would care to stop in some day."

letterbook, 1 p.

63. TE to Committee on Exhibitions, 7 Mar 1904.

desires to be represented in the St. Louis Exposition by *The Cello Player* and begs that it will be lent for the purpose.

2 pp.

64. Harrison S. Morris to TE, 15 Mar 1904.

The Cello Player has been authorized for loan to St. Louis Exposition.

letterbook, 1 p.

65. Harrison S. Morris to TE, 2 Nov 1904.

wishes to use a photo of the portrait of Mr. Thos. Kenton [*sic*] for an article in *Century Magazine*.

letterbook, 1 p. [Morris was referring to the portrait of Louis N. Kenton, known today as *The Thinker*.]

66. TE to Harrison S. Morris, 19 Dec 1904.

[transcription] I have written to Mrs. Schussele and asked her to communicate with you. I think she will have no objections to lending the portrait.

1 p. [Apparently Morris had wanted to secure Susan Eakins' *Portrait of Prof. Schussele* for the Annual Exhibition of 1895—see Morris to TE, 20 May 1894. The painting was shown in the 1905 Annual, listed as property of Mrs. Henry J. Crump, who was Schuessele's daughter.]

67. TE to Harrison S. Morris, 13 Feb 1905.

accepts invitation to dinner for the centenary celebration.

1 p.

68. Harrison S. Morris to TE, 8 Apr 1905.

[transcription] Here is Mr. Drake's letter about the half-tone plate of the "Thomas" Kenton. I hope it will be what you want.

letterbook, 1 p.

69. Harrison S. Morris to TE, 2 May 1905.

invites him to serve on the Stewardson jury.

letterbook, 1 p.

70. TE to Harrison S. Morris, 7 May 1905.

will serve on Stewardson jury; suggests that for each entry some part of the figure be carried as far as possible in order that the jury can better judge the merits.

1 p.

71. Harrison S. Morris to TE, 15 Jun 1905.

thanks for serving on the Stewardson jury.

letterbook, 1 p.

72. Harrison S. Morris to TE, 12 Aug 1905.

invitation to serve on selection jury for Annual Exhibition.

letterbook, 1 p.

73. John E. D. Trask to TE, 7 Oct 1905.

encloses advance circular and entry cards for 101st Annual Exhibition; asks that TE "use these blue cards for your own entries rather than the card which is issued to the general exhibitor.... Please do not forget that in addition to your other duties on the Jury a duty of great importance is to see that your own exhibit is thoroughly representative."

1 p.

74. TE to Edward H. Coates, 14 Dec 1905.

did not authorize Mr. Morris to use his opinions in the printed circular; although he respects Morris he would never allow his words to be used in this way.

2 pp. [In the fall of 1905 Harrison S. Morris printed and distributed a circular stating his desire to be elected to the Board of Directors. It implied approval of this proposal by Eakins and several other persons.]

75. John E. D. Trask to TE, n.d. [1906].

asks TE to submit bill for expenses in conjunction with serving as juror for Annual Exhibition.

1 p.

76. TE to Pennsylvania Academy, n.d. [1906].

bill for expenses in conjunction with the Annual Exhibition.

1 p.

77. [office of] John E. D. Trask to TE, 18 Apr [1906].

encloses "a small bill for insurance on the painting of Mr. Gest."

1 p.

78. John E. D. Trask to TE, 17 Dec 1906.

[transcription] My dear Mr. Eakins:/ What are you going to do this year for our Annual Show? The time for making up our collection lists is now at hand and, of course, we want you represented by your latest and best work. I have been hoping to get a chance to get up and see you but after all, it would be very presuming of me to suppose that my judgement about your pictures be just as good as your own. Will you not, therefore fill out and return the enclosed entry cards for two works of your own selection. These, of course, are especially invited and do not go to the jury. We hope therefore, that you will pick out your very best./ Very sincerely yours,

1 p.

79. [office of] John E. D. Trask to TE, 27 Dec 1906.

thank you for entry cards; encloses picture tags.

1 p.

80. TE to John E. D. Trask, 22 Dec 1907.

"I want to exhibit one more head 4 in all. I will stop at the Academy tomorrow and get another card."

1 p.

81. TE to John E. D. Trask, 6 Jan 1908.

lists names of 3 owners of portraits he is exhibiting suggesting they be given spare tickets to opening—if these are available.

1 p.

82. TE to John E. D. Trask, 14 Jan 1908.

kindly send invitation to Major Waldteufel, a portrait owner, who has not received one.

1 p.

83. John E. D. Trask to TE, 29 Oct 1908.

invited to serve on jury for 1909 Annual Exhibition; meetings: one day each in Boston, Philadelphia, and New York "and after the exhibition is hung, one day in Philadelphia for the award of prizes."

1 p.

84. Thomas B. Harned and TE to John E. D. Trask, 7 Nov 1908.

authorizes delivery of the *Walt Whitman* to Haseltine's.

1 p.

85. TE to John E. D. Trask, 25 Dec 1908.

regarding dates, travel, and expenses as juror.

1 p.

86. John E. D. Trask to TE, 26 Dec 1908.

will see you in Boston.

1 p.

87. TE to John E. D. Trask, 26 Jan 1909.

requests reception invitation for Miss Helen Parker.

1 p.

88. John E. D. Trask to TE, [Feb 1909].

conveys thanks for "services as a member of the jury"

1 p.

89. John E. D. Trask to TE, [Feb 1909].

requests bill for expenses.

1 p.

90. TE to John E. D. Trask, 8 Feb 1909.

bill for jury expenses.

1 p.

91. [office of] John E. D. Trask to TE, 10 Mar 1909.

encloses check for expenses.

1 p.

92. TE to John E. D. Trask, 15 Jan 1910.

requests invitations for "the sitters for my exhibition portraits" whose names and addresses he lists.

1 p.

93. John E. D. Trask to TE, 9 Mar 1910.

requests that TE serve as juror for Stewardson prize.

1 p.

94. TE to John E. D. Trask, 14 Mar 1910.

"I shall do as you request and shall be happy to dine with you and Graefly afterwards . . . It would be good if you would ask competition to select a small portion of their figures and finish such portion The judges could then give a more valuable decision."

1 p.

95. John E. D. Trask to TE, 16 Mar 1910.

"we shall expect you here at 4 o'clock on March 23rd" to serve on jury.

1 p.

96. John E. D. Trask to TE, 18 Mar 1910.

"your suggestion is in accordance with the instruction which will be given to the competitors in the Stewardson Prize Competition"; a former student asks to be remembered to TE.

1 p.

97. TE to John E. D. Trask, 19 Feb 1911.

"Please send home my Homer and oblige."

postcard.

98. [office of] John E. D. Trask to TE, 10 Mar 1911.

"am returning to you photograph which Mr. Trask turned over to me with instructions to search the catalogues of the Academy for traces of the exhibition in the Academy's Galleries of a picture of himself by Thomas Buchann[sic] Reed"; unable to trace portrait.

1 p.

99. John E. D. Trask to TE, 13 Jan 1912.

acknowledges "two entry cards just received."

1 p.

100. TE to John E. D. Trask, 28 Jan 1912.

requests invitation for Colonel Alfred Reynolds and daughter.

1 p.

101. John E. D. Trask to TE, 29 Jan 1912.

invitation sent.

1 p.

102. [office of] John E. D. Trask to TE, 20 Mar 1912.

"Mr Trask asked me to send you the enclosed photograph with his compliments."

1 p.

103. TE to John E. D. Trask, n.d. [1913].

requests reception ticket for Mr. and Mrs. Robert Arthur.

1 p.

104. John A. Myers to TE, 12 Dec 1913.

encloses blue cards of invitation to exhibit in the 109th Annual
Exhibition.

1 p.

105. John A. Myers to TE, 13 Jan 1914.

wishes to exhibit *Portrait of Professor Barker* "provided, of course, it has not
been previously shown in Philadelphia."

1 p.

106. TE to John A. Myers, 14 Jan 1914.

"I entered but two pictures Study for the Agnew Clinic and Dr. Leonard
(Martyr) [to Science] I painted the Barker many years ago, and it was
exhibited. Afterwards it took a medal at the Columbian World's Fair at
Chicago. I know you sometimes violate your rule for previous exhibition.
If you still want the picture you can have it."

2 pp.

107. John A. Myers, 15 Jan 1914.

"Portrait of Dr. Barker" ineligible.

1 p.

108. TE to John A. Myers, 22 Jan 1914.

"Mr Murray among other things entered at the Academy a bust of
Monsignor Kieran. An accident happened in casting. I told Mr Murray
you would doubtless extend his time. The bust is now ready."

1 p.

109. John A. Myers to TE, 23 Jan 1914.

"We are quite willing under the circumstances that Mr. Murray should
send in his bust of Monsignor Kieran."

1 p.

110. TE to John A. Myers, n.d. [Feb. 1914].

request for reception card for Rev. H. J. Heuser.

1 p.

111. TE [per SME] to John Andrew Myers, 26 Jan 1916.

Mr. Eakins would like cards for exhibition sent to Mr. and Mrs. William G. Macdowell, Miss Blanche Hurlbut, Mr. & Mrs. Nicholas Douty (care of Charles Adamson).

1 p., signed by SME.

112. TE [per SME] to John A. Myers, 9 Mar 1916.

"If the painting "Pushing for Rail" is still in my possession when this exhibition closes, The Metropolitan Museum will send for it. Please let them have the picture."

1 p., signed by SME.

113. John A. Myers to TE, 4 Apr 1916.

requests date and signature on card giving information about the painting *Music*.

1 p.

114. Miscellaneous sales and shipping receipts including sales receipts for: Study for Agnew Clinic, Starting Out for Rail, and Music.

9 items.

Series II: Letters from Thomas Eakins to members of the Sartain family

1. TE to William Sartain and Emily Sartain, 12 Jun 1866, [Philadelphia].

writes on root meaning of the word *naif* and a dozen synonyms for it; note to Emily on certain verbs.

4 pp., initialed.

2. TE to Emily Sartain, 17 Sep 1866, Philadelphia.

is sailing from New York on Saturday. "Willie expects to spend the last of the week with you in New York where I can see you Friday evening or Saturday morning. He suggests a picture gallery as the place of our meeting and parting."

1 p., signed "Tom."

3. TE to Emily Sartain, 18 Sep 1866, Philadelphia.

letter in Italian, written on eve of his departure for New York, before sailing for France; assures her that he realizes she will miss him, but greater will be his yearning for home and family.

2 pp., signed "Tom."

4. TE to Emily Sartain, 16 Oct 1866, Paris.

letter written in Italian; asks after her health; is glad that she has begun to appreciate the noble qualities of one of his friends; assures her that the exhibition [Salon] will indeed take place.

2 pp., initialed.

5. TE to John Sartain, William Sartain, and Emily Sartain, 29 and 30 Oct 1866, Paris.

to John Sartain: thanks him fervently for good letters of recommendation and for entrusting him with a commission from which has sprung his good fortune of entering the Imperial School.

to William Sartain: writes in French, reminding him that he has promised to begin studying French. He has been admitted to L'École Imperiale and begins his studies under Gérome.

to Emily Sartain: writes in Italian; apologizes for not writing sooner, but has been very pressed in finally gaining admittance to the Imperial School

of Fine Arts; has acquired three friends in Paris: Crepon, Dr. Hornor, and Lenoir; speaks of the expected arrival of William Sartain.

4 pp., initialed.

6. TE to Emily Sartain, 16 Nov 1866, Paris.

in answer to letter from E. S., touching upon his love of and pride in his home city, Philadelphia, his definitions of a polite man, etc. "I know nothing yet of Miss Casat but from what I know of Gérome I think the whole story extremely probable."

3 pp.

7. TE to Emily Sartain, 12 Apr 1867, Paris.

has fulfilled his "mission" for Henry; glad to have a letter from her.

1 p.

8. TE to Emily Sartain, May [1867], Paris.

in Italian; thanks her for her recent letter and is grateful for her kindness to his friend Mr. Irwin, whose paralysis continues.

1 p., initialed.

9. TE to John Sartain, 24 Nov 1867, Paris.

very glad to get letter from you. "I have again settled down to work the school being reopened. . . . I have a letter from Gastaldi, but do not dare send it to London for fear it wont get there in time."

1 p.

10. TE to Emily Sartain, 20 Dec 1867, Paris.

defends himself against her charges that he is hard and cynical and that he has written about other matters instead of about her family. "They were very erratic, had no plans very fixed except general ones." "There is one thing though very funny in your letter. I insist that the duties and responsibilities of men and women are equal, etc. Tell me truly, how hard

did you set down your pretty little foot after writing that." "You never learned that from yourself Emily or my mother or your mother."

2 pp.

11. TE to Emily Sartain, n.d. [probably 1867] [Paris].

Letter in Italian, beginning with a poem: "Non era ancor"; long discussion of the poem and its proper translation; has been to see Mr. Waugh, whose health is not much better.

3 pp., salutation page missing. [In this letter TE discussed parts of Canto XIII of Dante's *Inferno*.]

12. TE to Emily Sartain, 11 Jun 1868, Paris.

"I will be very glad to see you so soon.... You will probably choose a train coming to Paris in the evening. I will meet you at the depot on your arrival, and if such is the wish of your friends, I will have two rooms engaged."

2 pp.

13. TE to Emily Sartain, 7 Mar 1886, Philadelphia.

offers to recommend her to principalship of the School of Design left vacant by the death of the principal. "I consider you as better qualified than anyone else to direct such a large school: for you have great and good influence over young people and old too for that matter, and combine art talent, art education, and a thorough practical knowledge of one technical branch, engraving."

2 pp.

14. TE to Emily Sartain, 25 Mar 1886, Philadelphia.

"I send you a statement which I leave entirely to your own discretion. It is comprehensive, & shown to some persons might do a deal of good. It is carefully written and covers all the ground. Anshutz is teaching in all my classes at the Academy having given one class to Kelly the class formerly taught by himself." Statement enclosed: Has frequently used as models for himself his male pupils; very rarely female, and then only with the knowledge and consent of their mothers. A list of these pupils came to the hands of Mr. Frank Stephens, who since that time has boasted about his power over me to turn me out of the Academy, etc.

1 p., 2-page enclosure.

Series III: Letters from Benjamin Eakins to Emily and Paul Sartain

1. BE to Emily Sartain, 15 Oct 1869, Philadelphia.

short note with message from a Miss Lidie Lang, that she will be out of town for several months.

1 p.

2. BE to Emily Sartain, 20 May 1871, Philadelphia.

"Yesterday I was speaking to Mrs. Misschert about your little visitors—she says they are called the 'Shad fly'."

1 p.

3. BE to Paul Judd Sartain, 14 May 1885, Philadelphia.

Hope you all had a good time last evening. Disappointed that he could not go but felt some people might be made uncomfortable by his presence. A person of good judgement thought it wrong for him to go to the schools as he might carry the measles contagion in his clothes and give it to pupils. "Perhaps we can get out into the country as we did up the Delaware. Perhaps you would like to rough it a few days down on the Cohansey at our Fish-house."

2 pp.

Series IV: Documents relating to various members of the Eakins and Crowell families acquired from the estate of Gordon Hendricks, 1988.

Bond of Warrant: W. Reed to S. Cowperthwait, 9 Sep 1795
Citizenship certificate of Alexander Eakins, 1828 [TE's paternal grandfather]
2 pages from an Eakins family Bible, n.d. [record of births, deaths, and marriages]
3 samples of Benjamin Eakins' handwriting, n.d.
Copy of a book of poems, *The Betrothed, A Nation's Vow* by Dr. W. E.

Guthrie, 1867; inscribed by the author: "Presented to Miss Fanny Eakins with best compliments of the author/ March 4th, 68"; volume contains a photograph of the author

Diary of Fanny Eakins for 1868

Philadelphia Art Students' League printed circular for 1892/93

Offprint from the *Proceedings of the Academy of Natural Sciences,* 1894, "The Differential Action of Certain Muscles Passing More Than One Joint," by Thomas Eakins

Telegram from Thomas Eakins to Will Crowell, 18 Dec 1899.

Receipt for $10 from Frank R. Savidge to Mrs. Frances E. Crowell, 17 Nov 1900

SME to Frances Crowell, 30 Apr and 5 May 1938, 2 pp. each.

Other Repositories of Thomas Eakins and Susan Macdowell Eakins Papers

Listed below are the *major* institutions and private collectors with holdings of papers. Note that all of these collections, including that of the Pennsylvania Academy, are open only by appointment.

Philadelphia Museum of Art

The Eakins collection at the Philadelphia Museum of Art is the single largest concentration of his work in existence. The bulk of the collection was the gift of Susan Macdowell Eakins and Mary Adeline Williams in 1929 and 1930. Other works have been added by gift or purchase. The American Art Department at the Museum has assembled the "Thomas Eakins Research Collection," a large body of research files including:

> photocopies or transcripts of most of the surviving primary documents relating to Eakins (other than Bregler Collection)
> copies of reviews of exhibitions or other published material from Eakins' lifetime
> copies of major publications
> correspondence with researchers, collectors, and descendants
> subject files on individuals, art organizations, or general historical topics
> object files containing background information on works by Eakins

A card catalogue has been prepared for these research materials. The Eakins collection at the PMA is fully documented in *The Thomas Eakins Collection* by Theodor Siegl, Philadelphia Museum of Art, 1978.

The Philadelphia Museum of Art also owns a number of original Eakins manuscripts:

> 108 sheets of notes on linear perspective, mechanical drawing, and other aspects of drawing, ca. 1884
>
> notebook containing expenses, addresses, and letterbook kept by Eakins in Europe, 1866–1868
>
> account of expenses, April 12, 1867
>
> notebook (Exhibition Record), similar in content to that in the Bregler Collection.
>
> three letters: FE to Caroline Eakins, 7 July 1868; BE to Caroline Eakins, [7 July 1868]; TE to Mrs. Edward Russell Jones, 4 Feb 1905

In addition to these files and manuscripts, the Philadelphia Museum of Art was the recipient in 1987 of Lloyd Goodrich's research files on Eakins. These contain hundreds of topical and correspondence files, as well as Goodrich's notebooks for his unfinished catalogue raisonné of Eakins' works.

Smithsonian Institution, Hirshhorn Museum and Sculpture Garden

The Hirshhorn Museum and Sculpture Garden in Washington, D.C., houses an important collection of art, photographs, and manuscripts by Thomas Eakins. The collection is especially relevant to the Academy's Bregler Collection because its original source was Charles Bregler himself. In 1944 Bregler sold a part of his collection, including oil sketches, drawings, photographs, and a few manuscripts, to Joseph Katz, a Baltimore collector. Katz apparently kept the collection in a warehouse until his death. It was purchased by Joseph H. Hirshhorn in 1961.

This collection has been thoroughly documented in the 1977 catalogue, *The Thomas Eakins Collection of the Hirshhorn Museum and Sculpture Garden* by Phyllis D. Rosenzweig. Photographs of every item are included. (Also see Rosenzweig, "Problems and Resources in Thomas Eakins Research: The Hirshhorn Museum's Samuel Murray Collection," *Arts Magazine,* vol. 53, no. 9 [May 1979] pp. 118–20 a special Eakins issue.)

Manuscripts make up only a small part of the Hirshhorn's ex-Bregler collection. However, the Hirshhorn owns another collection of materials

related to Eakins that does contain a good deal of manuscript material. In 1966 Joseph Hirshhorn purchased five scrapbooks containing many photographs as well as letters and clippings of the sculptor Samuel Murray. There are letters from both Thomas Eakins and Susan Macdowell Eakins as well as a few other important figures. The scrapbooks have been well indexed and are available for study on microfilm. The collection also includes a small amount of loose correspondence (mostly letters received by Murray).

Smithsonian Institution, Archives of American Art

The Archives of American Art, in Washington, D.C., houses original documents, as well as photocopies, of numerous Thomas Eakins and Susan Macdowell Eakins manuscripts. All of these, as well as many other documents in private collections, have been microfilmed and are available to scholars via Interlibrary Loan. The most significant items, among the original manuscripts *owned* by the AAA, are the 21 letters, and fragments of letters, written by Eakins to his family from France in the late 1860s. For detailed listings of the holdings consult the published indexes of the AAA.

Bryn Mawr College

The collection at Bryn Mawr College was the gift of Seymour Adelman (1906–1985), a Philadelphia bibliophile. He was a close friend of Susan Macdowell Eakins in the 1930s and and an avid admirer of the work of Thomas Eakins. His collection of Eakins memorabilia was at one time quite large. He sold the bulk of his Eakins material in 1969 to Daniel Dietrich, q.v. He used the proceeds of the sale to purchase the Eakins home at 1729 Mount Vernon Street, which was then given to the Philadelphia Museum of Art. Now restored, it serves as a community art center. (Adelman's attempts to preserve the home can be traced back as far as 1939 in letters to Bregler at the Academy.) Before his death Adelman designed and paid for a grave marker for the then-unmarked graves of Thomas Eakins and Susan Macdowell Eakins at Woodlands Cemetery in Philadelphia.

The Adelman collection encompasses the following:

5 paintings by Susan Macdowell Eakins
over 160 letters from Susan Macdowell Eakins to Seymour Adelman, 1931–1938

over 100 letters from Charles Bregler to Adelman, 1931–1957
1 Thomas Eakins letter: TE to BE, 18 Sep 1868
over 150 photographs of or by Eakins, or his circle

The collection is housed in the Bryn Mawr College Library, Rare Book Room.

Dietrich Foundation

The collection of Mr. and Mrs. Daniel W. Dietrich II of Phoenixville, Pennsylvania, is the largest private collection of Thomas Eakins material in existence. Most of the over 80 objects were acquired from Seymour Adelman in 1969, although the Dietrichs began collecting Eakins memorabilia several years earlier and have added many objects since that time.

The collection encompasses the following:

17 paintings
39 vintage photographs by Thomas Eakins
18 vintage photographs of Thomas Eakins
11 letters by Thomas Eakins
other miscellaneous memorabilia such as Eakins' palette, and books and
 photographs owned by Eakins

Most of the collection has been documented in William Innes Homer (ed.), *Eakins at Avondale and Thomas Eakins: A Personal Collection.*

Macdowell Family Papers

Materials pertaining to both Thomas Eakins and Susan Macdowell Eakins are held by her descendants in Roanoke, Virginia. Although this collection has not been completely catalogued or published, portions appeared in the exhibition *Thomas Eakins, Susan Macdowell Eakins, Elizabeth Macdowell Kenton,* or were cited in the essay by David Sellin that accompanied that exhibition at the North Cross School in Roanoke, Virginia in 1977.

Bibliography

This bibliography lists only the major sources of information and commentary on Thomas Eakins and Susan Macdowell Eakins, and sources frequently cited in the present text. A comprehensive listing can be found in Goodrich's 1982 two-volume work.

Charles Bregler. "Thomas Eakins as a Teacher." *The Arts,* vol. 17 (March 1931), pp. 376–86; "Thomas Eakins as a Teacher: Second Article." vol. 18 (October 1931), pp. 27–42.

Alan Burroughs. "Catalogue of Works by Thomas Eakins (1868–1916)." *The Arts,* vol. 5, no. 6 (June 1924), pp. 328–33.

Carnegie Institute, Pittsburgh, Pa. *Thomas Eakins Centennial Exhibition, 1844–1944.* April 26–June 1, 1945.

Susan M. Casteras. *Susan Macdowell Eakins, 1851–1938.* Philadelphia: Pennsylvania Academy of Fine Arts, 1973.

Kathleen A. Foster. "An Important Eakins Collection." *The Magazine Antiques,* vol. CXXX, no. 6 (December 1986), pp. 1228–37.

———. "Philadelphia and Paris: Thomas Eakins and the Beaux-Arts." Master's thesis, Yale University, 1972.

A Loan Exhibition of the Works of Thomas Eakins. Washington, D.C.: Corcoran Gallery of Art, 1969.

Michael Fried. *Realism, Writing, Disfiguration: Thomas Eakins and Stephen Crane.* Chicago: University of Chicago Press, 1988.

Lloyd Goodrich. *Thomas Eakins: His Life and Works.* New York: Whitney Museum of American Art, 1933.

———. *Thomas Eakins.* 2 vols. Cambridge, Mass.: Harvard University Press for the National Gallery of Art, 1982.

Gordon Hendricks. *The Life and Work of Thomas Eakins*. New York: Grossman, 1974.
———. *The Photographs of Thomas Eakins*. New York: Grossman, 1972.
———. *Thomas Eakins: His Photographic Works*. Philadelphia: Pennsylvania Academy of the Fine Arts, 1969.
William Innes Homer, ed. *Eakins at Avondale, and Thomas Eakins: A Personal Collection* [Dietrich Collection]. Chadds Ford, Pa.: Watson-Guptill, Brandywine River Museum, 1980.
Donelson F. Hoopes. *Eakins Watercolors*. New York: Watson-Guptill, 1971.
Elizabeth Johns. *Thomas Eakins: The Heroism of Modern Life*. Princeton, N.J.: Princeton University Press, 1983.
Cheryl Leibold. "Thomas Eakins in the Badlands." *Archives of American Art Journal*, vol. 28, no. 2 (1988).
A Loan Exhibition of the Works of Thomas Eakins. [New York, Metropolitan Museum of Art], November 5–December 3, 1917.
Henry Marceau. "Catalogue of Works of Thomas Eakins." *Philadelphia Museum Bulletin*, vol. 25, no. 133 (March 1930), pp. 17–33.
Margaret McHenry. *Thomas Eakins, who painted*. Oreland, Pa.: Privately printed, 1946.
Memorial Exhibition of the Works of the Late Thomas Eakins. [Philadelphia: Pennsylvania Academy of the Fine Arts], December 23, 1917–January 13, 1918.
Elizabeth C. M. Milroy. "Thomas Eakins' Artistic Training, 1860–1870." Doctoral dissertation, University of Pennsylvania, 1986.
———. "Transcript of Interview with Lloyd Goodrich: 23 March, 1983." Typescript on deposit in the Thomas Eakins Research Collection, Philadelphia Museum of Art.
Phyllis D. Rosenzweig. *The Thomas Eakins Collection of the Hirshhorn Museum and Sculpture Garden*. Washington, D.C.: Smithsonian Institution Press, 1977.
Sylvan Schendler. *Eakins*. Boston: Little, Brown & Co., 1967.
David Sellin, ed. *The First Pose*. New York: Norton, 1976.
———. *Thomas Eakins, Susan Macdowell Eakins, Elizabeth Macdowell Kenton*. Roanoke, Va., North Cross School, September 18–October 2, 1977.
Darrel Sewell. *Thomas Eakins: Artist of Philadelphia*. Philadelphia: Philadelphia Museum of Art, 1982.
Theodor Siegl. *The Thomas Eakins Collection*. Philadelphia: Philadelphia Museum of Art, 1978.
"Thomas Eakins Centennial Exhibition." *Philadelphia Museum Bulletin*, vol. 39, no. 201 (May 1944).

Biographical Key to Correspondence

The names of senders or recipients of letters in the Bregler Collection to or from Thomas Eakins or Susan Macdowell Eakins are capitalized. Susan Eakins' correspondents are differentiated with an asterisk. Names not capitalized represent individuals who are mentioned in the correspondence of either principal, or who are very important to the study of their lives. All references to portraits are to portraits of persons painted by Eakins. The Academy would appreciate hearing from persons who have additional information on these individuals.

*ADAMSON, CHARLES (), sent condolences on TE's death to SME in 1916.

Adelman, Seymour (1906–1985), bibliophile and art collector; close friend of SME; purchased the Eakins home which he donated to the city as a community art center and Eakins memorial.

Anshutz, Thomas P. (1851–1912), American painter; student and later fellow instructor of TE at the Academy; sided against TE when TE resigned; headed life classes at the Academy until 1892; after two years in Paris resumed teaching, ultimately becoming Director of the Academy's School in 1909.

ARTHUR, ROBERT (1850–1914), painter, summered at Ogunquit, Maine, where he had a studio. His mother's 1900 portrait by TE is inscribed to him.

*BABCOCK, EDMUND C. (ca. 1872–1941), became partner in John Snedecor's New York gallery in 1914; the gallery was later renamed Babcock Gallery and after 1927 Babcock was the New York dealer for the estate of TE.

Barber, Alice. See Stephens, Alice Barber.

BARKER, GEORGE (1882–1965), student of John Laurie Wallace in Omaha, Nebraska; wrote asking TE for advice on art study in 1906.

*BARROW, GEORGE D.(), Academy student 1884–86, never pursued a career in art.

*BEAR, DONALD J. (1905–1952), museum curator; Director, Denver Art Museum 1935–40.

*BECKWITH, BERTHA HALL (–1925), wife of J. Carroll Beckwith whose TE portrait dates from 1904 and is inscribed to her.

BECKWITH, JAMES CARROLL (1852–1917), portrait painter, close friend of TE; portrait 1904; correspondent of both TE and SME.

BLASHFIELD, EDWIN HOWLAND (1848–1936), studied in Paris 1866–70; instructor at the Pennsylvania Academy 1916–18; mural painter, president of the National Academy of Design 1920–26, corresponded with TE concerning anatomy lectures there.

Bonnat, Léon (1834–1923), French painter with whom TE studied in Paris in the late summer of 1869.

Boulton, Edward W. (), painter, pupil of TE at the Art Students' League; portrait ca. 1888; posed for *Cowboys in the Badlands*, 1888.

BRASHEAR, JOHN A. (1840–1920), scientist, inventor, maker of astronomical lenses; corresponded with TE in 1912 about a possible portrait commission.

*BREGLER, CHARLES (1864–1958), student of TE at PAFA and at the Art Students' League; friend of SME after TE's death; owned TE manuscripts, artwork, and photographs.

*BRUMMER, JOSEPH (1883–1947), New York City art dealer who showed work by TE 1923–27.

BRYANT, WALTER COPELAND (1867–1919), Brockton, Mass., businessman and collector of American art; portrait 1903.

Burroughs, Alan (1898–1965), writer, son of Bryson Burroughs, author of three early articles on TE.

*BURROUGHS, BRYSON (1869–1934), Curator of paintings at the Metropolitan Museum of Art 1907–34.

Carlsen, Emil (1853–1932), painter, known in his lifetime for still-lifes; Academy faculty 1912–18.

CHURCH, FREDERICK STEWART (1842–1923), painter and illustrator, active in many New York artists' societies.

*CLARK, STEPHEN C. (1882–1960), collector of TE art; Trustee of the Metropolitan Museum of Art 1932–45 and 1950–60.

COATES, EDWARD HORNOR (1846–1921), served on Board of Directors of Pennsylvania Academy of the Fine Arts 1877–1906, President 1890–1906. As Chairman of the Committee on Instruction, Coates requested TE's resignation in 1886. He was also a patron of TE's, commissioning or buying several works.

COBURN, FREDERICK W. (1870–1953), writer and critic; Secretary of the Copley Society, Boston; requested TE to submit work to a portrait exhibition.

*COLEN, ARTHUR, W. (), Director, Modern Galleries, Philadelphia.

Cook, Weda, (1867–1937), well-known singer; subject of painting *The Concert Singer*, 1892; married Stanley Addicks.

Corliss, George (1839–1908), Secretary of the Academy, 1877–91.

COWPERTHWAIT, ELIZA (1806–1899), TE's aunt on his mother's side.

COX, CHARLES B. (1864–1905), sculptor, Academy student 1880s.

*CRANMER, CLARENCE (ca. 1874?–after 1952), newspaper reporter and friend of TE; acted as agent in SME's early efforts to sell TE works.

Crépon, Lucien (1828–1887), French painter who had known TE from the Pennsylvania Academy and helped him find housing and studio space in Paris; see p. 129, note 3.

Crowell, Ben (1877–1960), TE and SME's nephew; son of William and Frances Eakins Crowell.

*CROWELL, CAROLINE (1893–1972), TE and SME's niece; youngest child of William and Frances Eakins Crowell; became a physician.

Crowell, Ella (1873–1897), TE's and SME's niece, daughter of William and Frances Eakins Crowell; after her suicide in 1897 relations between the two sides of the family were severed. Several family members believed that her insanity and suicide were brought about by her affection for her uncle.

*CROWELL, FRANCES (1890–1971), TE and SME's niece; daughter of William and Frances Eakins Crowell.

Crowell, Frances Eakins (TE's sister). *See* EAKINS, FRANCES.

CROWELL, KATHRIN (1851–1879), TE's fiancée from 1874 to her death; sister of his close friend William J. Crowell; portrait 1872; the collection contains 11 letters written to her by TE.

Crowell, Maggie (1876–1920/24), TE's and SME's niece, one of the 10 children of William and Frances Eakins Crowell. TE's sister and niece were both named Margaret. Their nickname is spelled "Maggy" in several manuscripts.

CROWELL, WILLIAM J. (1844–1929), TE's friend from high school and Academy days; traveled in Europe with TE in 1868; married TE's sister Frances in 1872. After 1877 he moved his family to a farm at Avondale, Pennsylvania, which Eakins often visited. As a youth he was known as "Billy". Later he was known as either "Bill" or "Will".

CURE, LOUIS (), French friend of TE; they met in Gérôme's class at the École des Beaux Arts.

*DALESIO, CARMINE (1887–1959), Director, Babcock Galleries, New York, after the death of Edmund Babcock.

Douglas, W. F. (), a man in the Dakota Territory who was asked by Howard Eaton, Manager of the Badger Cattle Ranch, to assist TE during his stay in the area.

Dumont, Augustin-Alexandre (1801–1884), French sculptor with whom TE studied while in Paris.

DUNK, WALTER (1855–), Academy student 1876–81; member of the Sketch Club and Philadelphia Society of Artists; had a studio at 1338 Chestnut St.; little is known of his life.

Eagan, Thomas J. (), painter; Academy student in 1885; portrait 1907; known as "Tommy."

EAKINS, BENJAMIN (1818–1899), TE's father, a successful writing master and professional penman.

EAKINS, CAROLINE ("Caddy"), (1865–89), TE's youngest sister, in 1885 married George Frank Stephens, who was one of the primary instigators of rumors about TE's morality in 1886.

EAKINS, CAROLINE COWPERTHWAIT, (1820–1872), TE's mother.

EAKINS, FRANCES ("Fanny") (1848–1940), TE's oldest sister, married William J. Crowell in 1872; TE and Fanny shared a love for scholarship and music; correspondent of both TE and SME.

EAKINS, MARGARET ("Maggie"), (1853–1882), TE's sister, for whom he felt great affection. Her death from typhoid was a severe blow. TE's sister and niece were both named Margaret. Their nickname is spelled "Maggy" in several manuscripts.

EAKINS, SUSAN MACDOWELL (1851–1938), painter and TE's wife; they were married in 1884; studied at PAFA 1876–1882.

EATON, HOWARD (ca. 1850–1922), Pennsylvania native who, with his three brothers, operated several ranches in Dakota Territory, including the Badger Cattle Ranch which TE may have visited.

FROMUTH, CHARLES (1861–1937), Academy student 1877–82; painter; spent most of his career in Europe.

FROST, ARTHUR B. (1851–1928), Academy student 1878–81; illustrator; friend of TE; sat for two portraits; TE rented his Chestnut Street studio after Frost moved to Long Island.

Fussell, Charles L. (1840–1909), Academy student 1864; landscape painter; friend of TE, portrait ca. 1905.

Gardel, Bertrand (ca. 1808–1885), TE's French teacher and friend of Benjamin Eakins; he is the figure on the left in TE's painting *The Chess Players*. •

GÉRÔME, JEAN-LÉON (1824–1904), French painter; TE's teacher at the École des Beaux-Arts, Paris. TE often omitted the accents in Gérôme's surname.

GODLEY, HENRY (), father of Jesse Godley (1862–89), an Academy student under TE who appears in many of the motion photographs. 16 casts by Jessie Godley were shown at the 1890 Annual Exhibition as a memorial to him.

Goodrich, Lloyd (1897–1987), art historian; expert on TE; published first major monograph on TE in 1933 using research material provided to him by SME, much of which is now in the Bregler Collection.

GRAYSON, CLIFFORD P. (1857–1951), Academy student 1876; painter; won Temple Gold medal 1887; member of the 1891 Committee of Selection which refused to hang TE's *The Agnew Clinic*.

HAMMITT, LILIAN (1865–) and FAMILY, student of TE at the Academy 1883–86; caused a scandal in the mid-1890's by claiming to be Mrs. Eakins; portrait 1887–88; correspondent of both TE and SME.

*HARTMANN, SADAKICHI (1869–1944), writer and critic.

*HENRI, ROBERT (1865–1929), painter; Academy student 1886–94.

HEUSER, REV. HERMAN J. (1851–1933), professor of Latin at St. Charles Seminary; wrote Latin inscriptions for several TE portraits.

HOLLAND, JAMES W. (1849–1922), Prof. Holland, the subject of TE's painting *The Dean's Roll Call;* was dean of Jefferson Medical College.

Holmes, George W. (ca. 1812–1895), Philadelphia painter and teacher; friend of Benjamin Eakins; he is the figure on the right in TE's painting *The Chess Players*.

HOLMES, WILLIAM HENRY (1846–1933), anthropologist and artist; curator of the National Gallery of Art, Washington, D.C., 1907–20; Director, 1920–33.

*HORN, ESTELLE (), wife of Milton Horn, sculptor.

HUEY, SAMUEL B. (1843–1901), attorney and officer of the Art Club of Philadelphia, who was sympathetic to TE's problems in 1886–87.

*HUSSON, LOUIS (1844–1923), photographer/photo-engraver; friend of TE whose portrait of him is dated 1899; served as a pallbearer at TE's funeral; ostensible translator of now-lost letters from J. L. Gérôme to TE.

*IRELAND, SUSAN BAILY (), owner of a New Jersey art gallery. Probably related to Leroy Ireland (1889–1970), a student at the Academy, painter and art historian.

Jordan, David Wilson (1859–1935), landscape painter; Academy student and close friend of TE; portrait 1899.

*KENT, HENRY W., (1866–1948), Secretary, Metropolitan Museum of Art, 1913–40.

KENTON, ELIZABETH MACDOWELL (1858–1953), TE's sister-in-law; SME's younger sister; a painter and art instructor; married Louis Kenton in 1904; her nickname was "Lid."

KER, WILLIAM BALFOUR (), son-in-law of Rear-Admiral Charles D. Sigsbee, whose 1903 portrait was apparently owned by Mr. and Mrs. Ker by 1905.

*KETCHUM, MRS. M. W., (1859–1941), well-known Philadelphia charitable worker who operated the Kensington Neighborhood House; also known as the "Angel of Kensington."

*KIMBALL, SIDNEY FISKE (1888–1955), Director of the Pennsylvania Museum and School of Industrial Arts (now the Philadelphia Museum of Art) 1925–54.

*KING, DONALD B. (), attorney for the estate of Hariette B. Macdowell, SME's sister-in-law.

Lenoir, Albert (), secretary of the École des Beaux Arts, Paris, when TE entered the school; a personal friend of John Sartain, he assisted TE in gaining entrance to the École.

Linton, Frank B. A. (1871–1943), student of TE at the Art Students' League in Philadelphia; portrait 1904.

MACDOWELL, WILLIAM G. (1845–1926), TE's brother in law; SME's older brother; he was very close to them both and very supportive during the period of TE's dismissal from the Academy; correspondent of both TE and SME.

Macdowell, William H., (ca. 1823–1906), TE's father-in-law; a distinguished Philadelphia engraver.

Macklin, Lt. (), a man in the Dakota Territory who was asked by Howard Eaton of the Badger Cattle Ranch to show TE the sights.

*MARCEAU, HENRI GABRIEL (1896–1969), art historian; curator at the Pennsylvania Museum and School of Industrial Arts (now the Philadelphia Museum of Art) at the time of SME's gift of works by TE, and Director 1955–64; organized 1944 centennial exhibition of TE works at PMA.

*MARSH, REGINALD (1898–1954), American painter; son-in-law of Bryson Burroughs; owned several works by TE.

MAYNARD, LAURENS (1866–1917), Boston publisher and book designer; asked TE to donate photographs of Walt Whitman to the Boston Public Library. His firm, Small, Maynard & Co., published an edition of Whitman in 1898 for which TE loaned a negative.

McCREARY, GEORGE (), Chairman of the Union League of Philadelphia committee charged with arranging for TE to paint a portrait of President Rutherford B. Hayes in 1877.

McNiden, William. (), a man in Dakota Territory who was asked by Howard Eaton, Manager of the Badger Cattle Ranch, to assist TE while in the area.

MITCHELL, E. (), a man, probably at the Art Students' League, New York, to whom TE wrote in 1888 defending the use of the completely nude model in anatomy study.

MOELLER, ARCHBISHOP HENRY (1849–1925), Coadjutor Archbishop of Cincinnati; arranged for TE to paint portrait of Archbishop William Henry Elder.

Moore, Harry Humphrey (1844–1926), a fellow student of TE at the Academy and the École des Beaux Arts; Moore, a Philadelphian who lived most of his life in Europe, was a deaf-mute; TE befriended him from their earliest days in Paris. He exhibited in the Academy Annuals between 1876 and 1896. Was a pallbearer at TE's funeral. His painting career in Europe was long and successful.

Morris, Harrison S. (1856–1948), Managing Director of the Pennsylvania Academy of the Fine Arts 1892–1905; portrait 1896; Morris acquired *The Cello Player* for the Academy's collection in 1897.

Murray, Jane (ca. 1866–1952), (Mrs. Samuel Murray, née Jennie Dean Kershaw), wife of TE's close friend and collaborator, Samuel Murray; portrait ca. 1897; several photographs of her may be by TE.

Murray, Samuel (1869–1941), sculptor; student, and close personal friend of TE; shared the Chestnut Street studio of TE from 1889–1900s; collaborated on several projects with TE; portrait 1899.

NELSON, MRS. L. B., () woman in Atlanta, Ga. who corresponded with TE concerning Lilian Hammitt.

O'CONNELL, REV. DENIS JOSEPH (1849–1927), Rector of Catholic University of America; agreed to lend Martinelli portrait to an exhibition.

O'Donovan, William (1844–1920), self-taught sculptor, TE's friend and collaborator on the Soldier's and Sailor's Memorial Arch, Brooklyn; portrait 1891–92.

OGDEN, ROBERT C. (1836–1913), Philadelphia merchant and member of the firm of John Wanamaker; portrait 1904.

*O'STEEN, ALTON (1905–), music educator; acquaintance of SME to whom she gave a relief by TE.

*PACH, WALTER (1883–1958), artist, writer, and critic.

Parker, Ernest Lee (), art restorer; curator of paintings at the Pennsylvania Academy of the Fine Arts 1927–37; brother of Gilbert S. Parker; portrait 1910.

*PARKER, GILBERT SUNDERLAND (ca. 1871–1921), art historian; Curator of paintings at the Pennsylvania Academy of the Fine Arts 1914–1921; organizer of the TE retrospective 1917–18; portrait 1910.

PHILLIPS, LARRY (), a Philadelphia carpenter.

*"PYTHAGORAS," nickname of Franklin Schenck, probably bestowed upon him at the Art Students' League.

Quinn, Edmond T. (1868–1929), sculptor; student of TE at the Academy in 1885–86.

REDFIELD, EDWARD (1869–1965), American landscape painter, one of the first artists to discover and work in the New Hope, Pa. area; portrait 1905.

Richards, Frederick de Bourg (1822–1903), Philadelphia painter and photographer; may have known TE in Paris in 1867–68.

Roberts, Howard (1843–1900), Philadelphia sculptor who studied at the Academy in the 1860s and then in Paris at the École des Beaux Arts while TE was in attendance.

*ROBINSON, EDWARD (1858–1931), museum curator; Director Metropolitan Museum of Art 1910–31.

ROGERS, FAIRMAN (1833–1900), civil engineer and sportsman; a Director of the Academy 1871–83 and member of the Committee on Instruction until 1882; a close friend of TE, he commissioned TE to paint his four-in-hand coach in 1879.

Rothermel, Peter F. (1817–1895), Philadelphia painter; Academy instructor (before 1869 when first building at 10th and Chestnut was in use) and Board member (1846–55); the Rothermel and Macdowell families were close; Rothermel's daughter Blanche married SME's older brother James.

ROWLAND, HENRY A. (1848–1901), American physicist and professor at Johns Hopkins University. TE's portrait of him (1891) is one of his most famous works. The collection contains 12 letters written by TE to SME while he was working on the portrait at Rowland's summer home in Maine.

*SALKO, SAMUEL (1888–1968), Philadelphia mural painter who was befriended by SME.

SARGENT, JOHN SINGER (1856–1925), American painter; lived mostly in Europe; he visited Philadelphia for a few weeks in 1903, staying with Dr. and Mrs. J. William White (q.v.).

SARTAIN, EMILY (1841–1927), friend of TE with whom he may have had a romantic attachment in the 1860s; the daughter of John Sartain, q.v., she too pursued a successful career in art and served as Director of the Philadelphia School of Design for Women for many years.

Sartain, John (1808–1897), Philadelphia engraver and painter; served on Board of Academy 1855–77.

SARTAIN, WILLIAM (1843–1924), close friend of TE from high school and Academy classes; son of John Sartain, q.v.; successful career as a painter and engraver; known as either "Bill" or "Will".

*SAWYER, CHARLES H. (1906–), Director, Addison Gallery of American Art, 1931–40.

SCHENCK, FRANKLIN (1855–1926), a student of TE's at the Art Students' League and "curator" of its studio; a Bohemian "free spirit," he posed for several of Eakins' pictures; wrote to SME in 1916 under the pen name "Pythagoras"; correspondent of both TE and SME.

SCHMITT, JOANNA (), sister of Max Schmitt, q.v.

SCHMITT, MAX (1842–1900), boyhood friend of TE, classmate at Central High; a champion oarsman, he is pictured in the painting *Max Schmitt in a Single Shell*.

Schuessele, Christian (1824–1879), Alsatian-born painter whose Philadelphia career was long and successful; taught at the Academy 1868–79; teacher of TE 1862–65. Eakins served as his assistant at the Academy when failing health after 1876 made Schuessele's teaching duties more difficult. While he apparently spelled

his name as seen here, it was frequently mispelled, even by those who knew him well.

SCOTT, JAMES P. (), wealthy Philadelphia businessman who commissioned the *Knitting* and *Spinning* panels from TE for his new house in 1883.

SEARS, JOHN V. (), Chairman of the Philadelphia Sketch Club; art critic for several Philadelphia newspapers.

SEISS, C. FEW (), Secretary of the Philadelphia Sketch Club; Secretary of the Academy Art Club; Academy student 1878–83; exhibited at Philadelphia Society of Artists Watercolor Exhibition, 1883, and at the Pennsylvania Academy in 1881, and 87.

*SHAEFER, FRANCIS, (), Academy student 1890, 92, 94.

Shinn, Earl (1837–1886), fellow student of TE at the École des Beaux Arts in Paris; successful career as a critic, usually under the pen name of "Edward Strahan"; friend and champion of TE.

SIGSBEE, CHARLES (1845–1923), American naval officer; portrait 1903.

SINN, ANDREW C. (), father of Fanny P. Sinn, who was an Academy student during various years 1878–97.

*SMITH, EDGAR F. (1854–1928), University of Pennsylvania Provost, 1910–20.

SPIEL, RUDOLPH (), Secretary, Art Students' League of Philadelphia; Academy student 1885, 1886, 1891.

Stephens, Alice Barber (1858–1932), PAFA student 1876–80;

Stephens, Charles H. (1855–1931), cousin of George Frank Stephens; known as "Charley"; studied at PAFA 1876, 1879–82; married fellow student Alice Barber in 1890.

*STEPHENS, DONALD (1887–), TE and SME's nephew; son of George Frank and Caroline Eakins Stephens.

Stephens, George Frank (1859–1935), student at the Academy 1879, 1880, 1882, and 1885; usually called Frank; married Eakins's sister Caroline in 1885. First President of the Academy Art Club; worked as a decorator and held a studio at 1338 Chestnut St. He and his cousin, Charles H. Stephens, q.v., were two of the major antagonists in TE's troubles in 1886.

STEPHENS, LOUIS (), uncle of George Frank Stephens and father of Charles H. Stephens.

STOKES, FRANK W. (1858–1955), painter and pupil of TE; introduced TE to Robert C. Ogden and lent his studio for work on Ogden's portrait. Participated in several Antarctic expeditions and specialized in paintings of polar scenes; his 1903 portrait by TE is now unlocated.

THACHER, JOHN BOYD (1847–1909), historian and collector of rare books and manuscripts; twice mayor of Albany, New York; Chairman, Executive Committee on Awards, World's Columbian Exposition.

THOMPSON, MYRA RADIS (1860–), student of TE at Academy, 1885; lived and painted in Tennessee.

TRIPP, ALBERT (), manager of the B–T Ranch in Dakota Territory, where TE spent ten weeks in 1887.

TURNER, MSGR. JAMES P. (1857–1929), Vicar General of the Archdiocese of Philadelphia, 1902–10; friend of TE in later years; 2 portraits ca. 1900 and ca. 1906.

TYSON, JAMES (1841–1919), Philadelphia physician; faculty member at the University of Pennsylvania to whom TE gave photographs of *The Gross Clinic* and *The Agnew Clinic*.

VAN BUREN, AMELIA (1856–1942), a student of TE at the Academy 1884 and 1885; her nickname was "Minnie"; later she frequently visited at the Mount Vernon Street house; pursued a career as a photographer; TE painted her portrait about 1890 and produced several striking photographic portraits of her; correspondent of TE and SME.

*VAN VECHTEN, CARL (1880–1964), writer and critic; photographed SME and CB in 1938.

WALLACE, JOHN LAURIE (1864–1953), painter and pupil of TE at the Academy; close friend of Eakins, he spent most of his career in the Midwest; portrait 1885; correspondent of both TE and SME; known as Johnny.

WHITE, DR. J. WILLIAM, (1850–1916), surgeon and professor at University of Pennsylvania; depicted in *The Agnew Clinic;* TE's unfinished portrait of him (1904; unlocated) was praised by J. Singer Sargent, q.v., who received it as a gift from TE; Sargent's own portrait of Dr. White had appeared at the Academy a year earlier.

WILCRAFT, J. R. (), congratulated TE on his conduct in the Drexel Institute affair.

WILLIAMS, MARY ADELINE (1853–1941), known as "Addie"; childhood friend of the Eakins family; lived with TE and SME from 1900 on. TE painted two portraits of her, 1899 and 1900.

Wood, George Bacon (1871–1954), physician, son of Horatio C. Wood; he was also at the B-T ranch in the summer of 1887.

*WOOD, HORATIO C. (1841–1920), Philadelphia physician and naturalist; part-owner of the B-T Ranch in Dakota Territory; portrait 1886; corresponded with SME over ownership of it in 1917. Wood's son (see above entry) and brother, George Bacon Wood (1832–1909), a well-known Philadelphia painter/photographer, were both named after George Bacon Wood, M. D. (1797–1879), who was Horatio C. Wood's father.

Manuscripts Reproduced in Full in This Volume

Index to This Volume

This index gives page references for names of correspondents, subjects, and internal references in this volume. For readers using the Microfiche Edition of the manuscripts a separate Location Index to the Microfiche Edition follows the Volume Index.

Location Index to the Microfiche Edition

This index lists all the correspondents for the letters of Thomas Eakins, Susan Macdowell Eakins, and Benjamin Eakins, as well as selected subjects of other important documents. The location of the desired item on the microfiche can be determined by reference to the Fiche Location Number in column three. The letter 'R" indicates an item that has been reproduced in full in this volume. Asterisks indicate an item for which a transcription was prepared and filmed. See the chapter on "Editing and Filming Procedures" for detailed instructions on how to locate a specific document in the Microfiche Edition

NAME	DATE	FICHE LOC. NO.
Academy Art Club		
from TE	n.d. [late May 1886] R	I 6/F/1–4
to TE	22 Mar 1886	I 6/F/1–4
Adamson, Charles		
to SME	7 Jun 1916	II 2/F/10–11
Art Students' League		
to TE	1 Jun 1886	I 6/F/9–10
	13 Apr 1888	I 7/B/9
	23 Apr 1888	I 7/B/10
Arthur, Robert		
to TE	*31 Mar 1895 R	I 7/D/11–12
Babcock, Edward		
to SME	22 Nov 1929	II 3/C/3
	25 Nov 1929	II 3/C/6
Barker, George		
from TE	24 Feb 1906	I 5/D/9–10
from SME	*n.d. [Jul 1936] R	II 1/D/4,6

Barrow, George D.
 to SME

27 Jun 1929 II 3/B/14
11 Jul 1929 II 3/C/1

Bear, Donald J.
 to SME 9 Apr 1936 II 3/E/14

Beckwith, Bertha
 from SME n.d. [Mar 1918] II 1/C/3–4
 to SME 1 Apr 1918 II 2/G/8–9

Beckwith, J. Carroll
 to TE 9 Sep 1907 II 8/A/7–8
 to SME 12 Sep 1917 II 2/F/14 to 2/G/1

Blashfield, Edwin Howland
 from TE 22 Dec 1894 I 5/A/12–13

Brashear, John A.
 from TE n.d. [1912] I 5/E/1
 to TE 9 May 1912 I 8/A/11

Bregler, Charles
 from TE 15 May [1888?] I 4/F/11
 from SME n.d., 1917–1938 R (partial) IV 6/C/7 to 8/B/6
 to SME 11 Sep 1920 II 2/G/12
 n.d. [ca. 1929] II 3/D/4–5
 12 Jan 1931 II 3/D/11–12
 other letters sent, n.d., 1923–1951 IV 1/A/4 to 3/F/6
 other letters received, n.d., 1894–1955 IV 5/E/13 to 12/A/3
 correspondence: SME's
 estate 1939–1941 IV 3/F/7 to 5/B/6
 correspondence with the
 Pennsylvania Museum 1944 IV 5/B/7–14
 correspondence with
 Knoedler & Co. 1944 IV 5/C/1 to 5/E/12
 other papers and printed
 matter IV 12/A/4 to 13/E/10
 notes on TE's lectures I 10/E/2 to 11/E/5
 1931 article on TE IV 16/F/7 to 16/G/13

Brummer, Joseph
 to SME

26 Nov 1923 II 3/A/8
12 Apr 1929 II 3/B/13

Bryant, Walter Copeland
 to TE 27 Apr 1904 I 7/G/1–8

Burroughs, Bryson
 from SME n.d. [Nov 1929] II 1/C/9
 n.d. [Apr 1931] II 1/C/14
 to SME 12 Dec 1917 II 2/G/2–3
 9 Dec 1921 II 2/G/13–14
 13 Dec 1921 II 3/A/1–2
 20 Dec 1921 II 3/A/3
 27 Dec 1921 II 3/A/4
 20 Jul 1923 II 3/A/5–6
 20 May 1924 II 3/A/10
 6 Jun 1924 II 3/A/12–13
 1 Apr 1925 II 3/A/14
 9 Apr 1925 II 3/B/1–2
 28 Apr 1925 II 3/B/3
 30 Mar 1927 II 3/B/6
 31 May 1927 II 3/B/4–5
 22 Nov 1929 II 3/C/4–5
 27 Nov 1929 II 3/C/7
 4 Apr 1931 II 3/E/1–3
 9 Apr 1931 II 3/E/4

Church, Frederick Stewart
 from TE 25 Oct 1888 I 4/G/3–4

Clark, Stephen C.
 to SME 21 Jan 1930 II 3/D/7–8
 23 Jan 1930 II 3/D/9
 5 Feb 1930 II 3/D/10

Coates, Edward Hornor
 from TE *15 Feb 1886 R I 3/F/11 to 3/G/1
 n.d. [ca. 10 Mar 1886] R I 4/B/7–8
 *11 Sep 1886 R I 3/G/7 to 4/A/11
 *12 Sep 1886 R I 4/A/12 to 4/B/6
 to TE 27 Nov 1885 I 6/D/12 to I 6/E/1
 11 Jan 1886 I 6/E/2
 14 Jan 1886 I 6/E/3
 8 Feb 1886 I 6/E/4
 10 Feb 1886 I 6/E/5
 13 Feb 1886 I 6/E/6
 18 Feb 1886 I 6/E/7
 24 Mar 1886 I 6/E/8
 13 Sep 1886 I 6/E/9–10

Coburn, Frederick W.
 to TE 26 Jan 1914 I 8/A/12–13

Colen, Arthur
 to SME 5 Jan 1933 II 3/E/7